Rembrandt and His Time

MASTERWORKS FROM THE ALBERTINA, VIENNA

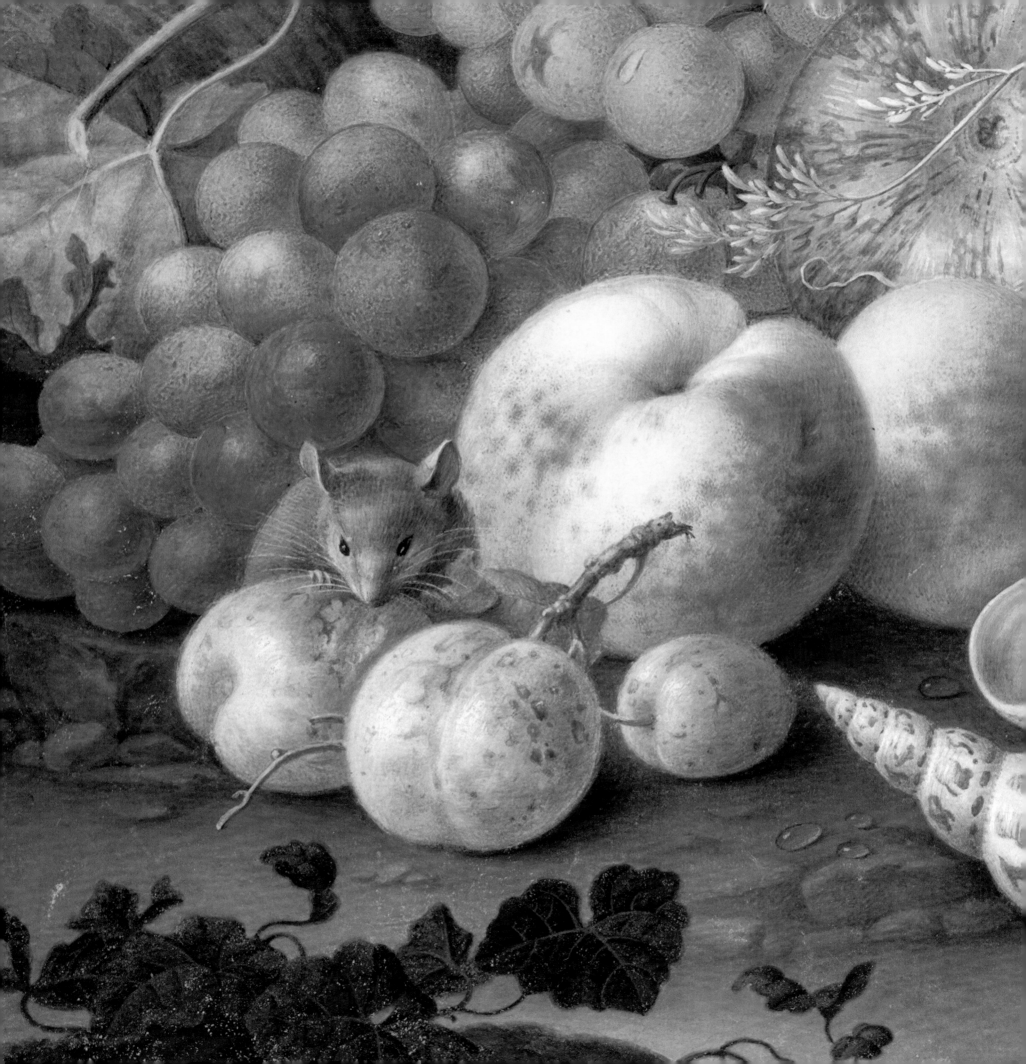

Rembrandt and His Time

MASTERWORKS FROM THE ALBERTINA, VIENNA

Marian Bisanz-Prakken

MILWAUKEE ART MUSEUM
IN ASSOCIATION WITH

HUDSON HILLS PRESS
NEW YORK AND MANCHESTER

Rembrandt and His Time: Masterworks from the Albertina, Vienna is published
on the occasion of the exhibition of the same name on view at the Milwaukee Art Museum
from October 8, 2005 through January 8, 2006.

First Edition © Milwaukee Art Museum 2005

Published in the United States by Hudson Hills Press LLC,
74–2 Union Street, Manchester, Vermont 05254.
Distributed in the United States, its territories and possessions, and Canada by National
Book Network, Inc. Distributed in the United Kingdom, Eire, and Europe by Windsor Books
International.

Co-Directors: Randall Perkins and Leslie van Breen
Founding Publisher: Paul Anbinder

Coordinator and Editor: Terry Ann R. Neff, t. a. neff associates, inc.
Production Manager: David Skolkin
Designer: Steve Biel, Milwaukee Art Museum
Photographer: Peter Ertl, courtesy of the Albertina, Vienna
Proofreader: Laura Addison
Indexer: Karla Knight
Printed and bound by CS Graphics, Singapore

Library of Congress Cataloging-in-Publication Data

Bisanz-Prakken, Marian, 1947–
Rembrandt and his time: masterworks from the Albertina / by Marian Bisanz-Prakken.
p. cm.
Catalogue of an exhibition to be held at the Milwaukee Art Museum on the occasion of
Rembrandt's 400th anniversary in 2006.
Includes bibliographical references and index.
ISBN 1-55595-264-X (alk. paper)
1. Rembrandt Harmenszoon van Rijn, 1606–1669—Exhibitions. 2. Drawing, Dutch—17th
century—Exhibitions. 3. Prints, Dutch—17th century—Exhibitions. 4. Drawing—Austria—
Vienna—Exhibitions. 5. Prints—Austria—Vienna—Exhibitions. 6. Graphische Sammlung
Albertina—Exhibitions. I. Rembrandt Harmenszoon van Rijn, 1606–1669. II. Graphische
Sammlung Albertina. III. Milwaukee Art Museum. IV. Title.
NC263.R4A4 2005
741.9492—dc22
2005014229

FRONT COVER: Rembrandt Harmensz. van Rijn, *Cottages under a Stormy Sky*, c. mid-1630s
(cat. no. 29, detail)
BACK COVER: Aelbert Cuyp, *Reclining Dog*, c. 1645 (cat. no. 68)
FRONTISPIECE: Herman Henstenburgh, *Still Life of Fruit with a Finch and Sea Snail Shells*,
c. 1700 (cat. no. 109, detail)

ILLUSTRATIONS
PAGE 10: Pieter Jansz. Saenredam, *Interior of the Groote Kerk (Church of St. Lawrence) in
Alkmaar*, 1661 (cat. no. 90, detail)
PAGE 16: Jacques de Gheyn II, *Wooded Landscape with a Lancer (?) and a Barking Dog*, c. 1603
(cat. no. 1, detail)
PAGE 52: Rembrandt Harmensz. van Rijn, *A Young Woman at Her Toilet*, mid-1630s
(cat. no. 26, detail)
PAGE 104: Frans van Mieris the Elder, *Sick Woman in Bed*, 1663 (cat. no. 57, detail)
PAGE 140: Roelant Roghman, *Swieten Castle*, 1646/47 (cat. no. 85, detail)
PAGE 196: Willem van de Velde the Younger, *The Naval Battle at La Hogue*, c. 1701
(cat. no. 95, detail)
PAGE 230: Jan van Huysum, *Still Life of Flowers: Vase in front of an Arched Niche*, c. 1734
(cat. no. 111, detail)

Contents

6

FOREWORD

KLAUS ALBRECHT SCHRÖDER

DAVID GORDON

8

SPONSORS' STATEMENTS

GALE KLAPPA, WISCONSIN ENERGY FOUNDATION

CHRIS ABELE, ARGOSY FOUNDATION

9

ACKNOWLEDGMENTS

LAURIE WINTERS

10

INTRODUCTION

MARIAN BISANZ-PRAKKEN

16

CATALOGUE ENTRIES

MARIAN BISANZ-PRAKKEN

Early Genre and Landscape 16

Rembrandt 52

Mid-Century Figures, Genre, and Portraiture 104

Mid-Century Landscape and Topography 140

Marine and Italianate Landscape 196

Still Life 230

242

BIBLIOGRAPHY

250

INDEX

FOREWORD—THE ALBERTINA, VIENNA

KLAUS ALBRECHT SCHRÖDER, DIRECTOR

The Albertina has always had a special relationship with the United States. Oddly coincidental is the fact that they share a milestone date: July 4, 1776 marks both the birth of the United States of America and the establishment of the collection of Duke Albert von Sachsen-Teschen, which formed the basis for the Albertina's renowned collections. However, a feeling of gratitude is the real underpinning of our extensive program of exhibitions in America. It is indeed thanks to the prudence of the American soldiers that, after the end of World War II, a million works of art were successfully returned from the evacuation tunnels in the salt mines of Upper Austria without the least damage or loss.

In the last two decades, the Albertina has chiefly mounted exhibitions of master drawings from several centuries, from the 1400s to the present day, in many American museums, including the Solomon R. Guggenheim Museum, The Pierpont Morgan Library, and the Frick Collection in New York; the National Gallery in Washington, D.C.; the Getty Museum in Los Angeles; the Kimbell Art Museum in Fort Worth, Texas; and the Speed Art Museum in Louisville, Kentucky. While these exhibitions have enabled us to give an overview of the historic breadth of our collections, *Landscape in the Age of Rembrandt*, which traveled to the United States in 1995, provided a deeper look into one specific period. The present exhibition, which was conceived and developed exclusively for the Milwaukee Art Museum, differs from this earlier exhibition in that it presents not only landscape drawings, but encompasses all thematic areas and schools of seventeenth-century Netherlandish drawings. The towering figure of Rembrandt once again stands at the center point, for he was at home in any given category: landscape, biblical narrative, common folk, portraiture.

Rembrandt and His Time inaugurates a collaborative relationship between the Albertina and the Milwaukee Art Museum. I would first like to thank Director David Gordon as well as Laurie Winters, curator of earlier European art at the Milwaukee Art Museum, for the close cooperation between our two museums. In Laurie Winters, we found a capable partner who actively participated in the conception of the exhibition. The exhibition was conceived and developed at the Albertina by the curator of Netherlandish drawings, Marian Bisanz-Prakken. Thanks to her intimate knowledge of the field, she revealed many surprising new insights for us in familiar and famous artworks; new attributions and dates also resulted in the course of her work on this exhibition. I owe Marian Bisanz-Prakken my deepest gratitude for her profound examination of our holdings. I would like to extend my express thanks also to the restorers Elisabeth Thobois, Ulrike Ertl, Hannah Singer, and Karine Bovagnet for their conservation and restoration work on the objects for the exhibition. For the professional administration and logistical arrangements of the exhibition, we thank Loan Management under the direction of Heinz Widauer. Finally, I would like to extend my appreciation to all of my colleagues at the Albertina in Vienna and at the Milwaukee Art Museum, without whose personal engagement and passion for one of the most beautiful chapters of European art history, this project could not have been realized in its desired form.

FOREWORD—MILWAUKEE ART MUSEUM

DAVID GORDON, DIRECTOR

The opening of the exhibition *Rembrandt and His Time: Masterworks from the Albertina, Vienna* is a deeply rewarding occasion that celebrates both the past and the future. It is a distinct privilege as the director of the Milwaukee Art Museum to be able to offer an exhibition of the seminal work of one of the world's greatest artists to American audiences in conjunction with Rembrandt's 400th anniversary celebration in 2006. Rembrandt's unique humanity and immediacy of touch—in landscapes, genre scenes, and biblical and mythological subjects—have remained accessible to viewers through the centuries. His drawings and prints are remarkable for their keen sense of observation combined with soaring leaps of the imagination. We are delighted to bring this spirit of excellence and imagination to the Milwaukee Art Museum.

I am especially grateful to the Albertina's director, Klaus Albrecht Schröder, for his initial conception of the exhibition and his essential support throughout all stages of its realization. We are doubly pleased that this important project was developed as part of an ongoing collaboration with the Albertina that has much promise for the future. The combined efforts of our mutual institutions have resulted in an exhibition of the highest standards. *Rembrandt and His Time* features a selection of one hundred and twelve works on paper from the Albertina; twenty-six examples by Rembrandt constitute the largest number of his works ever lent on exhibition, and there are equally impressive works by many of his contemporaries. The exhibition demonstrates not only the rich holdings of Rembrandt's work but the depth and diversity of the Albertina's collections. Duke Albert von Sachsen-Teschen assembled the core collection of the Albertina during the Age of Enlightenment and today the museum possesses more than one million drawings and prints—one of the largest graphic collections in the world.

We owe special thanks to Marian Bisanz-Prakken, curator of Netherlandish drawings at the Albertina, for her enormous contribution to shaping the content of the exhibition and articulating that vision in the catalogue. Quite simply, the project would not have happened without her hard work and professionalism. In Milwaukee, I would particularly like to acknowledge the work of our curator Laurie Winters, who initiated and refined the concept of the exhibition with her colleagues in Vienna and who coordinated the publication of the catalogue and the installation of the exhibition. The talented staff of the Milwaukee Art Museum should also be acknowledged for their dedication.

For their generous support of this exhibition, I would like to extend my gratitude to the presenting sponsor Wisconsin Energy Foundation and to Chris Abele of the Argosy Foundation. We are genuinely grateful to these sponsors for helping us share Rembrandt's unique vision of the human experience with a broad audience.

SPONSORS' STATEMENTS

GALE KLAPPA, CHAIRMAN AND CHIEF EXECUTIVE OFFICER
WISCONSIN ENERGY CORPORATION

CHRIS ABELE, CHIEF EXECUTIVE OFFICER
ARGOSY FOUNDATION

Wisconsin Energy Foundation is pleased to support the world-class exhibition *Rembrandt and His Time*, which brings from Vienna to Milwaukee the rich diversity of the Albertina's Netherlandish collections. The Albertina has one of the finest collections of works on paper in the world. Its holdings travel only infrequently, and then usually to museums in major cities globally. For this important exhibition, Milwaukee is the sole venue.

The exhibition is intended to help launch the celebration of the 400th anniversary of Rembrandt's birth in 2006. We are excited about working with the Milwaukee Art Museum to bring the work of an artist of Rembrandt's stature to the United States and to share with the people of our city the rich tradition of seventeenth-century Dutch art.

The Wisconsin Energy Foundation believes that partnering with the Milwaukee Art Museum on significant exhibitions is of mutual benefit. Art enhances the quality of life, and first-rate cultural offerings add great value to the community, the area, and the state. In the case of an international exhibition such as *Rembrandt and His Time*, the communal benefits have international resonance.

The opportunity to work with the Milwaukee Art Museum in bringing exhibitions of excellence to Milwaukee has been extremely rewarding. *Rembrandt and His Time* continues this experience through an extraordinary display of important works by remarkable artists from the Golden Age in Holland. Rembrandt was a pivotal and crowning figure in the evolution of Dutch seventeenth-century painting and drawing. To dramatically break with stylistic tradition takes courage; to do so with such confidence and aplomb as to establish new traditions takes even more.

Rembrandt's work is characterized by his dynamic depiction of light and extraordinarily rich palette. To conventional portraiture, he added an uncanny ability to capture complex personality and character. All of this he did with apparently intuitive technique, visible in his spontaneous, swift strokes of pen or brush, finely detailed etching, or fluid application of paint. His work reflects his interest in all aspects of his world, offering a glimpse into the human condition through landscape, portraits, biblical and mythological subjects, and the everyday activities of life. This exhibition is a window on an exceptional talent and the Argosy Foundation is proud to support it.

ACKNOWLEDGMENTS

LAURIE WINTERS, CURATOR OF EARLIER EUROPEAN ART, MILWAUKEE ART MUSEUM

The seeds for this exhibition were sown in Vienna during conversations with Albertina Director Klaus Albrecht Schröder about exhibition collaborations between our two institutions. Director Schröder's unbounded enthusiasm for the great collections of the Albertina and his dedication to new scholarship spurred my commitment to an ongoing partnership. Back in the United States, Milwaukee Art Museum Director David Gordon wholeheartedly embraced the idea of an international collaboration and has championed the project throughout its progress. Helping to launch the 400th anniversary celebration of Rembrandt in 2006, the exhibition presents a thoughtful examination of the work of this master and his contemporaries. As the coordinating curator for the exhibition in Milwaukee, I am deeply grateful to both directors for their encouragement and support in this important tribute to one of the greatest artists of all time.

The book that accompanies this exhibition is the impressive achievement of Marian Bisanz-Prakken, curator of Netherlandish drawings at the Albertina, who authored virtually the entire volume. Her exceptional knowledge, professionalism, and commitment to the project are demonstrated on every page of the catalogue. On her behalf, I would like to extend a special note of gratitude to the many scholars of Dutch and Flemish art who contributed to new research on the entries. Of particular note are Baukje Coenen, Alice Davies, Susanne H. Karau, Wouter Kloek, Robert-Jan te Rijdt, William W. Robinson, Marijn Schapelhouman, Peter Schatborn, Annemarie Stefes, Marja Stijkel, Frank van de Velde, and Anne M. Zaal. I would also like to thank Heinz Widauer, Cornelia Zöchling, and Peter Ertl for the essential support they contributed from Vienna to the exhibition and publication.

Colleagues in every department of the Milwaukee Art Museum have worked tirelessly behind the scenes to help bring the project to fruition. I am particularly grateful to Catherine Sawinski, curatorial assistant, who helped with every aspect of the exhibition and has become a dear friend. For her enthusiasm and energy, I also thank Mary Weaver Chapin, assistant curator of earlier European art, who helped with grant applications and countless other details. Among the many others who provided assistance is Peggy MacArthur, director of grants and restricted gifts, who took on the daunting task of fundraising for the exhibition. Very much appreciated are the efforts of Brigid Globensky, director of Education, who, with her staff, planned the innovative programming for the exhibition. My sincere thanks also go to Leigh Albritton, registrar, who dealt with the often complex matters of insurance and shipping. For their help in many ways, it is a pleasure also to thank James DeYoung, Christine Davidian, Vicky Reddin, Larry Stadler, and John Irion.

For the beautiful catalogue that accompanies this exhibition, I am grateful to Steve Biel, director of Design, whose sensitivity and clear-sightedness have produced a volume of exceptional elegance. I also want to acknowledge Leslie van Breen of Hudson Hills Press for so enthusiastically agreeing to copublish this catalogue with the Milwaukee Art Museum. Tawney L. Becker is to be commended as well for her outstanding translation of the German entries and her careful and dedicated contributions to every stage of the book's development.

My greatest debt is in many ways to Terry Ann R. Neff of t. a. neff associates, inc., who brought the manuscript to completion with assurance and an unparalleled professionalism. She not only immeasurably improved the text, but her enthusiasm for the exhibition and the accompanying catalogue has inspired and sustained me throughout the project. Finally, to all who made this far-reaching enterprise possible, I extend my most sincere thanks.

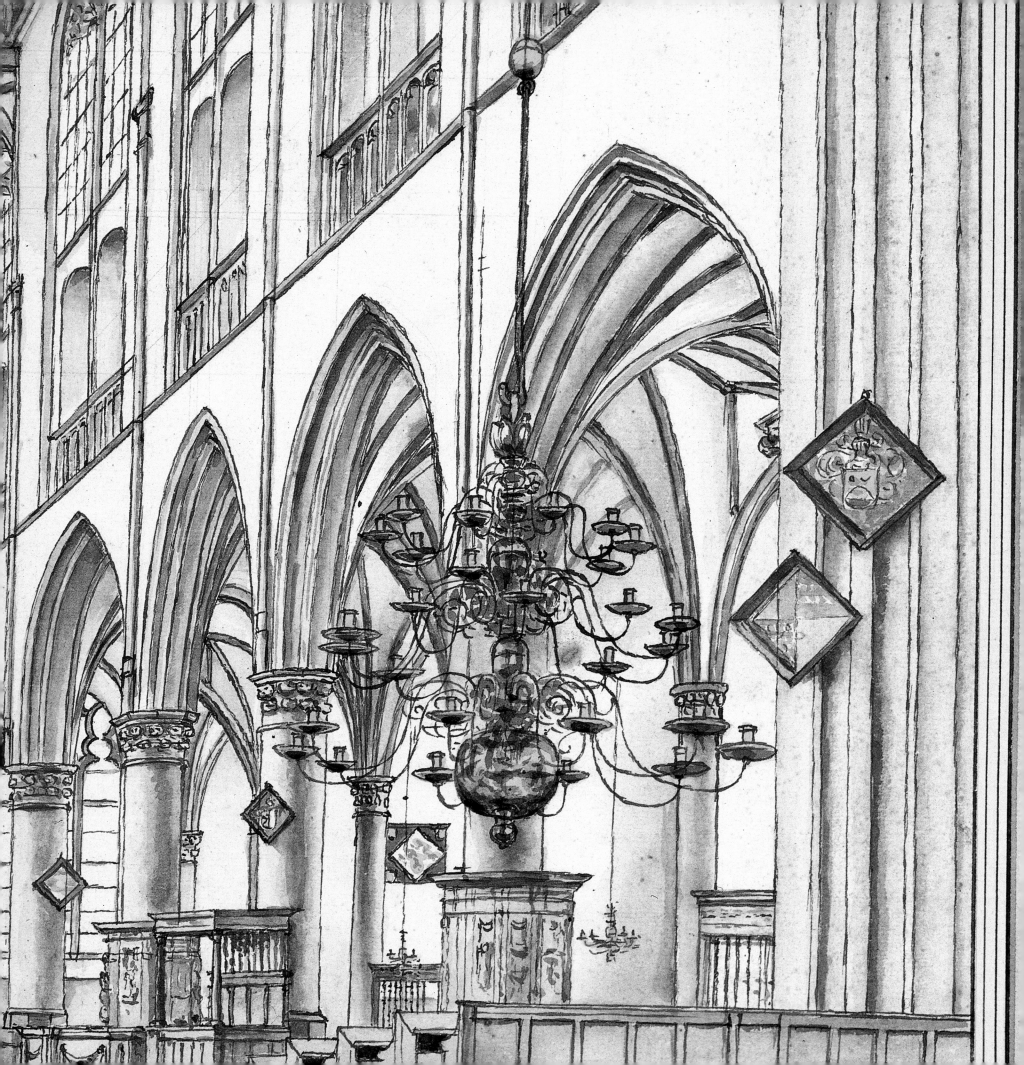

Introduction

MARIAN BISANZ-PRAKKEN

LIKE NO OTHER ARTISTIC PERIOD, THE SEVENTEENTH CENTURY in the Netherlands offered a diversity of works of art on paper and a concentration of outstanding talent and artistic high points that remain unequaled. Through their numerous techniques and functions, intimacy and immediacy, the drawings encompass a far greater range and variety than the paintings of the same period. It is important to note in this regard that the spectrum of the art of drawing in the Golden Age diverged somewhat from that of painting. Of many famous painters—for example, Jan Steen, Frans Hals, Jan Vermeer, or Salomon van Ruysdael—no drawings or only a very few are known. By contrast, there was a succession of extraordinarily gifted artists who were active exclusively or predominantly as draftsmen. A large number of artists who excelled in both areas fall between these two extremes: Rembrandt, first of all, but also Aelbert Cuyp, Willem van de Velde the Elder and the Younger, Nicolaes Berchem, Allart van Everdingen, the van Ostade brothers, to name only a few.

The works of art on paper featured in this book and the accompanying exhibition beautifully demonstrate this diversity. They have been arranged according to chronological, thematic, or individual criteria within six general categories: Early Genre and Landscape; Rembrandt; Mid-Century Figures, Genre, and Portraiture; Mid-Century Landscape and Topography; Marine and Italianate Landscape; and Still Life.

Unlike the exhibition organized by the Albertina in 1993, *Landscape in the Age of Rembrandt* (which traveled to the United States in 1995), here all categories of drawings are represented. Famous masters and frequently published drawings appear along with the works of lesser-known artists presented to the public for the first time. Naturally, the selection of works greatly reflects the preferences of the collector. Duke Albert von Sachsen-Teschen's particular interest in pictorially complete compositions and highly finished studies largely reflected the taste of the period at the end of the seventeenth and early eighteenth centuries. Thus, the Albertina has outstanding holdings of colorful still lifes by Herman Henstenburgh, an artist largely unknown today, and by his famous younger contemporary Jan van Huysum, as well as exquisite watercolors by Adriaen van Ostade, Cornelis Dusart, and many others. Also characteristic of the Albertina's

collection of Netherlandish seventeenth-century drawings are the high number of portraits and richly detailed, topographically oriented landscapes. The heart of this present catalogue and exhibition is certainly the Rembrandt collection, whose impressive comprehensiveness and variety bear witness to Duke Albert's unerring sense for work of the highest caliber.

The first section of the book is devoted to the fascinating period of the early seventeenth century, in which the depiction of visible reality was conquered step by step. Landscape, animal, and genre drawings by great artists such as Jacques de Gheyn II, Roelant Savery, and David Vinckboons point to the substantial contribution Flemish immigrants made to the development of the new realism in the northern Netherlands. Their works laid the foundation for the pioneering achievements that Esaias and Jan van de Velde effected in Haarlem through the landscape drawings inspired by their homeland. The artistic development of the famous landscape artist Jan van Goyen also began in this fertile Haarlem milieu. While van Goyen employed as his predominant medium the black chalk that had been introduced by his master Esaias van de Velde, Hendrick Avercamp, who worked in nearby Kampen, preferred watercolor for his landscape drawings. In so doing, he made reference to the detailed colorfulness of Flemish examples, though he transposed this inspiration into a new visual vocabulary with a typically Dutch character. The works included by Vinckboons, Gillis d'Hondecoeter, and Maerten de Cock impressively demonstrate that the Flemish Mannerist tradition could live on alongside the new realistic landscape.

The core group of works by Rembrandt includes eighteen master drawings and one from a student—approximately half of the approximately forty original drawings in the Albertina collections—augmented by eight highlights from his brilliant oeuvre of prints. The selection spans the early 1630s through his late period of production around 1660. In both its technical and thematic versatility, this exquisite group brings to life the full power of Rembrandt's artistic genius. Included are extraordinary figure studies "from life," several highlights from his landscape drawings, a striking study of an elephant, a very individual rendering after an exotic model, a highly evocative

biblical story, and a rare, late self-portrait. Rembrandt's virtuoso skills in handling the drawing media are revealed in subtle works in black or red chalk, in drawings exclusively in pen, and in sheets in which pen and brush are combined. The etchings and drypoints dating from various periods of Rembrandt's career attest to his constant urge to experiment—a virtually boundless drive passionately expressed in the impressions of his visionary masterpiece *The Three Crosses*.

Together, the drawings and prints present the great scope of Rembrandt's oeuvre, from studies "from life" to those "from the imagination." His work ranges from the intimate, human observations of his small figural sheets to the monumental staging of his narratives; from the immediacy of landscape sketches from nature to the Baroque drama of drawings and etchings produced from the imagination, which are dominated by stormy atmospheric effects. For Rembrandt, drawing from nature and the living model was the unconditional prerequisite to working from the imagination. Drawing served not only his immediate purpose in preparing his compositions, it notably provided practice in rendering as convincingly and as realistically as possible the emotion and light effects of the history pictures he composed in his imagination.

Rembrandt passed along to generations of pupils his artistic credo of drawing "from life." Three artists who emerged from his circle of students mark the beginning of the group of figure, portrait, and genre drawings from the second half of the seventeenth century that followed, in which studies both from life and from the imagination were realized in a number of ways. Govaert Flinck, Nicolaes Maes, and Gerbrand van den Eeckhout developed their Rembrandt training in drawing from the living model in different directions; common to them all, however, is the fundamental role played by light.

There are numerous outstanding examples of figure drawing from this period. Published here for the first time is a red-chalk study of a standing boy by Adriaen van de Velde, one of the most brilliant figural draftsmen of the time; it served as the direct model for a painting. Moses ter Borch, who died at age twenty-two in a sea battle, was the brother of the famous genre painter Gerard ter Borch. Noted for his small portrait drawings, which are suffused with light

and highly focused, Moses ter Borch was one of the most original talents among the seventeenth-century draftsmen; his smiling self-portrait on blue paper is an especially moving work.

The peasant genre, which developed out of the sixteenth-century Flemish allegorical tradition into an independent, realistic category of representation, holds an important place within the art of the Golden Age. The most famous portrayers of peasant life were the Haarlem artists Adriaen van Ostade and his considerably younger brother Isack, whose drawings display a sure and spontaneous hand. Most of their scenes depict taverns filled with gatherings of peasants indulging uninhibitedly in human pleasures; they are based on intense study "from life." Scenes that appear natural yet are composed from the imagination demonstrate the impressive range of Adriaen's diverse technical skills—from the spontaneous, preparatory sketch to the meticulously composed watercolor that equals the status of a painting. Adriaen's follower, Cornelis Dusart, produced detailed studies of heads and single figures in addition to carefully rendered watercolor compositions on costly vellum. His fine hatching recalls the figure studies of his older Haarlem contemporary Cornelis Bega, an earlier pupil of Adriaen van Ostade. Characteristic of Bega's studies of monumental single figures—as of the whole group of Haarlem artists—are powerful strokes and pronounced chiaroscuro effects. Dominating the Haarlem milieu was the classicist Salomon de Bray, whose three sons continued his motifs and compositions. The Haarlem artist Leendert van der Cooghen, a highly talented dilettante close to the circle of Bega, created a drawing after a figure by Salomon de Bray.

Far removed from the classical Haarlem style of figure drawing and the peasant genre of the Ostades was Leiden "fine painting," represented most prominently by Frans van Mieris. His richly detailed genre scenes—exemplified here by a highly finished grisaille on vellum—are characterized by dazzling surface effects and meticulously describe the life of the well-to-do. Jacob Toorenvliet was among the last exponents of this artistic trend; his genre scenes attest to the numerous sources of inspiration he experienced on his extended journeys.

The years 1640–80 saw considerable exploration into many facets of Netherlandish landscape art and the study of nature and architecture.

Some of the works from this period originated while Rembrandt and van Goyen were still alive, but later examples also show their influence. Other artists, however, looked back further to earlier interpretations, which they revived afresh, each in his own manner. There are remarkable drawings by talented dilettantes as well as those by renowned masters. Some landscapes were drawn "from life," while others were done from the imagination. Works of classical greatness and minute, realistically detailed compositions exhibit impressive mastery.

In the spacious landscape drawings by Aelbert Cuyp, one of the great classicists of the middle of the century, architecture and nature are organically unified by a harmonizing atmosphere. His masterful study of a reclining dog showcases his rhythmic black-chalk lines and subtle brush technique. The expansive beach view by Simon de Vlieger reveals a harmonious pairing of human activity and atmospheric space. In contrast to these classically balanced drawings are the dense and texturally diverse forest views—a landscape type that evolved out of the sixteenth-century Mannerist forest interior. The works range from the abstract dots of Cornelis Hendricksz. Vroom's very rare pen drawings, to Anthonie Waterloo's broadly rendered forests suffused with sunlight, to Joris van der Hagen's majestic, towering groups of trees.

The great landscape artist Allart van Everdingen, who, after his return from Scandinavia, produced many autonomous sheets that often included watercolor, drew Netherlandish as well as Nordic motifs. The equally prolific Herman Saftleven drew the Dutch landscape as well as "Rhine fantasies" inspired by Savery and Brueghel. The pen and wash drawings by Rembrandt followers Lambert Doomer, Johannes Leupenius, and Philips Koninck integrate the pen and wash style and chiaroscuro effects of the master within their own individual manners. The landscapes of Jan Lievens, an early friend of Rembrandt, are more Flemish in character.

The topographically oriented views—a type of landscape that became increasingly popular beginning in the mid-seventeenth century—encompass a broad range. Two sheets from an extensive series of large-format depictions of various Netherlandish castles by the young Roelant Roghman mark the beginning of the trend. Three very different artists—Jan de Bisschop, Gerrit Battem, and Allart

van Everdingen—took divergent approaches to the city panorama, also represented in the group of works by Cuyp. Van Everdingen's view with the Church of St. Lawrence in Alkmaar shows the exterior of the structure whose interior Pieter Saenredam had captured a few years earlier in a large-format drawing in pen and watercolor. The latest sheet in this group is the winter river landscape drawn in the 1680s by the silk merchant and very original amateur draftsman Abraham Rutgers, in which the figures of the ice skaters are by Ludolf Bakhuizen.

The marine drawings represent a separate and distinctly Netherlandish category of representation, in which the proud presentation of trade and war ships, in addition to the rendering of naval battles, was often linked to the national conscience. The highly popular representations of ships in distress, on the other hand, were considered metaphors for the limitations of human endeavor. The marine theme offered numerous artists ample opportunity to demonstrate their skill in rendering changing light conditions, dramatic cloud formations, churning water, and atmospheric open space. The chief exponents of marines included here belonged to different generations and were creative as painters as well as draftsmen.

Because of his atmospheric monochrome works in pen and brush from the 1620s, Jan Porcellis is considered an important forerunner of tonalism in landscape art. Allart van Everdingen's richly nuanced, dramatic drawing of a storm at sea is of singular importance; he is the only artist in this group who was neither exclusively nor predominantly a marine painter. Willem van de Velde the Elder executed a meticulous pen drawing on vellum of a flotilla of merchant ships in the tradition of "penwerken" by Hendrick Goltzius; six decades later, around 1700, his son Willem the Younger rendered a highly evocative depiction of a naval battle using minimal media. The detailed harbor views and naval catastrophes in the monochrome compositions by Ludolf Bakhuizen are fascinating in their virtuosity and theatrical light conditions.

There are many aspects to the selection representing the various generations of Netherlandish artists who traveled to Rome and influenced their followers. Bartholomeus Breenbergh and Cornelis van Poelenburch were the first to capture in the broad washes of their

drawings the effects of the brilliant sunlight on southern architectural forms and on the rural environs of Rome. Characteristic of these exceptionally dynamic works are the angular perspectives and powerful chiaroscuro contrasts. In the more subdued drawings by Jan Asselyn, who, like Jan Both, belonged to the second generation of Italianizing artists, sunlight reflects on the walls of historic structures. After his return to the Netherlands in 1641, Both created a number of richly textured landscapes suffused with light in which he lyrically elaborated on the memory of his southern travels. Willem Schellinks, whose view of Valletta is characterized by a variety of exotic forms and light conditions, created topographical views on site.

Many artists, such as Aelbert Cuyp, who remained in their homeland, were influenced in their representation of the Netherlandish landscape by the light effects and pastoral themes of their colleagues who traveled to Italy; a succession of artists, including the extremely versatile Nicolaes Berchem, the highly talented draftsman Adriaen van de Velde, and the attorney Jan de Bisschop, whose brush drawings of hilly southern landscapes executed in brown ink display astonishingly convincing light effects, devoted themselves to the southern landscape even though they never went to Italy.

In contrast to still-life paintings, which had flourished since the early seventeenth century, the subject did not gain ground in the area of drawing until the late seventeenth and early eighteenth centuries. The examples included here are the work of two very different artists. Herman Henstenburgh, a pie maker by trade, specialized in highly detailed and decorative still lifes of fruit and flowers shortly before and after 1700. He cultivated an exacting technique in watercolor and bodycolor in which he typically used a fine vellum as a support. As a brilliant painter of refined and apparently realistic fruit and flower arrangements, Jan van Huysum achieved international fame in the early eighteenth century. Unlike his paintings, his chalk drawings, which often include watercolor, exhibit a surprising freshness and spontaneity.

This overview can scarcely do justice to the range and wealth of the works on paper presented here. Beyond the organization of the exhibition and catalogue discussed above, there are innumerable ways in which to consider and understand the unique qualities and relationships among the Netherlandish drawings. One might compare the gestures and gaze of the attentive mother in the small pen drawing by Jacques de Gheyn II with the psychologically insightful studies of women and children by Rembrandt. Or one could juxtapose Roelant Savery's striking rendering of an elephant with Rembrandt's moving, immediate, "from life" studies of the animal. It would doubtless be highly rewarding to pursue the thousand variations on the theme of light throughout the entire selection; Rembrandt, once again, would appear as the crystallization point. Rembrandt found inspiration in early realism and developed it further in a highly individual manner. Although he did not travel, he was the most universal of all artists since he drew inspiration from his extensive international collection. It is appropriate indeed that his name rightfully graces the title of the book and the exhibition as a whole.

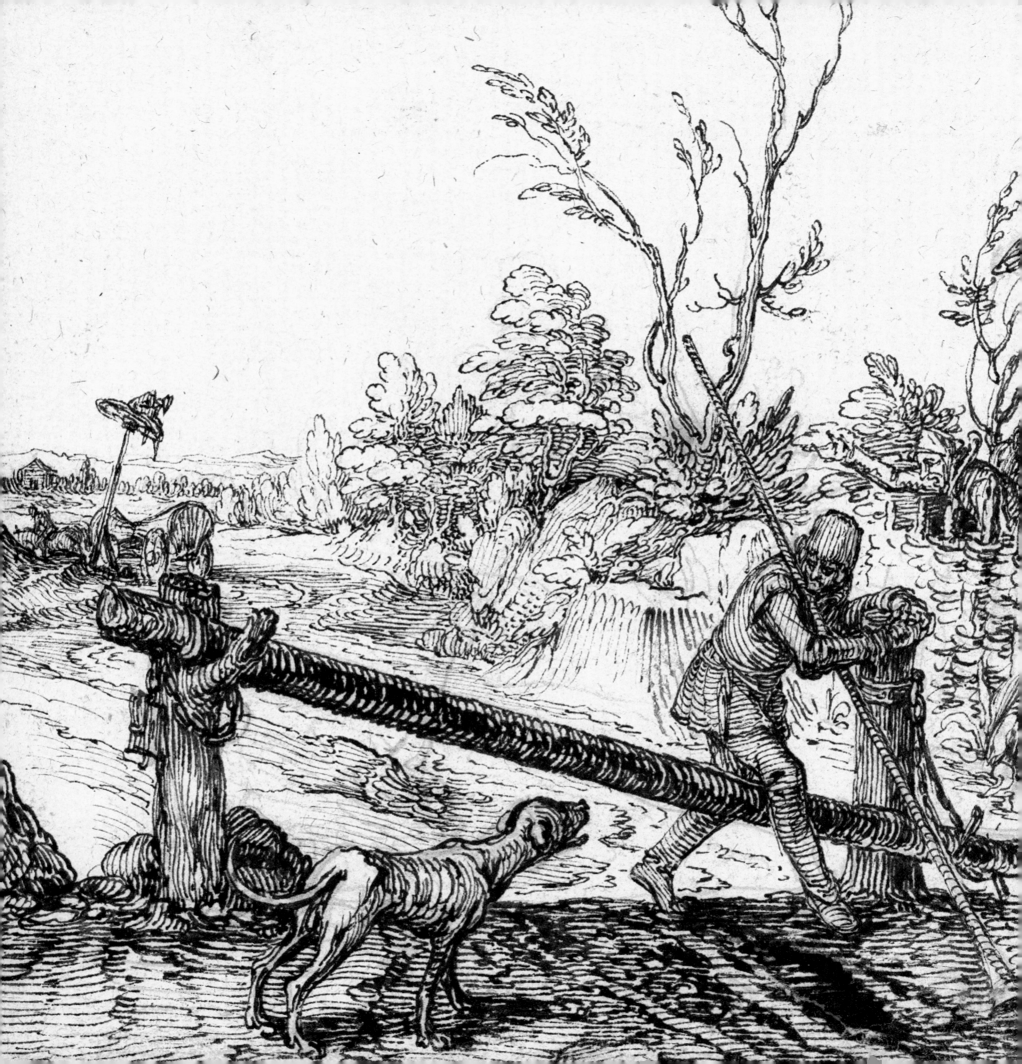

Early Genre and Landscape

Jacques de Gheyn II

ANTWERP 1565–1629 THE HAGUE

1 *Wooded Landscape with a Lancer (?) and a Barking Dog, c. 1603*

Pen and brown ink over lead stylus

23.9 x 31.4 cm

PROVENANCE: Vienna, Hofbibliothek; Duke Albert von Sachsen-Teschen
INV. NO. 8730

BIBLIOGRAPHY: Benesch 1928, no. N 392; van Regteren Altena 1936,
p. 55; Haverkamp-Begemann 1959, pp. 39, 217; Judson 1973, p. 21,
pl. 39; van Regteren Altena 1983, vol. 2, no. 958, vol. 3, pl. 81; Vienna
1993, no. 2, illus.; New York/Fort Worth 1995, no. 2, illus.

After the death of his father and teacher, Jacques de Gheyn I, who
was a glass painter, miniaturist, and designer of engravings in Antwerp,
Jacques de Gheyn II immigrated to the northern Netherlands in 1581.
After two years at Hendrick Goltzius's studio in Haarlem (1585–87),
de Gheyn established and ran his own print workshop, first in Haarlem
and later in Amsterdam. After 1603, he worked at The Hague for the
stadtholder Prince Maurice and his court. Although after 1600 he
devoted himself to painting, de Gheyn's outstanding significance was
decidedly as a draftsman and printmaker. Like Goltzius, de Gheyn
was a proponent of the shift toward the new realism that was emerging
in the northern Netherlands around 1600. This trend is evidenced in
his drawings of portraits, figures, landscapes, and scenes from everyday
life, as well as in his exceptional studies of plants and animals.

In addition to representations of imaginary rock formations,
de Gheyn's oeuvre contains a number of landscapes in which fantasy
and reality are combined in a characteristic way.[1] For example, this
landscape from around 1603 is composed of elements based as much in
the observation of nature as in the imagination. The heavy repoussoir
of trees and rocks is reminiscent of examples by Paul Bril and Girolamo
Muziano; de Gheyn's predilection for crooked trees is evident in

numerous nature studies. Next to these calligraphically stylized, natural
forms are realistic accents such as the landing at left, while a flat
expanse of land edged with dunes extends into the background.
Unlike the elevated perspective still commonly used around 1600, the
horizon appears at the viewer's eye level. Characteristically for the
artist, the narrative connects with themes of misfortune and foreboding.
A man carrying a lance (?) slips over a barricade that has been
lowered, while an emaciated dog barks at him in warning; he may have
secretly deserted from the army passing in the background. An old
farm couple stands behind a fence, the farmer pointing accusatorily in
the direction of the procession of soldiers. A further indication of
wartime conditions is the execution site, next to which stands a covered
wagon that appears to have been raided.[2]

With purely linear means and powerful, elastic strokes,
de Gheyn created a great variety of textures and light and dark effects,
deliberately using the tone of the paper support to impart light values.
Hence, the country road, which recedes at a diagonal, stands out in
bright contrast to the foreground, while the light sky area contrasts
noticeably with the dense lines of the ground and vegetation. Around
1600, de Gheyn's graphic work was shaped by Venetian influences as
well as by his teacher Goltzius. Added to this were his own studies
"from life" and his unconventional imagination. As the present drawing
exemplifies, the combination of these factors led to an unmistakably
unique synthesis.

1 Stylistically related compositions that show a similarly close connection to narrative,
 (i.e., allegory), are located in Berlin, Amsterdam, and Munich. See van Regteren Altena 1983,
 vol. 2, nos. 50, 950, 959.

2 The iconography of the representation leaves several questions open; in the Amsterdam
 drawing (see note 1), the lowered barricade conforms with common emblematic representations
 of decay. See Vienna 1993, no. 2, n. 3.

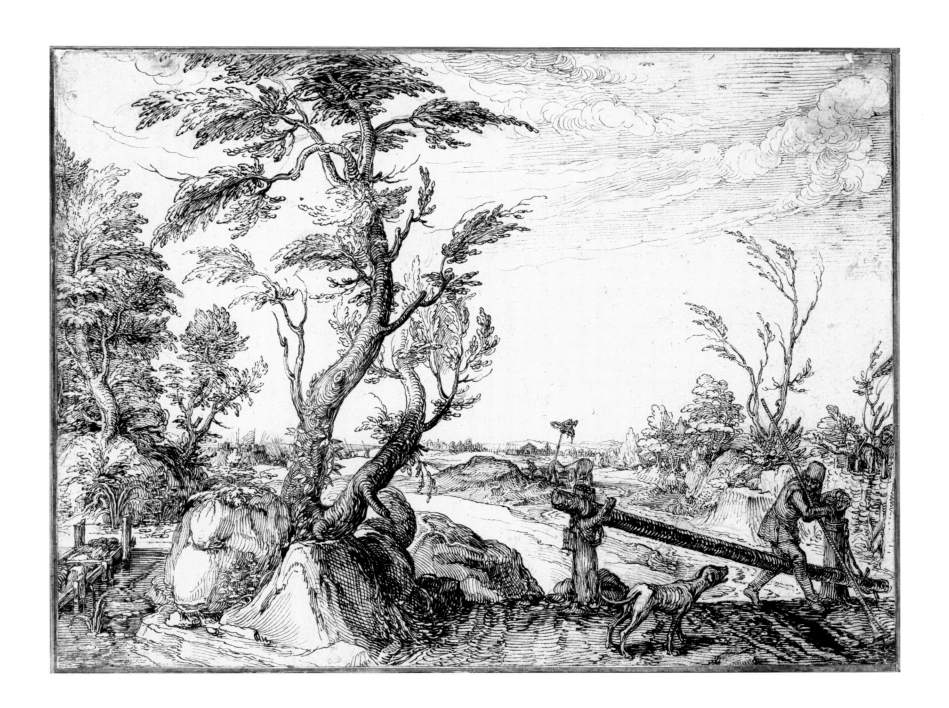

Jacques de Gheyn II

ANTWERP 1565–1629 THE HAGUE

2 *Seated Gypsy Woman and Child,* early seventeenth century

Black chalk, pen and gray-brown ink, red chalk

19 x 15.9 cm

PROVENANCE: Duke Albert von Sachsen-Teschen

INV. NO. 7572

BIBLIOGRAPHY: Benesch 1928, no. N 389; van Regteren Altena 1983, vol. 1, p. 89; vol. 2, no. 573; vol. 3, pl. 300; Amsterdam/Vienna/New York/Cambridge 1991–92, p. 38, under no. 10, n. 5

Jacques de Gheyn II's versatile approach to drawing included studies "from life," resulting in countless scientifically accurate representations of plants and animals. With regard to the human figure, which plays a central role in his work, the spectrum ranges from anatomical detail studies, to model sheets of heads, individual parts of the body, and figure studies in various poses, to scenes from everyday life. On one hand, the artist continued the practices of famous predecessors such as Albrecht Dürer and Lucas van Leyden; at the same time, he developed his own highly individual process of drawing from the live model— a practice that had been initiated by earlier artists such as Hendrick Goltzius, Karel van Mander, and Cornelis van Haarlem.[1] The innovative quality of de Gheyn's life studies lies in his sharp observation of detail and his manner of emphasizing the human, intimate moments of a scene. It has often been noted that his drawings of mothers with children anticipate Rembrandt's numerous studies in his album *The Life of Women with Children* (see cat. nos. 22, 23).[2]

The present drawing of a seated gypsy woman, who has just uncovered her right breast so that she can nurse her baby, displays an expressive intimacy. The "from life" character of the drawing is also apparent in the realistic detail of the basket that stands next to her. The rhythmic flow of the pen lines is characteristic of de Gheyn's

drawing style at the start of the seventeenth century. Here, the long, parallel loops and crossing zigzag lines alternate in density, leaving areas of the paper untouched and convincingly indicating the modeling role of the light. The many folds of the cape, which is spread out on the ground, comprise the most heavily shaded areas. A constant component of de Gheyn's unmistakable stylistic repertoire is his use of the confidently drawn, distinctive outline. Calligraphy rooted in Mannerism blends with an immediate naturalness, resulting in a particular psychological dimension that is expressed here in the mother's tender attention to her child. In an outstanding way, Jacques de Gheyn in his drawings represented the transition from Mannerism to a new realism in the Netherlands at the beginning of the seventeenth century.

De Gheyn's interest in the daily habits and dress of the gypsies, who were banned from city life in an edict of 1595 and thus forced to an existence on the fringes of society, was manifest in a number of drawn studies.[3] The type of clothing worn by the young woman in the Albertina drawing—the cape and headgear—identifies her as a gypsy. The areas in red chalk in this sheet may have been added by a later hand.

1 Regarding Jacques de Gheyn II's drawing style, see Judson 1973, pp. 9–45; and van Regteren Altena 1983, vol. 1, passim. Regarding de Gheyn and the "Haarlem Drawing Academy," see William W. Robinson in Amsterdam/Vienna/New York/Cambridge 1991–92, p. 36, under no. 9; and Peter Schatborn in ibid. pp. 7–8.

2 See especially Judson 1973, p. 21.

3 Van Regteren Altena 1983, vol. 2, nos. 534–39; regarding this theme, see ibid., vol. 1, p. 89.

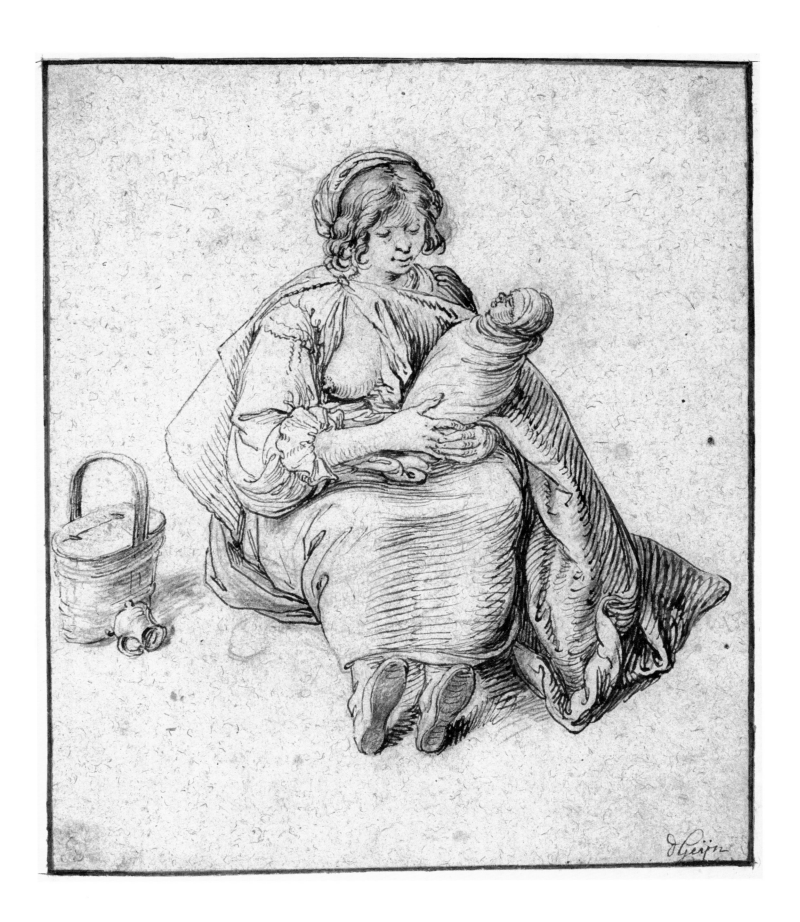

Roelant Savery

Kortrijk c. 1576/78–1639 Utrecht

3 *Elephant Rubbing against a Tree*, c. 1608/12

Black and red chalk

MONOGRAMMED AT LOWER RIGHT: "R S"

43.3 x 55.7 cm

PROVENANCE: Duke Albert von Sachsen-Teschen

INV. NO. 15092

BIBLIOGRAPHY: Ghent 1954, no. 104; Paris 1960, no. 208; Erasmus 1908, no. Z 82, pp. 146–47; Erasmus 1911, p. 8; Spicer-Durham 1979, vol. 1, pp. 171–73; vol. 2, nos. C 140, F 138, Pr 14, F 268; Cologne/Utrecht 1985–86, p. 52

Roelant Savery emigrated with his family from the southern to the northern Netherlands in 1585 and, around 1601, became the pupil and later the colleague of his considerably older brother, Jacques (1565–1603), in Amsterdam. Jacques Savery was an important painter of landscapes that include numerous animals.[1] Around 1604, Roelant moved to Prague and entered the service of Emperor Rudolf II (d. 1612), who was succeeded by his brother, Emperor Matthias. Between 1606 and 1608, Savery traveled through the Tyrol, producing "from life" drawings of mountain landscapes on commission from the emperor. This trip, along with his contact with famous international artists at the court in Prague, deeply affected Savery's artistic development. In 1613, he returned to Amsterdam and, after a short stay in Prague, settled permanently in the Netherlands by 1616, first residing in Haarlem and then in Utrecht from 1619 until his death. A highly respected and influential artist, he remained true to the Mannerist landscape tradition, and also produced genre scenes and flower paintings.

The majority of Savery's some 250 drawings originated during his sojourn in Prague, where Rudolf II kept an exotic menagerie.[2] In comparison to his numerous paintings with animals, most dating from after 1614, the animal drawings form a rather small group; many of his study sheets may have been lost.[3] The present large-format, presumably autonomous drawing of an elephant rubbing against a tree is captivating in its sensitive rendering of the wrinkled skin through dense layering of diverse strokes in black and red chalk. The novel, nearly portraitlike depiction is far removed from the scientific character of sixteenth-century animal images.[4] Savery captured the individuality of the Indian elephant, including its apparent irritation at an itch possibly induced by the sting of the dragonfly departing at the right— an appealing, anecdotal touch.[5] The size of the sheet and the virtuoso handling of the chalk point to a dating following the Tyrolean trip. In this period, Savery abandoned the meticulously detailed style of the Bruegel tradition and discovered chalk as a medium for rendering densely forested mountain landscapes.[6] Together with another representation of an elephant by Savery, *Elephant with a Monkey on Its Back*, the sheet was referred to in the production of a print by Crispijn de Passe II.[7] Just thirty years later, Rembrandt similarly reached an undisputed high point in his appealing use of chalk to convey the character of an elephant (cat. no. 24).

1 On the life of Roelant Savery, see Spicer-Durham 1979, vol. 1, pp. 11–34; Cologne/Utrecht 1985–86, pp. 31–38.

2 For basic information on Savery's drawings, see Spicer-Durham 1979.

3 Regarding the animal drawings, see ibid., vol. 2, nos. C 120–C 147.

4 See ibid., pp. 126–90; see also Anne-Caroline Buysschaert, "Roelant Savery als Tiermaler," in Cologne/Utrecht 1985–86, pp. 51–54.

5 On the symbolism of an elephant annoyed by insects, see Spicer-Durham 1979, vol. 2, pp. 569, 560.

6 On this theme, see William W. Robinson in Washington/New York 1986–87, pp. 260–61, with additional bibliography.

7 See Crispijn de Passe, *Luce del Dipingere* (Amsterdam, 1643), pl. XXIII. See Spicer-Durham 1979, vol. 2, nos. Pr 14, F 268.

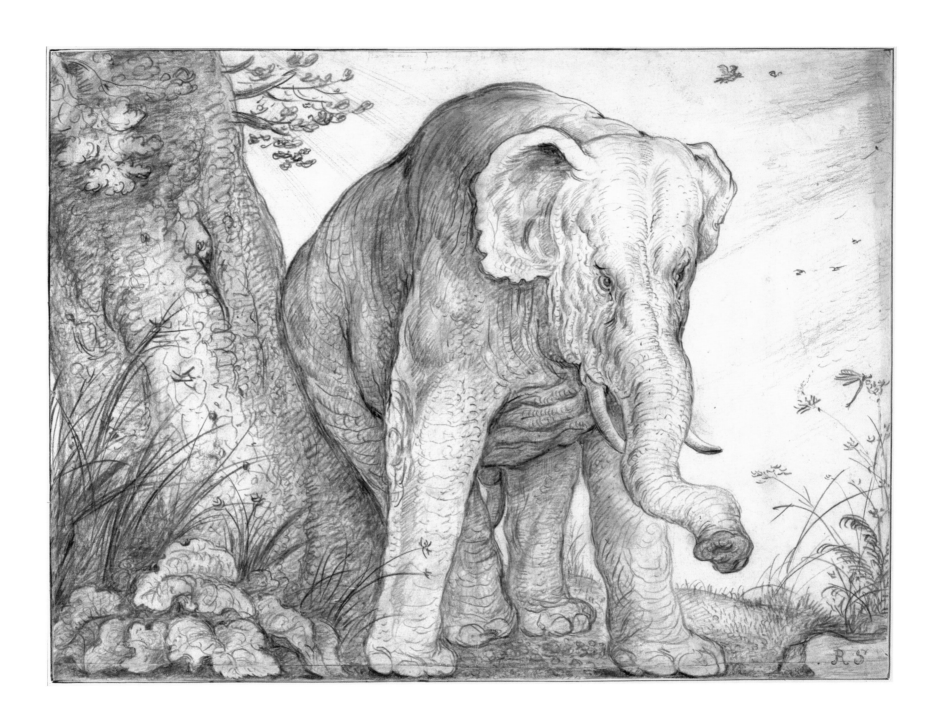

Roelant Savery

KORTRIJK C. 1576/78–1639 UTRECHT

4 *Farmyard with a Beggar Woman,* c. 1608

Black and red chalk, light brown, green, and gray washes, white bodycolor

MONOGRAMMED AT LOWER LEFT: "R S" (by another hand)

43.4 x 55.9 cm

PROVENANCE: Rembrandt van Rijn (?); Lambert Doomer (?); George Earl Spencer; Duke Albert von Sachsen-Teschen

INV. NO. 9944

BIBLIOGRAPHY: Bernt 1957–58, no. 534, illus.; Spicer 1970, p. 6; Schulz 1974, under no. 262; Spicer-Durham 1979, no. 89; Sumowski 1979–92, vol. 2, under no. 498; Vienna 1988, no. 638, illus.

At the beginning of the seventeenth century in the Netherlands, an interest in rustic interiors, decaying and overgrown houses and court-yards, village streets, and random farm equipment was one of the many facets of the new realism artists were exploring.[1] This "painterly" elevation of visible reality, for which Karel van Mander laid the theo-retical underpinnings in his influential publication "Den Grondt der Edel vrij Schilder-const" of 1604, is particularly manifest in the drawings and paintings of Roelant Savery, Jacques de Gheyn II (cat. nos. 1, 2), and Abraham Bloemaert.[2] Like many other types of images that emerged independently from their original allegorical context during the transitional period between the sixteenth and seventeenth centuries, this category blurred the distinction between the original genre picture and landscapes staffed with naturally appearing, rustic figures and "bizarre" (according to van Mander) dwellings.[3]

The present drawing offers an eloquent example of this type, which was developed further over the course of the seventeenth century by artists such as Adriaen Brouwer, Herman Saftleven (cat. nos. 79, 80), and the van Ostade brothers (cat. nos. 58–61). The dilapidated farmyard is distinctive in its rich, picturesque details and complicated perspectival configurations and views. When compared with later versions of this composition, the sheet must have been trimmed at the right edge, where originally there was a view of a village.[4]

Despite the impression of a strong relationship to objective reality, the sheet was not drawn "from life." The composition displays unmistakable similarities to an undated engraving produced around 1607/1608 by Jan Saenredam after a design by Bloemaert. According to van Mander, Bloemaert had drawn numerous "odd" farmhouses and farm equipment "from life" in the area surrounding Utrecht.[5] For stylistic reasons—the soft modeling and delicate contours in chalk recall the execution of Savery's Tyrolean landscape drawings—the drawing has been dated to around 1608.[6] The figures of the beggar woman and her somewhat hidden companion relate to Savery's countless studies "from life" of bohemian farmers, beggars, and the poor, giving a new, realistic twist to the strongly influential Bruegel tradition.[7]

1 On this theme, see Hans-Joachim Raupp in Cologne/Utrecht 1985–86, pp. 44–45, with extensive bibliography.

2 van Mander 1604, ch. 8, verses 31–32.

3 Hans-Joachim Raupp (note 1), p. 45.

4 The later versions are mentioned in Spicer-Durham 1979, no. 89, and by J. Spicer in Cologne/Utrecht 1985–86, p. 169. See, for example, Roelant Savery's painting *The Lost Son,* Brussels, Musée de la Ville de Bruxelles, or a drawing by Lambert Doomer. For the latter, see Sumowski 1979–92, vol. 2, no. 498x.

5 Spicer-Durham 1979 and J. Spicer (note 4).

6 Spicer-Durham 1979 and J. Spicer (note 4).

7 The reference to the relationship to Savery's studies of bohemian costumes is in Spicer-Durham 1979, p. 493, with additional bibliography.

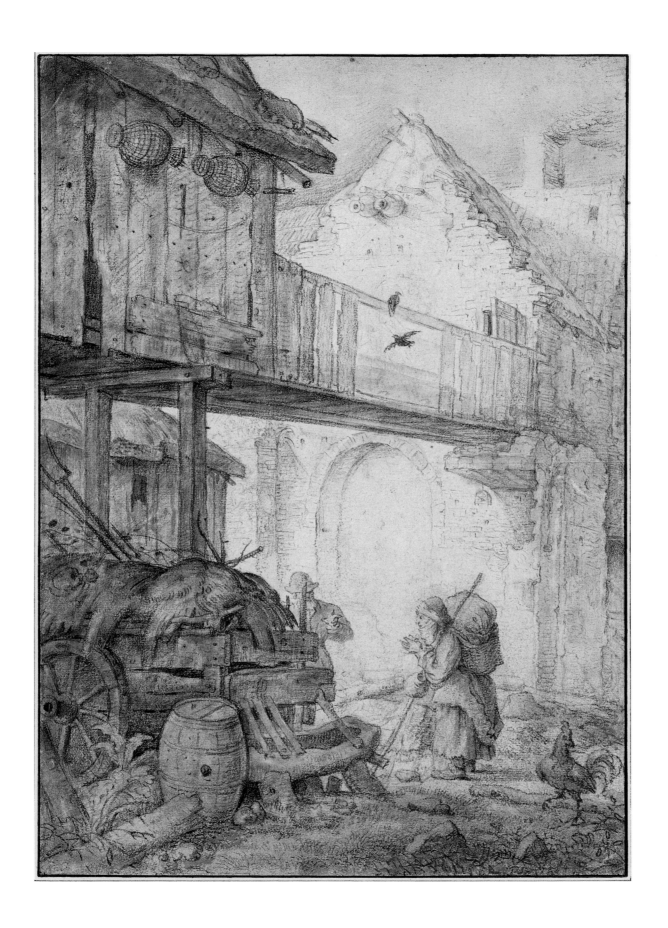

David Vinckboons

Mechelen 1576–1629 Amsterdam

5 *Nautical Company,* c. 1610

Black chalk, pen and brown ink, brown, blue, and gray washes, traces of white heightening

21.4 x 28.1 cm

inscribed in black chalk at lower left: "1594" (presumably by a later hand)

provenance: Prince de Ligne; Duke Albert von Sachsen-Teschen

inv. no. 13372

bibliography: Wegner and Pée 1980, p. 46, no. 53, illus. p. 103; Schapelhouman 1987, p. 170, under no. 100; Sydney 2002, no. 37, illus.

In 1586, ten-year-old David Vinckboons left Antwerp with his parents and moved north. He was trained by his father, the watercolorist Philip Vinckboons. David Vinckboons's imaginary landscapes, which abound with figures, were clearly shaped shortly after 1600 by compositions by Gillis van Coninxloo. While few drawings by Coninxloo are known, around sixty-five drawings by Vinckboons exist.[1] From 1603 onward, representations of kermisses and fairs played an important role. Historical, mythological, and biblical themes predominate in his late drawings.

Within the artist's small group of drawings of interior scenes, the present sheet from around 1610 stands out in its quality. It also represents one of the earliest examples of a realistically depicted interior in Netherlandish drawing from the early part of the century. The gentlemen engaged in lively discussion with one another are informally gathered around a table. They are partly occupied with measuring areas on a globe, while additional measuring devices and nautical equipment are situated on the wall and in the foreground. Below the large marine painting in the upper part of the image are briefly sketched world maps. The same interior is depicted in *Religious Gathering,* a fine, though less spectacular, drawing by Vinckboons in the Rijksmuseum, Amsterdam.[2] Despite the small globe in the foreground and the large marine paintings high on the wall, the gathering of men and women seem to be focusing on studying the bible rather than on nautical topics. The connection between the two drawings is as unclear as their function: perhaps they originated as designs for title sheets.[3]

Figures with measuring instruments are encountered in Vinckboons's study for a cartouche for *Blaeu's World Map* (1605), in which cartography is allegorically represented.[4] In the present work, however, the activity of measuring is depicted in a very natural manner. The unerring, lively pen strokes combine in a suggestive manner with the rapidly applied washes. Soft daylight, fragmented by the dense glass patterns of the windows, partially illuminates the figures and objects, establishing the overall atmosphere of the scene, which is an important document in the new realism being developed in the Netherlands in this period.

1 Vinckboons's drawings are catalogued in Wegner and Pée 1980.

2 Amsterdam, Rijksmuseum, inv. no. 1932:19. See Schapelhouman 1987, no. 100, illus.

3 Regarding the identification of the image and the presumed function of the drawings as designs for title sheets, see Schapelhouman 1987, p. 170, under no. 100.

4 Munich, Staatliche Graphische Sammlung, inv. no. 1132. See *Kunst in Kaart: Decoratieve aspecten van de cartographie* (Amsterdam: Rijksmuseum, Rijksprentenkabinet 1989), p. 65, illus. p. 66.

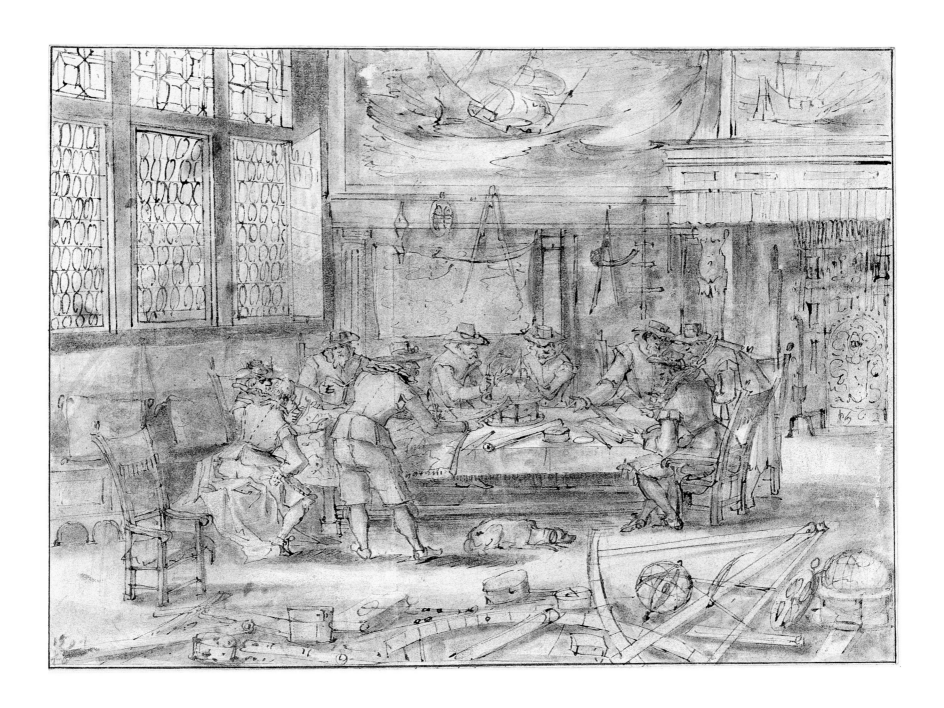

David Vinckboons

MECHELEN 1576–1629 AMSTERDAM

6 *Landscape with a Hare Hunt,* 1601/1602

Pen and brown ink, blue, gray, and brown wash; incised

36 x 50.2 cm

PROVENANCE: G. Winckler; Duke Albert von Sachsen-Teschen

INV. NO. 8343

BIBLIOGRAPHY: Wegner and Pée 1980, pp. 39, 62, no. 12, illus.; Vienna, Albertina 1993, no. 6, illus.; New York/Fort Worth 1995, no. 5, illus.; Pittsburgh/Louisville/Fresno 2002, no. 64, illus.

David Vinckboons achieved great fame particularly for his numerous engravings, which were produced primarily by Nicolaes de Bruyn and Johannes Londerseel after his designs. The present work belongs to an original group of some twenty drawings that were engraved by Londerseel. Nine of these designs, which were drawn around 1601–1602 and are among the artist's earliest works, have survived. The majority of them treat biblical themes; three drawings, including the Albertina sheet, are devoted to secular subjects.[1] The series as a whole is characterized by a highly detailed style of drawing that fills the sheet with many small figures and groups of trees arranged in layers. Also typical of the series is the fantastic architecture that embellishes the background of an overview of a landscape.

The present drawing captures a moment of great excitement: in the foreground, hunters and dogs descend on their prey from all sides. Their movements are captured in quick, sure pen lines and accentuated by lively brushstrokes. The artist's energetic and simultaneously loose pen- and brushwork is revealed in the trees as well; using the traditionally Flemish brown and blue palette, Vinckboons achieved an extraordinarily rich range of nuances of color and light. The lively play of lines and pale blue washes becomes more refined in the background. Here, behind the seemingly Flemish riverside castle, a landscape of fantastic buildings, fields, canals, and villages stretches to the horizon, which is characterized by the mills and churches of a Dutch town.

The elevated perspective of the landscape, the tunnellike forest views at the left, and the powerful repoussoirs of trees are among the Late Mannerist traits of the drawing. Despite the dominance of these artistic devices in its manner of representation, *Landscape with a Hare Hunt* displays great immediacy in its liveliness and fresh execution.

1 Wegner and Pée 1980, pp. 36–37. See also Washington/New York 1986–87, no. 119, illus.

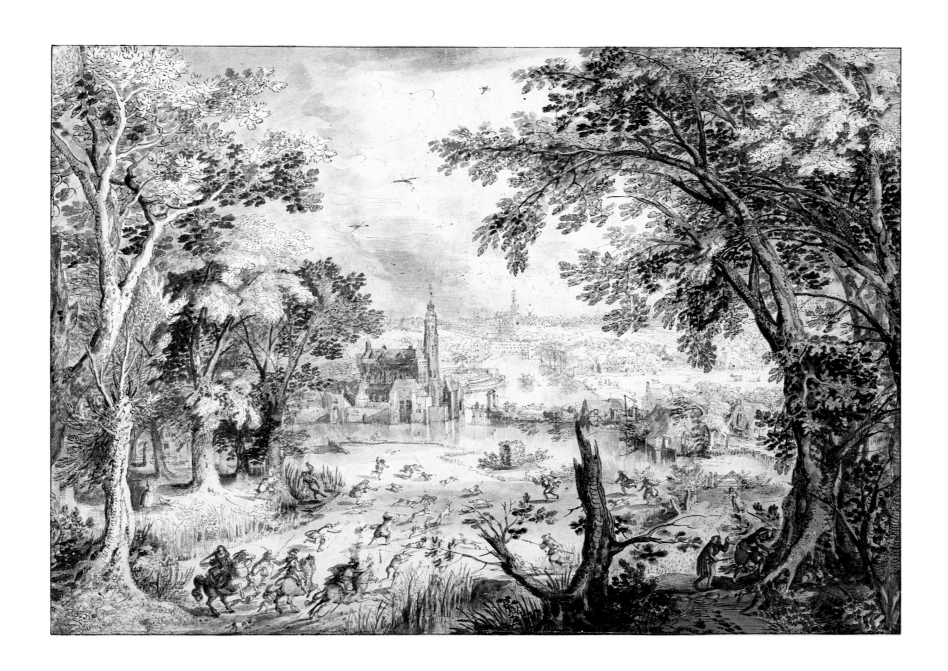

David Vinckboons

MECHELEN 1576–1629 AMSTERDAM

7 *Adam and Eve in Paradise with Animals,* c. 1615–18 or later

Pen and brown ink, brush and brown, gray, and blue inks,
white bodycolor

43.5 x 68.2 cm

PROVENANCE: Duke Albert von Sachsen-Teschen

INV. NO. 15091

BIBLIOGRAPHY: Benesch 1964, no. 144, illus.; Vienna 1965, no. 81;
Wegner and Pée 1980, no. 61, p. 110, illus., pp. 46–47; Vienna 1993,
no. 7, illus.; New York/Fort Worth 1995, no. 6, illus.

Among the idealized forest scenes that Flemish artists imported to the
northern Netherlands, scenes of paradise hold a position of their own
from 1600 to around 1630. Themes such as Adam and Eve, Orpheus,
or Noah's Ark were very popular in this context as they offered the
opportunity of simultaneously portraying many types of animals.[1]
In the northern Netherlands, the actual founder of scenes of animals
in the landscape was Jacques Savery, who emigrated with his family
from Antwerp to the northern Netherlands in 1685. His paintings
Orpheus and the Animals and *Earthly Paradise*, both dated 1601, were
significant as examples of this genre for his considerably younger brother,
Roelant (see cat. nos. 3, 4), as well as for Gillis Claesz. d'Hondecoeter
(see cat. no. 8) and other Flemish emigrants. The modellike poses of
the animals and their lack of relationship to one another, characteristic
of this type of landscape, are traits that can be traced to the practice
of systematically recording types of animals, whether in model-books
or series of prints. Important centers of this activity were Antwerp
and Prague, where the reception of Albrecht Dürer's representations
of plants and animals played a key role around 1600. The popularity
of scenes of paradise is also to be understood in the context of the
ideals of the "Golden Age."[2]

Not many scenes of paradise by David Vinckboons are known.
The present drawing, which represents an unusually large format for
the artist, originated as a study for an undated print by B. A. Bolswert.
Vinckboons was undoubtedly inspired by the many landscapes with
animals that Roelant Savery produced after his final return to the
Netherlands from Prague in 1615. Motifs such as the horse standing
next to the Tree of Knowledge or the broad division of space into
alternately light and dark zones are reminiscent of examples by Jacques
Savery from 1601[3]; however, in Vinckboons's work, the recession
into depth is accomplished in soft transitions rather than in sharply
defined vertical planes. These atmospheric qualities and the density
of the drawing medium appear to point to a date between 1615 and
1618 (or later).[4] The numerous details yield to an overall idyllic
impression rich in tone, which, despite the work's origin in the northern
Netherlands, is thoroughly Flemish in character.

1 On this theme, see Briels 1987, pp. 190–205.

2 See E. Mai in Cologne/Utrecht 1985–86, p. 26. See also in this context the drawing
The Golden Age by Abraham Bloemaert, Frankfurt; see Frankfurt 1992, no. 18, for more
extensive bibliography.

3 Jacques Savery, *Orpheus and the Animals* and *Earthly Paradise*, in Briels 1987, p. 193,
fig. 241 and pp. 194–95, fig. 243.

4 Wegner and Pée 1980, no. 61, p. 110. illus., pp. 46–47.

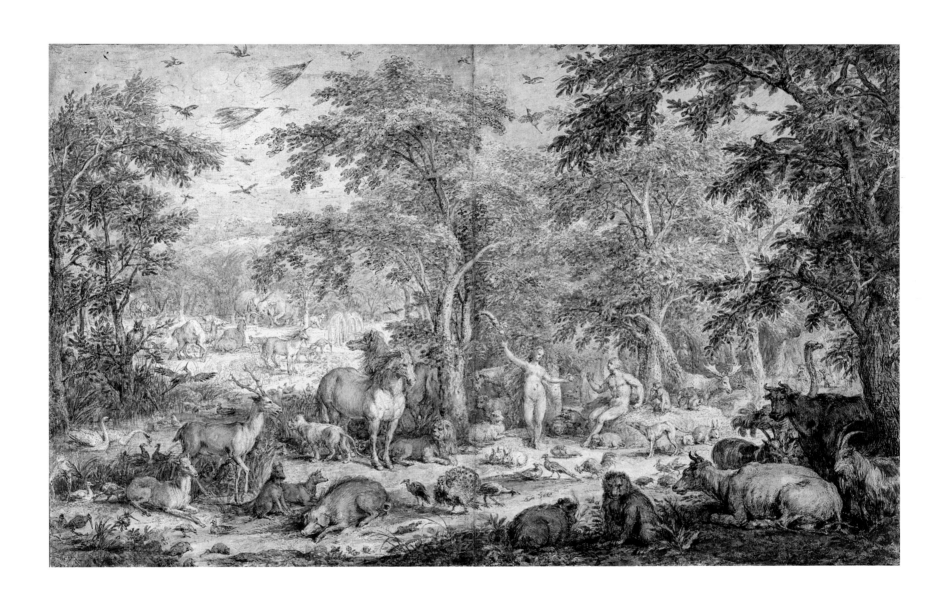

Gillis Claesz. d'Hondecoeter

ANTWERP C. 1575/80–1638 AMSTERDAM

8 *Densely Wooded Landscape with a Water Mill and Houses,* c. 1610/20

Pen and brown ink, brush and blue ink, brown and blue wash

21.1 x 33 cm

PROVENANCE: Baron van Isendoorn à Blois; acquired by the Albertina in 1956 from Gutekunst and Klipstein

INV. NO. 32486

BIBLIOGRAPHY: Benesch 1957, p. 22, fig. 16; Vienna 1958, no. 27; Gerszi 1979, pp. 131–34, fig. 90; Wegner and Pée 1980, pp. 114–15, no. Z 4; Vienna 1993, no. 8, illus.; New York/Fort Worth 1995, no. 7, illus.

Gillis Claesz. d'Hondecoeter was born in Antwerp and immigrated with his family before 1601 to the northern Netherlands. His father, Nicolaes Jansz., and his brother Hans also were painters.[1] Gillis's son and grandson, the painters Gijsbert (1604–1653) and Melchior (1636–1695), continued to practice the profession; thus, the d'Hondecoeter family of painters stretched over four generations.

Gillis is known above all as a painter of landscapes that often included religious or mythological scenes. Especially at the beginning of his career—his earliest work is dated 1602—his paintings demonstrate the unmistakable influence of painters who also emigrated from the south: Gillis van Coninxloo, Roelant Savery (cat. nos. 3, 4), and David Vinckboons (cat. nos. 5–7).

The present landscape drawing was acquired by the Albertina as a work by David Vinckboons—an attribution that was later questioned. In 1979, Teréz Gerszi placed the sheet convincingly in the oeuvre of Gillis d'Hondecoeter, establishing a close connection between it and one of the artist's monogrammed paintings. The panel painting, known only through a photograph, is scarcely larger than the drawing, yet it shows more details in the area of the waterwheel, the houses, and the staffage.[2] Whether the drawing originated before or after the painting cannot be conclusively determined. In any case, its pictorial completeness represents an exception among the few drawings firmly attributed to d'Hondecoeter. The work dates to the second decade of the seventeenth century, a period in which d'Hondecoeter appears to have gradually freed himself from the traditional Flemish landscape style of his supposed teacher, Gillis van Coninxloo. The drawing exhibits gentle transitions in the blue and brown areas rather than the separation of color zones that was common earlier. Late Mannerist effects, such as the repoussoir of trees, the "two tunnel perspective" at left, and the position of the houses in conjunction with the divergent views, are softened through the free brush- and penwork. Beginning in 1615, similar effects can be noted in paintings by d'Hondecoeter, which exhibit restrained tones of brown and green. Their atmospheric character appears to point to the then recent tonal development in Netherlandish landscape represented by pioneers such as Esaias van de Velde (cat. nos. 13–16), Jan van Goyen (cat. nos. 17–20), and Pieter Molyn.[3]

1 Biographical information is from Amsterdam/Boston/Philadelphia 1987–88, pp. 354–55.

2 Gerszi 1979, p. 131, fig. 91, oil on wood, 24 x 34 cm, monogrammed. Photograph from Charpentier auction catalogue, Paris, May 28, 1964, p. 87, pl. 17.

3 Stechow 1966, p. 67.

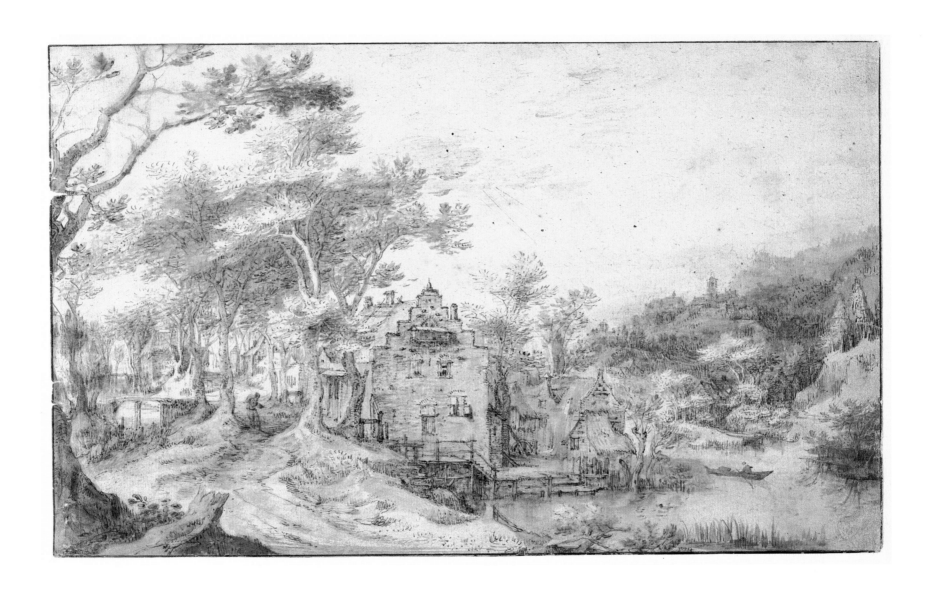

Maerten de Cock

ANTWERP 1578 (?)–1661 (?) AUGSBURG

9 *Herd of Cattle at the Edge of a Forest,* 1628

Pen and brown ink, brown wash, blue and green watercolor

21.7 x 33.1 cm

INSCRIBED AT LOWER RIGHT: "Cock fec 1628"

PROVENANCE: Sybrand Feitama (Auction Amsterdam, October 16, 1758; Kunstboek B, no. 32); Duke Albert von Sachsen-Teschen

BIBLIOGRAPHY: Schönbrunner and Meder 1896–1908, vol. 11, no. 1208, illus.; Bernt 1957–58, vol. 1, no. 149, illus.; Broos 1987, pp. 188–89, fig. 365; Darmstadt 1992, p. 64, under no. 18; Vienna 1993, no. 12, illus.; Schapelhouman 1998, vol. 1, p. 65, under no. 109

Information on the life of Maerten de Cock is scant; his birth in Antwerp in 1578 and death in Augsburg in 1661, as noted by Cornelis Ploos van Amstel in the eighteenth century, have not been verified.[1] The period he spent in Amsterdam in 1630 has been documented, and dated works from between 1620 and 1646 are known.

The majority of de Cock's oeuvre consists of delicately rendered drawings of imaginary landscapes. Like many artists who emigrated from the southern Netherlands to the north, de Cock faithfully continued the Flemish Mannerist landscape tradition of the sixteenth century. In the present drawing, which is dated 1628, the heavy repoussoir of trees and the overlapping layers in a brown-green-blue scheme that define the space recall the influential Flemish artist Paul Bril, who had recently died in 1626 in Rome.[2] The decorative, stylized handling of the pen lines in brown ink is also reminiscent of Bril. In contrast to the artist's imaginary mountain landscapes, this present idealized and flat Netherlandish landscape is animated by realistic details: the resting figure and the draftsman in the foreground, the grazing cattle, the farm, and the distant village that lies low on the horizon. The light effects, which illuminate the meadow and subtly model the trees and buildings,

create a sense of space, recalling to an extent the tonal experiments of de Cock's innovative contemporaries such as Esaias van de Velde (cat. nos. 13–16). Three additional drawings from 1628–29 correspond to the Albertina sheet in style, format, color, and in the pastoral theme.[3] It is possible that the sheets were conceived as a series.

1 Schapelhouman 1998, p. 64.

2 Cf., for example, the drawing in the British Museum, Department of Prints and Drawings, inv. no. 1895–9–15–1029. See London 1986, no. 3, illus.

3 Amsterdam, Rijksmuseum, Rijksprentenkabinet, inv. no. RP-T-1948–388; Berlin, Staatliche Museen Preussischer Kulturbesitz, KdZ 12647; Windsor Castle, in van Puyvelde 1944, no. R 106, illus.

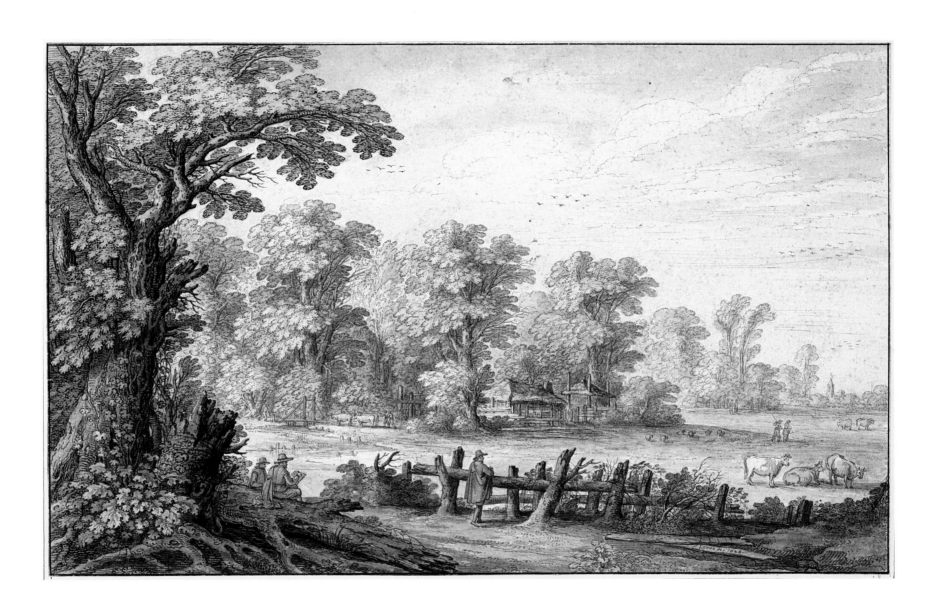

Hendrick Avercamp

AMSTERDAM 1585–1634 KAMPEN

10 *Small Harbor with a Tavern on a River Estuary,* before 1620

Pen and brown ink over graphite, watercolor, white bodycolor
17.9 x 25.8 cm
MONOGRAMMED AT LOWER CENTER ON BARREL: "HA" (combined)
PROVENANCE: Jan Delcourt (?); Duke Albert von Sachsen-Teschen
INV. NO. 8591
BIBLIOGRAPHY: Welker 1933, nos. T 132, T 16; Vienna 1936, no. 3; Benesch 1964, no. 158, illus.; Vienna 1993, no. 19, illus.; New York/ Fort Worth 1995, no. 17, illus.

Hendrick Avercamp, the son of an apothecary, spent most of his life in Kampen. He is believed to have apprenticed in Amsterdam with the history and portrait painter Pieter Isacks (1569–1626). It is not known whether he lived in other areas or traveled. A reference to him as "de Stomme" (the Mute) appears in a document from 1622, but the details of his disability are not known.

Famous for his paintings and drawings of winter landscapes populated with many figures, Avercamp emerged in the seventeenth century as one of the first artists in the northern Netherlands to produce finished ink drawings that included watercolor and occasionally bodycolor. Presumably the drawings of Jan Brueghel the Elder and works by Flemish immigrants who lived in Amsterdam, especially Hans Bol, Jacques Savery, and David Vinckboons (cat. nos. 5–7), inspired him in this direction.

Summer scenes, in which (as in his winter landscapes) water is the focal point, are much more common in Avercamp's drawings than in his paintings. The present drawing, which presumably dates to before 1620, captures a bustle of activity: near a river landing, men and women fish, sail, or load hay, and a figure sits in front of a tavern. In the foreground, different classes of society are highlighted: an elegant couple comes upon a peasant man and woman. In the background on the opposite shore is a gallows—a motif common in Avercamp's work.[1]

Avercamp's carefully composed landscapes are based on numerous studies from life. Figures, objects, and buildings are defined in evenly penned ink contours. This objective style of drawing, in which the artist records detail, recalls contemporaneous or earlier works by Claes Jansz. Visscher and by Esaias van de Velde (cat. nos. 13–16), the principal exponents of early realism in the Netherlands. Despite their detailed rendering, in the present drawing, the numerous small figures fit into their environment in a natural manner. The delicate gradation in watercolor contributes greatly to this impression: Avercamp subtly differentiated the earth tones of the terrain and the play of light and reflections on the surface of the water. A delicate mist envelops the sailboats that gather in the distance. The pronounced diagonal of the river considerably intensifies the impression of depth.

In a larger drawing in Berlin that corresponds closely in motif to the present sheet, Amsterdam's coat-of-arms is recognizable on the façade of the inn that appears at the right. Whether the two sheets represent a scene of the Amstel River, however, remains unknown.[2] Avercamp typically constructed his landscapes from various elements, in which undoubtedly his residence in Kampen and its watery environs were important inspirations.

1 See Wolfgang Schulz in Berlin 1974, pp. 2–3, under no. 4.

2 Berlin, Staatliche Museen Preussischer Kulturbesitz, Kupferstichkabinett, inv. no. KdZ 118, pen and brown and green inks, watercolor, 27.4 x 35.8 cm. See Wolfgang Schulz in Berlin 1974, no. 5, fig. 13, with the title *The Amstel near Amsterdam.*

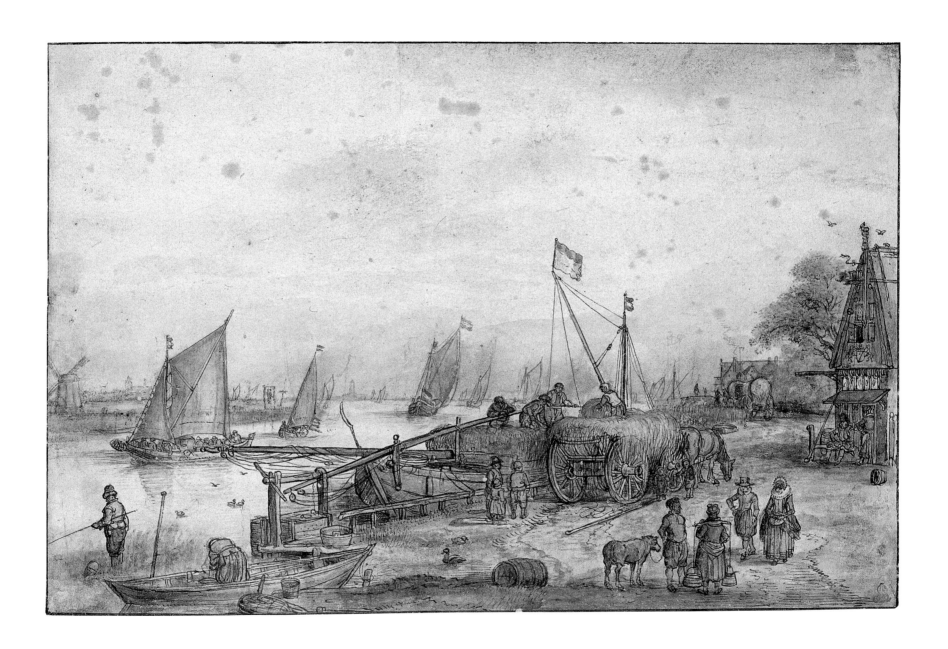

Jan van de Velde II

ROTTERDAM (?) 1593–1641 ENKHUIZEN

11 *Pastoral Landscape with a Farm and Ruins,* c. 1615
12 *Dune Landscape with Two Resting Figures,* c. 1615

CAT. NO. 11

Pen and brown ink

10.1 x 31.5 cm

PROVENANCE: Duke Albert von Sachsen-Teschen

INV. NO. 8084

BIBLIOGRAPHY: van Gelder 1933, p. 52, no. 69, fig. 26; Vienna 1936, no. 6; Benesch 1964, no. 4, illus.; Vienna 1993, no. 26, illus.; New York/Fort Worth 1995, no. 21, illus.

CAT. NO. 12

Pen and brown ink

10.1 x 31.7 cm

PROVENANCE: Duke Albert von Sachsen-Teschen

INV. NO. 8083

BIBLIOGRAPHY: Meder 1919, p. 479, fig. 215; van Gelder 1933, p. 52, no. 68; Vienna 1936, no. 7; Vienna 1993, no. 27, illus.; New York/Fort Worth 1995, no. 22, illus.

Jan van de Velde II was the son of the famous calligrapher Jan van de Velde the Elder (1561–1623), who had emigrated from Antwerp to the northern Netherlands. Jan van de Velde II grew up in Rotterdam. Documents show that in 1613 he was in Haarlem, where he apprenticed with Jacob Matham, a pupil of Hendrick Goltzius. In 1614, he entered the Haarlem Guild of St. Luke, joining his cousin Esaias van de Velde (cat. nos. 13–16), Hercules Seghers, and Willem Buytewech. While the Late Mannerist line drawings of Matham and Cornelis Claesz. van Wieringen had greatly impacted van de Velde's drawing style, the realistic works of his cousin Esaias, Buytewech, and the Amsterdam artist

Claes Jansz. Visscher also were influential. Van de Velde's numerous etchings after his own and other artists' designs helped disseminate the new landscape art that was flourishing in Haarlem.

Conceived as pendants, these two sheets are among van de Velde's earliest and most outstanding drawings. Their style and distinctly horizontal format link them to his series of eighteen landscape etchings dated 1615.[1] Cat. no. 11 depicts a flat landscape with the ruins of a castle, which recalls the "Huis te Kleef" near Haarlem—a motif popular among seventeenth-century artists. Cat. no. 12 represents the dunes near Haarlem.

The calligraphy of the attenuated, slightly undulating lines points to Haarlem Mannerism, exemplified by his teacher Matham. The lively interplay between the delicate lines and the light areas of the paper convincingly conveys the spatial zones.

The extremely horizontal format, already in use in the sixteenth century for profile views of cities, played a significant role in realistic panoramic landscapes of the early seventeenth century.[2] Among the greatest artistic achievements in this regard are Rembrandt's expansive, flat landscapes and Aelbert Cuyp's black chalk and watercolor panoramas (cat. nos. 65, 66).

The motif of foreground figures that invite the viewer to enjoy the vista also appears in the title sheet drawing for the series *Amoenissimae aliquot regiunculae* (*Some Pleasing Landscapes*), which Jan van de Velde published in 1616.[3] These images demonstrate the new appeal of the rural environment for city dwellers.

1 Hollstein 1949–, vol. 33, pp. 60–65, nos. 178–95. First established by van Gelder in 1933, p. 52, no. 68.

2 Vienna 1993 and New York/Fort Worth 1995.

3 Rotterdam, Museum Boijmans Van Beuningen, inv. no. H 175; see New York/Fort Worth/ Cleveland 1990–91, no. 27.

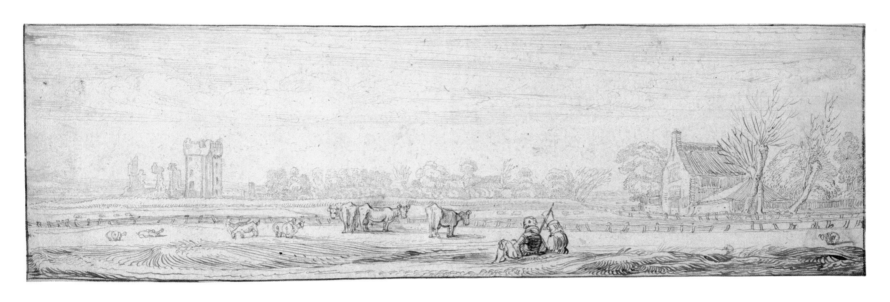

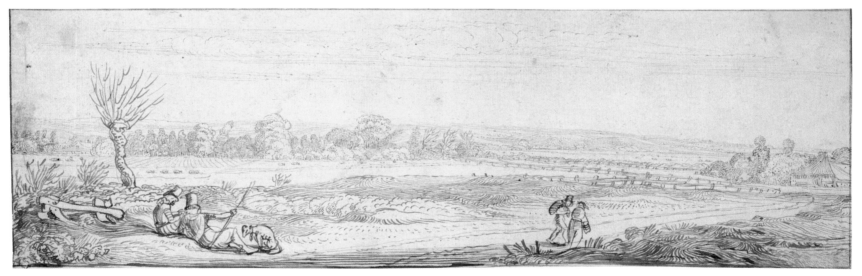

Esaias van de Velde

Amsterdam 1587–1630 The Hague

13 *Winter Landscape with Ice Skaters,* 1615/16

14 *Fortified City on a River,* 1615/16

15 *Village Street with a Dilapidated Mill,* 1615/16

CAT. NO. 13

Pen and brown ink, on reddish prepared paper

7.4 x 17.1 cm

PROVENANCE: Duke Albert von Sachsen-Teschen

INV. NO. 8085

BIBLIOGRAPHY: Meder 1919, p. 47; van Gelder 1933, no. 73 (erroneously given as inv. no. 8588); Keyes 1984, no. D 82, fig. 18, p. 32; Vienna 1993, no. 20, illus.; New York/Fort Worth 1995, no. 18, illus.

CAT. NO. 14

Pen and brown ink, brown wash, on reddish-brown prepared paper; some features extended by a later hand onto the nineteenth-century mount at the left and right

7.3 x 16.7 cm

PROVENANCE: Duke Albert von Sachsen-Teschen

INV. NO. 8086

BIBLIOGRAPHY: Meder 1919, p. 47; van Gelder 1933, no. 74 (erroneously given as inv. no. 8589); van Gelder 1955, p. 29; Haverkamp-Begemann 1959, p. 217; Keyes 1984, no. D 121, figs. 19, 20, p. 32; Vienna 1993, no. 21, illus.; New York/Fort Worth 1995, no. 19, illus.

CAT. NO. 15

Pen and brown ink, on reddish prepared paper

7.3 x 16.7 cm

PROVENANCE: Duke Albert von Sachsen-Teschen

INV. NO. 8087

BIBLIOGRAPHY: Meder 1919, p. 47; van Gelder 1933, no. 75 (erroneously given as inv. no. 8590); van Gelder 1955, p. 29; Haverkamp-Begemann 1959, p. 217; Keyes 1984, no. D 178, fig. 20, pp. 32, 53; Vienna 1993, no. 22, illus.; New York/Fort Worth 1995, no. 20, illus.

Esaias van de Velde was the son of the artist and art dealer Hans van de Velde, who emigrated from Antwerp to Amsterdam in 1585, and a cousin of Jan van de Velde II (cat. nos. 11, 12). Presumably Esaias apprenticed with his father, with Gillis van Coninxloo until this artist's death in 1607, and with David Vinckboons (cat. nos. 5–7). Beginning in 1609, Esaias resided in Haarlem, where in 1612 he became a member of the Guild of St. Luke (at the same time as Willem Buytewech and Hercules Seghers). He lived in The Hague from 1618 until his death. Equally talented as a painter, draftsman, and etcher, Esaias van de Velde played a key role in the development of the early realism in landscape art that unfolded particularly in Haarlem in the first decades of the seventeenth century. Jan van Goyen (cat. nos. 17–20), who apprenticed with him in 1617, was essentially inspired by his work.

The present sheets belong to a group of over twenty similarly formatted landscapes drawn in ink on reddish-brown prepared paper, all originally part of the same sketchbook. Some of these small sheets

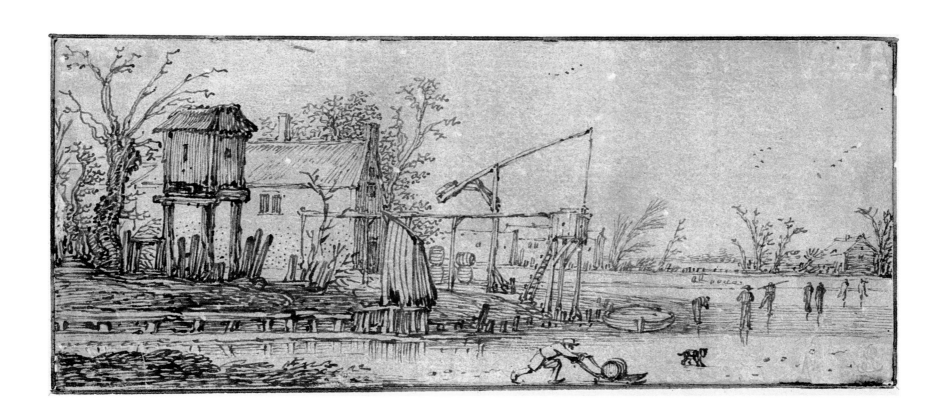

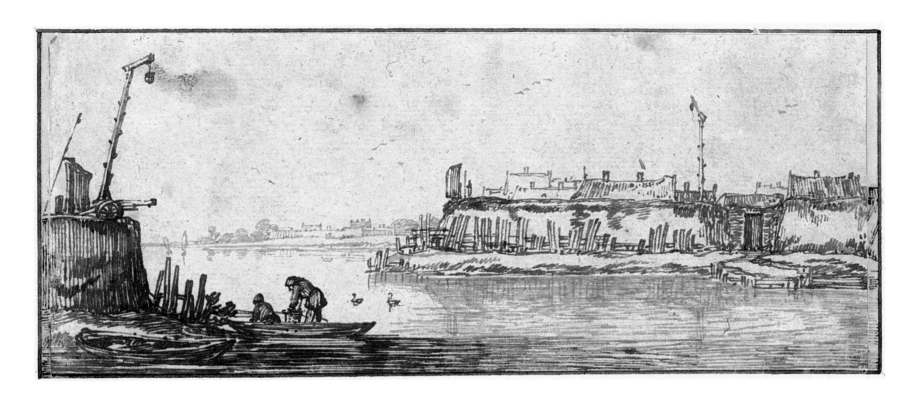

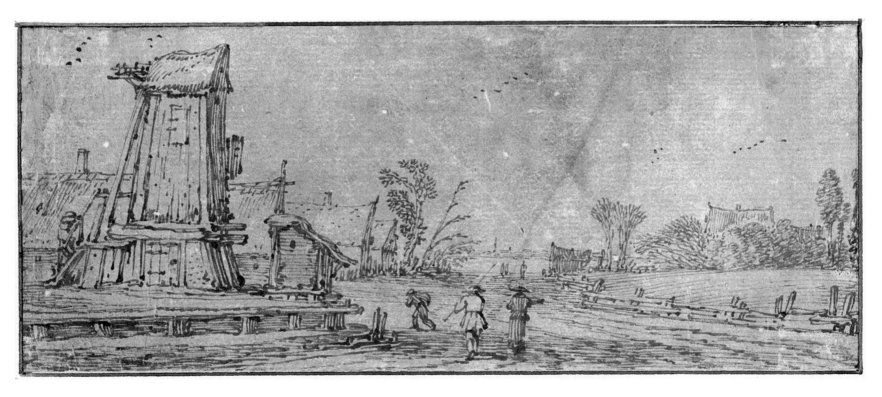

are by Esaias van de Velde; others are by his cousin Jan van de Velde II (cat. nos. 11, 12), who was about six years younger.[1]

Based on their similarity to several etched landscapes that Esaias van de Velde produced in 1615–16, his sketchbook sheets have also been dated to this period.[2] Despite their small size, these drawings convey the impression of a nearly endless expanse. The completely open foreground area draws the viewer directly into the landscape; the extremely low vantage point and low horizon line intensify the sense of depth. At the time these drawings were created, this was an innovative formula that became highly significant for Dutch seventeenth-century landscape art. The sharp curve of the frozen body of water that provides dimension to the scene in *Winter Landscape with Ice Skaters* (cat. no. 13) is characteristic of the artist.[3] Van de Velde's skilled handling of the line extends from the sure definition of the contours of the figures, buildings, and objects to the largely linear abstraction of the reflections in the water and the shadows. In *Fortified City on a River* (cat. no. 14), van de Velde defined the space in systems of lines that alternate in a lively manner, enhanced effectively by gradations of light and dark.

These innovative landscape drawings demonstrate the artist's objective interest in a simple, rural motif and in the manner in which spatial relationships, light, and atmosphere are conveyed through purely linear means. The reddish tone that forms the foundation of these images contributes significantly to their effectiveness. These traits position these small but impressive works among the important documents of early realism in landscape art in the northern Netherlands.

1 Three of the sketches by Jan van de Velde II are located in the Albertina (inv. nos. 8088, 8089, 8090; see Vienna 1993, nos. 23, 24, 25).

2 Keyes 1984, nos. E 19, 15, 17. See also Vienna 1993, p. 52; New York/Fort Worth 1995, p. 63.

3 Keyes 1984, p. 32.

Esaias van de Velde

AMSTERDAM 1587–1630 THE HAGUE

16 *Ruins of a Tower and Houses on a Country Road,* 1624

Black chalk

19.1 x 30.3 cm

INSCRIBED AT UPPER RIGHT: "E.V.VELDE 1624"

PROVENANCE: Duke Albert von Sachsen-Teschen

INV. NO. 8682

BIBLIOGRAPHY: Vienna 1936, no. 5; Benesch 1964, no. 159, illus.;
Keyes 1984, no. D 179, fig. 239; Vienna 1993, no. 28, illus.;
New York/Fort Worth 1995, no. 23, illus.

In Dutch seventeenth-century landscape art, Esaias van de Velde is
considered one of the pioneers of drawing in black chalk—a technique
that, beginning in the mid-1620s, also enjoyed great popularity with
many artists, including Jan van Goyen (cat. nos. 17–20) and Pieter
Molyn.[1] Van de Velde had made a few solitary attempts in this direction
in Haarlem, though at that time he worked predominantly in pen
(cf. cat. nos. 13–15).[2] It was not until after he moved to The Hague
in 1618 that the artist turned with increasing interest to the medium
of black chalk; its soft, granular substance was ideally suited to the
rendering of light and shadow, space and atmosphere.

The present work, which is dated 1624, displays some of the
elements of van de Velde's early pen drawings: the open foreground,
the individually accentuated trees, and the broad curve of the road
that leads into depth. Light, however, plays a much more significant role.
By constantly altering the pressure of the chalk, the artist worked out
the transitions between the sunlit and shadowed areas, while differ-
entiating the various surface textures in a lively manner. According to
the play of the light, contours are either sharply defined or faintly
indicated. The artist's concentration on the central motif—the hero-
ically isolated ruins of a tower depicted from a moderately low

viewpoint—is striking. The atmospheric unity and ease of handling
the chalk are characteristic of the mature period of Esaias van de
Velde's development as a draftsman.

1 On the significance of Esaias van de Velde in the use of black chalk, see Keyes 1984,
 pp. 33–35; Keyes 1987; William W. Robinson in Amsterdam/Vienna/New York/Cambridge
 1991–92, no. 28.

2 The artist's earliest drawing in black chalk is dated 1616. See Keyes 1984, D 77.

Jan van Goyen

LEIDEN 1596–1656 THE HAGUE

17 *Country Road with a Farm and a One-Horse Cart,* 1626

Black chalk, gray wash

18.8 x 30.2 cm

INSCRIBED AT LOWER CENTER: "(I) V GOYEN (1)626"

PROVENANCE: G. Winckler; Duke Albert von Sachsen-Teschen

INV. NO. 8528

BIBLIOGRAPHY: Beck 1972–91, vol. 1, no. 60, illus.; Leiden 1976–77, fig. 46; Adelaide/Sydney/Melbourne 1977, no. 35, illus.; Vienna 1993, no, 30, illus.; New York/Fort Worth 1995, no. 25, illus.

According to his contemporary Jan J. Orlers, beginning in 1606, Jan van Goyen, the son of a shoemaker, apprenticed in his birthplace of Leiden with the painters Conraet van Schilperoort, Isaack Claesz. van Swanenburgh, and Jan Arentsz. de Man, and with the glass painter Cornelis Cornlisz. Clock.[1] Orlers further claims that after studying with Willem Gerritsz. for two years in Hoorn, van Goyen returned to Leiden, spent a year in France, and finally returned to Haarlem, where he apprenticed with Esaias van de Velde (cat. nos. 13–16). From 1618 onward, he was again in Leiden, where he married Annetje Willemsdr. van Raelst. From probably 1632 until his death, he lived mainly in The Hague. As an extraordinarily productive painter and draftsman, van Goyen is considered one of the most significant and influential exponents of seventeenth-century Dutch landscape art.

The present drawing, which is dated 1626, marks an important transitional phase in the development of the artist. Whereas landscape did not play a particular role in his early compositions, which are animated with figures, here it has become the focal point. In addition, this work was among the artist's first experiments in black chalk.[2] In the same period, van Goyen was completing the transition from a colorful to a monochrome palette in his paintings, seen also in the work of his famous contemporaries Salomon van Ruysdael, Pieter van Santvoort, and Pieter Molyn.

This landscape drawing represents one of the earliest and most notable examples of this new artistic direction. The lively handling of the chalk and the realistic rendering of the landscape reflect the influence of van Goyen's master Esaias van de Velde. The impression of space arises from the low horizon and the broad shadows, with the effect of depth achieved through pronounced diagonals in the composition (a device that he later largely abandoned). The artist's technique in chalk as well as his compositional methods—particularly in the broad, open foreground, combined with the strong emphasis on the farm building and the tall, solitary trees—recall the work of van de Velde.[3] Nevertheless, the works of the two artists reveal considerable differences. Van Goyen drew in short, powerful, often slightly bowed strokes, and he clearly defined the shadows executed in wash from the light areas, especially in the foreground. Van de Velde's drawings are characterized by a greater openness and transparency. Unlike van de Velde, van Goyen accentuated his figures in a narrative manner, recalling Flemish examples. In this drawing, a unifying atmosphere connects the figures, the buildings, and the landscape. The free, dynamic handling of line anticipates van Goyen's dune landscapes from around 1630 (cat. no. 18).

1 Orlers 1641, pp. 373–74.

2 For information on the technical and stylistic development of van Goyen's early period and on the influence of Esaias van de Velde, see Beck 1972–91, vol. 1, pp. 40–42.

3 Regarding the similarity to Esaias van de Velde's manner of signing and dating his work, see Vienna 1993, p. 62, n. 2, and New York/Fort Worth 1995, p. 70, n. 2.

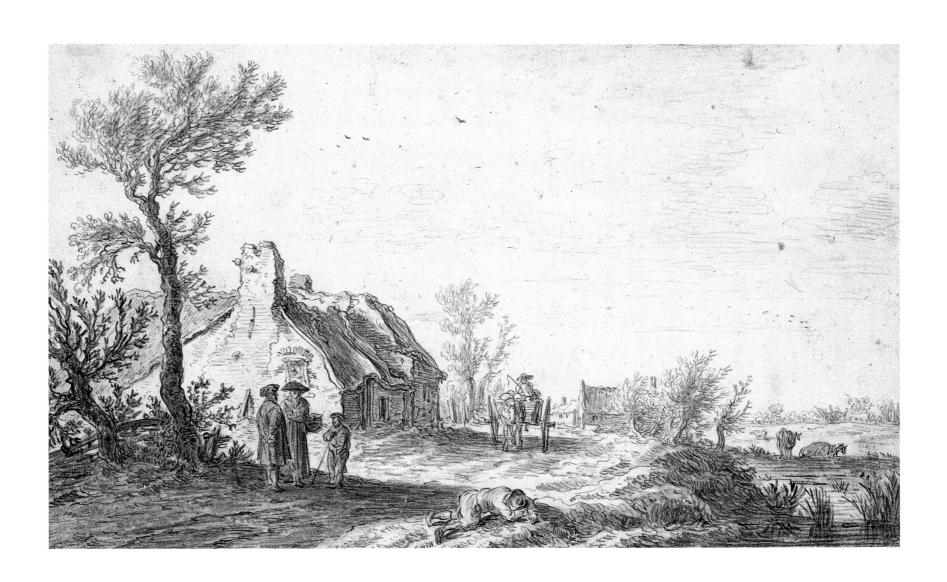

Jan van Goyen

LEIDEN 1596–1656 THE HAGUE

18 *Dune Landscape with Houses and Two Figures,* c. 1630

19 *Bridge with a Horseman and Two Figures outside a Village,* c. 1630

CAT. NO. 18

Black chalk

11.6 x 23.6 cm

INSCRIBED AT LOWER LEFT BY A LATER HAND: "17"; at lower right by a later hand: "v. Goyen inv. & fec."

PROVENANCE: Duke Albert von Sachsen-Teschen

INV. NO. 8554

BIBLIOGRAPHY: Beck 1972–91, vol. 1, no. 843/17; Vienna 1993, no. 31, illus.; New York/Fort Worth 1995, no. 26, illus.

CAT. NO. 19

Black chalk

11.3 x 24.7 cm

INSCRIBED AT LOWER LEFT BY A LATER HAND: "5"

PROVENANCE: Duke Albert von Sachsen-Teschen

INV. NO. 8555

BIBLIOGRAPHY: Beck 1972–91, vol. 1, no. 843/5, illus.; Vienna 1993, no. 32, illus.; New York/Fort Worth 1995, no. 27, illus.

The study of nature was an essential component of Jan van Goyen's artistic activity. In small sketchbooks, he recorded impressions that he collected in the rural area where he lived or on extended walks that occasionally took him beyond the borders of the Netherlands.[1] In this manner, he captured views of rivers, meadows, village streets, fairs, city scenes, farmhouses, and more, which served as points of departure for the carefully articulated drawings he prepared in his studio. Many of these motifs also found their way into his paintings.

The Albertina Sketchbook, represented here by two drawings, is one of these volumes, which have been partially preserved in their original form and partially reconstructed. Duke Albert von Sachsen-Teschen acquired twenty-eight individual sheets of this series from an unknown source; only two drawings from this volume are located in other collections.[2] These sheets, which were produced around 1630, are homogeneous in appearance and each is numbered in sequence at the lower left by a later hand. They comprise studies of dunes and meadows or small farmhouses, typically surrounded by trees.

These drawings, which are executed in black chalk without wash, are among the artist's earliest works in which a distinctly individual drawing style is manifest. Shadows indicated by attenuated strokes and overlapping, looping lines engage the open, light areas in a lively manner. The various forms of the terrain, the trees, and the buildings are subtly differentiated from one another. The vibrating flow of the line, which unifies natural and architectural forms as if in a single stroke, extends even to the wavy lines that demarcate the lower areas of the drawings.

The artist's rather low vantage point draws the viewer directly into the landscape. In both drawings, the defined, solitary figures strengthen the impression of depth. The simple immediacy of these compositions recalls van Goyen's paintings of dunes from the late 1620s and early 1630s, in which their intimacy is particularly underscored by the harmonious, monochrome rendering.

1 See Beck 1972–91, vol. 1, pp. 17–18, 254–315.

2 Ibid., nos. 843/1–28.

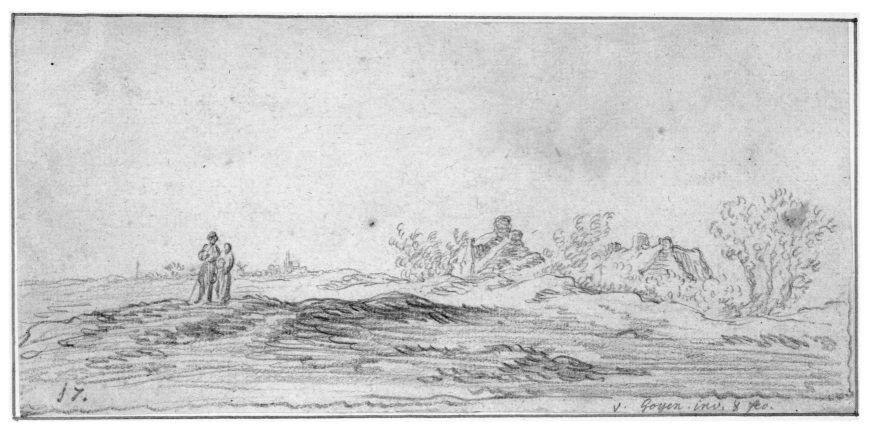

17.

v. Goyen inv. & fec.

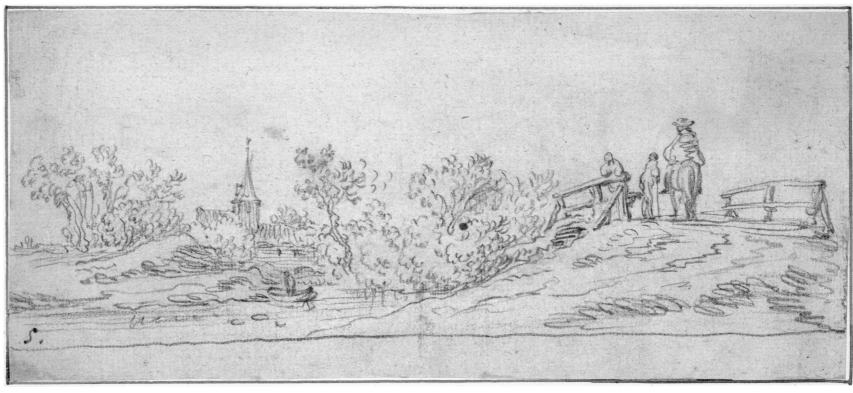

Jan van Goyen

LEIDEN 1596–1656 THE HAGUE

20 *Country Road with Groups of Figures in Front of a Village with a Church,* c. 1650

Black chalk, brush and brown ink, brown wash

18.6 x 29.8 cm

PROVENANCE: G. Winckler; Duke Albert von Sachsen-Teschen

INV. NO. 8524

BIBLIOGRAPHY: Beck 1972–91, vol. 1, no. 829; Sydney 2002, no. 76, illus.

appear to blend organically with their natural environment. Within the monochrome of the black chalk lines and the brown washes, a rich palette unfolds in the range of shading between the light and dark areas.

1 Beck 1972–91, vol. 1, no. 846/1–144 (*The Dresden Sketchbook*) and no. 847/1–290 and /A, B (*The Sketchbook from 1650–51*).

Jan van Goyen was particularly productive as a draftsman in the later years of his life. The beginning of this fruitful period is marked by two comprehensive sketchbooks that the artist compiled during a journey to Antwerp and Brussels in 1648 and on a walking trip from Kleve down the Rhine via Arnhem in 1650–51.[1] These spontaneous works created an inexhaustible reservoir of motifs for his paintings and for the drawings he produced in his studio, which were intended for sale.

The landscape drawings that van Goyen produced in his studio from memory or based on his travel sketches—despite at times a patternlike method of composition—still evoke an impression of the artist's spontaneous examination of reality. The present, undated drawing, presumably from around 1650, belongs to this category. In this relatively large sheet, van Goyen pursued in a highly individual fashion the traditional scheme of contrasting layers of space, which is rooted in the sixteenth century. The special liveliness of the landscape is achieved through rhythmic directions of movement: from the wavy lines of the bright country road that leads into depth to the vibrating contours of the church surrounded by houses; a loose configuration of strokes describes the cloudy sky, which commands the majority of the paper's surface. The artist's concern here was not to produce an exact, detailed rendering, but rather to convey the atmosphere of a landscape flooded with light in which the houses and the church

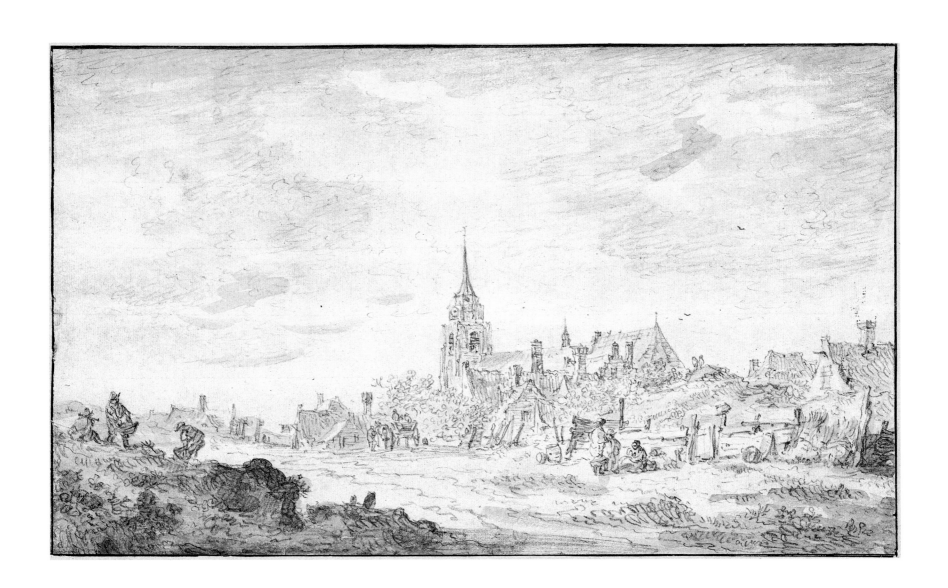

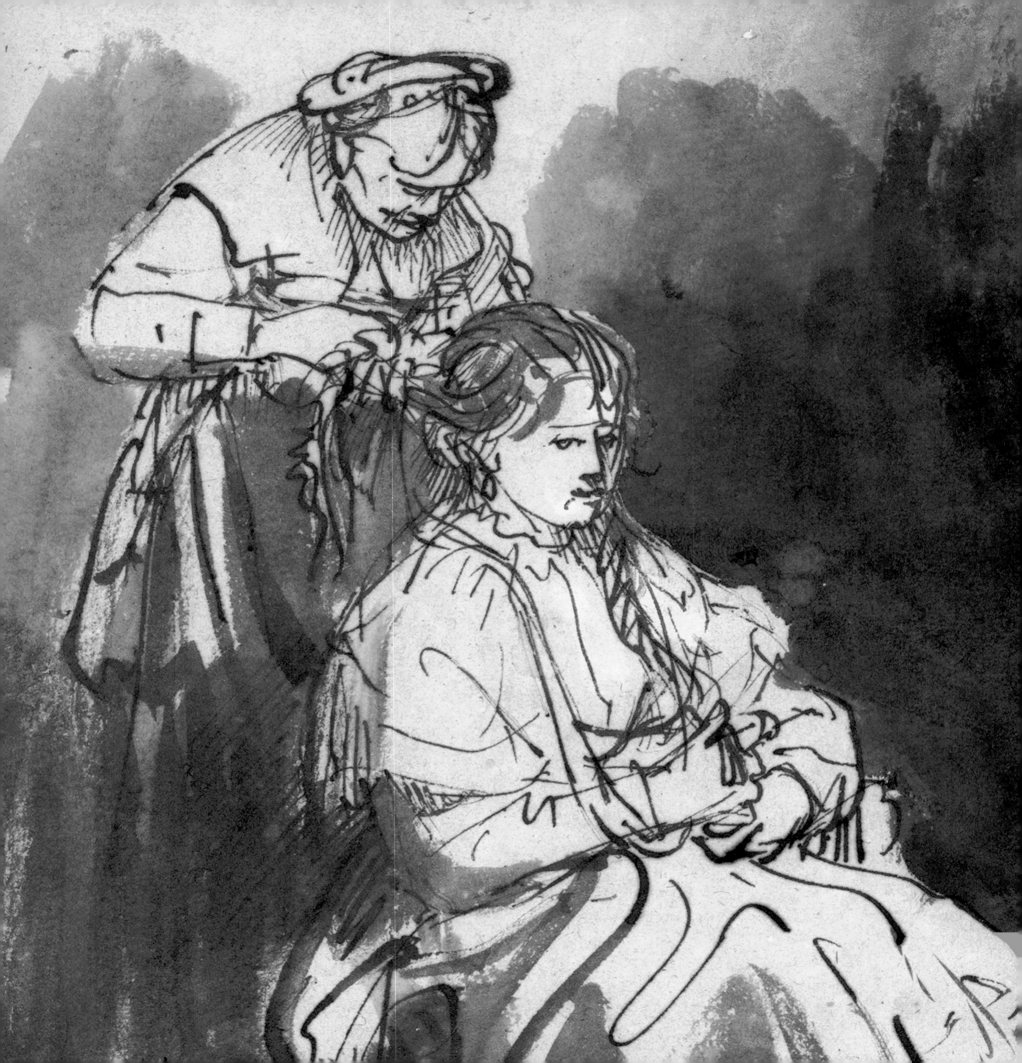

Rembrandt

Rembrandt Harmensz. van Rijn

LEIDEN 1606–1669 AMSTERDAM

21 *The Raising of Lazarus,* c. 1632

Etching and engraving, fourth state, unique

36.6 x 25.8 cm

Monogrammed and inscribed at center: "RHL v. Ryn f"

PROVENANCE: Vienna, Hofbibliothek

INV. NO. 1926/141

BIBLIOGRAPHY: B 73; White and Boon 1969, B 73, VI; Vienna 1970–71, no. 52, pl. 13

The Raising of Lazarus from around 1632 was produced during the period when Rembrandt was relocating from Leiden to Amsterdam. The etching occupies a special position in the artist's print production: as his largest print to date, it is his first fully realized work in which dramatic content, composition, and light effects are coordinated. The broad black border serves to frame the scene.

In this etching, Rembrandt picked up the theme of his painting by the same title from 1630/31.[1] Both works present the biblical story of the Resurrection of Lazarus, who had died and been buried for four days. After the stone that covered Lazarus's grave was removed, "Jesus cried out with a loud voice, 'Lazarus, come forth!' And he that was dead came out, bound hand and foot with graveclothes, and his face bound about with a cloth. Jesus said unto them: 'Loose him, and let him go'" (John 11: 39–45). Characteristic of the artist's extreme realism, both the etching and the painting capture the moment when the dead man, already showing the first signs of decay, begins to rise.[2] The greatest difference between the two works lies in the pose of Christ: in the painting, the figure, viewed from the front, stands behind the open grave; in the etching, the figure, seen largely from behind, dominates the scene like a powerful sculpture, giving new weight to Christ's gesture.

The theatrical link of the words spoken by Christ to the performance of the miracle is synoptically portrayed in the etching, as is evident in the highly emotional reaction of the people gathered around the grave. The open burial site and the half-upright figure of Lazarus are brightly illuminated, as are the figures who stand nearby gesturing dramatically with horrified expressions.

The figure of Christ is situated in the transitional area between light and darkness, emphasizing its sculptural form; chiaroscuro effects also model the group of figures behind him. Rembrandt added the dark figure of Martha leaning forward at the right in the third state, apparently to strengthen her connection to the other figures (in the earlier states, she recoils from the sight of Lazarus). The Albertina owns the only known example of this fourth state of the etching.[3]

1 Oil on wood, 96.2 x 81.3 cm, Los Angeles County Museum of Art. Regarding the question of the works' relationship in chronology and theme, see Amsterdam/London 2000–2001, pp. 121–22, n. 2; Corpus, vol. 1, no. A30, especially pp. 301–304.

2 Jan Lievens, Rembrandt's colleague and studio companion in Leiden, also portrayed the theme in a painting and a large etching in 1631, though he depicted only Lazarus's outstretched hand emerging from the grave.

3 Verbal communication with Erik Hinterding (Vienna 2004, p. 222, n. 5). In this state, the bearded man at the far left in the frontally depicted group of figures appears without a cap. In earlier references (White and Boon 1969; Vienna 1970–71), the sheet was known as the sixth state. According to the most recent research, five states of the etching have been identified (Amsterdam/London 2000–2001, no. 17).

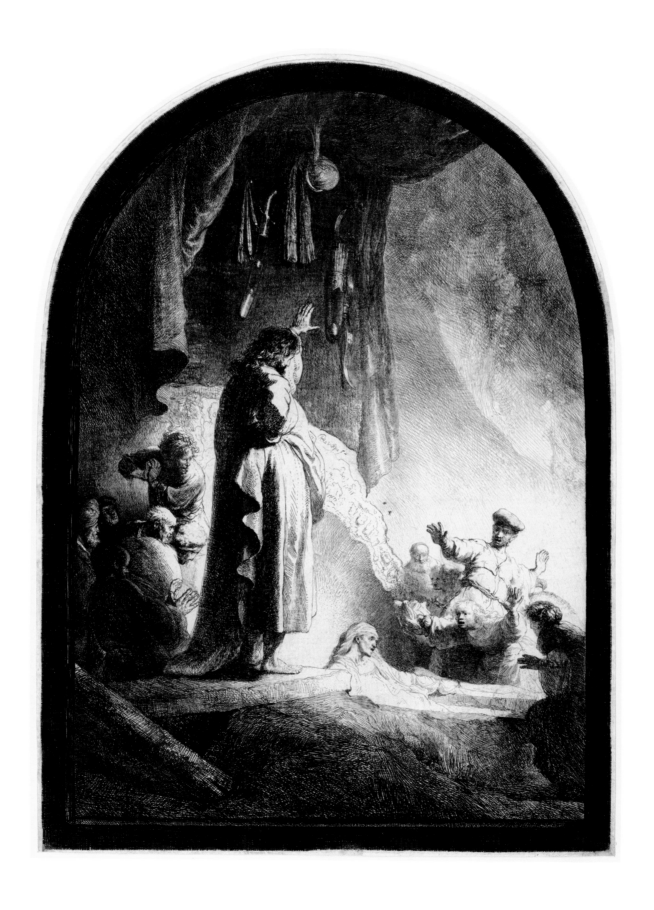

Rembrandt Harmensz. van Rijn

LEIDEN 1606–1669 AMSTERDAM

22 *Young Woman with a Child in a Harness; Half-Length Figure of a Man,* c. mid-1630s

23 *Child in a Small Chair with Nanny,* c. mid-1630s

CAT. NO. 22

Red chalk

16.3 x 15.3 cm

PROVENANCE: Prince de Ligne; Duke Albert von Sachsen-Teschen

INV. NO. 8836

BIBLIOGRAPHY: Benesch 1954–57, vol. 2, no. 308, fig. 346; Vienna 1956, no. 20; Rotterdam/Amsterdam 1956, no. 58; Stockholm 1956, no. 84; Haverkamp-Begemann 1961, p. 25; Vienna 1969–70, no. 9, illus.; Milan 1970, no. 6, illus.; Benesch 1973, vol. 2, no. 308, fig. 373; Vienna 2004, no. 44, illus.

CAT. NO. 23

Black chalk

15.5 x 10.3 cm

PROVENANCE: J. Chr. Endris; Dr. Juré; F. O. Schmidt (acquired in 1948)

INV. NO. 30628

BIBLIOGRAPHY: Benesch 1954–57, vol. 2, no. 277, fig. 304; Vienna 1956, no. 14; Haverkamp-Begemann 1961, p. 24; van Gelder 1961, p. 150; Vienna 1969–70, no. 5; Benesch 1973, vol. 2, no. 277, fig. 327; Sydney 2002, no. 77, illus.; Vienna 2004, no. 46, illus.

Studies of women and children occupy an essential place among Rembrandt's drawings of the 1630s and 1640s. It is believed that a majority of these sheets, which are dispersed throughout the world, originate from the collection of the painter Jan van de Capelle, who, according to the inventory of his estate compiled in 1680, owned a total of 500 drawings by Rembrandt. Among them was the album *The Life of Women with Children*, which was composed of 135 representations of the theme and was most likely assembled by the artist himself.[1]

It was long assumed that Rembrandt used his wife, Saskia, and their children as models for these drawings. However, as none of the children lived longer than two months until Titus was born in 1641, and Saskia died two months after his birth, this assumption cannot be correct. Until 1635, Rembrandt could have chosen as models the children of Hendrick Uylenburgh, in whose workshop he painted. After he moved to Amsterdam, he may have portrayed the mothers, nannies, and children from neighboring households.

These two examples from this large group of studies date to around the middle of the 1630s. In *Young Woman with a Child in a Harness* (cat. no. 22), Rembrandt employed red chalk in an appealing manner. At this time, the artist often used red chalk in figural studies as well as in larger compositions. This drawing was put down in simple lines, yet it demonstrates richly nuanced shading that moves between light, delicate tones and heavy, dark accents. The active hands of the woman, whose complete concentration and care are focused on the child in the harness, are rendered in the darkest red and the most forceful lines. With great economy, Rembrandt eloquently captured her concerned expression in the single line of her knitted brow, executed in a decisive stroke of the chalk. By contrast, the lines depicting the child, who wears a wide, protective headband as he (or she—the gender

is unknown) takes his first hesitant steps, possess the greatest delicacy and brightness. The little hands, which hold a toy, are rendered somewhat more powerfully. The figure of a man, represented only in half-length view from the back in caricaturelike profile, delivers a distractedly nervous gesture, waving a finger of his right hand as he imparts instructions to the pair. This hand forms one of the darkest accents within the simple yet expressive scene.

In the black chalk *Child in a Small Chair with Nanny* (cat. no. 23), Rembrandt's keen psychological observation is effectively brought into play. The powerful lines that overlay and to an extent correct the delicate underdrawing are reduced to the essentials of a pose, a gesture, or a look; large hatched areas of shadow set off the illuminated figure of the child and the lower body of the woman, her knees angularly accentuated. The artist convincingly captured the way in which the seated older woman gently leans toward the child as she speaks to him; possibly she is trying to feed him. The chubby-cheeked boy (or girl—again the gender is unknown), however, trapped in his little chair and bundled up in his clothing, balls his fists in a clearly resistant manner. His angry demeanor—lips pressed together and his prominent eyes defined in the darkest medium—constitutes the emotional as well as the compositional focus of this intimate, masterfully rendered scene.

1 See Peter Schatborn in Berlin/Amsterdam/London 1991–92, vol. 2, p. 46.

Rembrandt Harmensz. van Rijn

LEIDEN 1606–1669 AMSTERDAM

24 *Three Studies of an Elephant, an Attendant Alongside*, c. 1637

Black chalk

23.9 x 35.4 cm

PROVENANCE: Vienna, Hofbibliothek; Duke Albert von Sachsen-Teschen

INV. NO. 8900

BIBLIOGRAPHY: Benesch 1954–57, vol. 2, no. 458, fig. 516; Vienna 1956, no. 29; Vienna 1969–70, no. 13, illus.; Benesch 1973, vol. 2, B. 2, no. 458, fig. 547; Slatkes 1980, p. 8, n. 8; Berlin/Amsterdam/London 1991–92, vol. 2, no. 13, illus.; New York 1997, no. 52; Berlin 1998, no. 27, illus.; Vienna 2004, no. 70, illus.

The belief that animals were an important theme for Rembrandt stems from the mention in the 1656 inventory of his possessions of a "book full of drawings by Rembrandt of animals drawn from life."[1] Within the impressive series of animal drawings by Rembrandt that we know today, the Albertina's two elephant studies are among the undisputed high points. In addition, these works display two different aspects of Rembrandt's approach to the subject, in which black chalk was particularly suited to the rendering of the wrinkled skin and the ponderous movements of the exotic animal. The detailed, almost portraitlike, execution of the study *An Elephant*, signed and dated 1637, reveals a distinctly representative, modellike character, underscored by the animal's emphatic profile pose.

The sheet presented here, *Three Studies of an Elephant, an Attendant Alongside*, is by contrast a study in movement in which Rembrandt captured the same animal in three different positions: walking, reclining, and standing. Whereas in the former sheet, he concentrated on the surface of the wrinkled skin, in the group of three poses, he emphasized the outlines above all else and created a particular tension by overlapping the forms. The foremost elephant, which

steps toward the viewer, is drawn in greatest detail, with corrections evident on the head, trunk, and left front leg. It is characterized in the most sensitive manner—from the ponderous movements of the massive, angular head and the curving trunk to the penetrating gaze of the small eye set in delicate folds of skin. The raised right front leg lifts away from the denser configuration of lines, apparently catching the light. The liveliness of the study is intensified by the rapidly sketched figure of the attendant at the right. The model for both studies may have been the female elephant known as "Hansken," which, as recorded in several sources, was exhibited in several European countries.[2]

About a year after producing this drawing, Rembrandt included a small representation of an elephant with its trunk raised in the background of his etching *Adam and Eve* (1638).[3] Although the pose of the animal is reminiscent of the walking elephant in the group of three, this miniaturelike, rather patternlike rendering is far removed from the immediate realism of the two Albertina sheets.

1 "vol teeckeninge van Rembrant, bestaende in beesten "nae 't leven," Rembrandt Documents, 1656/12, no. 249.

2 The animal was born in 1630 in Ceylon and died in 1655. Slatkes 1980, p. 8, n. 8.

3 White and Boon 1969, B 28.

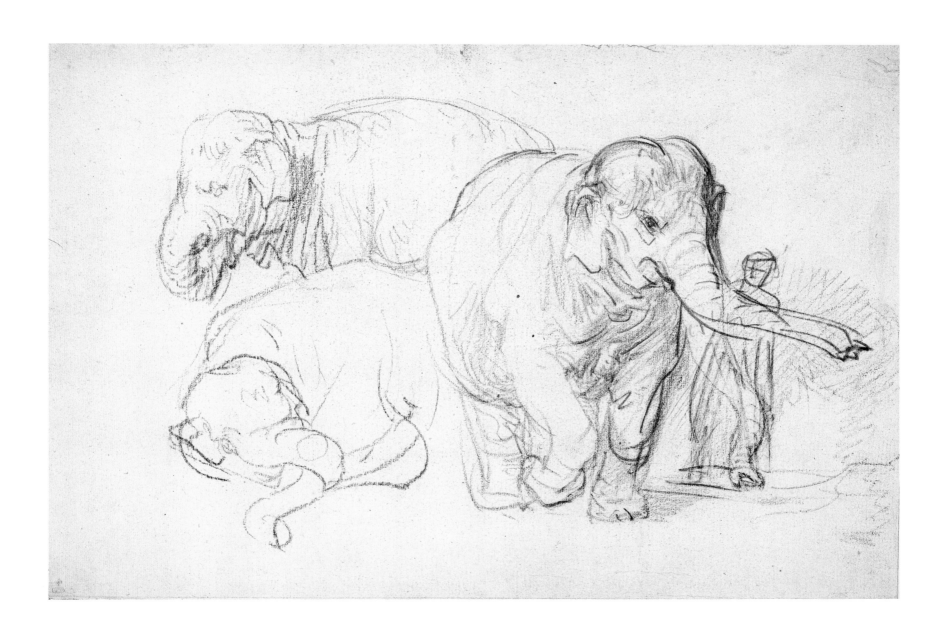

Rembrandt Harmensz. van Rijn

LEIDEN 1606–1669 AMSTERDAM

25 *The Quack,* late 1630s

Pen and brown ink

17.4 x 12.7 cm

PROVENANCE: Roland, Browse & Delbanco, London; acquired 1957

INV. NO. 32765

BIBLIOGRAPHY: Vienna 1958, no. 31, illus.; Benesch 1960, no. 17, illus.; Milan 1970, no. 10, illus.; Benesch 1973, vol. 2, no. 294A, fig. 360; Albach 1979, p. 4, fig. 3; Vienna/Amsterdam 1989–90, no. 41, illus.; New York 1997, no. 54, illus.; Berlin 1998, no. 28, illus.; Berlin 2002–2003, p. 186, under no. 76; Vienna 2004, no. 40, illus.

In the late 1630s, Rembrandt drew a number of single figures relating, in the narrower or broader sense, to the theater. The artist drew these figures in pen, at times also adding the brush.[1] The activity of the quack or charlatan, who often presented his questionable medicines to the public at fairs, has much in common with the art of acting.

In his feathered hat, fantastic costume, and especially with the baton fastened to his belt, Rembrandt's quack closely resembles the figure of Pantalone in the Commedia dell'Arte.[2] From his platform, he speaks to his public with broad gestures and a sly demeanor. Indicated behind him in a few rapid strokes is an easel, which, like the parrot sitting on his shoulder, is a standard attribute of his profession. At the lower left, a spectator rendered in brief lines reaches toward him. Rembrandt captured the central figure in greatly varied, at times forceful, strokes, where the greatest contrast lies between the fine lines of the partially shaded face and the heavy lines of the beret. The intensity of the psychological interpretation of the figure—seen here in the quack's sly expression—is characteristic of Rembrandt's drawing style of the late 1630s. The summarily indicated environment only emphasizes further the main focus of the image.

A drawing in the Berlin Kupferstichkabinett of a quacksalver performing before the public depicts the event with considerably more detail.[3] Here one sees a stage, a promotional sign in the background, the parrot on the shoulder, and possibly a monkey sitting in front of him on a small stool. The parrot and the monkey, which both imitate people, belong to the seventeenth-century iconographic repertoire of representations of quacksalvers and market hawkers, and metaphorically relate to human foolishness and deception.[4] Both the Berlin and Vienna drawings focus on the mischievous expression of the charlatan, whom the crowd knowingly allow to deceive them.

1 Regarding this theme, see Albach 1979.

2 Peter Schatborn in Vienna/Amsterdam 1989–90, no. 41.

3 For more detailed information on this drawing, see Holm Bevers in Berlin 2002–2003, no. 76.

4 See Amsterdam 1976, no. 16.

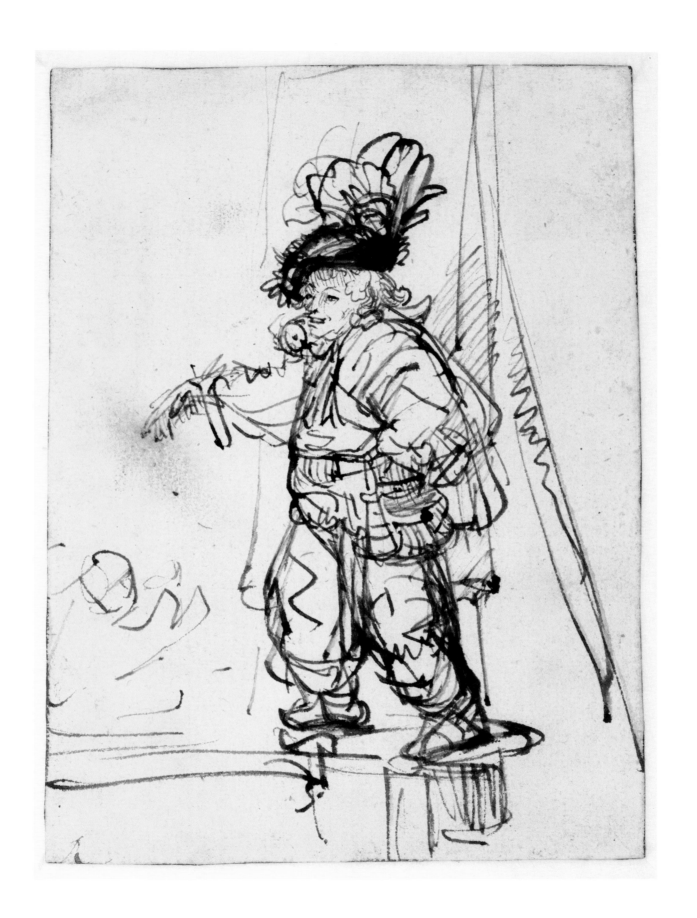

Rembrandt Harmensz. van Rijn

LEIDEN 1606–1669 AMSTERDAM

26 *A Young Woman at Her Toilet,* mid-1630s

Pen and brown ink, brush and brown and gray inks
(gray ink by a later hand)
23.4 x 18 cm
PROVENANCE: Vienna, Hofbibliothek; Duke Albert von Sachsen-Teschen
INV. NO. 8825
BIBLIOGRAPHY: Benesch 1954–57, vol. 2, no. 395, fig. 445; Stockholm
1956, no. 75; Rotterdam/Amsterdam 1956, no. 33, fig. 12; Vienna
1956, no. 11; Rosenberg 1964, fig. 280; Benesch 1964, no. XVII;
Vienna 1969, no. 346; Vienna 1969–70, no. 3, illus.; Benesch 1973,
vol. 2, no. 396, fig. 475; Corpus, vol. 2, p. 273 (under no. A64);
Vienna/Amsterdam 1989–90, no. 39, illus.; Edinburgh/London 2001,
no. 30, illus.; Vienna 2004, no. 75, illus.

This intimate scene was long considered a preparatory study for
Rembrandt's painting from around 1632/33 of an unidentified biblical
heroine also being assisted at her toilet by an older woman (now in the
collection of the National Gallery of Canada in Ottawa). However,
for stylistic reasons, the drawing has more recently been dated to the
middle of the 1630s, and thus cannot be a preparatory study for the
Ottawa painting.[1] Today it is assumed that the sheet, like most of
Rembrandt's drawings, originated as an independent work. It was likely
created during the period when he produced several paintings and
etchings depicting biblical heroines. Indeed, in this respect, the Albertina
drawing is the work most closely related to the Ottawa painting,
although it lacks the biblical component and instead presents a scene
from everyday life, in which Rembrandt's model may have been his
wife, Saskia.[2]

The drawing, which is one of the highlights of the Albertina's
collection, is an outstanding example of Rembrandt's chiaroscuro
technique of the 1630s. (The gray ink at the upper right was added
by a later hand.) The free handling of the pen in long strokes that are
often looped at the ends is characteristic. With a few powerful lines,
the artist sketched the basic elements of the scene: an older woman
braids the hair of a younger woman, who holds the end of a braid in
her lap; a shawl drapes her shoulders. The broadly applied washes
serve to convey light and spatial relationships, contrasting sharply with
the bright, untouched areas of the paper support. In this manner,
Rembrandt achieved the effect of light streaming down from above,
dramatically illuminating the pair of figures.

1 Corpus, vol. 2, p. 273 (under no. A64); Peter Schatborn in Vienna/Amsterdam 1989–90,
no. 39, illus.

2 The drawing may have been part of a portfolio that was described in the 1680 estate inventory
of the marine painter Jan van de Capelle as "een Portfolio, daerin sijn 135 tekeningen sijnde
het vrouweleven met kinderen, van Rembrandt" ("a portfolio, containing 135 drawings that
[depict] the life of women with children, by Rembrandt"), Vienna/Amsterdam 1989–90,
no. 39, illus.

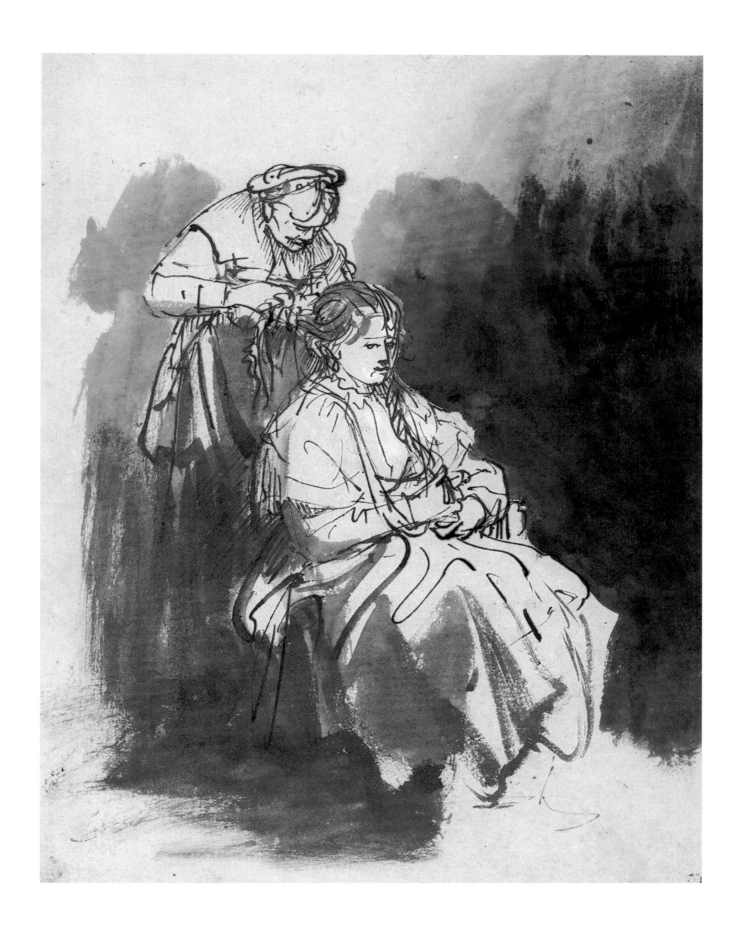

School of Rembrandt

27 *Standing Male Nude*, c. 1646

Rembrandt Harmensz. van Rijn

LEIDEN 1606–1669 AMSTERDAM

28 *Male Nude, Standing and Sitting (The Child's Walker)*, c. 1646

CAT. NO. 27

Pen and brush and brown ink, brown wash, white bodycolor

19.9 x 13.7 cm

PROVENANCE: Unidentified collection (star at lower right);
Prince de Ligne; Duke Albert von Sachsen-Teschen

INV. NO. 8827

BIBLIOGRAPHY: Benesch 1954–57, vol. 4, no. 709, fig. 852; Benesch 1960,
no. 48, illus.; Benesch 1973, vol. 4, no. 709, fig. 900; Vienna 1969–70,
no. 33, illus.; Amsterdam/London 2000–2001, pp. 215, 231, fig. A;
Vienna 2004, no. 62, illus.

CAT. NO. 28

Etching, first state

19.4 x 12.8 cm

PROVENANCE: Albertina, earliest collections

INV. NO. 1926/333

BIBLIOGRAPHY: B 194; White and Boon 1969, B 194, I; Vienna 1970–71,
no. 173 (with additional bibliography); Vienna 2004, no. 63, illus.

Rembrandt's representations of nudes offer distinctly authentic, often unconventional, and broadly diverse imagery. Between 1631 and 1658, in his drawings and etchings, the artist intermittently explored this theme, which was uncommon in Netherlandish art in the seventeenth century. His male and female nudes appear not only in mythological, biblical, and allegorical contexts, but also in representations with a "from life" character. The present etching (cat. no. 28) from around 1646 belongs to this last-named category and depicts the same male model in two different poses.[1]

The pronounced realism in the rendering of the young man is characteristic of Rembrandt. The emphasis on the skin—its folds and its irregularities, which are accentuated by the modeling effects of the light—and the crude bone structure as well as the naturalness of the figure's seemingly awkward poses are far removed from the classical, heroic ideal of the body. It is supposed that Rembrandt worked directly on the plate, presumably executing first the sitting and then the standing figure. The same model appears in three known studies by different pupils, each presenting the same pose from a different vantage point. Together, they establish that Rembrandt, like his pupils, drew the model as part of one and the same working procedure in his workshop; the studies even allow one to reconstruct where the master and his pupils were situated. The unidentified draftsman of the Albertina study (cat. no. 27), which is characterized by its distinctive light and dark effects, occupied the vantage point farthest to the left. Next to him sat Rembrandt, who worked directly on the copper plate.

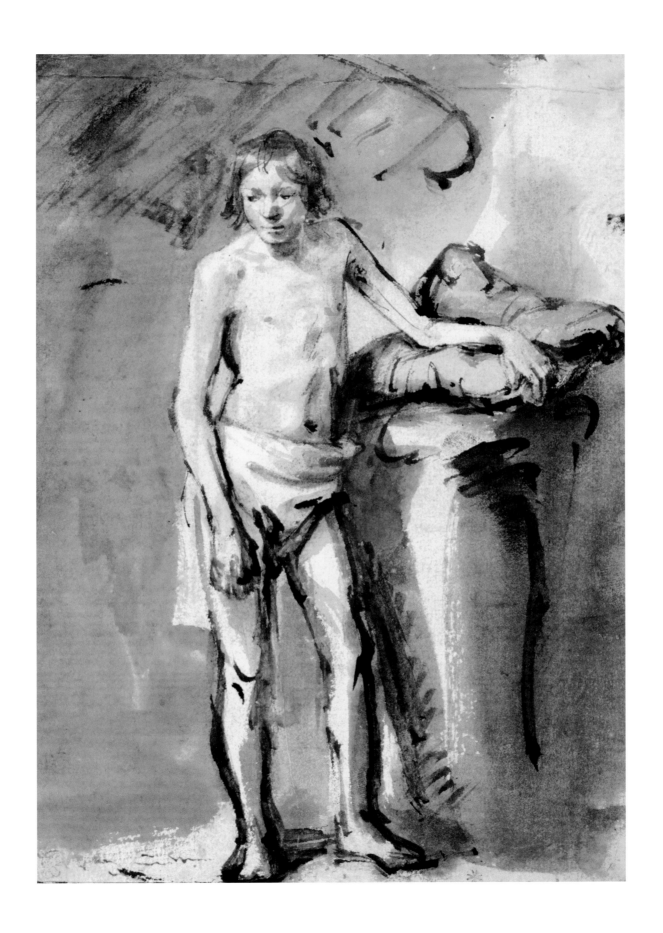

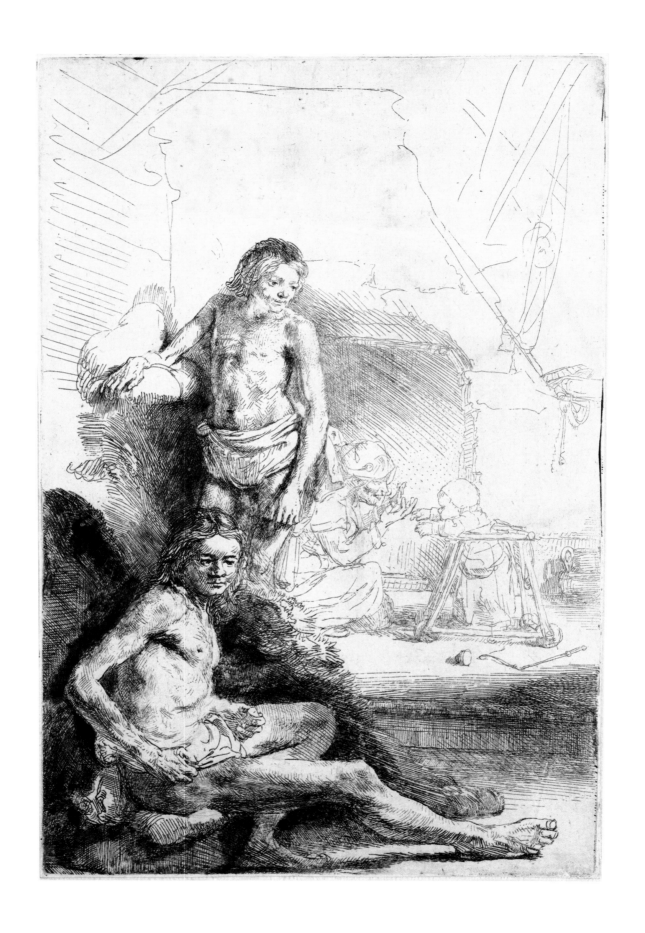

Samuel van Hoogstraten sat to the right of Rembrandt, and farthest to the right was an unidentified pupil whose drawing is now in the British Museum.[2] This group of study drawings and their relationship to Rembrandt's etching provide unique insights into the artist's teaching methods.

This didactic aspect finds its allegorical expression in the etching's background. Rembrandt used delicate lines to render a woman, who coaxes a child in a walker to step toward her. This scene gave the etching its name, *Het Rolwagentje (The Child's Walker)*, in the eighteenth century. In the seventeenth century in the Netherlands, the theme of a child learning to walk was sometimes a metaphor for learning through practice in the general sense. It is thought that by depicting this activity in connection with study from the living model, Rembrandt was representing symbolically the idea that young artists can reach their goals only through constant practice.[3]

1 Among his etchings, this and two additional representations from around 1646 (B 193, B 196) are the earliest examples of Rembrandt's analysis of the male nude. For more complete information and additional bibliography on this etching, see Holm Bevers in Berlin/Amsterdam/London 1991–92, vol. 2, Etchings, no. 21; Erik Hinterding in Amsterdam/London 2000–2001, no. 51.

2 Samuel van Hoogstraten, *Standing Male Nude*, c. 1646, pen and brown ink, brown wash, white bodycolor, 24.7 x 15.5 cm, Paris, Musée du Louvre, Cabinet des Dessins, Benesch A 55; Pupil of Rembrandt, *Standing Male Nude*, c. 1646, pen and brown ink, brown and gray wash, white bodycolor, over white chalk, 25.2 x 19.3 cm, London, British Museum, Benesch 710.

3 Emmens 1968, pp. 155–57.

Rembrandt Harmensz. van Rijn

LEIDEN 1606–1669 AMSTERDAM

29 *Cottages under a Stormy Sky,* c. mid-1630s

Pen and brown ink, brown and gray wash, white bodycolor, on brownish prepared paper; missing corner at upper left, restored

18.2 x 24.5 cm

PROVENANCE: Vienna, Hofbibliothek; Duke Albert von Sachsen-Teschen

INV. NO. 8880

BIBLIOGRAPHY: Benesch 1954–57, vol. 4, no. 800, fig. 947; Stockholm 1956, no. 106; Rotterdam/Amsterdam 1956, no. 117, fig. 42; Vienna 1956, no. 56; Benesch 1960, no. 37; Vienna 1969–70, no. 28, illus.; Benesch 1973, vol. 4, no. 800, fig. 1002; Vienna/Amsterdam 1989–90, no. 37, illus.; Washington 1990, p. 77, fig. 2; Schneider 1990, pp. 32, 34, fig. 23; Vienna 1993, no, 43, illus.; New York/Fort Worth 1995, no. 35, illus.; Vienna 2004, no. 151, illus.

Ranked as one of the greatest of Rembrandt's achievements in landscape art and one of the Albertina's most famous sheets, this drawing is among the artist's earliest landscape drawings, dating around the mid-1630s. Most of these drawings are rendered in pen and ink, with and without wash. Many such early works confirm the artist's predilection for depicting farmhouses, singly or in groups, which he observed in nature, including a distinct type of straw-roofed house from the Gooi region, a rural area southeast of Amsterdam.[1]

The present drawing depicts this type of farmhouse, although the pictorially executed, balanced composition originated in the artist's imagination rather than as a study from nature. Nevertheless, in his working process, Rembrandt most likely referred back to his drawings made in situ. The overall unreal quality of this imaginary landscape is due largely to the Baroque lighting effects. While the houses and trees visible in the background are cast in shadow by a dark mass of clouds at the left, brilliant sunlight works like a spotlight to emphasize the small country road and distinct areas of the vegetation and buildings in the foreground. Broad hatching strokes and generous dark washes add definition to large areas. The dramatic chiaroscuro relates the drawing to two drawings in Budapest in which dazzling sunlight boldly highlights the irregular forms of houses most likely drawn "from life."[2] Whereas spontaneous observation of nature dominates these studies, the Albertina drawing is distinguished by its carefully balanced contrasts of light and dark

Rembrandt's landscape drawings typically are sketchlike in nature; this pictorially complete sheet is a rarity. It is also the only landscape drawing that includes a dark, cloudy sky. An etching from around the same time, Rembrandt's *Annunciation to the Shepherds* (1634), offers a related example in a nocturnal scene.[3] With its dark masses of clouds and brilliantly lit areas of landscape, the small painting *Landscape with Stone Bridge* (late 1630s) displays similar dramatic chiaroscuro effects.[4]

1 See Amsterdam/Paris 1998–99, pp. 30–31.

2 Budapest, Szépmüveszeti Museum, inv. nos. 1576 and 1577. See Benesch 1973, vol. 2, nos. 464, 463.

3 Vienna/Amsterdam 1989–90, p. 102, under no. 37.

4 *Landscape with Stone Bridge,* oil on wood, 29.5 x 42.5 cm, Amsterdam, Rijksmuseum, inv. no. SK-A 1935. See Vienna 2004, no. 150.

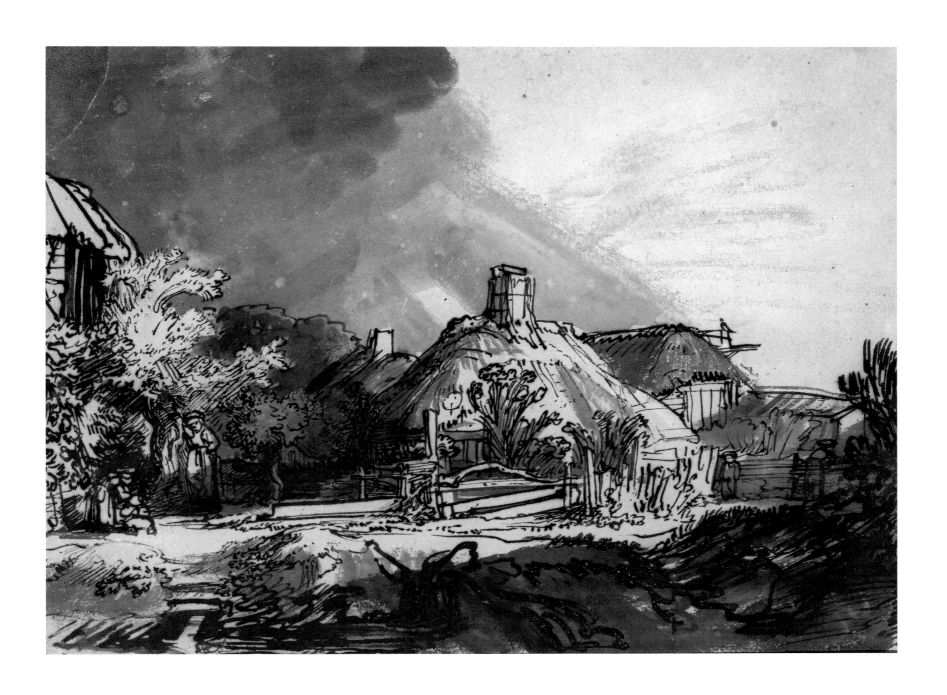

Rembrandt Harmensz. van Rijn

LEIDEN 1606–1669 AMSTERDAM

30 *The Three Trees,* 1643

Etching, drypoint, and engraving; single state

21.3 x 27.9 cm

INSCRIBED AT LOWER LEFT: "Rembrandt f 1643"

PROVENANCE: Vienna, Hofbibliothek

INV. NO. 1926/363

BIBLIOGRAPHY: B 212; White and Boon 1969, B 212; Vienna 1970–71, no. 154, pl. 38; Vienna 2004, no. 169, illus.

Whereas the dates of Rembrandt's landscape drawings range from around 1634 to 1660, his etched landscapes were produced for only eleven years, from 1641 to 1652. Considered among the greatest achievements of Netherlandish landscape art, these prints vary from the unique realism of scenes recorded in sparse lines to the dramatic chiaroscuro of imaginary landscapes. The landscape theme appears to have offered the artist a broad field for artistic and technical experimentation.

The Three Trees etching dated 1643 is one of the most famous landscapes in the history of Western European art. This visionary scene, characterized by its stormy atmosphere, is the subject of many hypotheses regarding its symbolism—for example, speculations about the role of the three trees and their association with the three crosses on Golgotha—though final proof is lacking.[1]

In any case, it is an imaginary panoramic landscape in which the city seen on the horizon is only broadly reminiscent of Amsterdam. On one hand, the print offers a breathtaking impression of a landscape defined by depth and atmosphere; the finely contoured layers of space brighten increasingly with proximity to the horizon. On the other hand, the dark masses of clouds, penetrating rays of light, and the three trees create an unreal, melodramatic atmosphere that dominates the image. The towering, silhouetted trees contrast emphatically with the bright sky behind them. In odd opposition to the threatening mood of the approaching storm is the completely unmoved comportment of the figures dispersed throughout the landscape: two shepherds, a group of people in a horse-cart, a pair of lovers, and a draftsman.[2]

Large areas of this famous print, of which only a single state is known, were etched in dense constellations of often deep lines. The foreground and sky areas were partially reworked with the burin and drypoint. Rembrandt's use of sulphur tint allowed him to achieve a plate tone that ranges from a granular texture to subtle nuances of light and shadow. Perhaps it was his intention to create in this imaginary landscape a Netherlandish counterpart to the southern, idealized type of landscape seen in the etchings of Claude Lorrain, which had been circulated since 1630. At the same time, the etched visions of landscape by his somewhat older contemporary Hercules Seghers may have been his inspiration. Seghers, whose unique experiments are still astonishing today, is known to have been deeply admired by Rembrandt.[3] However, as always for Rembrandt, diverse inspirations led to a highly authentic result.

1 In regard to this landscape, see Holm Bevers in Berlin/Amsterdam/London 1991–92, vol. 2, no. 19; White 1999, pp. 219–20; and Martin Royalton-Kisch in Amsterdam/London 2000–2001, no. 48.

2 Martin Royalton-Kisch (note 1), p. 207, n. 6.

3 Ibid., p. 219.

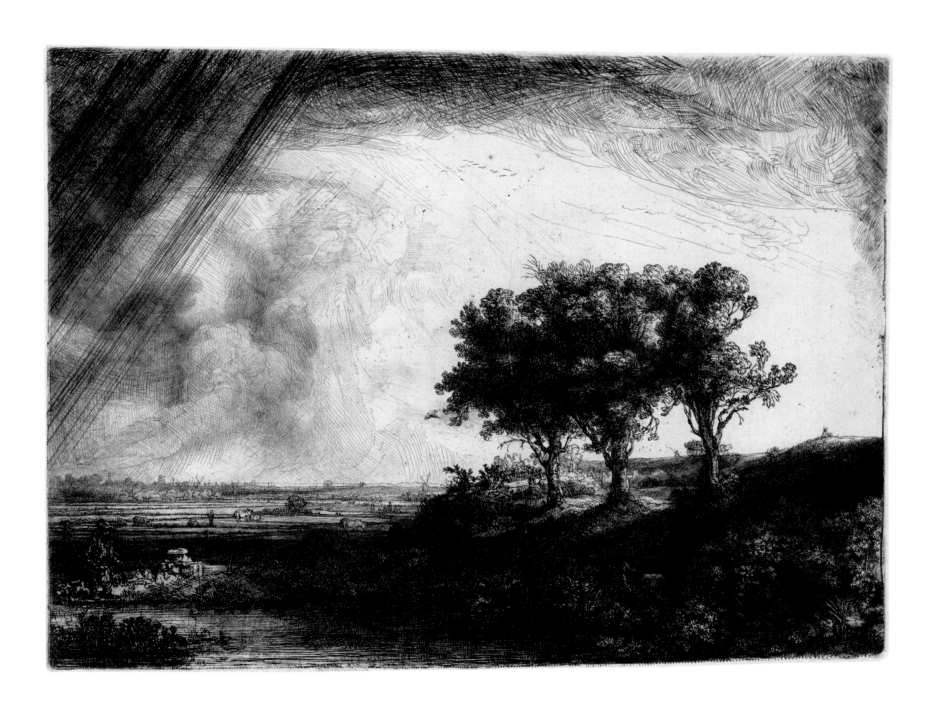

Rembrandt Harmensz. van Rijn

LEIDEN 1606–1669 AMSTERDAM

31 *Two Boyers at Anchor, with a Man Taking in Sail,* early 1640s

Black chalk, heightened with white

14 x 15.8 cm

PROVENANCE: Vienna, Hofbibliothek; Duke Albert von Sachsen-Teschen

INV. NO. 17561

BIBLIOGRAPHY: Benesch 1954–57, vol. 2, no. 468, fig. 527; Stockholm 1956, no. 100; Rotterdam/Amsterdam 1956, no. 49, fig. 25; Vienna 1956, no. 22; Vienna 1969–70, no. 11, illus.; Benesch 1973, vol. 2, no. 468, fig. 560; New York 1997, no. 56, illus.; Bilbao/Vienna 1999, no. 28, illus.; Vienna 2004, no. 154, illus.

The area around Amsterdam is defined by water, and there, in the early 1640s, Rembrandt drew two small boyers tied together and lying at anchor. (A boyer is a type of small boat designed for use on the open water and equipped with a yard.)[1] The sail of the foremost boat has been taken in; the yard is positioned across the mast at an angle. On the other boat, a man, rendered in a few summary lines, is visibly occupied with furling the sail. The gentle motion of the small flags on the mast above and the slight breaks in the reflections in the water at the lower left point to quiet, relatively still, weather conditions. The diagonal yard casts a shadow on the furled sail. The shadow of the foremost boat can be seen on the port bow of the other boat. The position of the shadow indicates that the sun is high in the sky at the right. Emphatic contrasts of light and dark on the half-lowered centerboard and accents added in white bodycolor in the illuminated areas suggest bright sunlight. The man's actions form the centerpoint of the composition, where the folds of the sail come together.

Rembrandt filled the sheet with this rendering of the two boats; his focus on the objects makes it a rarity among his landscape drawings. Typically, the artist integrated boats or ships into a broadly defined landscape composition. Other rare examples of Rembrandt's concentration on an object are the etching *The Snail* (1650) and the drawing *A Coach* (c. 1660–63), in which, as in the present sheet, the environment is only faintly indicated.[2]

1 Regarding the identification of the type of boat and the dating, see Marian Bisanz-Prakken, New York 1997, no. 56, illus.

2 *The Snail*, B 159, see Vienna 2004, no. 143, p. 318; *A Coach*, London, The British Museum, Department of Prints and Drawings, Inv. no. Oo, 9–112. See Vienna 2004, no. 167, p. 318.

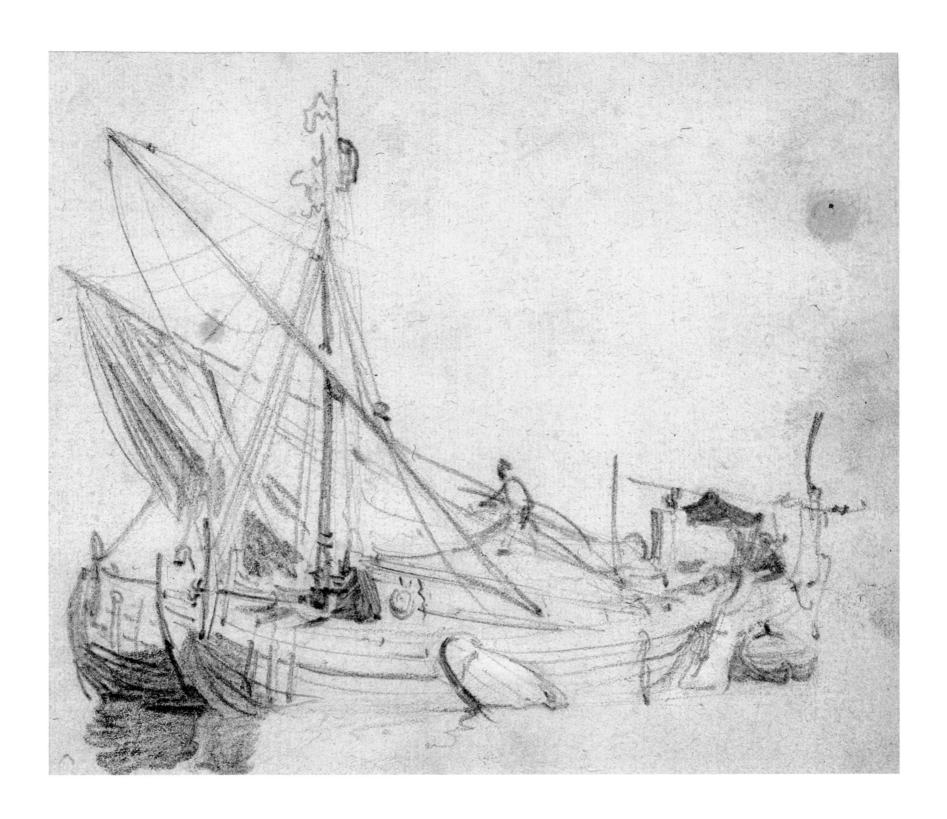

Rembrandt Harmensz. van Rijn

LEIDEN 1606–1669 AMSTERDAM

32 *View over the Ramparts near the Heiligewegspoort,* late 1640s

33 *View over the Ramparts near the "De Tor" Mill,* late 1640s

34 *View of the Pesthuis from the Ramparts,* late 1640s

CAT. NO. 32

Black chalk

8.5 x 16 cm

PROVENANCE: Vienna, Hofbibliothek; Duke Albert von Sachsen-Teschen

INV. NO. 17569

BIBLIOGRAPHY: Benesch 1954–57, vol. 4, no. 805, fig. 952; Stockholm 1956, no. 102; Rotterdam/Amsterdam 1956, no. 153; Vienna 1956, no. 52; Vienna 1969–70, no. 23, illus.; Benesch 1973, vol. 4, no. 805, fig. 1006; Schatborn and Bakker 1976, p. vi, no. 10, illus.; Washington 1990, pp. 213–14, under no. 61, fig. 1; Vienna 1993, no. 46, illus.; New York/Fort Worth 1995, no. 38, illus.; Amsterdam/Paris 1998–99, p. 187, fig. 2, p. 188 (III.2), plate p. 102; Vienna 2004, no. 157, illus.

CAT. NO. 33

Black chalk

7.8 x 15.8 cm

PROVENANCE: Vienna, Hofbibliothek; Duke Albert von Sachsen-Teschen

INV. NO. 17570

BIBLIOGRAPHY: Benesch 1954–57, vol. 4, no. 808, fig. 945; Stockholm 1956, no. 103; Rotterdam/Amsterdam 1956, no. 154; Vienna 1956, no. 55; Vienna 1969–70, no. 26, illus.; Benesch 1973, vol. 4, no. 808, fig. 1009; Schatborn and Bakker 1976, p. vii, no. 11, illus.; Vienna 1993, no. 45, illus.; New York/Fort Worth 1995, no. 37, illus.; Amsterdam/Paris 1998–99, p. 187, fig. 4, p. 189, plate p. 103; Vienna 2004, no. 156, illus.

CAT. NO. 34

Black chalk

8 x 15.8 cm

PROVENANCE: Vienna, Hofbibliothek; Duke Albert von Sachsen-Teschen

INV. NO. 17571

BIBLIOGRAPHY: Benesch 1954–57, vol. 4, no. 807, fig. 955; Stockholm 1956, no. 104; Rotterdam/Amsterdam 1956, no. 155; Vienna 1956, no. 54; Vienna 1969–70, no. 25, illus.; Benesch 1973, vol. 4, nos. 807, 1008; Schatborn and Bakker 1976, p. vii, no. 14, illus.; Vienna 1993, no. 47, illus.; Amsterdam/Paris 1998–99, p. 193, fig. 3, p. 194; New York/Fort Worth 1995, no. 39, illus.

After moving to his new house on Amsterdam's St. Antonisbreestraat in 1639, a new creative field opened up for Rembrandt. He had drawn farmhouses in the outdoors using pen; now he turned to black chalk, adding it as a new medium for numerous sketches in nature. Exploring the rural environs on extended walks, he recorded motifs in small sketchbooks. In many respects, he took up the pioneering achievements of his predecessor Esaias van de Velde (see cat. nos. 13–16). In the early seventeenth century, van de Velde had created small drawings and etchings that display a new, object-oriented interest in simple, rural motifs. In addition, like Jan van Goyen, he was among the first to use black chalk to achieve effects of light, space, and atmosphere in landscape art.

Some twenty years later, Rembrandt added a new dimension: he integrated the moment of subjective perception into his landscape sketches. His spontaneous and sure handling of his medium was

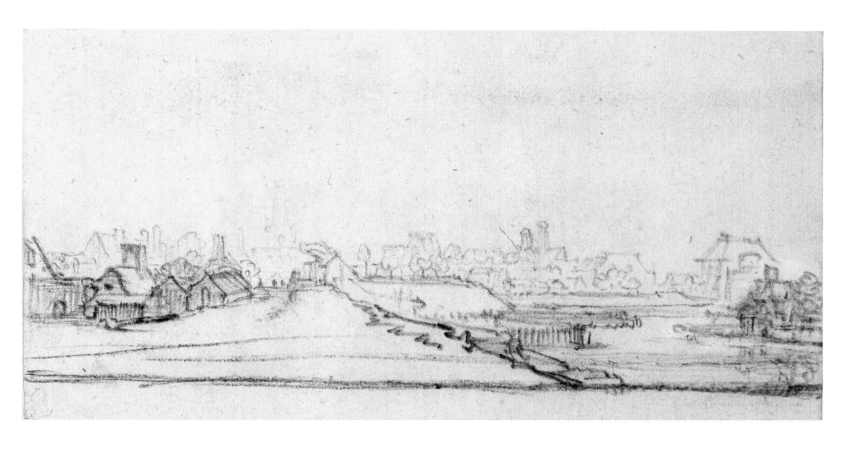

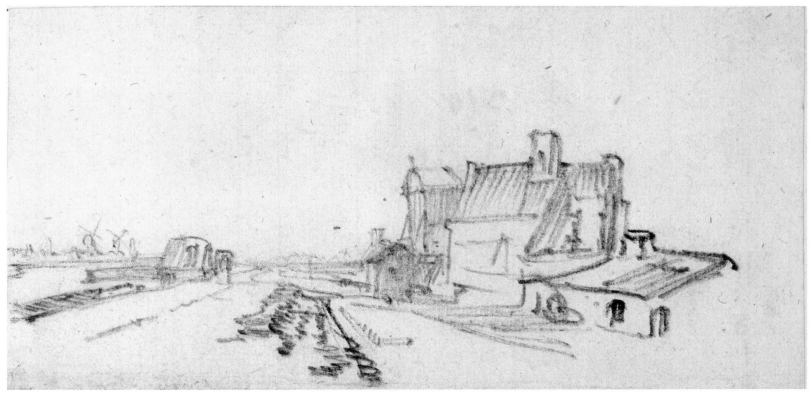

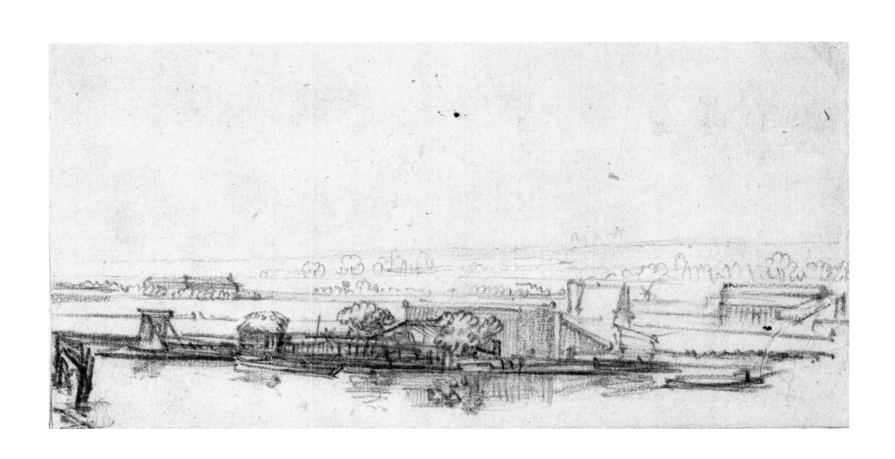

based on an apparently innate feeling for the balance of line and mass. Each stroke plays a crucially essential role in the composition; empty space between the lines fulfills a dynamic function—becoming a country road, a field, the glittering surface of water, or the atmospheric sky area.

Rembrandt's landscape sketches are nearly all autonomous works that are not directly tied to any particular purpose. Their immediacy and liveliness stem from the artist's focus—unique in his time—on replicating in his drawings the physical act of seeing. The eye naturally concentrates on a certain point or focal area and perceives the surrounding area only in broad lines and schematic forms. The recognition of this naturally selective process of vision led Rembrandt to a new form of realism, easily evident in these three sheets from the late 1640s, originally belonging to the same sketchbook.

In *View over the Ramparts near the Heiligewegspoort* (cat. no. 32), Rembrandt suggested spatial relationships with a few lines: the broad stroke in the foreground indicates the ramparts from which he viewed the landscape with the city as a backdrop.[1] The greatly foreshortened road that leads directly into town accentuates the sense of near and far.

The emphasis is placed most heavily on the middle ground, encompassing the houses visible at the left, the right edge of the road, and the banks that jut out into the water. In contrast, the forms in the background are visible only in brief outlines. Appearing quite natural, this recession into space conveys on a small surface a high degree of depth and atmospheric effects.

In *View over the Ramparts near the "De Tor" Mill* (cat. no. 33), Rembrandt was standing in approximately the same location as in cat. no. 32, but looking in the opposite direction, away from the city. Here his attention was turned toward the overlapping, irregular forms of the houses in the foreground at the right; he rendered their distinct shapes convincingly with only the most essential, schematic lines. By varying the pressure of the chalk, the artist created a particularly lively effect; the forceful zig-zagging line at the road's edge leads directly back into the depth of the composition.

View of the Pesthuis from the Ramparts (cat. no. 34) focuses the viewer's eye on the buildings along the water's edge in the lower third of the composition. Straight horizontal lines and angular forms dominate the drawing. The clear outlines of the Pesthuis (literally "Plague House") stand out in the background. Such was the name of the hospital erected far from the city to house patients with contagious diseases.[2] The thin lines indicating the strata of the landscape disappear in the distance, suggesting unending space and a slightly misty atmosphere.

1 For topographical details, see nos. 33, 34; Amsterdam/Paris 1998–99, pp. 187–90.

2 For topographical details, see ibid., pp. 192, 194.

Rembrandt Harmensz. van Rijn

LEIDEN 1606–1669 AMSTERDAM

35 *Open Landscape with Houses and a Windmill (The Former Copper Mill on the Weesperzijde),* late 1640s

Pen and brown ink with brown wash

11 x 24.2 cm

PROVENANCE: Duke Albert von Sachsen-Teschen

INV. NO. 8892

BIBLIOGRAPHY: Benesch 1954–57, vol. 6, no. 1356, fig. 1590; Vienna 1956, no. 109; Benesch 1960, no. 77; Vienna 1969–70, no. 52, illus.; Benesch 1973, vol. 6, no. 1356, fig. 1673; Moscow/Leningrad 1973, pp. 112–13, illus.; Australia 1977, no. 39, illus.; Vienna 1993, no. 48, illus.; New York/Fort Worth 1995, no. 40, illus.; New York 1997, no. 58, illus.; Amsterdam/Paris 1998–99, pp. 256–58, figs., 3, 5, plate p. 132; Bilbao/Vienna 1999, no. 29, illus.; Vienna 2004, no. 160, illus.

The mill and the adjacent buildings depicted in this drawing were located on the Weesperzijde on the east bank of the Amstel River, which bends off to the right in the background.[1] Rembrandt must have positioned himself near some canals at a distance from the mill, apparently selecting his location in order to capture the group of buildings with the towering mill in the center of the open landscape. He rendered the foreground area in a few powerful, schematic outlines and sweeping, rapidly applied washes: the tree at the left, the bright reflections in the water, traces of a bridge, and the broad shadow below. A light expanse of meadow extends across the middle ground, rhythmically marked by long, horizontal strokes. Lines describing the small canal and the bank of the Amstel at the right emphatically parallel the delineations of the left foreground and draw the eye directly into the mill complex and the surrounding buildings. Here the rhythm of lines becomes more compressed and subtle: the fluid, twisting movements of the reed pen create short, distinct strokes that range by turns from saturated to brittle, dark to light. Carefully applied washes enhance their effect. Without detail, Rembrandt fully achieved the illusion of a shimmering range of diversely illuminated forms.

In cursory, yet exceptionally eloquent strokes, the artist conveyed the impression of the landscape's endless expanse. The surface of the Amstel brightens at the right, and the delicately noted bank on the horizon is caught in a diffuse light. A broad expanse of flat land opening at the left is indicated by just a few tense brush and pen strokes. The untouched areas of the paper play an especially vital role in this sheet, becoming an illuminated meadow, a reflective body of water, or space filled with light and air. In this drawing, Rembrandt took up a traditional compositional formula rooted in the sixteenth century: a repoussoir tree, dark foreground, animated middle ground, and distant view. Yet this model served him as a point of departure for the unfolding of a complex, tension-filled spatial dynamic that conveys an individually stylized illusion of reality. The powerful diagonals of the drawing combined with the attenuated pen strokes and fluidly applied washes date the drawing to the late 1640s.[2]

1 Regarding the topography, see Amsterdam/Paris 1998–99, p. 257. In another drawing, which Rembrandt produced from the same position though turned a little farther to the right, one can see to the other side of the Amstel. The images are placed together to create a panoramic view in Amsterdam/Paris 1998–99, p. 258, fig. 5.

2 Vienna 1993, no. 48, illus.

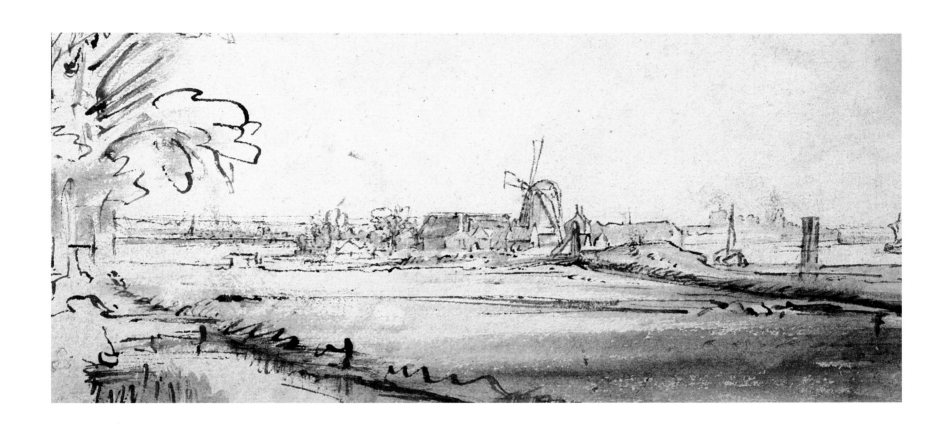

Rembrandt Harmensz. van Rijn

LEIDEN 1606–1669 AMSTERDAM

36 *View of "Het Molentje" ("The Little Windmill"), c. late 1650s*

Pen and brown ink, brown wash, white bodycolor

9.6 x 21.3 cm

PROVENANCE: Vienna, Hofbibliothek; Duke Albert von Sachsen-Teschen

INV. NO. 8870

BIBLIOGRAPHY: Lugt 1920, pp. 98–101; Vienna 1936, no. 42; Benesch 1947, no. 228; Paris 1950, no. 124; Benesch 1954–57, vol. 6, no. 1354, fig. 1588; Stockholm 1956, no. 143; Rotterdam/Amsterdam 1956, no. 195; Vienna 1956, no. 110; Vienna 1969–70, no. 53, illus.; Benesch 1964, no. 53. illus.; Benesch 1973, vol. 6, no. 1354, fig. 1668; Washington 1990, no. 71, illus.; Vienna 1993, no. 49, illus.; New York/Fort Worth 1995, no. 41, illus.; Amsterdam/Paris 1998–99, pp. 276–77, fig. 5; Vienna 2004, no. 164, illus.

This image of "Het Molentje" ("The Little Windmill"), a popular inn on the banks of the Amstel,[1] is a magnificent example of the sparse arrangement and highly evocative quality that characterize Rembrandt's drawing style of the late 1650s. Rembrandt divided the composition into four subtly differentiated horizontal planes. For the lower area, he mixed brown wash with white bodycolor, resulting in a dull, earthy tone. Long, horizontal brushstrokes emphasize the current of the water, and isolated streaks of white bodycolor impart a brilliant shimmer. The occasionally overlapping, simple forms of the sailboat, mill, and houses are partially encompassed by a light brown wash.

Spatial nuances are evoked largely through the artist's virtuoso use of the reed pen. The riverbank in the foreground is defined by broad, brushlike strokes and lines so delicate that they seem almost to disappear. Varied accents in the contours of the boats, mill, and houses define their spatial relationships to each other, while also emphasizing their tonal values. The small, light rectangle between the mill and the houses holds an almost magical allure for the eye as the single area in the drawing where the paper is completely untouched—a small bright spot within the otherwise misty atmosphere.

The loose, cursory style of the subtly differentiated strokes has led to dating the drawing to the second half of the 1650s.[2] The compositionally related drawing *"Het Molentje"* (Benesch 1353) in Cambridge exhibits the more uniform pen strokes of a very different style, suggesting that it was produced some years earlier than the Albertina sheet.[3] Because Rembrandt's landscape drawings are difficult to place in a chronology, a conclusive date cannot be determined with complete certainty.

1 Regarding the topography of this region, see Amsterdam/Paris 1998–99, pp. 276–80.

2 Vienna 1993, p. 88.

3 Ibid. Cynthia Schneider in Washington 1990, nos. 70, 71 dates both sheets to between 1649 and 1651, along with another drawing that Rembrandt produced of "Het Molentje" from a somewhat different vantage point.

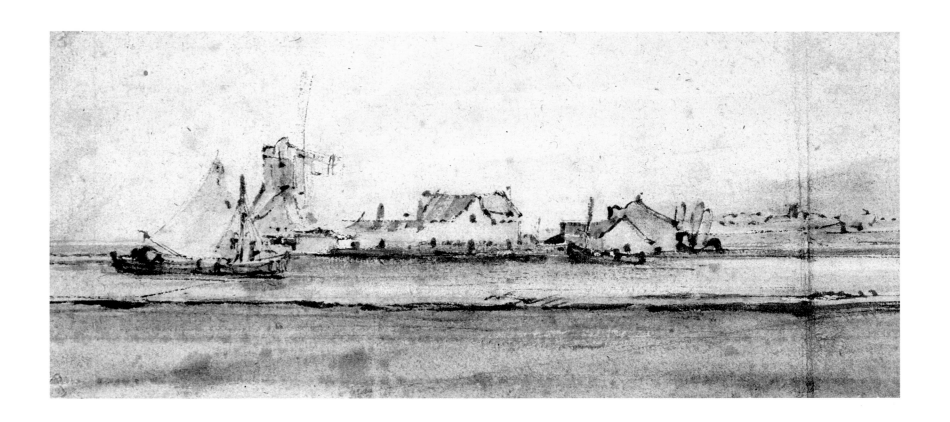

Rembrandt Harmensz. van Rijn

LEIDEN 1606–1669 AMSTERDAM

37 *Three Gabled Cottages,* 1650

Etching and drypoint, first state

16.1 x 20.2 cm

INSCRIBED AT LOWER LEFT: "Rembrandt f 1650"

PROVENANCE: Vienna, Hofbibliothek

INV. NO. 1926/369

BIBLIOGRAPHY: B 217; White and Boon 1969, B. 217; Vienna 1970–71, no. 195; Vienna 2004, no. 172, illus.

Rembrandt masterfully achieved a dramatic sense of depth in the velvety black lines of the first state of this relatively late etching dated 1650. The work is related to a sketch in which the artist captured the scene on the spot in rapid, summary pen strokes. Only rarely can a direct relationship be identified between Rembrandt's drawings and etchings. The insight offered here into his working methods is thus all the more interesting.[1]

It is evident that Rembrandt borrowed elements from the sketch for his etching; he may have also worked from another study made from a more distant viewpoint.[2] Corresponding motifs include the foremost house with the hooded chimney, the tall tree, the tree stump, and the small shed.[3] The road and its banked shoulder, the nearby body of water, and the houses in the distance appear to have been part of the actual scene viewed by the artist.[4] The motif of the row of houses, in which the rhythmically repeated gables add to the spatial recession, comes from several studies made elsewhere.[5] Rembrandt enlarged the tree in the foreground to create a powerful repoussoir element. Its heavy clusters of leaves merge with the neighboring trees in a dark, restless mass that casts a broad shadow across the foreground, greatly intensifying the contrast with the distant, perspectively reduced houses and the brightness of the broad sky.

Though he started with a real site, by altering the scale and borrowing motifs to complete the scene, Rembrandt succeeded in developing his own individual solution. Objectively recorded details from nature become a subjective, greatly intensified experience of space that is defined by bold contrasts of light and dark. In this partially imaginary landscape, where at times the handling of the line tends toward abstraction, the subtle lighting effects are very suggestively conveyed.

1 See Martin Royalton-Kisch, in Amsterdam/London 2000–2001, no. 63.

2 Pen and brown ink and wash, 9.4 x 17.2 cm, Berlin, Staatliche Museen, Kupferstichkabinett (Benesch 835).

3 Haverkamp-Begemann 1961, p. 57.

4 Amsterdam/Paris 1998–99, p. 334.

5 Ibid. (Benesch 1288, 1289, 1287).

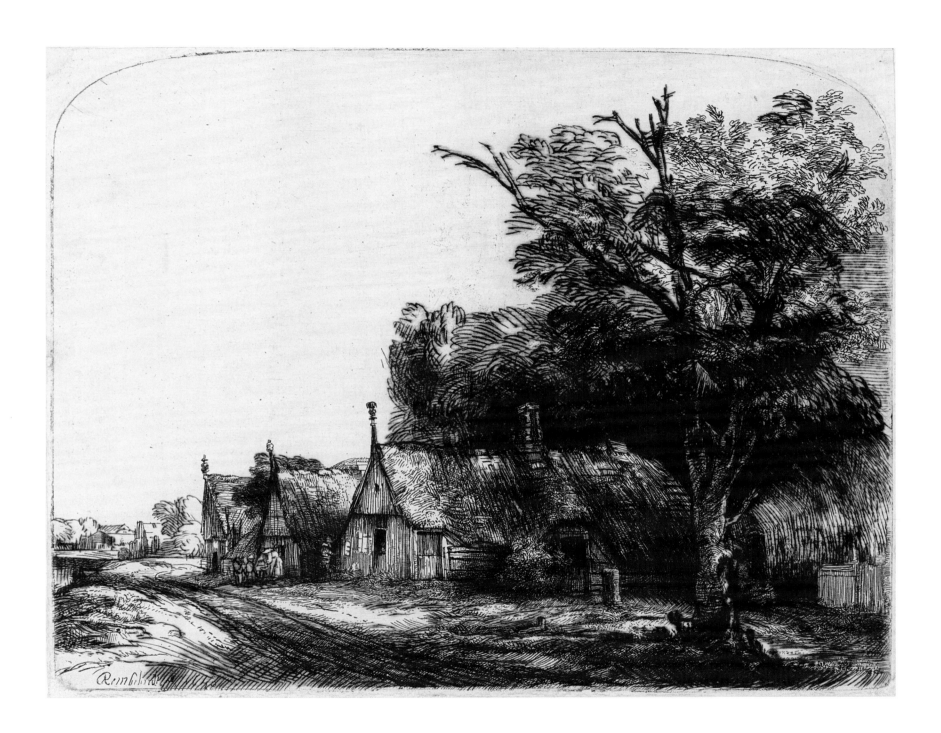

Rembrandt Harmensz. van Rijn

LEIDEN 1606–1669 AMSTERDAM

38 *Old Man with a Wide-Brimmed Hat, Seated,* c. 1647/52

39 *Bust of a Sleeping Child,* c. 1647/52

40 *Man with a Wooden Leg, a Crutch, and a Cane, Seen from Behind,* c. 1647/52

CAT. NO. 38

Black chalk

12.7 x 9.5 cm

PROVENANCE: Prince de Ligne; Duke Albert von Sachsen-Teschen

INV. NO. 17556

BIBLIOGRAPHY: Benesch 1954–57, vol. 5, no. 1075, fig. 1291; Rotterdam/ Amsterdam 1956, no. 192; Vienna 1956, no. 88; Vienna 1969–70, no. 44, illus.; Benesch 1973, vol. 5, no. 1075, fig. 1365; Robinson 1998, pp. 40, 44, n. 32; Sydney 2002, no. 78, illus.; Vienna 2004, no. 49, illus.

CAT. NO. 39

Black chalk on red-brown toned paper

9.3 x 9.2 cm

PROVENANCE: Prince de Ligne; Duke Albert von Sachsen-Teschen

INV. NO. 8851

BIBLIOGRAPHY: Benesch 1954–57, vol. 4, no. A 59a, fig. 1065; Benesch 1973, vol. 4, no. A 59a, fig. 1127; Robinson 1998, pp. 39, 40, 44, fig. 6

CAT. NO. 40

Black chalk

14.3 x 8.9 cm

PROVENANCE: Duke Albert von Sachsen-Teschen

INV. NO. 8847

BIBLIOGRAPHY: Benesch 1954–57, vol. 4, no. 721, fig. 876; Haverkamp-Begemann 1961, p. 87; Vienna 1969–70, no. 37, illus.; Benesch 1973, vol. 4, no. 721, fig. 913

A group of some forty figure studies, which are dispersed throughout the world, occupies a special place in Rembrandt's oeuvre. Although difficult to date, they generally are thought to have been done between 1647 and 1652.[1] Executed in black chalk and often small, these drawings depict the broad spectrum of the people of Rembrandt's time who were poor and lived on the fringes of society: beggars, cripples, poor Jews, or fragile elderly. Some are shown individually, others in groups. They are portrayed walking, standing, speaking with one another, sitting, and lying down. Within the Albertina's fine examples from this group are the three noteworthy studies presented here.

The short, abbreviated strokes and blocklike forms of *Old Man with a Wide-Brimmed Hat, Seated* (cat. no. 38) are typical of many drawings in the group. In contrast to the powerful lines of the clothing of the man, who leans forward slightly, his face and hat are delicately rendered. The shadow cast on the face by the hat's brim demonstrates the greatest subtlety; the untouched areas of the paper below the eyes, and upon the nose and cheeks represent the areas caught by the light. The left half of the face, from the contours of the cheek and the ear to the outline of the hat, is rendered somewhat more forcefully. In a characteristic manner, Rembrandt accentuated the left eye more than the right, which produces a very lively effect.

The drawing *Bust of a Sleeping Child* (cat. no. 39), excluded from Rembrandt's oeuvre by Otto Benesch, was convincingly reattributed to the artist by William Robinson.[2] The active interplay of the confidently sketched lines of the clothing and the softly rendered facial features is very convincing. The delicate, softly shaded face of the child lifts away from the heavily shaded areas of the broad head covering, which appears to be improvised to provide more protection than the close-fitting

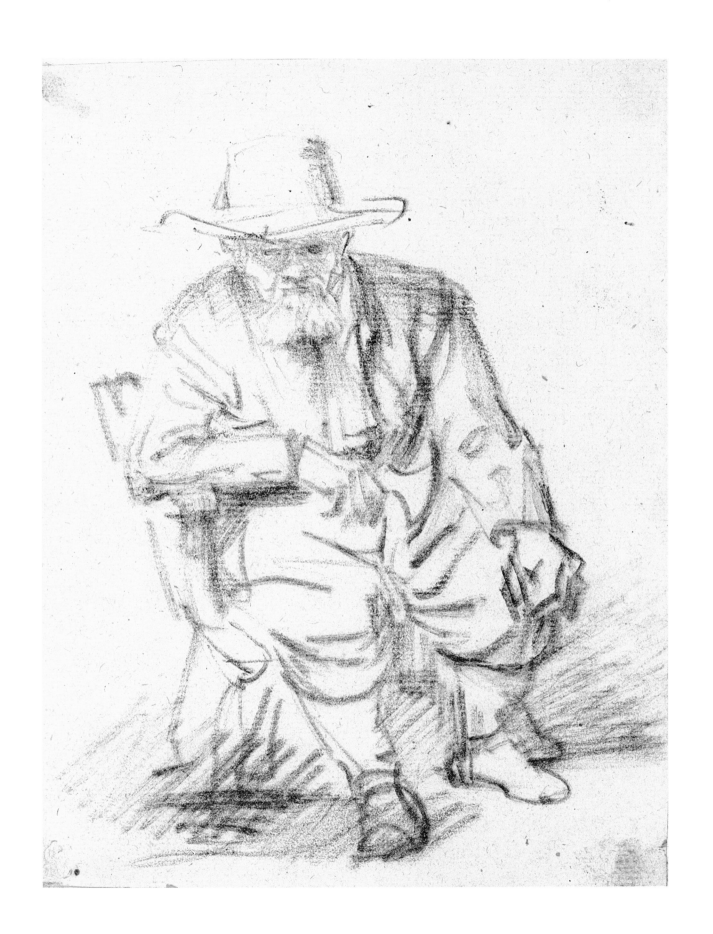

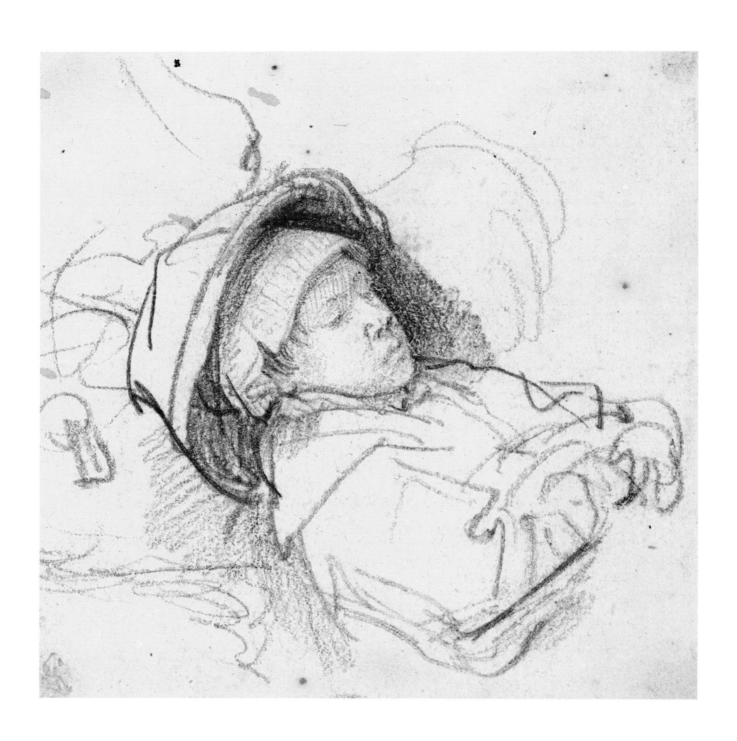

bonnet. With a few schematic lines, Rembrandt created a restless environment—perhaps indicating a scene of a family en route who have laid their child on their baggage to rest. The improvised, random quality of the scene defines the immediate "from life" character of this subtle study.

The small sheet *Man with a Wooden Leg, a Crutch, and a Cane, Seen from Behind* (cat. no. 40) is an impressive study "from life" in which, with great concentration, Rembrandt captured the complicated system of supports the disabled man uses as he shifts his weight to move forward. The black chalk is especially suited to the finely differentiated outlines and light and dark values. The artist pressed down forcefully on the chalk to draw the figure's active, heavily strained hands, whereas he sketched the limp, crippled foot in light strokes. The light effects add dimension to the foot and the rumpled fabric of the overcoat. With great care, Rembrandt recorded the shabby clothing, from the ragged edge of the coat and its tightness at the waist to the floppy hat with the crooked chinstrap. The light hatching of the folds and shaded areas of the clothing leave the illuminated areas untouched, producing subtle modeling effects. The satirical aspect noted in Pieter Bruegel's representations of poor and disabled people, the influence of which was still felt in the seventeenth century, is totally absent in Rembrandt's work. His beggars, like the one represented here, are often distinguished by their great dignity.

1 See, among other sources: Broos 1981, pp. 55–64; London 1992, no. 51; as well as Robinson 1998. The estimated dating of 1647–52 is based on one hand on a drawing of a beggar family (Benesch 749), the verso of which includes a preparatory study for the 1647 etched portrait of Jan Six (B 285). On the other hand, the etching dated 1652 *Christ Disputing with the Doctors* (B 65) relates to several studies from the group.

2 Robinson 1998, pp. 39, 40, 44, fig. 6.

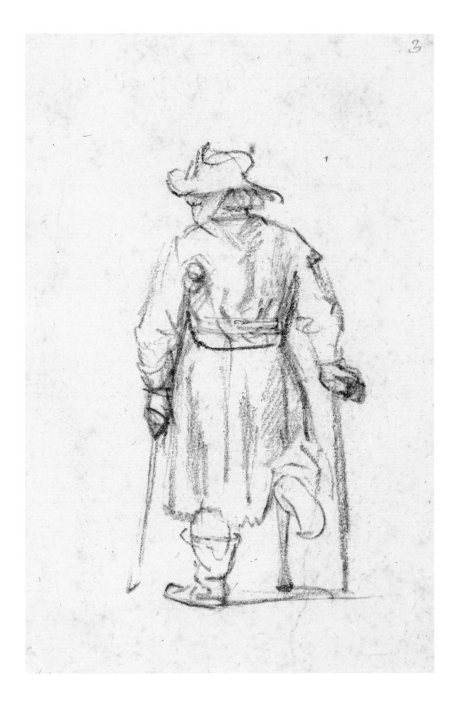

Rembrandt Harmensz. van Rijn

LEIDEN 1606–1669 AMSTERDAM

41 *Christ Healing the Sick ("The Hundred Guilder Print"),* c. 1648

Etching, drypoint, and engraving; first state on Japan paper

27.8 x 38.8 cm

PROVENANCE: Vienna, Hofbibliothek

INV. NO. 1926/1640

BIBLIOGRAPHY: B 74; White and Boon 1969, B 74; Vienna 1970–71, no. 186, pl. 54; Vienna 2004, no. 119, illus.

"The Hundred Guilder Print" is one of Rembrandt's most famous etchings. The legendary price mentioned in the title, found in different seventeenth- and eighteenth-century sources, is a reflection of the esteem shown toward the supreme technical and artistic achievement of the work.[1] The print, which was neither dated nor signed, was apparently never sold during the artist's lifetime, but may have been distributed only among his friends.[2] Rembrandt mustered his full technical abilities to do justice to the complex subject matter; for the finer lines, he used the etching needle, employing the burin and drypoint for the heavier accents. The stylistic variations within the depiction of the figures and the many additions in drypoint have led to the suggestion that the artist may have worked from the early 1640s on this ambitious project.[3]

The subject and its interpretation are highly unusual. The figures crowd together as on a stage to simultaneously enact various scenes from Matthew 19. Having arrived in Judea, a radiant Christ stands before a dark vaulted arch and blesses multitudes of followers, including many suffering from illness, whom he heals (Matthew 19: 2). The sculptural modeling of the group effectively accentuates the sick who lie, sit, or kneel in the foreground. An old woman with her hands raised in supplication casts a large shadow on Christ's robe. Two women with children occupy a prominent position in the left foreground.

The foremost figure is restrained by Peter, but Jesus blesses them: "Suffer the little children, and forbid them not, for such is the kingdom of heaven" (Matthew 19: 13–14). This figural group continues in an upward diagonal toward the Pharisees, flooded in light at the left edge of the image. The lively gestures and expressions reflect their concerns about the issue of divorce (Matthew 19: 1–12). Drawn in fine lines without shading, the luminously transparent figures contrast sharply with those obscured in shadows at the right. A camel in a passageway at the far right most likely relates to Matthew 19: 24, in which Jesus proclaimed that it would be easier for a camel to go through the eye of a needle than for a rich man to enter the kingdom of God. The rich young man distressed by Jesus's suggestion that he give his wealth to the poor is depicted sitting between the two mothers at the left.

Psychological differentiation among the figures is accompanied by delicate modulation and care in the surface values. Light plays a decisive role, determining whether the forms come forward or disappear in schematic outlines. In its diversity and density, the crowd stands out from the broad, dark areas that compose the background and the right foreground. The present example, printed on Japan paper, conveys a peculiar, hazy atmosphere, which similarly pervades the painting *The Night Watch* (Amsterdam, Rijksmuseum), completed in 1642.[4] The great artistic and technical skill required to achieve command of the diverse lighting effects and the complex arrangement of the figures in the painterly *"Hundred Guilder Print"* leads easily to a comparison with this masterpiece.

1 The sources are mentioned in Berlin/Amsterdam/London 1991–92, vol. 2, pp. 242, 245, n. 4, 5, 8; in Amsterdam/London 2000–2001, pp. 253, 255–56, 258, n. 3.

2 Amsterdam/London 2000–2001, p. 253.

3 Ibid., pp. 254–55. Drypoint was perhaps employed after around 1645. According to watermark reasearch, the known impressions were pulled only from around 1647/48. See ibid., p. 255.

4 Ibid., p. 254.

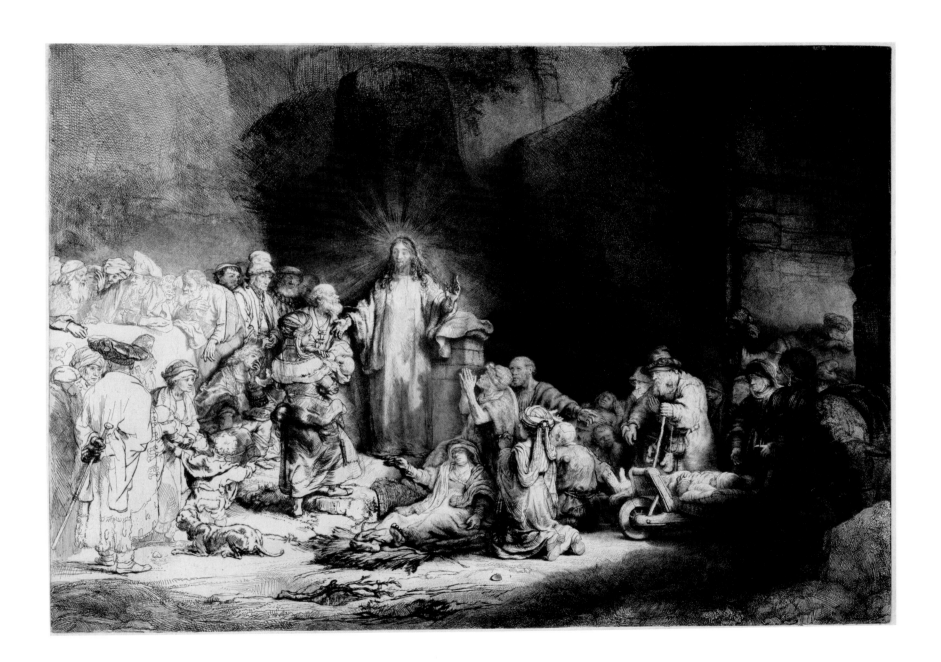

Rembrandt Harmensz. van Rijn

LEIDEN 1606–1669 AMSTERDAM

42 *The Three Crosses,* c. 1653
43 *The Three Crosses,* c. 1653

CAT. NO. 42

Drypoint and engraving, third state

38.5 x 45 cm

INSCRIBED AT LOWER CENTER: "Rembrandt. f. 1653"

PROVENANCE: Albertina, earliest collections

INV. NO. 1926/1657

BIBLIOGRAPHY: B 78; White and Boon 1969, B 78, III; Vienna 1970–71, no. 231; Vienna 2004, no. 122, illus.

CAT. NO. 43

Drypoint and engraving, fourth state on Japan paper

38.5 x 45 cm

PROVENANCE: Albertina, earliest collections

INV. NO. 1926/1659

BIBLIOGRAPHY: B 78; White and Boon 1969, B 78, IV; Vienna 1970–71, no. 232, pl. 71; Vienna 2004, no. 123, illus.

Artistically as well as technically, the monumental drypoint *The Three Crosses* (1653) is considered Rembrandt's most challenging printmaking project. Like its presumed pendant *Ecce Homo* (1655, cat. no. 44) and *"The Hundred Guilder Print"* (c. 1648, cat. no. 41), it ranks among Rembrandt's greatest achievements in the print medium. Documented in four states, the work is represented here in the third and fourth states. Rembrandt's relentless urge to experiment is manifested in the fundamental, virtuoso changes in the various states of the print. The artist's direct work on the copper plate in an unfamiliar, large format presented a great physical challenge and required a vast amount of concentration as well as technical control.[1]

For the motif of Calvary crowded with figures, uncommon in the seventeenth century, Rembrandt turned to sixteenth-century prints for images.[2] These inspirations from the past created a point of departure for a very personal interpretation of the subject: Rembrandt concentrated on the climax of the crucifixion scene when a sudden and dramatic darkness fell over earth at the moment of Christ's death. The artist combined this event with the deep shock of the people who had gathered there (Luke 23: 44–49):

> It was now about the sixth hour, and there was darkness over all the earth until the ninth hour. And the sun was darkened, and the veil of the temple was rent in the midst. And when Jesus had cried with a loud voice, he said, "Father, into thy hands I commend my spirit," and having said thus, he gave up the ghost. Now when the centurion saw what was done, he glorified God, saying, "Certainly this was a righteous man." And all the people that came together to that sight, beholding the things which were done, smote their breasts, and returned. And all his acquaintance, and the women that followed him from Galilee, stood afar off, beholding these things.

Out of the forbidding, turbulent heavens, a broad beam of light floods the central scene with Christ on the cross as its towering focal point. The condemned thieves at the right and left are positioned just at the edge of the rays of light. As in medieval representations, the feet of Christ are not crossed, but placed next to each other and nailed to the cross individually, resulting in the body's elongated, symmetrical pose. In this manner, the triumph of Christ is emphasized: he is filled

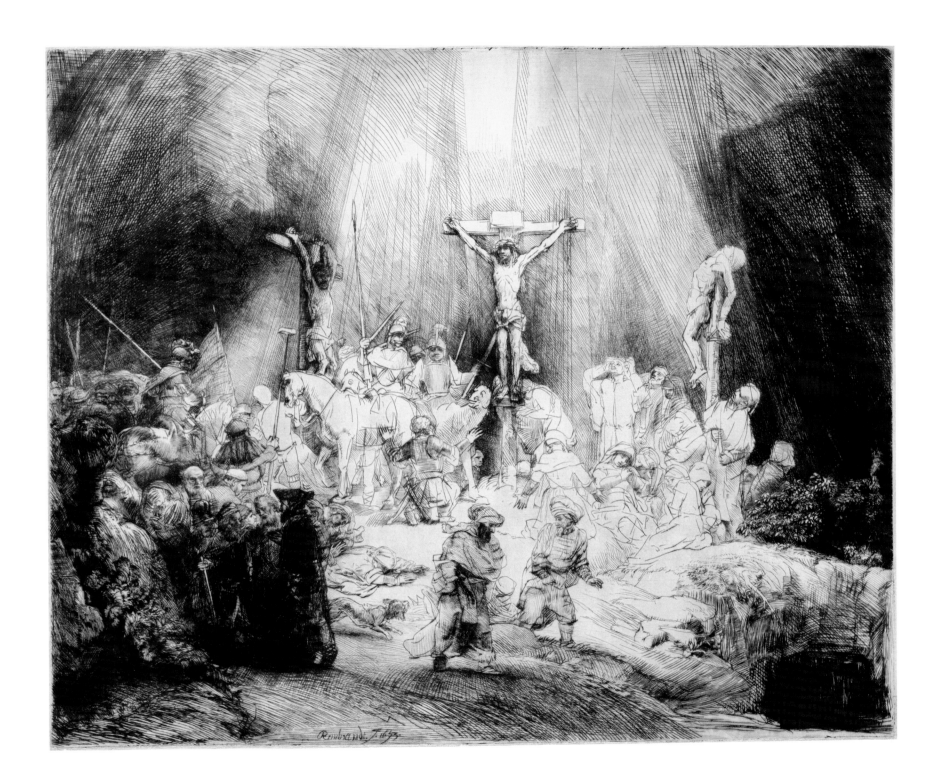

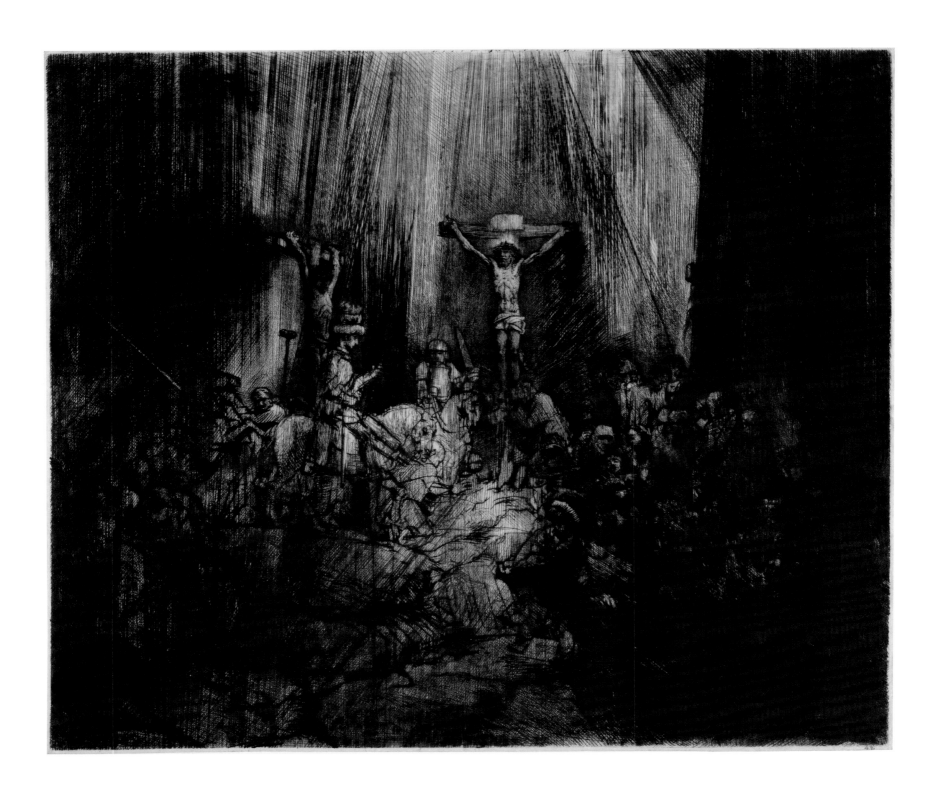

with a heavenly light that sublimely lifts him above the earthly chaos.[3] The Roman centurion kneels at the left of the foot of the cross, surrounded by his countrymen; at the right stands a group of mourning apostles and women sit on the ground. In their panicked departure from the scene, the spectators in the foreground create dramatic accents. The two men in the center foreground, perhaps Jewish scribes, hurry toward a dark opening in the earth, while in the left foreground, a deeply moved man is led away by two people. Still others have fallen to the ground or cover their eyes with their hands. The theatrical chiaroscuro effects extend from the momentary illumination of the horrified faces to the broad spotlighted area that emerges dramatically from the darkness.

In the present example of the third state of the drypoint (cat. no. 42), the outlines of the figures gathered around the cross are already weaker than in the first two states; usually the drypoint's burr deteriorates after the pulling of about fifty impressions. To reestablish the balance between light and dark, Rembrandt reworked the shadows at the left and right with forceful strokes of the drypoint needle and burin. Additional lines strengthened the foreground. He signed and dated this example of the third state 1653.

It is not known what prompted Rembrandt to alter the plate so fundamentally in the fourth state (cat. no. 43).[4] His extreme modifications transformed the image into a dramatic night scene. Its daring abstraction and visionary power seem to escape any rational criterion. The majority of the figures have been removed and replaced with new, schematically defined figures; only Christ, the condemned thief at the left, and one of the fleeing men in the foreground remain.[5]

A dense accumulation of long, parallel lines darkens the scene like a severe downpour of rain so that—especially in the heavily inked examples—the more distant spectators are scarcely visible. The greatest change in the earlier configuration of figures is the addition of the rider wearing an exotic headdress positioned in profile to the left of the cross. The image of the rider is based on a medallion depicting Gian Francesco Gonzaga, created in 1440 by Antonio Pisano (called Pisanello).[6] Despite several hypotheses, the role of this mysterious Renaissance figure remains unexplained.[7]

For Rembrandt, the production of this drypoint represented a great financial investment on his part; materials such as the large copper plate, the exquisite papers, and the precious vellum he used predominantly for the first state were costly. In addition, for technical reasons, the edition was limited to a small number.[8] These factors clearly point to the great significance this project held for him.

1 See also extensive descriptions of this work by Holm Bevers in Berlin/Amsterdam/London 1991–92, vol. 2, no. 35; White 1999, pp. 77–88; Erik Hinterding in Amsterdam/London 2000–2001, no. 73; Clifford S. Ackley in Boston/Chicago 2003–2004, nos. 168–71.

2 For examples by Master B with the Die, Giovanni Battista, and Lucas van Leyden, see Holm Bevers (note 1), p. 255, fig. 35c, p. 266; and Erik Hinterding (note 1), p. 301, fig. 4, p. 302, fig. b.

3 Holm Bevers (note 1), p. 266.

4 Until recently, based on stylistic reasons, the fourth state was thought to have been produced considerably later than the first three states (around 1661); see Holm Bevers (note 1), pp. 266, 269, n. 12, 13. Recent research has shown that the paper Rembrandt used in the fourth state exhibits the same watermark as that of the first three, while the impressions of the drypoint *Ecce Homo* (1655) all display a different watermark. This evidence points to a dating for the fourth state presumably shortly after the third state, which is dated 1653. See Amsterdam/London 2000–2001, p. 303.

5 In a transfer print of the fourth state in London's British Museum, one can see that Rembrandt had removed only the burr from the first three states and that the lines in the fourth state of the plate were still largely intact. See Erik Hinterding (note 1), p. 300, illus., pp. 303–304.

6 Holm Bevers (note 1), pp. 266, 267, fig. 35d, p. 269, n. 14.

7 Ibid., pp. 266, 268.

8 Erik Hinterding (note 1), p. 302.

Rembrandt Harmensz. van Rijn

LEIDEN 1606–1669 AMSTERDAM

44 *Ecce Homo,* c. 1655

Drypoint, second state

38.3 x 45.5 cm

PROVENANCE: Albertina, earliest collections

INV. NO. 1926/1646

BIBLIOGRAPHY: B 76, White and Boon 1969, B 76 II; Vienna 1970–71, no. 253, pl. 76; Vienna 2004, no. 128, illus.

Two years after completing *The Three Crosses* (1653, cat. nos. 42, 43), Rembrandt tackled his second large project: the monumental drypoint *Ecce Homo,* of which eight states are known.[1] He probably created these works as pendants; their large size, drypoint technique, and experimental qualities relate them closely to one another. They may have originated as part of a planned but unrealized Passion series.

This second state of the print (the first three states do not differ significantly) depicts the moment when the Roman governor Pontius Pilate leads Christ before the people and asks whether he should free Jesus or the criminal Barabbas (seen here in the background). The crowd chooses Barabbas and demands Christ's crucifixion (Matthew 27: 21–23).

Rembrandt synoptically presented different moments from the story: at the left, the governor's wife appears in the window after sending a messenger to tell her husband about her dream warning of Christ's crucifixion (Matthew 27: 19). On the platform to the left of the pedestal, a servant stands ready with the water pitcher and bowl in which Pilate will wash his hands to absolve himself of any responsibility. Below, the crowd is spread out in relieflike form. An old man, who breaks away from his group at the right, casts a heavy shadow on the brightly illuminated wall; this dark, distorted image is the single emotional gesture amidst the odd stiffness that characterizes the other figures.

An important precursor for the composition was the monumental engraving *Ecce Homo* by Lucas van Leyden, whose prints Rembrandt greatly admired and avidly collected. The two works differ significantly in the rendering of the justice building: for example, Rembrandt omitted a perspectival arrangement of the background in favor of an architectural backdrop of simple, symmetrically arranged planes. This backdrop dominates the scene, subordinating subdued figures scarcely different in appearance from the statues of Fortitude and Justice visible above. Drama is conveyed more through the architecture, which is punctuated by heavy contrasts in light and dark, than through the figures. The figures' angular contours and summary lines recall the restrained expressiveness of Rembrandt's drawings in reed pen from around the same time (cat. no. 45).

In states four through eight of the print, changes include the shortening of the plate at its upper edge, a reworking of the architecture, and the removal of the group of figures below the platform. In the seventh state, two dark, arched openings were added to the platform. In the last state, the mysterious bearded man between these openings has been shaded with hatching. Rembrandt's continual desire to experiment was directly linked to the fact that the plate had to be repeatedly reworked because of wear.[2] Rapid deterioration is caused by the exclusive use of drypoint, whose sensitive burr allows only a limited number of impressions. However, as in the case of *The Three Crosses,* Rembrandt's intrusive formal changes remain unexplained.

1 See Barbara Welzel in Berlin/Amsterdam/London 1991–92, vol. 2, no. 38; White 1999, pp. 97–104; Erik Hinterding in Amsterdam/London 2000–2001, no. 78; Clifford S. Ackley in Boston/Chicago 2003–2004, nos. 173, 174.

2 In this regard, see Erik Hinterding in Amsterdam/London 2001–2002, p. 320.

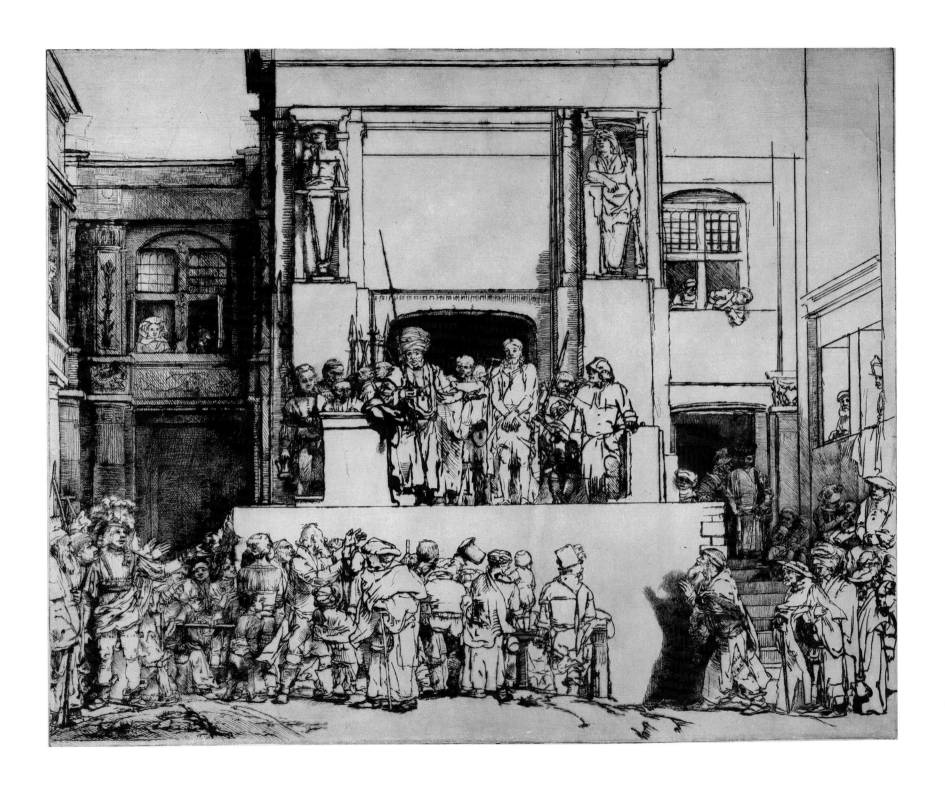

Rembrandt Harmensz. van Rijn

LEIDEN 1606–1669 AMSTERDAM

45 *Christ with His Disciples and the Bleeding Woman,* late 1650s

Pen and brown ink

15.2 x 22.6 cm

PROVENANCE: Duke Albert von Sachsen-Teschen

INV. NO. 8793

BIBLIOGRAPHY: Benesch 1954–57, vol. 5, no. 1052, fig. 1271; Vienna 1956, no. 139; Vienna 1969–70, no. 59, illus.; Benesch 1973, vol. 5, no. 1052, fig. 1339; Sumowski 1979–92, vol. 8, no. 1966 a-k; Vienna/Amsterdam 1989–90, no. 45, illus.; Sydney 2002, no. 80, illus.; Vienna 2004, no. 115, illus.

The subject of this drawing refers to one of Christ's miracles as described in Luke 8:40—the healing of the bleeding woman. A sick woman secretly approaches Christ in a crowd and touches his robe, instantly stopping her bleeding. When Jesus notices this, he turns to her. The woman falls down at his feet and confesses what she has done. Christ then tells her that her belief in him has healed her.

With great originality, Rembrandt concentrated on the emotional climax of the story. The abrupt, forceful strokes of the reed pen (his preferred medium of the mid- and late 1650s) capture the figures of Christ, his disciples, and the kneeling woman, at times broadening in emphasis. The interplay of the forceful and finer lines subtly expresses the forward and backward motion of the figures as they pause in their movements. The relieflike scene unfolds as if on a stage; angled parallel strokes in the background suggest spatial relationships. Despite the sparse strokes, a broad range of emotions in the group is revealed. Christ's countenance and gesture express compassion and forgiveness, while the position and facial expression of the woman speak of deep humility. The psychological dimension of the story is condensed into the tense moment of communication between the two main characters.

Reflecting their distance from the incident or degree of participation in the event, the apostles display reactions of skepticism, curiosity, amazement, and shock.

The sheet has been dated to the second half of the 1650s.[1] Rembrandt focused intensively on Old and New Testament themes in the many drawings and prints he produced during this period. Characteristic of the drawing style of these years is a retreat from spatial effects in preference to simple tectonic structures. The taut, abbreviated outlines in late works such as this splendid example suggest an astonishing range of light effects and a high degree of emotional content.

1 See Peter Schatborn in Vienna/Amsterdam 1989–90, p. 118.

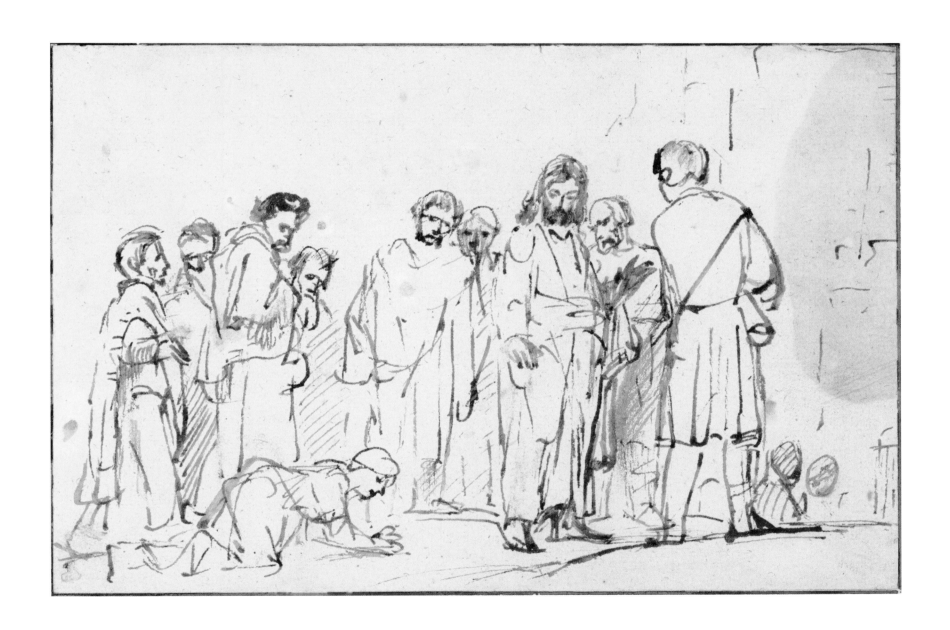

Rembrandt Harmensz. van Rijn

LEIDEN 1606–1669 AMSTERDAM

46 *Indian Prince, Presumably Emperor Jahangir,* 1656/early 1660s

Pen and gray-brown ink, gray-brown wash, on brown prepared
Japan paper
23 x 18 cm
PROVENANCE: Slg. J. Richardson, Sr.; Earl Brownlow (Sale London,
Sotheby's, April 29, 1926, no. 25); F. Lugt
INV. NO. 24471
BIBLIOGRAPHY: Benesch 1935, p. 56; Benesch 1954–57, vol. 5, no. 1192,
fig. 1416; Stockholm 1956, no. 174; Rotterdam/Amsterdam 1956,
no. 188; Vienna 1956, no. 115; Vienna 1969–70, no. 55, illus.; Benesch
1973, vol. 5, no. 1192, fig. 1490; Vienna 2004, no. 146, illus.

This sheet belongs to a highly remarkable, widespread group of
twenty-one drawings by Rembrandt that are free interpretations rather
than copies of Mughal miniatures mostly from the court of Shah
Jahan in seventeenth-century India.[1] During his rule (1627–58),
Shah Jahan played an important role in the development of painting.[2]
It is not known whether Rembrandt created these drawings for
personal use or for a commission. The Mughal miniatures may have
belonged to an album he owned that was described in his 1656
inventory as "filled with curious drawings in miniature as well as
woodcuts and engravings on copper of various [folk] costumes."[3]
Heinrich Glück established for the first time in 1933 that Rembrandt's
drawings share several similarities with the Mughal miniatures that
were part of the wall decoration in the "Million Room" at Schönbrunn
Castle in Vienna in the eighteenth century.[4] Whether these miniatures,
which have a Netherlandish provenance, were once in Rembrandt's
possession is not verifiable.

Characteristic of Rembrandt's drawings after Mughal miniatures
is the complete abandonment of a concrete background arrangement.
The artist concentrated only on the figures, capturing their contours
in rhythmically flowing, fine pen lines. His manner both refers to
the delicate, decorative linearity of the miniatures and gives a unique
tension and individuality to the exotically dressed figures.

The immediate model for the present work, which presumably
represents the Great Mughal Jahangir (1569–1627), remains unknown.
The broad, forceful brushstrokes of the dark surroundings contrast
strikingly with the delicate transparency of the figure's princely
profile; his spiritual reverie is underscored by the halolike lighting.
The Japan paper, which Rembrandt used for all the Mughal drawings,
contributes significantly to the sense of exotic refinement.

Conjectures as to the dates of the Mughal drawings range
from 1656, the year of the Rembrandt inventory, to the early 1660s.[5]
It is supposed that Rembrandt's creative examination of the Mughal
miniatures may have exerted some influence on the pen and wash style
of his late drawings.[6]

1 Schatborn 1985, p. 128.

2 Lunsingh Scheurleer 1980, pp. 11–14.

3 Rembrandt Documents 1656/12, no. 203.

4 Josef Strzygowski and Heinrich Glück, *Asiatische Miniaturmalerei* (Klagenfurt, Austria,
1933), pp. 18–21.

5 Peter Schatborn sees stylistic correspondences with the drawings of the 1650s and perhaps
the 1660s. See Schatborn 1985, p. 128. Martin Royalton-Kisch in London 1992, p. 142 sees most
of the stylistic correspondences with drawings from the early 1660s.

6 Schatborn 1985, pp. 128–29, n. 9; see also Peter Schatborn in Vienna 2004, p. 42.

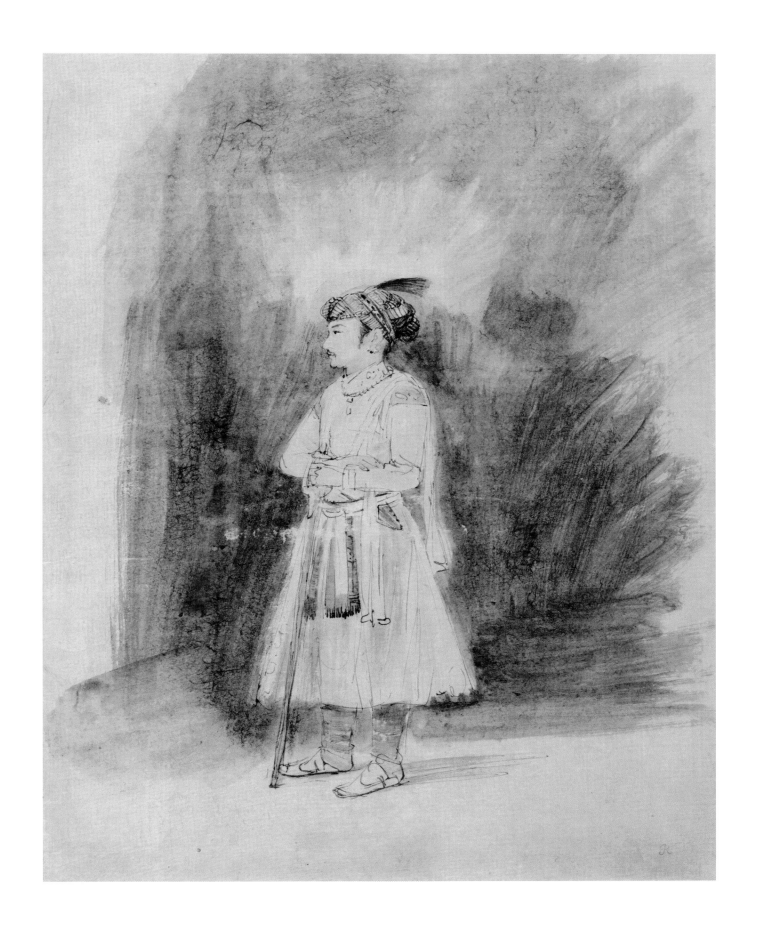

Rembrandt Harmensz. van Rijn

Leiden 1606–1669 Amsterdam

47 *Self-Portrait in Beret,* c. 1660

Pen and black-brown ink, brush and gray ink, white bodycolor, on brown toned paper

8.2 x 7.1 cm

PROVENANCE: acquired in 1927 from a dealer

INV. NO. 25449

BIBLIOGRAPHY: Benesch 1932, p. 30; Benesch 1954–57, vol. 5, no. 1177, fig. 1475; Benesch 1973, vol. 5, no. 1177, fig. 1475; New York 1997, no. 60, illus.; London/The Hague 1999–2000, no. 78, illus., and p. 206 (under no. 75); Vienna 2004, no. 14, illus.

Rembrandt's approximately eighty-five self-portraits include surprisingly few drawings: of the five to seven examples between 1629 and 1660, *Self-Portrait in Beret* is the latest.[1] Otto Benesch, who acquired the sheet for the Albertina, considered it a study for the painting *Self-Portrait at the Easel* (1660; Paris, Musée du Louvre). However, despite correspondences in the physiognomy and the hat, there are clear differences in the position of the head and the upper body. The face in the drawing leans farther forward, apparently positioned close to the mirror, and the forehead is largely covered by the beret. Perhaps instead the drawing captures an important transitional pose in the process of creating the painting: X-rays reveal an earlier broad, dark head covering below the upper layer of paint showing the white beret depicted in the drawing.[2]

The distinctly painterly approach in this work on paper is unusual. Research shows that Rembrandt worked very carefully in stages. After toning the paper freely in brown, leaving some areas untouched, he drew the principal lines with a reed pen. He covered much of the background, face, hair, and clothing with gray and white washes. Apparently he went over the background at the left and especially at the right side of the face with a wet brush, causing the dark color to collect in the paper fibers and creating an uneven texture.[3]

The working methods typical of his later paintings are demonstrated here in miniature format; maintaining the greatest precision, the artist exercised extreme painterly freedom with an often heavy application of color. The drawing is exceptional in its subtle handling of light, which saturates the beret, made luminously transparent by the application of thinned, white bodycolor. To strengthen the effect of the light, the beret's outlines are intermittently broken. The head is positioned asymmetrically: the bridge of the nose points slightly to the right, and the artist's gaze is oriented to the right rather than directly toward the viewer. The image focuses on Rembrandt's right eye, its penetrating expression intensified by the arched brow. The sheet of paper partially visible in the left foreground may allude to the artist's drawing activity, which is also referenced in his etched self-portraits.[4] It is possible that this distinctive work was produced for an "album amicorum," a memento shared with a friend or fellow artist.[5]

1 Ernst van de Wetering, "The Drawn Self-Portraits," in volume 4 of his forthcoming corpus. See Vienna 2004, p. 80, n. 4. Ernst van de Wetering generously made the manuscript available for reference.

2 Ibid. Additional self-portraits in which the white beret appears with other attributes of his artistic profession are the etching *Self-Portrait, The Artist Drawing on an Etching Plate* (1658; Vienna 2004, no. 13) and the painting *Self-Portrait with Two Circles* (c. 1665–69, London, English Heritage, Kenwood House, The Iveagh Bequest). See Bredius and Gerson 1969, no. 52.

3 Elisabeth Thobois and Marian Bisanz-Prakken made these observations together in their examination of the artist's materials and working methods. See New York 1997, no. 60, illus., and Vienna 2004, no. 60, illus.

4 In a comparison with the Paris painting, Otto Benesch's theory (see Benesch 1932, p. 30, and Benesch 1954–57, vol. 5, no. 1177, fig. 1475) that the vertical lines at the right edge indicate an easel is not convincing for technically spatial reasons (the artist is positioned too closely in the tight framing of the image).

5 Ernst van de Wetering (note 1).

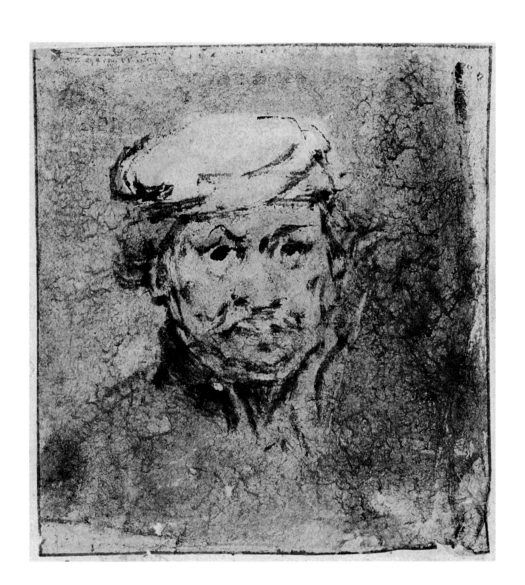

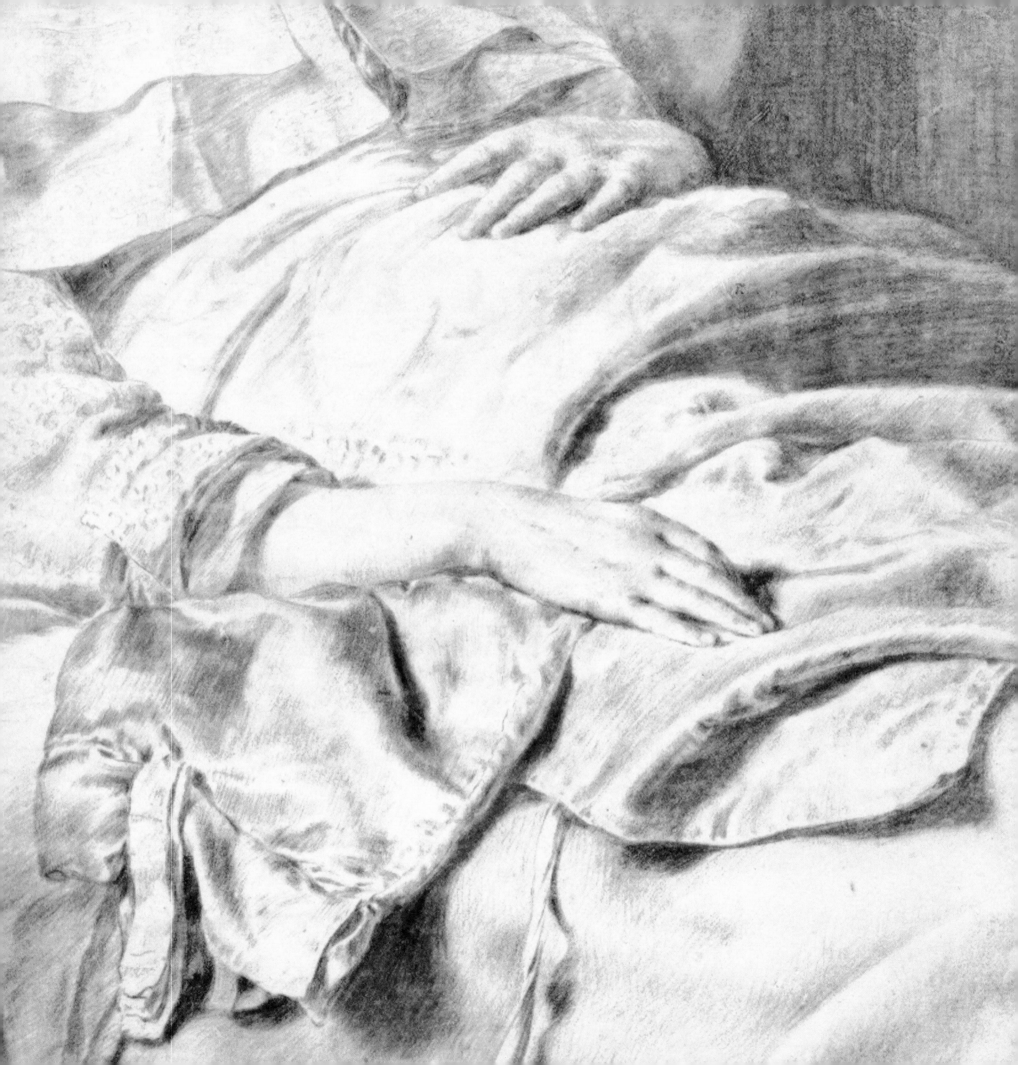

Mid-Century Figures, Genre, and Portraiture

Govaert Flinck

KLEVE 1615–1660 AMSTERDAM

48 *Seated Young Woman,* c. mid-1640s

Black and white chalk on blue paper

29.1 x 25.3 cm

INSCRIBED AT UPPER RIGHT: "G. Flinck f."

PROVENANCE: Duke Albert von Sachsen-Teschen

INV. NO. 9327

BIBLIOGRAPHY: Schönbrunner and Meder 1896–1908, vol. 3, no. 259, illus.; Wurzbach 1906–11, p. 538; Leporini 1925, fig. 245; Bernt 1957–58, vol. 1, no. 230, illus.; Benesch 1964, no. 178, illus.; von Moltke 1965, pp. 53, 188, D. 80, illus.; Sumowski 1979–92, vol. 4, no. 875, illus.

Govaert Flinck apprenticed with Lambert Jacobsz. in Leeuwarden around 1630. At the beginning of the 1630s, he moved with Jacob Backer, an older fellow pupil, to Amsterdam, where they both studied with Rembrandt. After 1642, the influence of his master began to lessen; increasingly, Flinck painted and drew in the style of the Flemish artists who were favored by the nobility and patrician circles. He was especially successful as a portrait painter, but he also produced history pictures, allegorical images, and genre scenes. Because of his early death, his most significant commission—the cycle of paintings of the history of Batavia for Amsterdam's City Hall—was uncompleted.[1]

The most famous of the approximately one hundred and twenty drawings by Flinck catalogued by Werner Sumowski is a group of around fifty figure studies executed in black and white chalk on blue paper—a combination of media that does not occur in Rembrandt's works. Jacob Backer also worked in this technique, and the style of the two artists, especially in their drawings of nudes, is closely related. Even today, their works are often mistaken for one another.[2]

The present drawing depicts a seated woman with her hands resting in her lap. Despite the lack of indication of a specific activity, the model is posed as if she is concentrating on a piece of fine needlework. Although Flinck's figure studies were often produced in preparation for a painting, no corresponding painting is known for this drawing. Based on its stylistic relationship with another figure study, which can be dated to around the mid-1640s, Sumowski assigns the same date to the present drawing.[3] He underscored its particular significance when he wrote: "For a Flinck drawing, it is of unusually high quality."[4] In a highly sensitive manner and with economy of means, the artist differentiated between the various surface values of the dress, the bright white collar, and the woman's skin and hair, while focusing on the expression of concentration on the woman's face and the activity of her hands. The angular folds in the rendering of the clothing fabric are a distinct feature in Flinck's work.

1 For biographical information on Govaert Flinck, see Sumowski 1979–92, vol. 4, p. 1883.

2 Regarding Flinck's drawings, see William W. Robinson in Amsterdam/Vienna/New York/Cambridge 1991–92, p. 122, under no. 52; Peter Schatborn in Amsterdam/Washington 1981–82, p. 88.

3 The comparative example in Sumowski 1979–92, vol. 4, no. 874.

4 Ibid., no. 875, illus.

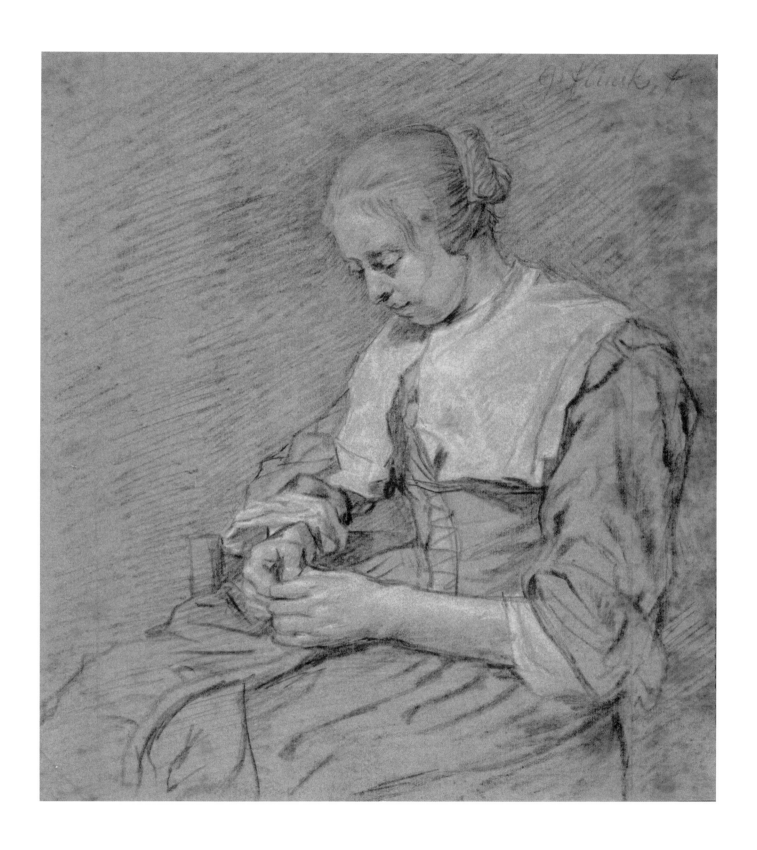

Nicolaes Maes

DORDRECHT 1634–1693 AMSTERDAM

49 *Old Woman Contemplating the Bible*, c. 1655

Red chalk, partially washed, black chalk

19.7 x 16 cm

PROVENANCE: Jonathan Richardson, Sr.; Duke Albert von Sachsen-Teschen

BIBLIOGRAPHY: Wurzbach 1906–11, vol. 2, p. 421; Valentiner 1924, p. 26, illus.; Hofstede de Groot 1929, pp. 144–45; Henkel 1943, p. 94, under no. 1; Lugt 1950, p. 44, under no. 359; Wegner 1973, p. 107, under no. 759; Sumowski 1979–92, vol. 8, no. 1810*

Around 1648, Nicolaes Maes moved from his birthplace, Dordrecht, to Amsterdam in order to apprentice with Rembrandt. His earliest dated works, mainly history paintings, originated in 1653, the year of his return to Dordrecht. These works reveal the influence of Rembrandt's style of the 1640s. Maes's interior and genre scenes from the mid-1650s onward, however, display a very independent character. Beginning in 1660, he worked exclusively as a portrait painter, largely in the Franco-Flemish tradition. In 1673, he moved to Amsterdam, where he remained until his death. No drawings from this period are known.

In Maes's studies of biblical and mythological scenes, which are mostly executed in pen, sometimes in combination with the brush, Rembrandt's influence is clearly evident. Maes also followed his master's drawing methods in his studies of individual figures rendered in black and red chalk, although these works reveal a very personal style as well. Like Rembrandt, Maes sought out models in his immediate surroundings. Thus, the young woman he depicted in several drawings was presumably his wife; the older female models were probably also from his circle of relatives or acquaintances.[1]

Within the category of figure studies, which the artist often produced in preparation for paintings, the present drawing is undoubtedly one of his most brilliant examples. The artist's skill in modeling is especially apparent in the face of the old woman, which is caught in bright, angular light. With delicate nuances, the fine chalk strokes capture the soft shadows and reflections of the wrinkled skin, including details such as the half-closed eyelids, the slight relief of the eyebrows, and the highlighting of the nose. The forceful outlines of the hands and clothing provide an eloquent contrast to these subtly described details. This careful feeling for surface values and their illumination, the emphasis in the rendering of the woman's advanced age, as well as the allegorical meditation on human mortality implied in reading the bible, inevitably bring to mind Rembrandt's early "tronies" (the seventeenth-century Dutch word for "character heads") of old men and women.[2] In these representations, the typological rather than the portrait aspect comes predominantly to the fore. Maes appears to have connected even to Rembrandt's predilection for exotic details, providing his model with a lively, patterned head scarf.[3]

The Albertina drawing, which presumably originated around 1655, is closely related to the red-chalk study *Old Woman with her Hands Folded Reading the Bible* (Frankfurt am Main, Städelsches Kunstinstitut), which depicts the same model in identical clothing.[4]

1 For information on the life and drawings of Nicolaes Maes, see Peter Schatborn in Amsterdam/Washington 1981–82, pp. 84, 140; and Sumowski 1979–92, vol. 8, p. 3951.

2 Regarding this theme, see Dagmar Hirschfelder, "Porträt oder Charakterkopf," in Kassel/Amsterdam 2001–2002, pp. 82–90.

3 Regarding Rembrandt's work, see *Rembrandts Mutter mit orientalischer Kopfbinde (Rembrandt's Mother Seated, in an Oriental Headdress)*, etching, Vienna 2004, no. 22.

4 For the drawing in Frankfurt, see Sumowski 1979–92, vol. 8, no. 1809*.

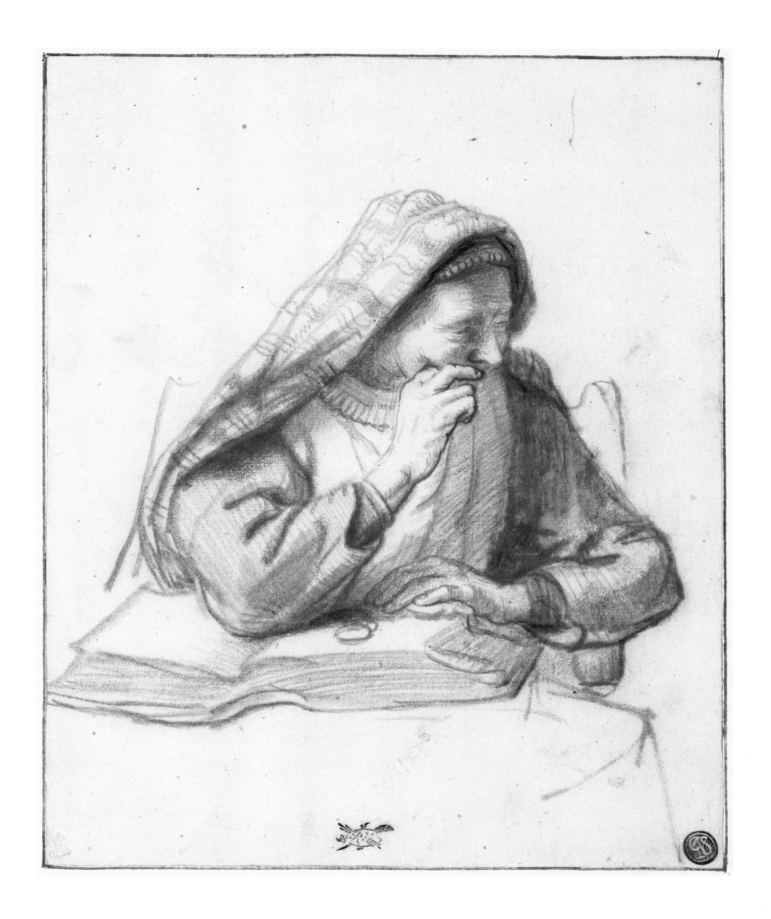

Gerbrand van den Eeckhout

AMSTERDAM 1621–1674 AMSTERDAM

50 *Boy Leaning on a Chair*, c. mid-1650s

Brush and wash in brown ink, over black chalk

18.3 x 14.8 cm

PROVENANCE: Duke Albert von Sachsen-Teschen

INV. NO. 9559

BIBLIOGRAPHY: Schönbrunner and Meder 1896–1908, vol. 9, no. 1019, illus.; Bode and Valentiner 1907, no. 40; Plietzsch 1911, p. 122; Hind 1915–32, p. 51; Tietze-Conrat 1922, p. 12, no. 17; Leporini 1928, pp. 247, 403; Sumowski 1962, p. 20, n. 24; Benesch 1964, no. 179, illus.; Sumowski 1980, pp. 1686, 1688, no. 785; New York/Washington/Vienna 1984–86, no. 31, illus.

Gerbrand van den Eeckhout was the son of the goldsmith Jan Pietersz. van den Eeckhout (1584–1652). Between 1635 and 1640, he apprenticed with Rembrandt, with whom he allegedly remained in friendly contact. Van den Eeckhout was a versatile artist who produced history and portrait paintings, landscapes, genre scenes, and figural works. He also executed designs for ornamental engravings and goldsmith work.

The majority of van den Eeckhout's oeuvre of drawings consists of carefully executed representations of biblical and mythological stories populated with figures. The artist used a variety of techniques in these works that demonstrate, above all, the influence of Rembrandt and to a certain extent that of Rembrandt's master, the history painter Pieter Lastman (1583–1633). A small group of figural brush drawings, which include the present work, stand out within van den Eeckhout's oeuvre. In these sheets, the artist captured in a few strokes individual figures modeled by intense light effects. It is presumed that these drawings, which are not dated, were produced around the middle of the 1650s.[1] They appear to reflect the instructions that Rembrandt

gave his pupils, which his student Samuel van Hoogstraten published in *Introduction to the High School of Painting* (1678): artists should view the model with half-closed eyes to avoid distracting details and indicate the hollow shadows of the eyes, nose, and mouth with loose dabs of the brush.[2]

In his exclusive use of the brush, van den Eeckhout deviated from Rembrandt, who combined brush and pen in his interior views.[3] Van den Eeckhout's masterful, extremely free brush drawings appear to belong more to the eighteenth than the seventeenth century; a sheet from this group was even once attributed to Fragonard.[4] The unusual character of these drawings has confused many scholars—as is reflected in the attribution history of the Albertina drawing. Although the sheet was considered to be the work of van den Eeckhout when it was acquired by Duke Albert, over the decades, it was attributed to Gerard ter Borch, Johannes Vermeer, Nicolaes Maes, and Samuel van Hoogstraten before it was reassigned to van den Eeckhout.[5] Both spare and rich, intimate yet monumental, this drawing is undoubtedly one of the most impressive examples of the group.

1 Sumowski 1979–92, vol. 3, pp. 1686, 1688, no. 785.

2 Samuel van Hoogstraten, *Inleyding tot de Hooge Schole der Schilderkunst: Anders de Zichtbaere Werelt* (Rotterdam, 1678), p. 27; Benesch 1964, no. 179, illus.

3 Peter Schatborn in Amsterdam/Washington 1981–82, p. 82.

4 Ibid.

5 The attribution history is summarized in New York/Washington/Vienna 1984–86, no. 31, illus.

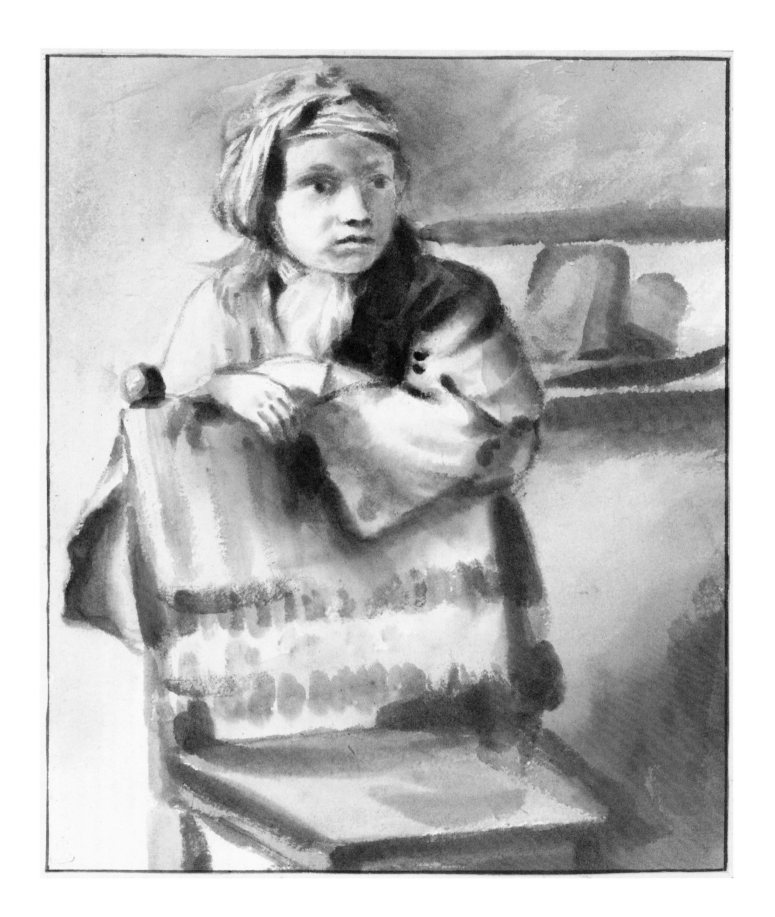

Cornelis Bega

HAARLEM C. 1631/32–1664 AMSTERDAM

51 *Young Woman Sitting in the Midday Sun,* c. 1660

Red chalk, blue wash

20.7 x 15.5 cm

INSCRIBED AT LOWER LEFT: "C bega" (by the artist?)

INSCRIBED AT UPPER LEFT: "22"

PROVENANCE: Duke Albert von Sachsen-Teschen

INV. NO. 9157

BIBLIOGRAPHY: Schönbrunner and Meder 1896–1908, vol. 7, no. 744, illus.

Cornelis Bega was the son of the Haarlem wood sculptor Pieter Jansz. Begeyn or Bega. He apprenticed with Adriaen van Ostade (cat. nos. 58–60) and, in 1653, toured Germany and Switzerland with Dirck Helmbreker, Guillaume Du Bois, and Vincent van der Vinne.[1] After his return to Haarlem, he joined the Guild of St. Luke in 1654. As a painter, he largely focused, like his master, on peasant subjects and motifs from everyday life, concentrating especially on tavern scenes. His thirty-five etchings are also devoted to this theme, and he drew a few other interior scenes as well. However, as a draftsman, he excelled primarily in figure studies in red chalk, which have little relationship to his master's working methods.[2] In the second half of the seventeenth century, several Haarlem artists, including Gerrit Berckheyde, Leendert van der Cooghen (cat. no. 53), and Jan de Bray, cultivated a similar style, and their works have often been confused.

The present drawing is a representative example of Bega's highly individualized figure studies, which he sometimes used in his painted compositions. The frontal, casual pose of the seated model and her slightly open décolletage convey a provocative impression that belongs to the type of woman that appears occasionally in Bega's paintings of peasants gathered in drink and song. Overturned barrels on the floor are a standard accouterment of such scenes and may provide a further clue to the interpretation of the present drawing.

Characteristic of Bega's drawing style are the pronounced contours, the broadly summarized forms, and the strong contrasts of light and dark. Long, evenly drawn parallel strokes define the shadowed areas; at times, these lines cross and, with varying density, subtly convey different gradations of tone. The sharply defined shadows cast by the woman's wide skirt play about her legs, forming the optical emphasis of the drawing. This style of drawing, which was partly inspired by Flemish examples, particularly by Rubens, found its own brand of expression in figure studies by Haarlem artists.

1 Houbraken 1753, vol. 1, p. 211.

2 Regarding Bega's drawings, see Peter Schatborn in Amsterdam/Washington 1981–82, p. 105.

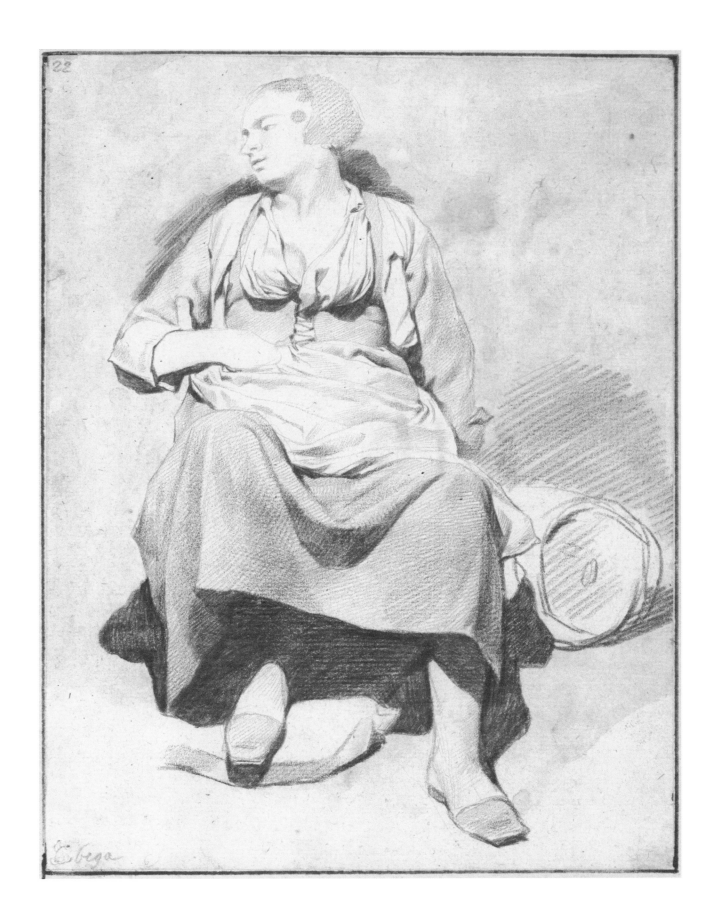

Salomon de Bray, circle of

AMSTERDAM 1597–1664 HAARLEM

52 *Boy Climbing a Stair, Viewed from behind, with a Fragment of a Wheel*, c. 1654

Black chalk, red chalk, pen and tusche

51 x 13.9 cm

PROVENANCE: Duke Albert von Sachsen-Teschen

INV. NO. 8358

BIBLIOGRAPHY: Von Moltke 1938, Z 113; Plomp 1997, p. 101, under no. 82; Giltaij and Lammertse 2001, p. 279, fig. 13, p. 393, n. 24.

Salomon de Bray was the son of Simon de Bray, who emigrated from the southern Netherlands. At a young age, Salomon moved from his birthplace, Amsterdam, to Haarlem, where he presumably apprenticed with Hendrick Goltzius (1558–1617) and Cornelis van Haarlem (1562–1638). In Haarlem, he excelled as a painter and draftsman of portraits and history pictures and also worked in the areas of poetry, architecture, and applied art. His most significant contribution involved the decoration of the Huis ten Bosch in 1649–50. De Bray's sons, Jan (born c. 1627), Dirck (born c. 1635), and Joseph (birthdate unknown) also worked as artists and copied many of their father's works.[1]

On exhibition for the first time, this compelling small drawing of a boy viewed from behind climbing a stair is the repetition of a detail from the composition *The Martyrdom of Saint Catherine of Alexandria* (Haarlem, Teylers Museum), which is inscribed "SD Bray 1654."[2] This powerful scene, executed in black and red chalk, depicts Saint Catherine kneeling before an imposing structure at the moment when her hair is cut off in preparation for her beheading. In the right foreground, a boy viewed from behind and apart from the main scene climbs up to the platform where the central event is taking place; he bears the attribute of Saint Catherine: a fragment of the wheel on which she was tortured, which was shattered by a divine light.

The boy in the present drawing, which is also executed in black and red chalk, is nearly identical to the figure in the larger composition.

The most recent research indicates that instead of being by Salomon de Bray himself, however, it is probably by his son Joseph, who copied the image from a lost painted or drawn model.[3] Nevertheless, the qualities of the drawing cannot be dismissed: the lovingly detailed realism in the rendering of the boy's clothing and shining locks of hair is striking. Characteristic for Salomon de Bray and other artists in the Haarlem milieu of these years is the delicate chalk hatching technique that produces various surface effects; with only two colors, a whole palette of diverse nuances is achieved. Despite the love of detail, the individual forms are clearly arranged, and though presented in small format, the figure possesses an almost classical, statuelike character.

It cannot be determined whether the paper support has been substantially trimmed. The function of the drawing, which is pictorially complete in its own right, is also unknown. In this small sheet, the Haarlem "from life" realism that began with Goltzius and was represented around 1600, above all, by Jacques de Gheyn II (cat. nos. 1, 2), still resonates.

1 Regarding the life of Salomon de Bray, see Rotterdam/Frankfurt 1999–2000, p. 84. On the workshop practice of the de Bray family, see Giltaij and Lammertse 2001.

2 Inv. no. O 50, see Plomp 1997, no. 83, illus.

3 Giltaij and Lammertse 2001, p. 279, fig. 13, p. 393, n. 24.

4 Michiel Plomp suggests that this drawing as well as two others, mythological compositions in the Teylers Museum (Plomp 1997, nos. 83, 84) that bear the date 1655, could be by Jan de Bray, who may have produced drawings after paintings by his father that are unknown today. See ibid., p. 101, n. 1.

Leendert van der Cooghen

HAARLEM 1632–1681 HAARLEM

53 *Standing Halberdier Holding a Lance; Study of a Halberd,* 1651

Black and red chalk, gray wash, pen and brown ink, stumped

INSCRIBED AT LOWER LEFT: "LVC 1651"

38.9 x 19.8 cm

PROVENANCE: Possibly Johannes Enschedé, Haarlem; possibly his sale, Haarlem, Jelgersma and van der Vinne, May 30 et seq., 1786, Album B, lot 59; Duke Albert von Sachsen-Teschen

INV. NO. 17566

BIBLIOGRAPHY: Schönbrunner and Meder 1896–1908, vol. 5, no. 533; Wurzbach 1906–11, vol. 1, p. 329; Amsterdam/Washington 1981–82, under no. 31; Giltaij and Lammertse 2001, pp. 371, 392, under n. 17; Coenen 2005, pp. 19–20, fig. 9, no. A7

Leendert van der Cooghen, a very talented dilettante from a wealthy family, lived his life in his birthplace of Haarlem. Houbraken mentions van der Cooghen's training with Jacob Jordaens (1593–1678), possibly in the early 1650s when Jordaens was working on decorative paintings for the "Oranjezaal" ("Orange Room") at the Huis ten Bosch in The Hague.[1] Like Jordaens, a number of artists from the northern Netherlands participated in this extensive memorial project for stadtholder Frederick Hendrik, who had died in 1647. Salomon de Bray (cat. no. 52), with whom van der Cooghen was in contact, was among the Haarlem artists involved in the project. Van der Cooghen studied with Cornelis Bega (cat. no. 51), and they became friends in the early 1650s. In 1652, he was admitted to the Guild of St. Luke.

Today some sixty-six drawings, three paintings, and ten etchings produced by van der Cooghen in the period between 1651 and 1669 are known.[2] His figure studies and portraits relate stylistically to the works of Haarlem draftsmen such as Bega, Cornelis Visscher the Younger, Dirck Helmbreker, Gerrit Berckheyde, and Salomon and Jan de Bray.

His preference for red and/or black chalk may have been influenced by Jordaens, whose work he copied in the early 1650s.[3]

The present drawing of a standing, richly dressed halberdier is dated 1651, the first year of the artist's production. One of a small group of his copies, it reproduces a figure in the left foreground of *Triumphal Procession of Frederick Hendrik*, a large painting that Salomon de Bray created in 1650 for the Huis ten Bosch.[4] After Frederick Hendrik's death, his widow, Amalia van Solms, planned the project with Constantijn Huijgens (1596–1687) as her advisor and the architect Jacob van Campen (1595–1657) supervising the proposed paintings. Whether the present sheet and another copy (*Head of a Soldier in a Plumed Beret*) in Haarlem were produced on site is not known.[5] Perhaps Jan de Bray's copy after his father's painting served as the model.[6] Whatever the case, van der Cooghen's early drawing demonstrates the fine hatching and carefully detailed technique that recall the style of the de Bray family. Red chalk is used alone and mixed with black to create subtle transitions. This early sheet, most likely produced for practice purposes, lacks the rich hatching and pronounced chiaroscuro effects of van der Cooghen's mature work. Nevertheless, the sure, defined contours and masterful modeling of this monumentally isolated figure give it an independent presence.

1 Houbraken 1753, vol. 1, p. 350. Current information on van der Cooghen, and details of this drawing's provenance, come from the seminal essay by Baukje Coenen. See Coenen 2005, pp. 19–20.

2 Coenen 2005, p. 5.

3 Ibid., p. 21.

4 Regarding Salomon de Bray's contribution, see Rotterdam/Frankfurt 1999–2000, pp. 88–93, no. 7.

5 Coenen 2005, p. 19.

6 Amsterdam, Rijksmuseum, inv. no. RP-T-1972–81. Red and black chalk, heightened with white; 51.1 x 26.5 cm. Coenen 2005, pp. 19–20, fig. 11, n. 41, with additional bibliography.

Adriaen van de Velde

AMSTERDAM 1636–1672 AMSTERDAM

54 *Standing Shepherd Boy*, c. 1663

Red chalk

22.4 x 17.4 cm

INSCRIBED AT UPPER RIGHT: "A vd. Velde / fc. —"

PROVENANCE: Duke Albert von Sachsen-Teschen

INV. NO. 10152

BIBLIOGRAPHY: Schönbrunner and Meder 1896–1908, vol. 3, no. 295, illus.; Wurzbach 1906–11, vol. 2, p. 750; Benesch 1964, no. 193, illus.

Adriaen van de Velde was the son of the marine painter Willem van de Velde the Elder (cat. no. 94). While his older brother, Willem van de Velde the Younger, practiced the specialization of his father (cat. no. 95), Adriaen devoted himself in his paintings, drawings, and etchings primarily to capturing scenes from Netherlandish and southern landscapes that included figures and animals.[1] According to Arnold Houbraken, van de Velde was trained by the Haarlem landscape painter Jan Wynants.[2] No later than 1657, he was again in Amsterdam, where he worked until the end of his short life at age thirty-six.

Houbraken reported that van de Velde went "into the field" daily to draw animals and landscapes.[3] There is no documentation of a trip to Italy and most scholars presume that he took his southern landscape motifs from works by his Italianizing colleagues. The influences of Pieter van Laer, Nicolaes Berchem (cat. nos. 102, 103), Karel Dujardin, Pieter Potter, and others can be seen in his works, but Adriaen van de Velde was nonetheless a highly individual artist. Although his drawings oeuvre has not yet been studied in its totality, the works demonstrate an unusually broad spectrum of techniques and methods. His drawings in black and in red chalk as well as in brush and pen reveal his great talent.[4]

Beginning in 1660, figures played an increasingly important role in van de Velde's landscapes; most of his figure studies date from the decade that followed.[5] The artist referred to many of these study sheets for his larger compositions. The present drawing represents a unique case: it is a precise, preparatory study for a small painting signed and dated 1663 that is devoted to the depiction of this single figure of a standing boy. Even the shadows in the two compositions correspond to each other.[6] As established by Otto Benesch, the figure of the little "lazzarone" or shepherd boy is linked to works by Italianizing artists such as van Laer. The sheet belongs to the category of carefully rendered figure studies in red chalk that stand out in their sure sense of form, careful modeling, and exceptionally subtle handling of light. As Peter Schatborn remarked, "Van de Velde's figures, with their beautiful representation of texture and nuanced light effects, represent a climax of Dutch draughtsmanship."[7]

1 Regarding Adriaen van de Velde's life, see Robinson 1979, p. 4.

2 Houbraken 1753, vol. 2, p. 90.

3 Ibid.

4 Regarding the drawings of Adriaen van de Velde, see Robinson 1979.

5 Peter Schatborn in Amsterdam/Washington 1981–82, p. 116.

6 Oil on canvas, 34 x 26 cm, monogrammed and dated 1663. Location unknown (Photograph, RKD Den Haag, with an indication of provenance at art dealers P. de Boer in Amsterdam, 1957, and A. Brod in London, 1958, and with an anonymous handwritten note concerning a comparison with the Albertina sheet.) In the painting, the boy stands in front of a partially visible wooden shed and a wooden trough. The support upon which he rests his right arm in the drawing is omitted in the painting. The connection of the Albertina drawing to the painting is published here for the first time.

7 Peter Schatborn in Amsterdam/Washington 1981–82, p. 118.

Moses ter Borch

Zwolle 1645–1667 near Harwich

55 *Self-Portrait*, c. 1660/61

56 *Head of a Young Woman*, c. 1659/60

CAT. NO. 55

Black chalk, gray wash, white chalk, on blue paper

12.6 x 10.8 cm

INSCRIBED ALONG LOWER EDGE: "Tborch near leven geteekend"

INSCRIBED AT UPPER LEFT: "19[…?]" (sheet overlaps)

PROVENANCE: C. Ploos van Amstel (Auction Amsterdam, March 3, 1800, O16); Ph. van der Schley; Duke Albert von Sachsen-Teschen

INV. NO. 9098

BIBLIOGRAPHY: Gudlaugsson 1959, p. 128, illus. p. 130; Kettering 1988, vol. 2, no. 83, illus.

CAT. NO. 56

Black chalk, brush and gray ink

11.9 x 9.2 cm

PROVENANCE: Duke Albert von Sachsen-Teschen

INV. NO. 9099

BIBLIOGRAPHY: Kettering 1988, vol. 2, no. 84

Moses ter Borch was the youngest of Gerard ter Borch the Elder's four children. The famous genre painter Gerard ter Borch the Younger (1617–1681) was a son from his first marriage; Gesina (1631–1690), Harmen (1638–before 1677), and Moses ter Borch were his considerably younger children from his third marriage.[1] Art from the ter Borch family's estate, including most of the drawings by Gerard the Elder and his children, has been housed since 1886 at the Rijksmuseum in Amsterdam.[2] Moses's work stands out among the children's drawings. When he was twenty years old, he joined the Dutch fleet and served in the Anglo-Dutch War (1665–67), losing his life during a minor defeat near Harwich, England, where he was buried. In many poems, allegorical scenes, and posthumous portraits in his memory, his family venerated him as a hero who died for his country. A total of 130 drawings by Moses ter Borch are located in the Rijksmuseum; the two present works belong to a relatively small number of sheets that entered other collections.[3]

Aside from studies of casts of sculptures and drawings after prints by various artists, ter Borch produced studies "from life," among them many small-format sheets of hands and heads, for which members of his family often served as models.[4] Beginning in 1660, he drew a series of self-portraits, many rendered in black and white chalk on blue paper, as in the present work (cat. no. 55). These small sheets are primarily studies of facial expressions, for which the artist sometimes posed very close to the mirror, leading to noticeable distortions in the proportions of his features. These "tronies" (a contemporaneous Netherlandish term for character studies of heads) were introduced by the young Rembrandt around 1630 when he was working in Leiden. Rembrandt used his own physiognomy in the study of feigned emotions, emotional reactions, and light effects, and captured the grimaces he studied in the mirror in a series of tiny etchings in which the type rather than the individual was the primary focus.[5]

Ter Borch's small self-portraits combine the study of facial expressions and grimaces with a very sensitive rendering of light effects, as the present sheet aptly demonstrates.[6] In the most subtle manner, the artist's smiling features and wavy hair, modeled by light and shadow, crystallize out of the blue paper tone, which, with the delicate black chalk, lightly applied gray washes, and carefully placed, white light reflections, form a richly nuanced spectrum of color. The highlight on the tip of the nose and the reflective, white eyelashes of the right

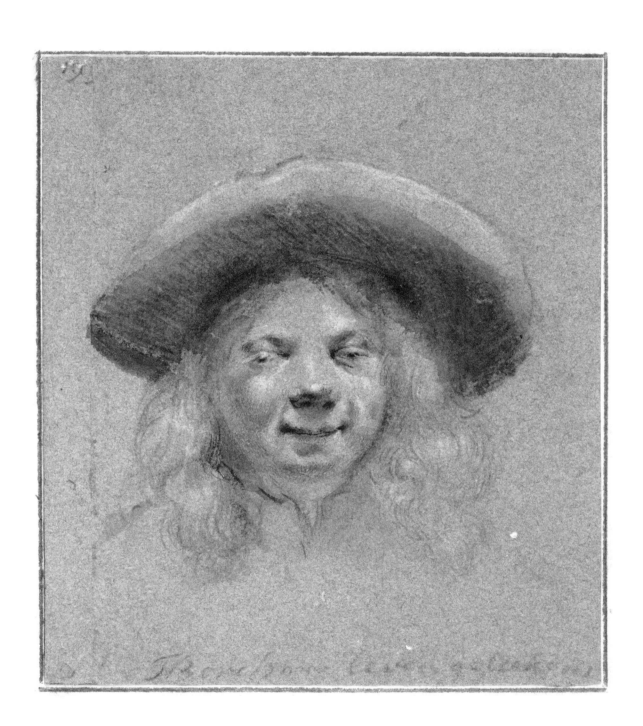

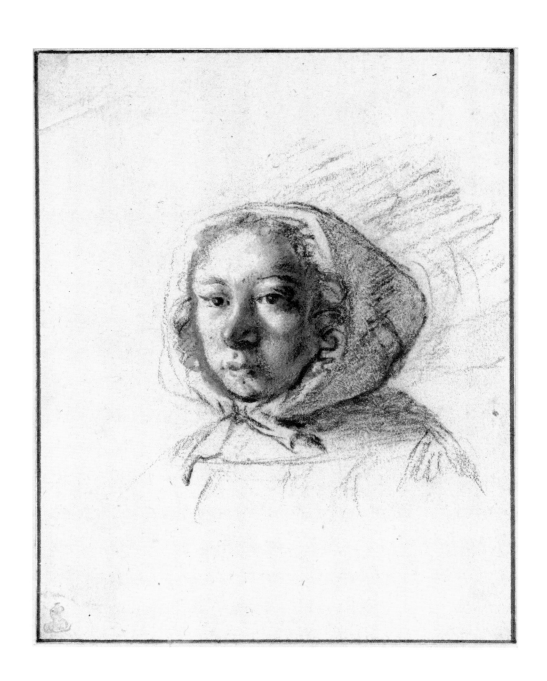

eye and the shadow they cast on the artist's cheek are some of the striking details of this drawing. The artist has here depicted himself at fifteen or sixteen years of age with a broad-brimmed hat—the only such example within his drawn self-portraits. The Albertina sheet relates closely to another self-portrait by the artist in London, which is similarly inscribed.[7]

The small portrait on white paper of a young woman with a head scarf (cat. no. 56), whose identity remains unknown, displays the unmistakable hand of this precocious talent. Ter Borch first applied the gray washes to model the face and followed with additional differentiations in fine strokes of black chalk. On a tiny surface, the free and simultaneously very concentrated handling of these media resulted in a lively play of light reflections and variously textured shaded areas. In its execution, this work relates to several portrait drawings of women that have been dated to around 1659–60.[8]

1 For the biography of Moses ter Borch, see Kettering 1988, vol. 1, p. 286.

2 Kettering 1988.

3 Regarding the sheets outside of the estate, see ibid., vol. 2, nos. 50–96.

4 Regarding Moses ter Borch's drawings, see ibid., vol. 1, pp. 286–88.

5 Regarding this theme, see Vienna 2004, nos. 2–6, with extensive bibliography.

6 On the "tronie" character of ter Borch's portraits, see Kettering 1988, vol. 1, p. 287.

7 London, British Museum, Collection of Prints and Drawings. See ibid., vol. 2, no. 67. "The first letter here, too, seems to have been changed; originally it may have been an 'M.'" (p. 854). The author suspects that the handwriting may be by another, unidentified hand that may also appear on other drawings.

8 Ibid., vol. 1, no. M 45 (dated 1659), M 63, M 64.

Frans van Mieris the Elder

Leiden 1635–1681 Leiden

57 *Sick Woman in Bed,* 1663

Black chalk, gray wash, on vellum

26.2 x 23.8 cm

INSCRIBED AT RIGHT OF CENTER: "F. van Mieris fecet/Anno 1663"; the numeral 3 is the (artist's own?) correction of a still visible numeral 4

PROVENANCE: C. Ploos van Amstel (Auction Amsterdam, March 3, 1800, C1, to Ph. van der Schley); Duke Albert von Sachsen-Teschen

INV. NO. 17599

BIBLIOGRAPHY: Schönbrunner and Meder 1896–1908, vol. 3, no. 304, illus.; Wurzbach 1906–11, vol. 2, p. 166; Benesch 1964, no. 203, illus.; Naumann 1978, pp. 11, 12, 30, no. 22, pl. 15b

Frans van Mieris, the son of the goldsmith Jan Bastiaensz. van Mieris, most likely trained in his father's profession before turning to painting.[1] According to Arnold Houbraken, his masters were Abraham Toorenvliet (1620–1692), Gerrit Dou (1613–1675), and Abraham van den Tempel (c. 1622–1672).[2] In 1658, van Mieris joined the painters' guild, becoming a director in 1664 and a dean in 1665. He was a leading member of the Leiden School of "Fijnschilders" ("fine painters"), which was started around 1630 by Dou, one of Rembrandt's earliest pupils in Leiden. The meticulous, highly finished painting style, used primarily in small, intimate genre scenes and portraits, characterized this artistic trend, which was named in the nineteenth century.[3] Van Mieris, who supposedly never left the city of his birth, enjoyed great recognition at home as well as among international nobility, despite his perpetual debt and legendary alcoholism. In 1681, he was buried in St. Pieterskerk next to prominent citizens. His sons Willem (1662–1747) and Jan (1660–1690), as well as his grandson Frans van Mieris the Younger (1689–1763), continued his meticulous style.

The present work, which is dated 1663, demonstrates van Mieris's great draftsmanship—which Houbraken noted.[4] Beginning in 1660, the drawings shift from sketchy renderings to carefully detailed, autonomous compositions on the same level as his paintings.[5] The sophisticated character of these delicate, black-chalk works, which were very popular among his patrons, is demonstrated, as here, in his frequent use of precious vellum. His extremely precise style is rooted in the tradition of the "Penwerken" ("artworks in pen") that originated with Hendrick Goltzius in the sixteenth century and continued in the seventeenth century (see Willem van de Velde the Elder, cat. no. 94).[6]

The motif of a sick young woman lying in bed was depicted by Rembrandt in the 1630s in several drawings. Whereas Rembrandt used a few expressive lines and spontaneous washes to focus on the facial expressions and chiaroscuro effects, some thirty years later, van Mieris chose a completely opposite approach to representing illness.[7] Opened bed curtains frame a softly illuminated scene. Using the finest nuances of black chalk, the artist differentiated between the textiles, glass objects, metal, and the woman's face, whose pale skin and swollen eyelids form the focal point of the image. This melancholy private world is dominated by the shimmering effects of a virtuoso description of textures.

1 For the biography of Frans van Mieris, see Philadelphia/Berlin/London 1984, p. 256; Leiden 1988, p. 127.

2 Houbraken 1753, vol. 3, pp. 2, 3.

3 Regarding Leiden "fine painting," see Philadelphia/Berlin/London 1984; Amsterdam 1989–90.

4 Ibid., p. 2.

5 Naumann 1978, p. 6.

6 Ibid., pp. 7–8.

7 Ibid., pp. 11–12.

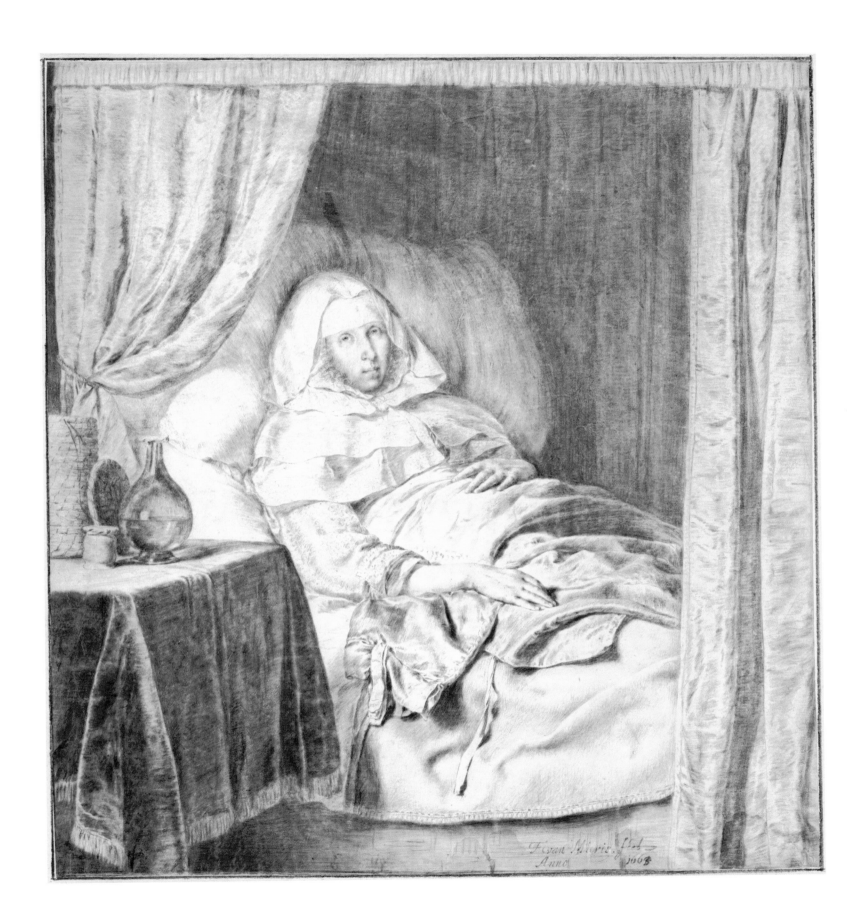

Adriaen van Ostade

HAARLEM 1610–1685 HAARLEM

58 *Group of Peasants in a Tavern,* **after 1670**

59 *Peasants Smoking and Drinking outside an Inn,* **c. 1675**

60 *Room at an Inn with Peasants Drinking, Smoking, and Playing Tric-Trac,* **1678**

CAT. NO. 58

Pen and light and dark brown inks, over graphite and black chalk, gray wash

17.3 x 22 cm

PROVENANCE: J. Gildemeester, Auction Amsterdam, November 24, 1800, Konstboek N. no. 50; G. Winckler; Duke Albert von Sachsen-Teschen INV. NO. 9134

BIBLIOGRAPHY: Wurzbach 1906–11, vol. 2, p. 280; Benesch 1964, no. 187, illus.; Schnackenburg 1981, vol. 1, no. 288; vol. 2, pl. 136; Sydney 2002, no. 81, illus.

CAT. NO. 59

Pen and brown ink, over black chalk, gray wash, watercolor, pricked for transfer

22.5 x 19.3 cm

INSCRIBED AT LOWER RIGHT: "A. Ostade" (by another hand)

PROVENANCE: J. Schepens, Auction Amsterdam, January 21, 1811, Konstboek A. no. 1; Duke Albert von Sachsen-Teschen INV. NO. 17597

BIBLIOGRAPHY: Rosenberg 1900, p. 79, fig. 79; Schönbrunner and Meder 1896–1908, vol. 1, no. 12, illus.; Schnackenburg 1981, vol. 1, no. 258, pp. 42, 65; vol. 2, pl .123

CAT. NO. 60

Pen and brown ink, watercolor, and bodycolor, over black chalk

22.8 x 19.5 cm

INSCRIBED ON THE STOOL: "1678 / AV. Ostade" ("AV" combined)

PROVENANCE: H. Willink, Auction Amsterdam, December 6, 1819, Kunstboek A. no. 1 (to Mensardt); Duke Albert von Sachsen-Teschen INV. NO. 17564

BIBLIOGRAPHY: Schönbrunner and Meder 1896–1908, vol. 3, no. 281, illus.; Rosenberg 1900, p. 82, fig. 83; Munich 1972–73, no. 74, pl. P. 73; Schnackenburg 1981, vol. 1, no. 269; vol. 2, pl. 126

The scant documentation on Adriaen van Ostade and his brother Isack (see cat. no. 61), who died young, hinders a definitive impression of the temperament and character of these famous artists, although their works suggest two very different personalities.[1] Their father, Jan Hendricx van Eindhoven, was a linen weaver; the name Ostade came from a hamlet near Eindhoven in the province of Brabant. Arnold Houbraken mentions that Adriaen van Ostade apprenticed with Frans Hals (c. 1580–1666) along with fellow pupil Adriaen Brouwer (1605–1638), who later became famous in the southern Netherlands as a painter specializing in peasant themes.[2] In 1634, Adriaen van Ostade joined the Haarlem painters' guild, becoming a director in 1647 and 1661 and dean in 1662. In 1636, he became a member of the Haarlem civilian army. He likely enjoyed distinguished social status: his final residence (from 1670 onward) was located in a wealthy area of Haarlem.

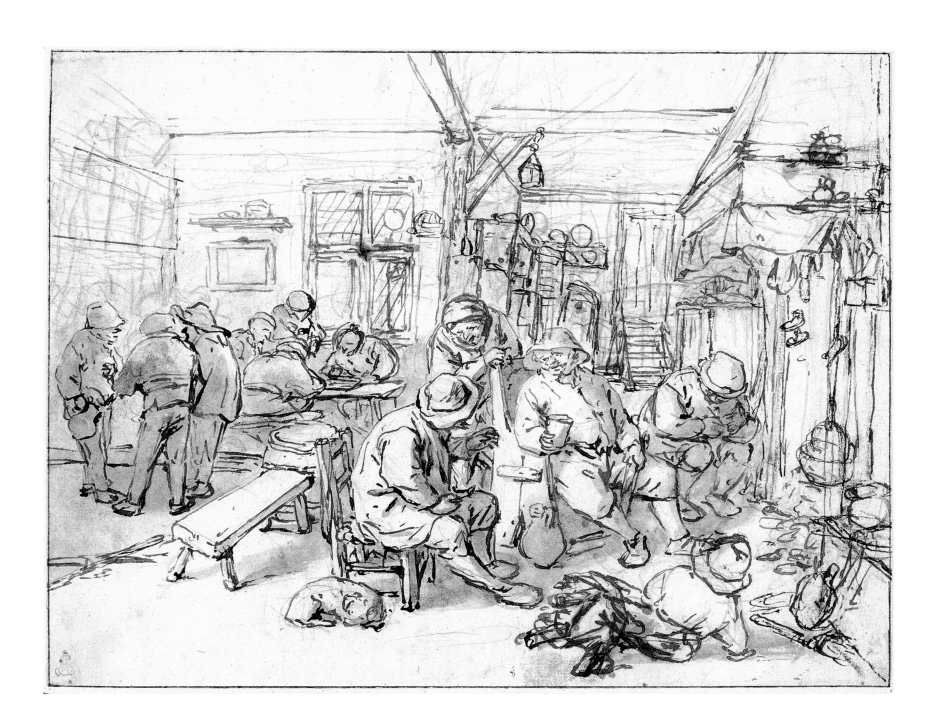

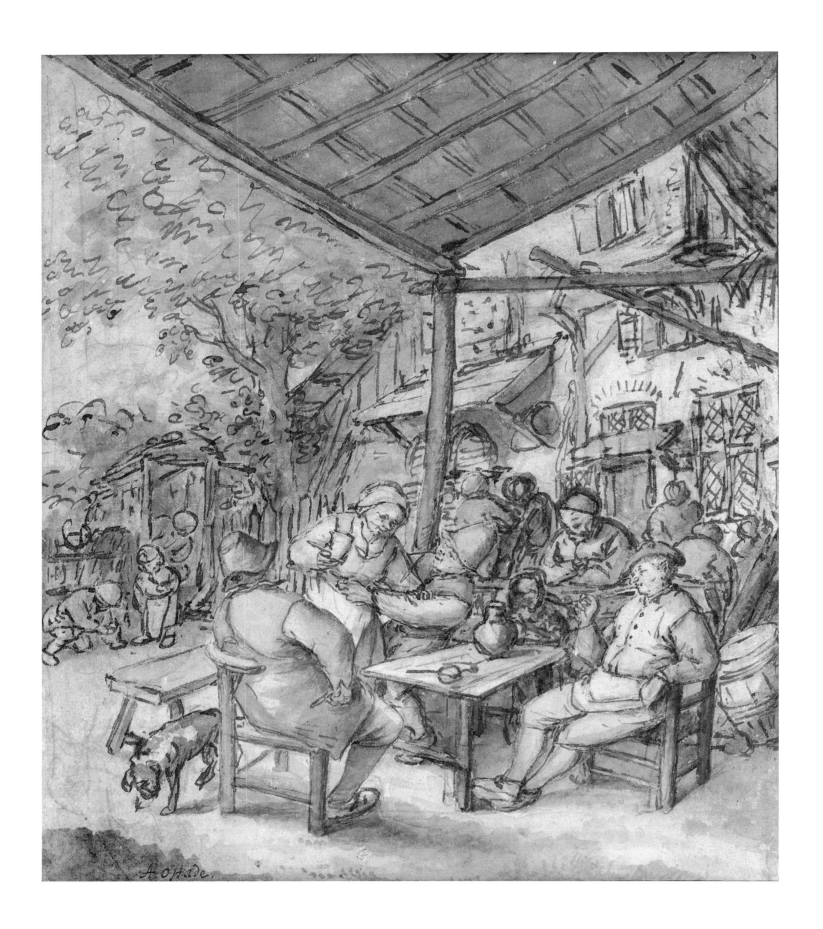

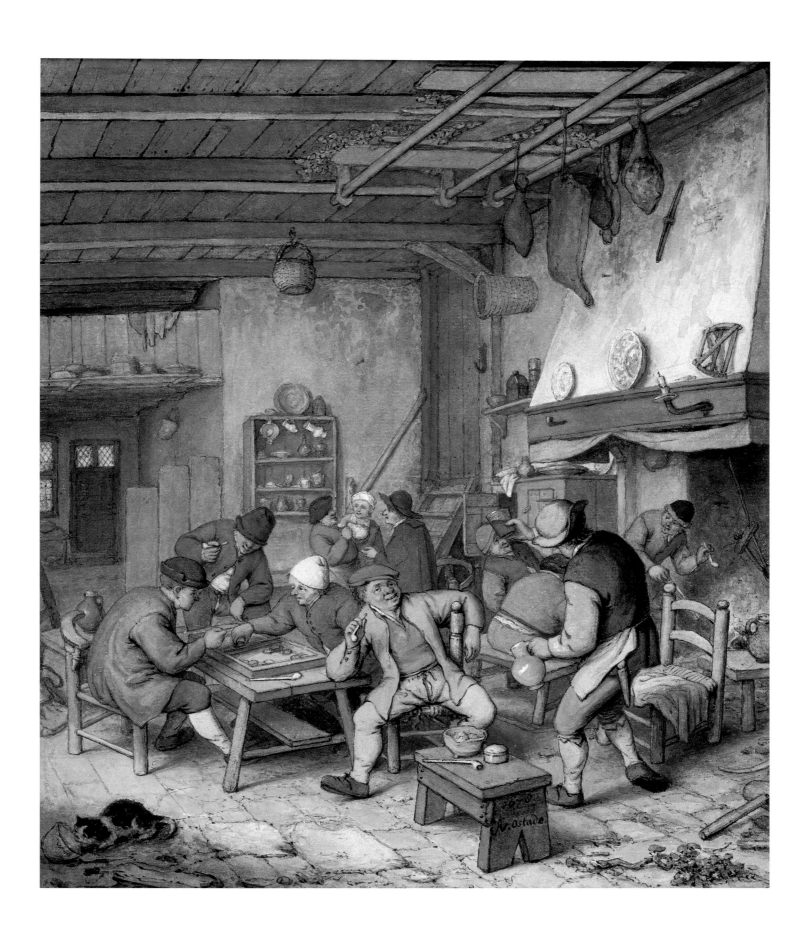

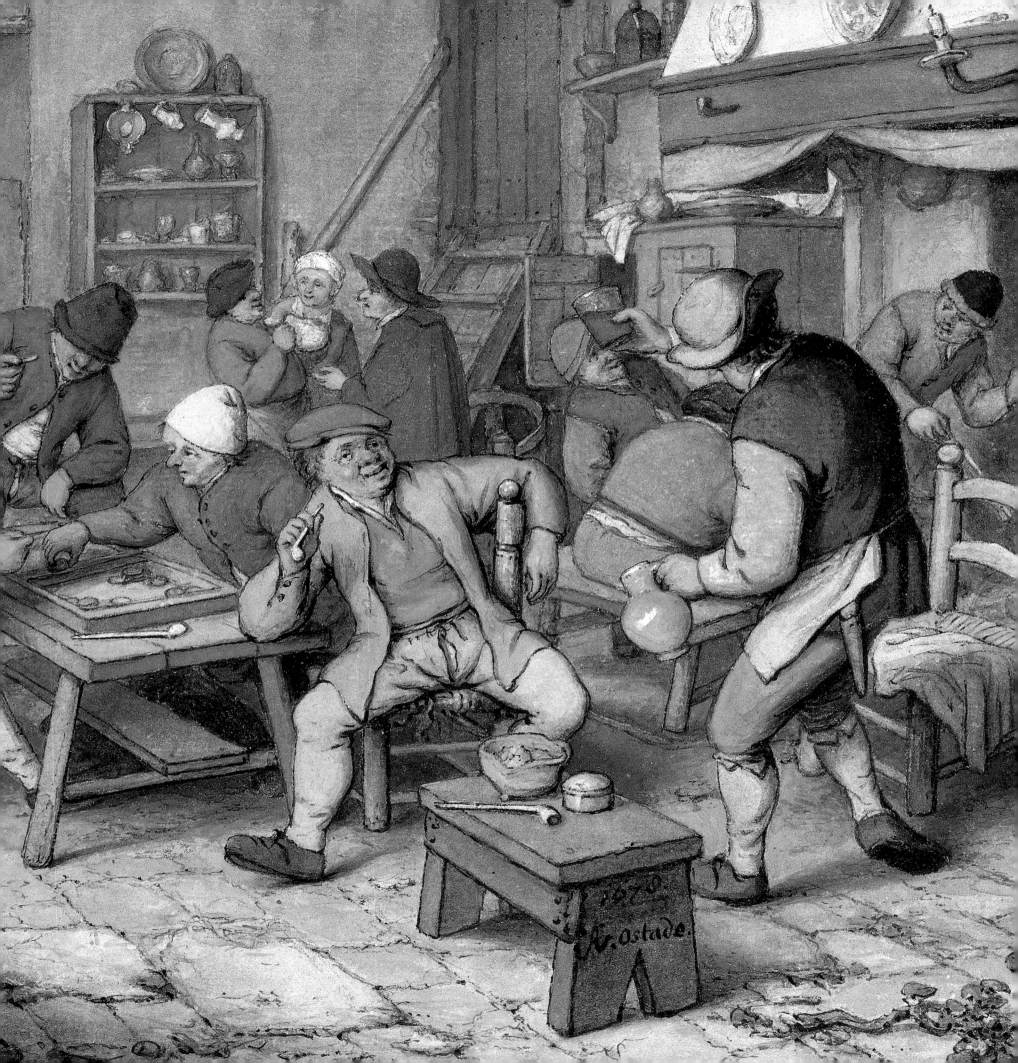

Adriaen van Ostade devoted himself primarily to rustic scenes; he and his younger brother and pupil, Isack, are considered the undisputed chief specialists in this genre. Spanning a good five decades, Adriaen's oeuvre comprises hundreds of paintings, some fifty etchings, and over four hundred drawings, including compositional sketches for paintings, etchings, and finished watercolors as well as figural and head studies and sketch sheets. Rather than conveying the reality of rural life, his images present coarse types whose uncouth behavior is expressed in uninhibited facial expressions and body language. The invented images continue the venerable tradition of Netherlandish low-life satire, expressed in popular writing since the Middle Ages and in sixteenth-century kermiss themes.[3] Brouwer's peasant images completed the shift from a depiction of the allegory of vice to a psychological description of human urges; Adriaen van Ostade's work emphasizes the good-natured, comic element of burlesque.[4]

The van Ostade brothers hold a key position regarding the significant role of drawing in Dutch genre painting, since almost no drawings by many great contemporaneous painters—Frans Hals, Jan Vermeer, or Jan Steen, for example—are known. The drawing tradition established by Rembrandt as well as Brouwer may have inspired the practices of the van Ostade brothers. Adriaen van Ostade, in particular, may have focused on earlier great Netherlandish genre draftsmen, especially Pieter Bruegel and Jan Brueghel, Jacques and Roelant Savery, David Vinckboons, Willem Buytewech, Hendrick Avercamp, and Esaias and Jan van de Velde.[5] Rembrandt's studies "from life" served to create the most natural renderings possible in his imaginary compositions.[6]

The three present drawings demonstrate the impressive diversity of Adriaen van Ostade's technical and artistic skills. All three sheets date from after 1670; approximately half his entire production of drawings derives from this last period in his artistic career. A notable phenomenon of the late work is the more than fifty watercolors known today, including most of the multifigural sketches. The highly finished watercolors largely assumed the function of paintings.

Peasants Smoking and Drinking outside an Inn (cat. no. 59) served as a preparatory study for a carefully executed watercolor dated 1675 by the same title. The function of the Albertina sheet is evident in the pricked lines used to transfer the composition onto the paper of the definitive watercolor. The preliminary drawing was set down spontaneously in very sketchy lines in pen, with watercolors only lightly applied. The artist then added his linear corrections and coloristic refinements.

Room at an Inn with Peasants Drinking, Smoking, and Playing Tric-Trac (cat. no. 60), dated 1678, is an excellent example of van Ostade's watercolor process. Within the fine pen contours, the artist developed carefully nuanced harmonies in watercolor, at times integrating white bodycolor. He also devoted considerable attention to the countless details of the furnishings, food, and everyday objects that are strewn about. A soft light suffuses the interior and brings out the diverse surface values. Such intimate, detailed, and highly finished watercolors enjoyed great popularity into the nineteenth century and were copied many times.[7] It is notable that in these late, aesthetically demanding works, the burlesque appears to have retreated in favor of a certain romanticizing element.

Group of Peasants in a Tavern (cat. no. 58) also conveys the impression of an atmospheric unity, though it is achieved through completely different means. Presumably from the 1670s, the composition was set down in spontaneous pen lines and rapidly applied washes. Its freshness and quality are a product of the artist's confident use of his media and the effective interplay of the limited palette. Within the subtle monochromy of the interior scene, the informally arranged group of figures in the foreground is specifically highlighted.

1 On the life of Adriaen van Ostade, see Schnackenburg 1981, pp. 13–16. Whereas Isack, judging from a 1641 self-portrait, appears to have emulated the romantic Bohemian type, Adriaen represented himself as a distinguished citizen in a 1655 group portrait (ibid., p. 22).

2 Houbraken 1753, vol. 1, p. 347.

3 See Schnackenburg 1981, vol. 1, pp. 25–28; Schnackenburg 1984; Raupp 1986; Renger 1970. Cited from Trnek 1992, p. 298, n. 1.

4 Cf. Renger 1970. See Schnackenburg 1984, pp. 35–36; Trnek 1992, p. 298, n. 2, 3.

5 Schnackenburg 1981, p. 21.

6 Regarding Adriaen van Ostade's drawings, see ibid., pp. 36–44.

7 Ibid., pp. 24, 60–68.

Isack van Ostade

HAARLEM 1621–1649 HAARLEM

61 *Peasants at an Inn with a Fiddler and Dancers,* c. 1644

Pen and brown ink, over graphite and black chalk, gray and brown wash
19.7 x 31.2 cm
INSCRIBED AT LOWER RIGHT: "Ostade f" (by another hand)
PROVENANCE: Duke Albert von Sachsen-Teschen
Inv. no. 9130
BIBLIOGRAPHY: Rosenberg 1900, p. 13, fig. 13; Adelaide/Sydney/Melbourne 1977, no. 40, illus.; Munich 1986, no. 51, illus.; Antwerp 1987, no. 53, illus.; Schnackenburg 1981, vol. 1, no. 522, p. 52; vol. 2, pl. 221, no. 522

According to Arnold Houbraken, Isack van Ostade apprenticed with his brother Adriaen, who was around eleven years older; in 1643, he joined the Guild of St. Luke in Haarlem.[1] His artistic career spanned the period from 1639, the year of his first dated paintings, to his early death in 1649. Despite the brevity of his career, Isack van Ostade was astonishingly productive as a painter and draftsman. Like his brother Adriaen, who outlived him by nearly four decades, Isack is considered one of the most significant representatives of the seventeenth-century Dutch low-life genre.

The approximately 225 catalogued drawings by the artist reveal a versatile and very original talent. Unlike the work of Adriaen, there are also nonfigural images among Isack's drawings, such as landscapes, topographical motifs, and architectural and object studies.[2] Although the younger Isack was largely shaped by the work of his brother in both theme as well as in his use of media, even his initial figural and compositional studies reveal a tendency toward a very lively handling of line and a great spontaneity of expression. The present drawing, which was originally attributed to Adriaen van Ostade, was reattributed to Isack for the first time by B. Schnackenburg. Schnackenburg places

the work in the artist's mature period, which is characterized by a larger number of compositional sketches of tavern scenes and interiors with peasant families. Together with a similar composition in Paris (*Peasant Inn with a Fiddler and a Dancer in the Middle of the Room*), the present drawing has been stylistically linked to a study by the artist dated 1644.[3]

What distinguishes the present sheet from comparable representations by Adriaen are the sweeping calligraphic strokes and the brief, yet distinct, characterization of the facial expressions and gestures of the peasant figures, especially the fiddler, the dancers, and the onlookers that flank them in the foreground. In all probability, the washes are by the hand of Cornelis Dusart (see cat. nos. 62, 63), who, after the death of Adriaen van Ostade in 1685, took over his former master's studio, including the remaining works of the Ostade brothers.[4] As a result of the numerous trimmings and alterations that Dusart applied to the sheets of his predecessors, many drawings by Isack are no longer in their original state.[5]

1 Houbraken 1753, vol. 1, p. 347. On the life of Isack van Ostade, see Schnackenburg 1981, vol. 1, pp. 16–19.

2 Schnackenburg 1981, vol. 1, nos. 405–580; 581–630 (reworked drawings); 631–33 (Isack and Adriaen van Ostade). On the drawings of Isack van Ostade, see ibid., pp. 47–55 (on their systematization, see p. 54).

3 Ibid., p. 52. The comparable drawing is located in Paris, Musée du Louvre, Cabinet des Dessins. See Schnackenburg 1981, vol. 2, no. 521 recto. Regarding the study dated 1644, see ibid., no. 511.

4 Schnackenburg 1981, vol. 1, no. 522, p. 52; vol. 2, pl. 221, no. 522 presumes that the washes are by Cornelis Dusart.

5 Regarding this problem, see ibid., vol. 1, pp. 60–63; in regard to Isack van Ostade, see especially p. 63.

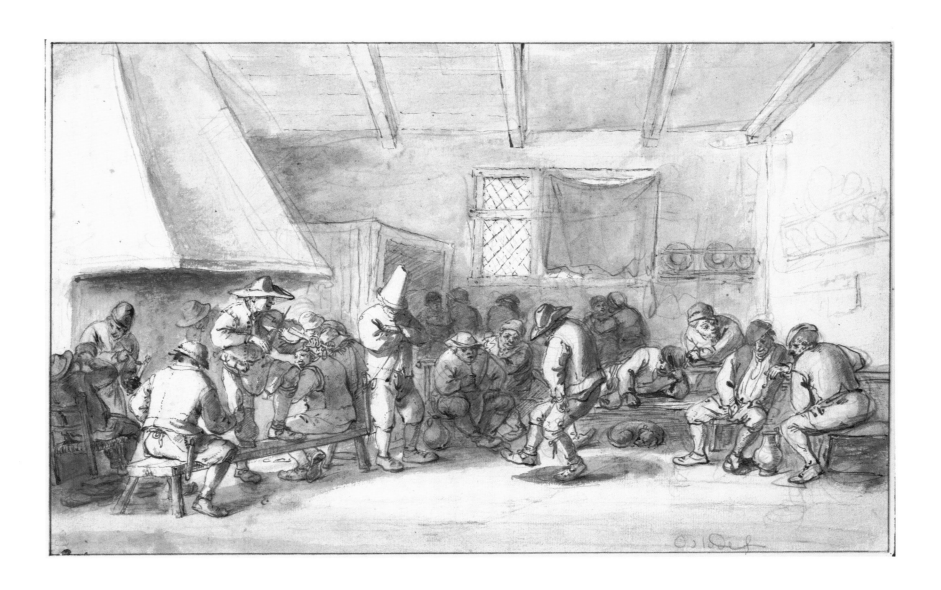

Cornelis Dusart

Haarlem 1660–1704 Haarlem

62 *Lively Peasant Group in a Barn,* 1687
63 *Seated Young Man with a Fur Hat and Vented Sleeves,* c. 1685/90

CAT. NO. 62

Black chalk, watercolor and gouache, on vellum

38.1 x 48.2 cm

INSCRIBED AT LOWER LEFT: "Cornelis Dusart/1687"

PROVENANCE: C. Ploos van Amstel (Auction Amsterdam, March 3, 1800, M 22); Ph. van der Schley; Duke Albert von Sachsen-Teschen

INV. NO. 15170

BIBLIOGRAPHY: none known

CAT. NO. 63

Black chalk, red chalk, watercolor

26.7 x 19.6 cm

PROVENANCE: Duke Albert von Sachsen-Teschen

INV. NO. 10402

BIBLIOGRAPHY: none known

Cornelis Dusart apprenticed in Haarlem with Adriaen van Ostade (cat. nos. 58–60) from around 1675 to 1679. After van Ostade's death in 1685, Dusart took over his workshop, including the remaining paintings and drawings, which he copied or enhanced. He joined the Guild of St. Luke in 1679. The peasant theme and his painting and drawing technique reveal the decisive influence of the van Ostade brothers. Numerous references to famous predecessors such as Adriaen Brouwer or Jan Steen also appear in his works. In addition, he owned a large collection of drawings and prints by contemporaries such as Cornelis Bega (cat. no. 51), Jan de Bray, Gerrit Berckheyde, and Adriaen van de Velde (cat. no. 105), which also inspired him considerably.[1] The present

works by Dusart, which are examples of two different types, have been neither published nor exhibited previously.

The catalogue of Dusart's estate, which was auctioned in 1708, includes among the many albums of his drawings a volume that contained "figures of men, drawn from life, 251 items."[2] It is probable that these studies are the ones that are now dispersed worldwide in several collections: they depict seated peasants, typically in awkward poses with distorted, caricaturelike expressions, carefully rendered in black and red chalk, at times combined with watercolor or colored chalk. Although in using this technique he emulated his master, van Ostade employed these media mainly for head studies and figural compositions and only rarely when representing individual figures.[3]

The Albertina's drawing of a seated young man leaning forward (cat. no. 63), perhaps from the second half of the 1680s, is one of Dusart's numerous studies of seated peasants. The combination of the aesthetically demanding, carefully worked out execution with the sloppy appearance of the clothing and the emphatically casual pose of the bent figure—perhaps a drunken man—is striking. Characteristic for Dusart is the concise realism of the face and hands, which are particularly emphasized through the use of red chalk. The surface effects of the clothing's texture are achieved in fine, even strokes overlaid multiple times.

It is presumed that Dusart prepared these highly finished drawings with the intention to sell them, although his estate inventory indicates that he kept many such sheets for himself, perhaps as reference material for his paintings.[5]

The scene of a lively peasant group in a barn (cat. no. 62) is perhaps the largest example known today of a number of finished

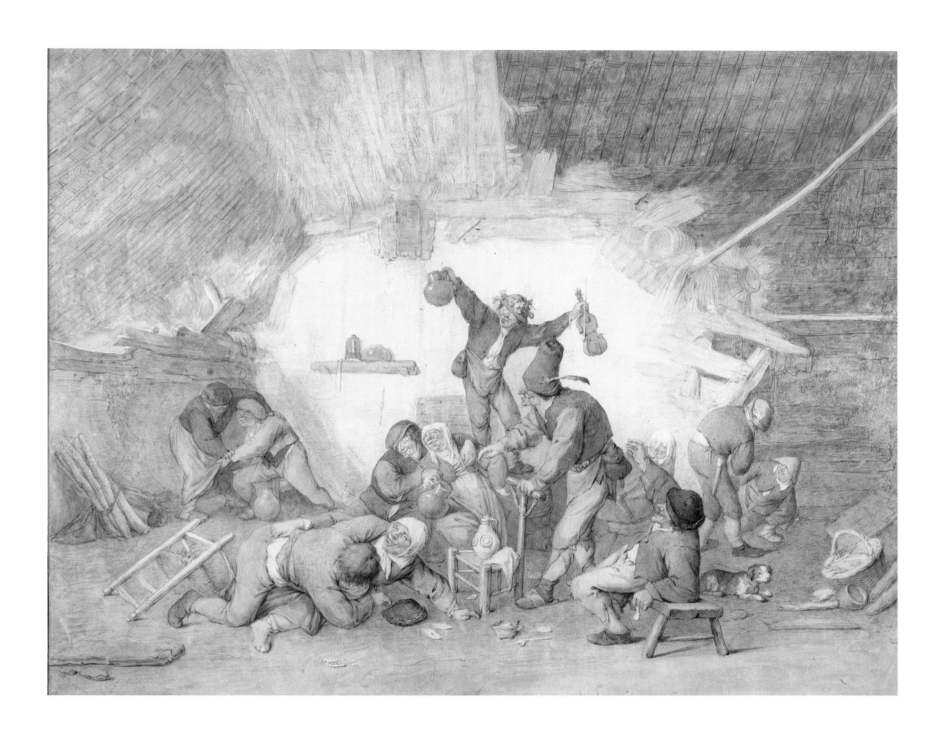

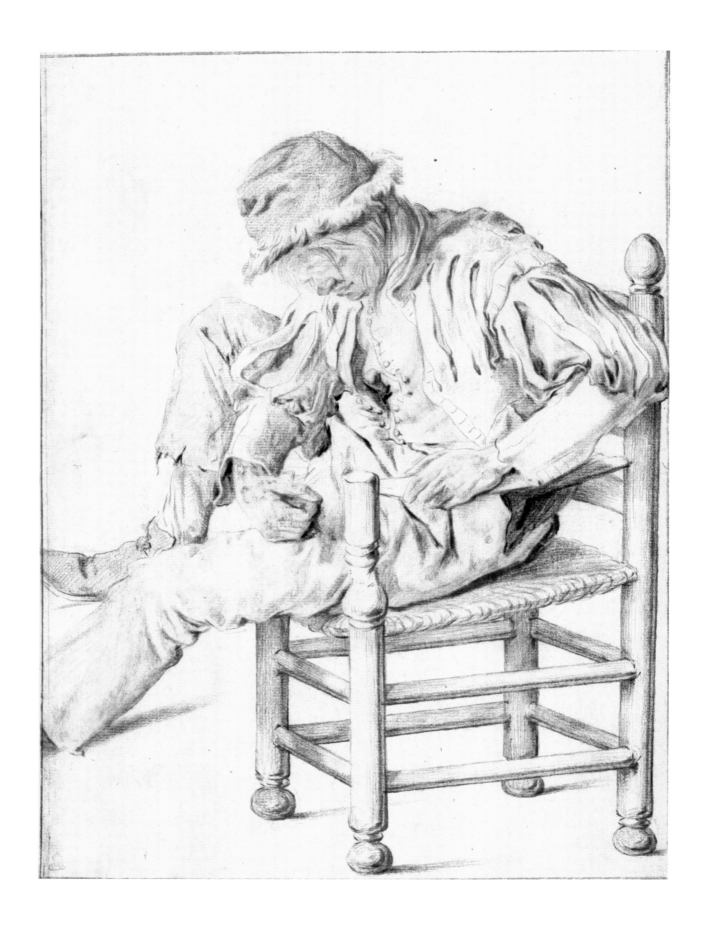

watercolors on vellum that Dusart produced for sale in the 1680s and 1690s.[6] The subjects range from complex figural compositions to representations of single figures. In their technique, these works relate to van Ostade's miniaturelike watercolors executed on vellum, of which only a few are known.[7]

The spatial effects and symmetry of the present watercolor are unusual for Dusart. A fiddler holding his instrument and a pitcher with his arms outstretched stands at the focal point of the composition; he crowns the pyramidal arrangement of a group of flirting, rowdy, and drunken peasants, who are flanked by two additional pairs of figures in the background. The lines of the barn's high interior run inward, creating a forceful perspective effect, which is directed at the bright, presumably unfinished, central wall. The whole scene unfolds as if on an open stage. Dusart's predilection for careful renderings of everyday objects is apparent in the still-life details.

1 On Dusart's drawings, see Peter Schatborn in Amsterdam/Washington 1981–82, pp. 110–12; Ger Luijten in New York/Fort Worth/Cleveland 1990–91, pp. 95–97; William W. Robinson in Amsterdam/Vienna/New York/Cambridge 1991–92, pp. 208–14.

2 William W. Robinson (note 1), p. 210.

3 Ger Luijten (note 1), p. 95.

4 Two drawings from the group, A *Seated Smoker, His Eyes Closed*, Boston, Collection of Maida and George Abrams, and a variant in Weimar, Staatliche Kunstsammlungen, Schlossmuseum, are dated 1686. See William W. Robinson (note 1), no. 79 and p. 212, fig. 2.

5 See note 3.

6 William W. Robinson (note 1), p. 214, n. 1 names a number of works in this technique, among which the largest example is 36 x 43.5 cm. In addition, the author discusses the particular character of this specific type.

7 Ibid.

Jacob Toorenvliet

LEIDEN 1640–1719 OEGSTGEEST

64 *Kitchen Maid Cleaning a Kettle with Two Joking Men,* early 1680s

Black and red chalk, watercolor, partially drawn over in graphite

24.6 x 22.4 cm

INSCRIBED AT LOWER CENTER: "J Toornvliet. F"

PROVENANCE: Duke Albert von Sachsen-Teschen

INV. NO. 10154

BIBLIOGRAPHY: Bernt 1957–58, vol. 2, no. 570, illus.; Karau 2002, no. E 3.28

Jacob Toorenvliet first trained with his father, the Leiden glass-painter and drawing instructor Abraham Toorenvliet (1620–1692), presumably like Frans van Mieris the Elder (cat. no. 57). Gerrit Dou (1613–1675) next was his instructor until 1659.[1] Around 1663, he apparently traveled through the southern Netherlands to Vienna. In 1669, he was in Rome for a portrait commission, returning briefly to the Netherlands. In 1671, he traveled to Rome with Nikolaes Rosendael (1636–1686), becoming a member of the "Bentveugels," and, according to Houbraken, copying Italian Renaissance paintings.[2] He lived in Venice (1670–73) and in Vienna (1673–74), where he specialized in painting single figures on copper. After a short period in Leiden in 1679, he moved to Amsterdam in 1680. Beginning in 1686, he was again in Leiden, joining the Guild of St. Luke and in 1694 cofounding the Leiden Drawing Academy. Between 1695 and 1712, he held important offices in the guild. After the death of van Mieris in 1618, Toorenvliet was among the last representatives of Leiden "fine painting," a trend begun by Dou in the 1630s. In addition to the meticulously detailed techniques that define this style, Toorenvliet's work—predominantly genre scenes, representations after the Antique, head studies, and small-format portraits—was also inspired by his travels.

Half-length figures sometimes in small groups and often depicting oddly matched pairs are one of Toorenvliet's characteristic motifs. The subject pictured here of a kitchen maid interrupted at work by the advances of men appears several times. Here, a young woman about to polish a copper pot stands between two men. One, dressed in an imaginative sixteenth-century costume, puts his arm around the willing maid; the other (a servant?) stands in shadow to the left, holding a pitcher and pointing to a prominently placed cabbage. The erotically charged scene unfolds before an idealized Italianate background. This thematic interpretation of a man wooing a woman seems derived from the portrait tradition of sixteenth-century Italy. The "fine painting" is evident in the carefully rendered cabbage and copper pot. The free handling of the chalk and brush appears Flemish in inspiration.

The sheet was apparently produced in the early 1680s; the signature "Toornvliet" (rather than "Toorenvliet") appears only in works after 1679.[3] Also of note is that over the course of the 1680s, the artist turned from half-length figures to compositions with greater numbers of figures.[4]

The connection of the Albertina drawing with a thematically identical painting that recently appeared on the art market has not yet been researched.[5] In any case, this highly finished sheet stands on its own, though it may have been produced as part of a series.

1 I heartily thank Susanne H. Karau for her assistance with numerous observations included here and this current biographical information on Toorenvliet. See also Leiden 1988, p. 239. Dou was the brother-in-law of Abraham Toorenvliet.

2 Houbraken 1753, vol. 3, p. 167.

3 Information courtesy of Susanne H. Karau.

4 On this topic, see Leiden 1988, cat. no. 85.

5 *Market Scene*, oil on canvas, 49 x 40.5 cm, signed at lower center: "J. Toornvliet." See Bedgate, auction 709, June 4, 2002, no. 1367; auction Bailly-Pommery & Ass., Drouot, March 21, 2003, no. 52; Kunsthandlung Rasmussen. Information courtesy of Susaune H. Karau.

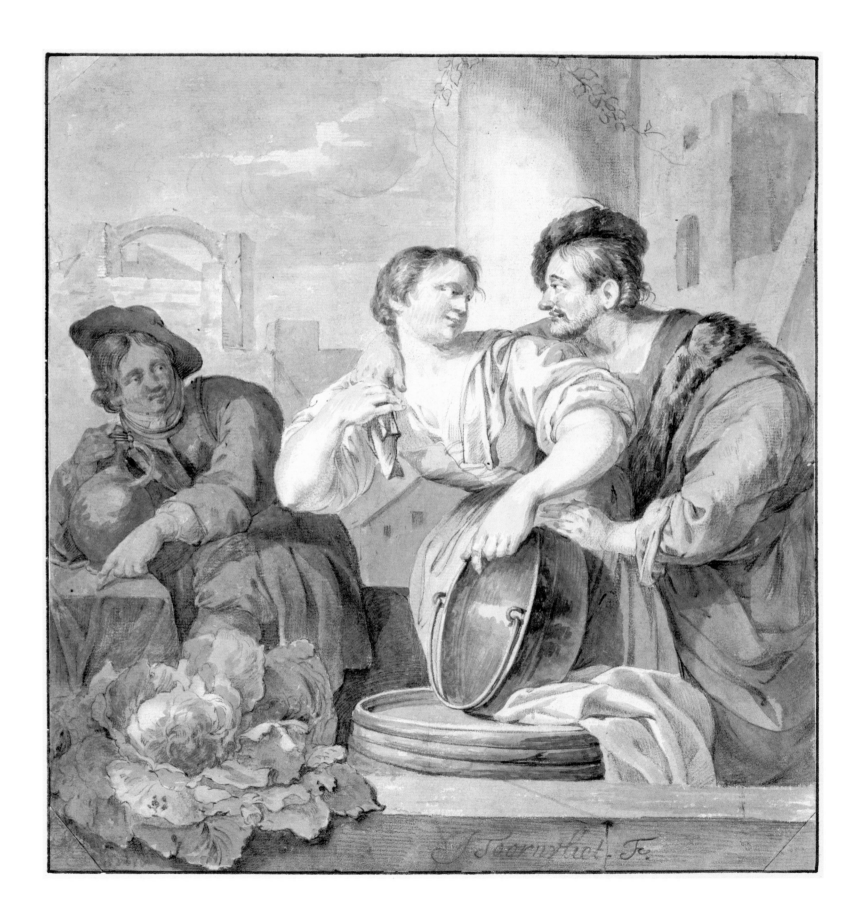

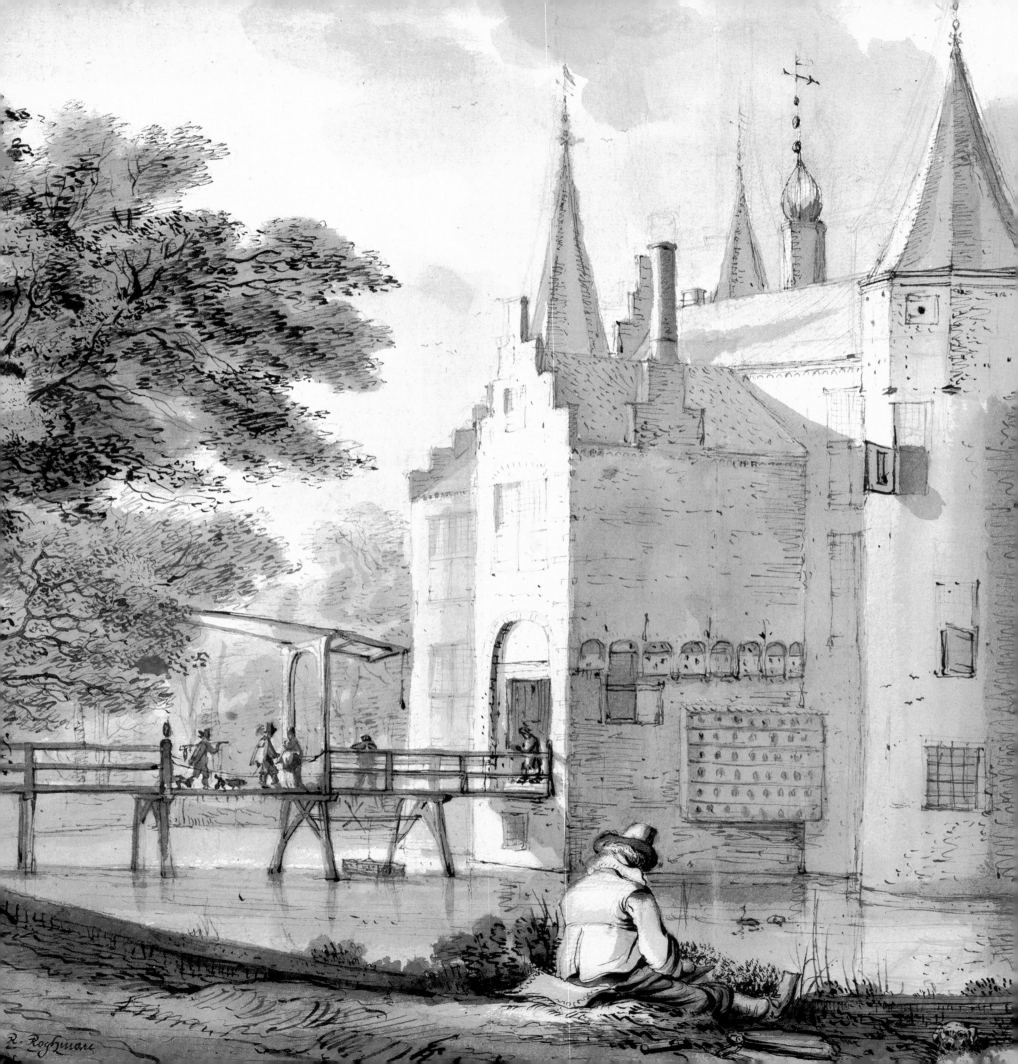

R. Roghman

Mid-Century Landscape and Topography

Aelbert Cuyp

DORDRECHT 1620–1691 DORDRECHT

65 *Panoramic Landscape with a View of the Dean's House in Maarsbergen,* c. 1639/40

Black chalk, gray wash, ocher, yellow, and blue watercolor, partially brushed with gum arabic

18.7 x 30.3 cm

PROVENANCE: Duke Albert von Sachsen-Teschen

INV. NO. 8755

BIBLIOGRAPHY: Munich/Bonn 1993, p. 132, no. 9; Washington/London/Amsterdam 2001–2002, p. 80, no. 58, illus.; van Groningen 2003, p. 85, fig. 4

The most famous member of a large Dordrecht family of painters, Aelbert Cuyp was trained by his father, the portrait and animal painter Jacob Gerritsz. Cuyp. Around 1640, Aelbert began doing the landscape backgrounds of his father's paintings. He specialized almost exclusively in landscape painting until the late 1650s. Though his paintings of the early 1640s were shaped by the compositional style and monochrome palette of Jan van Goyen (cat. nos. 17–20), beginning around 1645, Cuyp's Dutch landscapes reflected the influence of the Italianizing artist Jan Both (cat. no. 104) and were characterized henceforth by a golden, evocatively southern sunlight.[1]

Most of Cuyp's drawings are landscapes, with his most productive period between 1639 and 1642.[2] In 1639–40, he produced a series of autonomous drawings, in black chalk, watercolor, and white bodycolor, of Utrecht views and architectural motifs. These sheets reveal the young artist's familiarity with views of Prague by Roelant Savery (cat. nos. 3, 4), who spent the years 1619–39 in Utrecht.[3]

The present drawing's close relationship to this "Utrecht group" has been considered only recently. A short time ago, the sheet was considered a Rhine landscape, possibly from Cuyp's trip to Kleve between 1640 and 1642.[4] However, the main architectural motif of the drawing has now been identified as the dean's house in Maarsbergen, which lies near Utrecht. This identification supports the assumption that the sheet originated before 1640—at the same time as the artist's earliest views of Utrecht.[5]

Cuyp's characteristic use of media is evident: black chalk defines the contours of the terrain and the architectural forms, combined with a subtle application of gray washes and watercolors. Cuyp often subsequently intensified the black lines with gum arabic. Despite the monochrome hues, this early sheet possesses a particular luminosity. Cuyp masterfully commanded the gentle transitions of the ocher and brown tones, alternating with the blue-white of the illuminated area around the building and more distant reflections in the water. Typical also is the harmonious blending of nature and architecture. In contrast to van Goyen's drawings, for example, Cuyp's landscape drawings— unlike his paintings—include virtually no human or animal staffage; here, the inconspicuous carriage in the left foreground is an exception. These early panoramic compositions seem to refer to prints from the late sixteenth or early seventeenth centuries, to which Cuyp added a very immediate impression of light, air, and open space.[6]

1 On the life and work of Aelbert Cuyp, see Dordrecht 1977–78 and Washington/London/Amsterdam 2001–2002.

2 On Cuyp's drawings, see Egbert Haverkamp-Begemann in Washington/London/Amsterdam 2001–2002, pp. 75–85.

3 Ibid., p. 77.

4 Wouter Kloek in Washington/London/Amsterdam 2001–2002, no. 58.

5 The building is identified in van Groningen 2003, p. 85. Its conversion into a castle was completed not long after the present drawing was produced. Wouter Kloek, whom I would like to thank heartily for this information, considers c. 1639/40 a highly probable date for this drawing (written communication, April 29, 2005).

6 Egbert Haverkamp-Begemann (note 2), p. 80 refers in this context to the views published between 1572 and 1618 by Georg Braun and Franz Hohenberg under the title *Civitates orbis terrarum.*

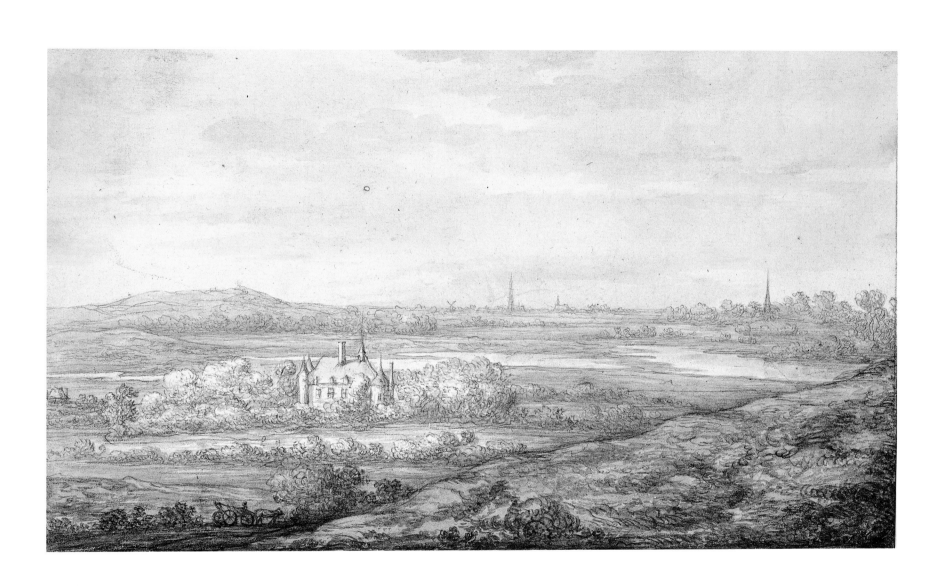

Aelbert Cuyp

DORDRECHT 1620–1691 DORDRECHT

66 *View of Arnhem from the South*, c. 1642/46

Black chalk, gray wash, ocher, yellow, green, and blue watercolor
18.4 x 50.1 cm
Provenance: Duke Albert von Sachsen-Teschen
INV. NO. 8756/8386 (originally catalogued as separate drawings)
BIBLIOGRAPHY INV. NO. 8756: Schönbrunner and Meder 1896–1908, vol.
6, no. 626, illus; Bernt 1957–58, vol. 1, no. 172, illus.; Benesch 1964,
no. 195, illus.; Washington/New York 1984–85, no. 32, illus.
BIBLIOGRAPHY INV. NO. 8386: Schönbrunner and Meder 1896–1908, vol.
10, no. 1198, illus.; Beck 1972–91, vol. 4, no. 382, illus.
BIBLIOGRAPHY INV. NO. 8756/8386: Vienna 1993, no. 59. illus.; New York/
Fort Worth 1995, no. 51, illus.; Washington/London/Amsterdam
2001–2002, no. 74, illus.

Measuring approximately 18 by 45/50 centimeters, fifteen "Large
Panoramas"—presumably created between 1642 and 1646—are among
Aelbert Cuyp's most impressive landscape drawings.[1] One of these
views is the present drawing, which at some point was cut into two
unequal sections that fortunately both found their separate ways into
Duke Albert von Sachsen-Teschen's collection. The two fragments were
rejoined in 1993; though there were no substantial losses of material,
the join remains apparent.[2]

The depiction of a city on the horizon in an elongated, hori-
zontal format derives from the tradition of profile views of cities that
were added to plans and maps in the sixteenth century. Jan van de
Velde II (cat. nos. 11, 12) was one of the first artists to employ this
utilitarian form of representation in the art context of the new realism.
Van de Velde, whose draftsmanship was still influenced by the callig-
raphy of the Mannerist tradition, undoubtedly inspired Cuyp in the
use of this compositional format.[3]

Cuyp's preference for slightly hilly, often forested areas that
present the profile of a distant city in its natural environs—among
them, Arnhem, The Hague, Rhenen, and Calcar—is distinct in his
"Large Panoramas."[4] Thus, in the present drawing, which portrays
the south side of the city of Arnhem, the topographical motif is unified
with the landscape in a complete, spacious, light-filled image.
With forceful, rhythmic strokes in black chalk, the artist clearly dis-
tinguished the layers of the terrain, the mounds of earth, and the
mesh of trees and shrubs from one another. Like other sheets in the
series, ocher and green hues predominate, with the gleam of the white
paper support regularly peeking out in between. The suggestive
effects of near and far result from the contrast between the heavy lines
of the foreground and the delicate contours of the city profile and
the towering Church of St. Eusebius. In this drawing, Cuyp did not
use gum arabic, as he often did to strengthen the black chalk lines.
The sky is revealed here in its original state without any disturbing
later, eighteenth-century enhancements such as clouds.[5]

1 For the dating of the "Large Panoramas" between c. 1642 and 1646, see Egbert Haverkamp-
Begemann in Washington/London/Amsterdam 2001–2002, p. 81.

2 For more detailed information on the reunification of the two fragments, see Vienna 1993,
no. 59, illus.; New York/Fort Worth 1995, no. 51, illus.

3 Egbert Haverkamp-Begemann (note 1), p. 82, fig. 5.

4 Ibid.

5 For an example of the use of gum arabic and the addition of clouds, see *View of Arnhem
from the Northwest*, Amsterdam, Rijksmuseum. See Washington/London/Amsterdam
2001–2002, no. 75, illus.

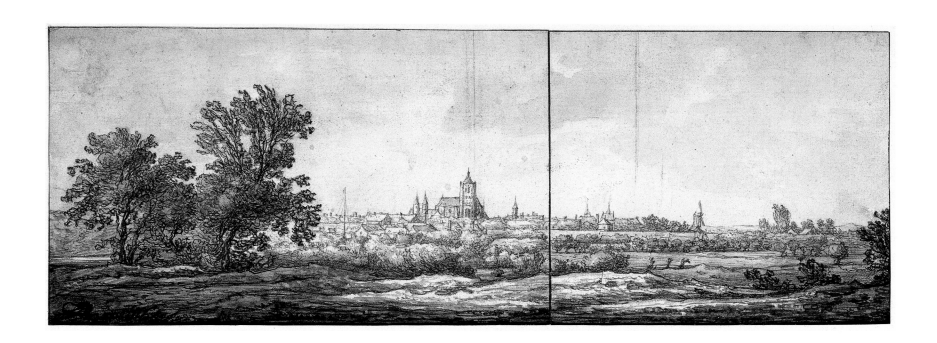

Aelbert Cuyp

DORDRECHT 1620–1691 DORDRECHT

67 *Ruins of Ubbergen Castle,* 1651/52

Black chalk, graphite, gray wash, white bodycolor

18 x 27.1 cm

INSCRIBED AT LOWER CENTER: "A. CUYP"

INSCRIBED AT UPPER CENTER: "ubberghe"

INSCRIBED AT UPPER LEFT: "Roghman" (by a later hand)

PROVENANCE: Charles de Ligne; Duke Albert von Sachsen-Teschen

INV. NO. 8568

BIBLIOGRAPHY: Reiss 1975, p. 175; A. Chong in Dordrecht 1992–93, p. 131, under no. 21, fig. 1; Vienna 1993, no. 60, illus.; New York/ Fort Worth 1995, no. 52, illus.; Washington/London/Amsterdam 2001–2002, no. 88, illus.

Ubbergen Castle near Nijmegen was heavily damaged during the battle against Spain in 1582[1]; it was dismantled in the eighteenth century. However, during the seventeenth century, the ruins, like those of many other destroyed castles, became in both poetry and painting a Romantic symbol for an independent Netherlands.

It is presumed that Aelbert Cuyp drew Ubbergen Castle while on his trip to Nijmegen and Kleve in 1651–52. The mountains visible in the background do not exist in reality and were presumably added later in the studio.[2] This imaginary addition to the flat landscape also appears in the painting that Cuyp produced based on the present drawing.[3] The mountains and the golden sunlight that suffuses the landscape imbue this relatively small painting with an idealized, southern character. The imposing repoussoir motif of the forcefully drawn tree at the left in the drawing is reduced to a small shrub in the painted version. A rider and a shepherd viewed from behind— appearing in the drawing in briefly sketched outlines—dominate the right foreground of the painting. Whereas in the painting the atmos- phere serves to harmonize the castle with its surroundings, in the drawing the separation between reality and fantasy is clearly apparent in the contrast between the sculpturally worked ruins and the flat, stage-set character of the mountains. The intense black of the forcefully applied chalk and the thin, shimmering gray and white veil of the fluidly applied washes are especially pronounced in the crumbling walls and their reflections in the water. It is possible that the clouds were a later addition in the eighteenth century.[4]

1 For historical information on the castle, see Washington/London/Amsterdam 2001–2002, p. 154, no. 31.

2 Alan Chong in Dordrecht 1992–93, p. 131.

3 Oil on panel, 32.1 x 54.5 cm; London, The National Gallery, inv. no. NG 824, see Washington/ London/Amsterdam 2001–2002, no. 31.

4 Wouter Kloek in ibid., p. 256.

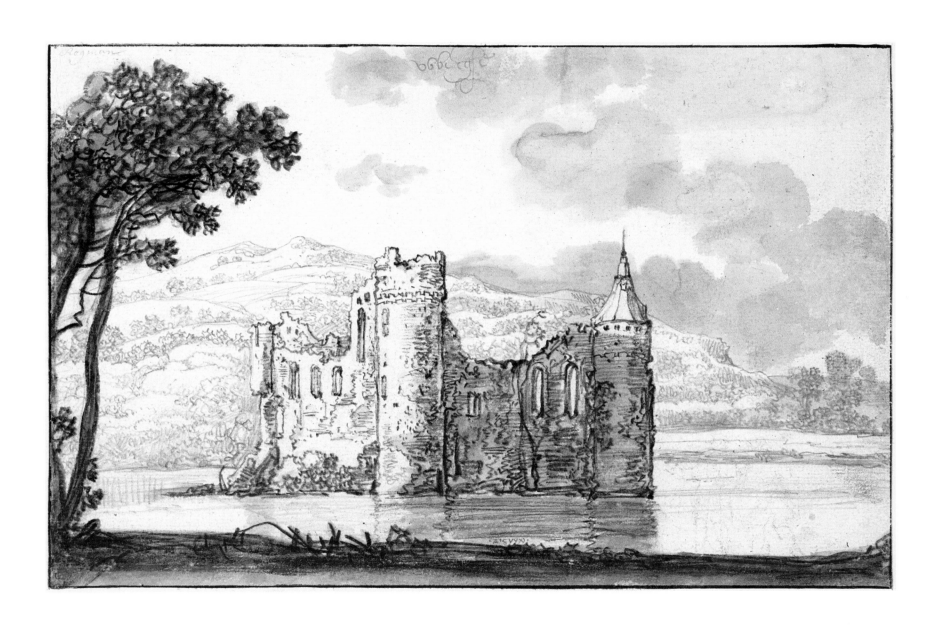

Aelbert Cuyp

DORDRECHT 1620–1691 DORDRECHT

68 *Reclining Dog,* c. 1645

Black chalk, gray wash, pale green watercolor

7.2 x 14.3 cm

PROVENANCE: Duke Albert von Sachsen-Teschen

INV. NO. 8388

BIBLIOGRAPHY: Washington/London/Amsterdam 2001–2002, no. 104, illus.

Within Aelbert Cuyp's oeuvre of drawings, which is dominated by landscapes, the representations of animals from the mid-1640s form a relatively small group. Within this category, the cow, which figures importantly in the artist's landscape paintings, is depicted the most frequently; studies of horses and sheep are less common. The present drawing of a dog is an even greater rarity among Cuyp's images of animals.

The position of the reclining dog recalls the somewhat mannered poses of the animals that Cuyp's father, Jacob, produced in a series of etchings from 1641. Jacob Cuyp's representations of animals, in turn, had been shaped by examples by the Utrecht Mannerist Abraham Bloemaert.[1] However, in the present drawing by Aelbert Cuyp, the dominant impression is of a careful, intensely focused study "from life," in which the artist masterfully applied the drawing media. Cuyp particularly devoted his attention to the characterization of the dog's short-haired, shiny coat, in which the finely shaded areas were first set down in brief strokes in black chalk. He followed this with supplemental accents in gray ink, applied with a fine brush, together with pale green watercolor, leaving untouched areas of the paper to define the highlights of the animal's shiny coat. The artist's rendering of the organic textures is unequaled, and the confidently drawn contours contribute greatly to the masterful characterization of the animal, whose nature is communicated to the viewer with great

immediacy. Cuyp may have been inspired in his use of watercolor by the animal drawings of his older contemporary Cornelis Saftleven.[2] This drawing of the reclining dog served Cuyp as a reference for several of his paintings.[3]

1 Reinier van Persijn after Jacob Cuyp, *Diversa animalia quadrupedia ad vivum delineata a Iacobo Cupio,* ed. Nicolaes Visscher (Hollstein, 1949–), vol. 17, Reinier van Persijn nos. 11–23, 73–74.

2 Wouter Kloek suggested this source of inspiration in a drawing of a standing cow. See Washington/London/Amsterdam 2001–2002, no. 102.

3 Especially for the painting *Orpheus Making Music for the Animals* in a private collection, which must have been executed around 1645. See Wouter Kloek, ibid., p. 272. For additional paintings, see ibid., n. 2.

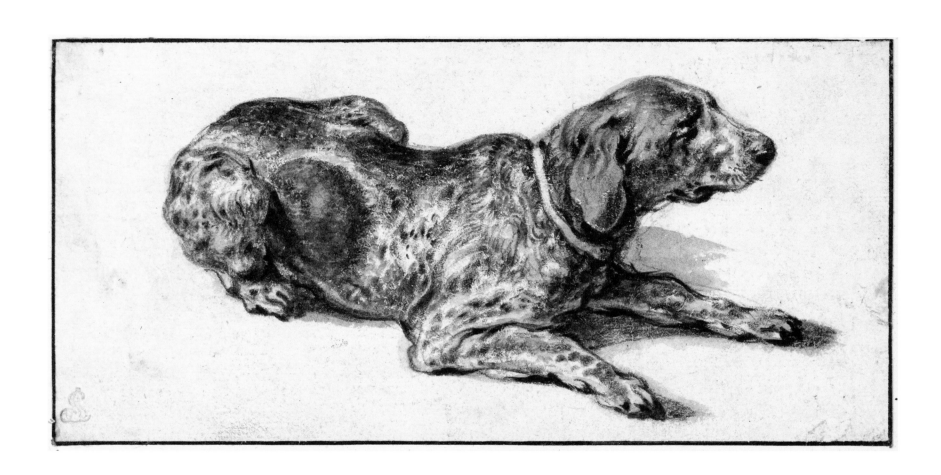

Simon de Vlieger

ROTTERDAM (?) 1600/1601–1653 WEESP

69 *Fish Market on the Beach in Egmond,* c. 1643

Black chalk, gray wash, pen and brown ink, over graphite

21 x 37.8 cm

PROVENANCE: Duke Albert von Sachsen-Teschen

INV. NO. 9170

BIBLIOGRAPHY: Bernt 1957–58, vol. 2, no. 653, illus.; Vienna 1993, no. 85, illus.; New York/Fort Worth 1995, no. 75, illus.

Simon de Vlieger lived in Delft until 1638, but there is no information about the artist's training. After 1638, he worked alternately in Rotterdam and Amsterdam, where he applied for residency in 1643. He spent the last years of his life in Weesp, a town not far from Amsterdam.

De Vlieger worked as a painter, draftsman, and etcher, focusing predominantly on forest scenes, city views, seascapes, and coastal landscapes. A typically Dutch type of landscape was the beach scene, which flourished particularly in the seventeenth century. While the late Mannerist coastal views of the sixteenth century were still dominated by fantastic rock formations, scenes of local beaches and dunes gradually began to appear in the late sixteenth and seventeenth centuries.[1] Simon de Vlieger and the marine painter Jan Porcellis (cat. no. 92) were among the earliest exponents of this new realism in the representation of the coastal landscape.

Simon de Vlieger's beach scenes, which originated in the 1630s and 1640s, evolved gradually from a colorful painting style into the famous silver-gray tonalism of paintings such as *Beach Scene* (1643; The Hague, Mauritshuis) or *Beach near Scheveningen* (1643; Cologne, Wallraf-Richartzmuseum).[2] This drawing appears to correspond to these signature mature beach paintings. Using his preferred media, black chalk and brush and gray wash, the artist devoted himself to the effects of the morning sunlight—judging by the easterly light, the figures' long shadows, and the slightly misty atmosphere. The stagelike clarity of the foreground group of fishmongers and their customers contrasts with the flowing, soft forms of the sandy terrain and the figures that seem to dissolve in the mist. Within the tones of gray, the brown ink of the figures' contours provides a subtle color accent.

In its pictorial completeness, this work is a rarity among de Vlieger's typically fragmentary sketches of views of the beach.[3] The purpose of this sheet is not known: is it a reduced version of a painting, a preparatory drawing, or an autonomous work?[4] The unique quality of the artist's rendering of light, expanse, and atmosphere, however, is undisputed.

1 Regarding the development of the Netherlandish coastal landscape, see Stechow 1966, pp. 101–109; Munich/Bonn 1993, pp. 61–93.

2 Bol 1973, pp. 182–84.

3 For example, the drawing of a beach scene in Paris, Institut Néerlandais, Fondation Custodia, inv. no. 2013. See Paris 1989, no. 81. Additional examples are mentioned in ibid., p. 81, n. 2.

4 The drawing *Beach near Egmond* displays a similar pictorial completeness (black chalk, gray wash, 11 x 30.8 cm, signed at lower left: S D VLI, formerly Haarlem, Collection of F. Koenigs, inv. no. H 55), details from Elen 1989, no. 510. A more detailed version in watercolor of this lost drawing is located in the Albertina Museum, Vienna, inv. no. 10112; it is perhaps a reproduction by an unknown hand of a lost painting by Simon de Vlieger. See Vienna 1993, pp. 158, 159, n. 10, 11; New York/Fort Worth 1995, pp. 158–59, n. 10, 11.

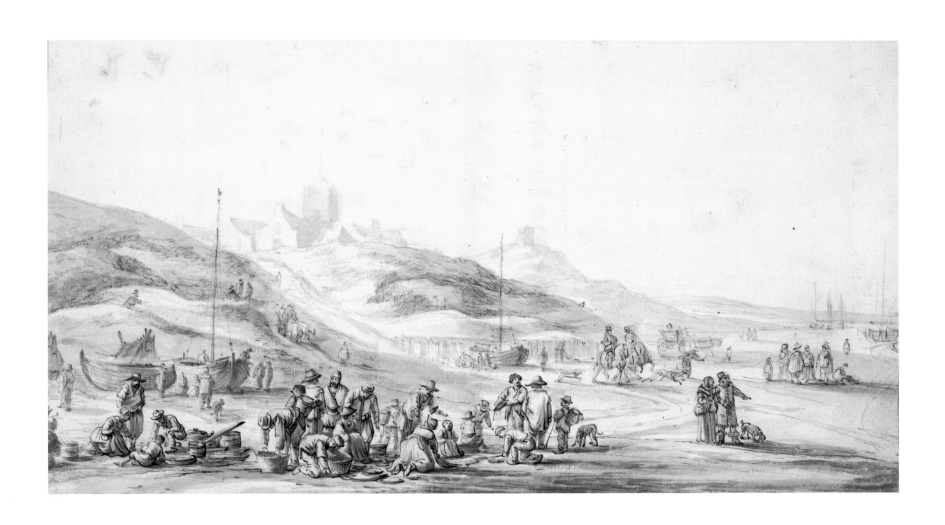

Cornelis Hendricksz. Vroom

Haarlem (?) 1591/92–1661 Haarlem

70 *Trees behind a Wooden Fence,* 1638/42

71 *Wooded Road with Two Horse-Drawn Carts,* 1638/42

72 *Wooded Country Road with a Traveler,* 1638/42

CAT. NO. 70

Pen and brown ink, brown wash

28.8 x 30.2 cm

INSCRIBED AT LOWER CENTER: "vroom" and "VROOM"

PROVENANCE: Duke Albert von Sachsen-Teschen

INV. NO. 8168

BIBLIOGRAPHY: Schönbrunner and Meder 1896–1908, vol. 7, no. 843, illus.; Wurzbach 1906–11, vol. 2, p. 833; Rosenberg 1928a, p. 110, no. B 9; Rosenberg 1928, pl. XIV, fig. 23; Simon 1930, p. 12; Henkel 1931, p. 53; Benesch 1964, no. 167, illus.; Keyes 1975, vol. 2, no. D 36, fig. 54, pp. 88, 90–91; Vienna 1993, no. 18, illus.; New York/Fort Worth 1995, no. 16, illus.

CAT. NO. 71

Pen and brown ink, brown wash, watercolor; cut at right, partially overlapping edges laid down, resulting in slight shift in image

36.7 x 31.7 cm

INSCRIBED AT LOWER LEFT: "CVROOM"

PROVENANCE: C. Ploos van Amstel (Auction Amsterdam, March 3, 1800, no. E 43); Ph. van der Schley; Duke Albert von Sachsen-Teschen

INV. NO. 8167

BIBLIOGRAPHY: Schönbrunner and Meder 1896–1908, vol. 1, no. 115, illus.; Rosenberg 1928, p. 110, no. B 9; Simon 1930, p. 12; Henkel 1931, p. 53; Vienna 1936, no. 12; Keyes 1975, vol. 1, pp. 88–91, vol. 2, no. D 35, fig. 51, p. 220, under no. D 21; Vienna 1993, no. 16, illus.; New York/Fort Worth 1995, no. 14, illus.

CAT. NO. 72

Pen and brown ink, brown wash, watercolor; sheet horizontally cut in two above center; overlapping edges laid down and retouched

36.5 x 31.1 cm

PROVENANCE: C. Ploos van Amstel (Auction Amsterdam, March 3, 1800, no. E 44); Ph. van der Schley; Duke Albert von Sachsen-Teschen

INV. NO. 8166

BIBLIOGRAPHY: Schönbrunner and Meder 1896–1908, vol. 1, no. 114, illus.; Rosenberg 1928, p. 110, no. B 8; Simon 1930, p. 12; Henkel 1931, p. 53; Vienna 1936, no. 10; Bernt 1957–58, vol. 2, no. 668; Keyes 1975, vol. 1, pp. 88–91; vol. 2, no. D 34, fig. 52; Vienna 1993, no. 17, illus.; NewYork/Fort Worth 1995, no. 15, illus.

Cornelis Hendricksz. Vroom was the son of the marine painter Hendrick Cornelisz. Vroom.[1] At first he specialized, like his father, in marine painting, but beginning in the early 1620s, his main interest shifted to the landscape. In the first decades of the seventeenth century, Haarlem was the center of the new realism in landscape art, and the first tonal experiments were begun by young artists with artistic roots in Haarlem: Esaias van de Velde (cat. nos. 13–16), Jan van Goyen (cat. nos. 17–20), and Pieter Molyn. In the early 1620s, these artists exchanged the pen for black chalk, which they innovatively employed in the rendering of atmospheric qualities. Vroom, on the other hand, remained true to the pen and thereby continued the Haarlem drawing tradition of around 1600, which had been shaped by Hendrick Goltzius, Jacques de Gheyn II, and not least by his father, Hendrick Cornelisz.

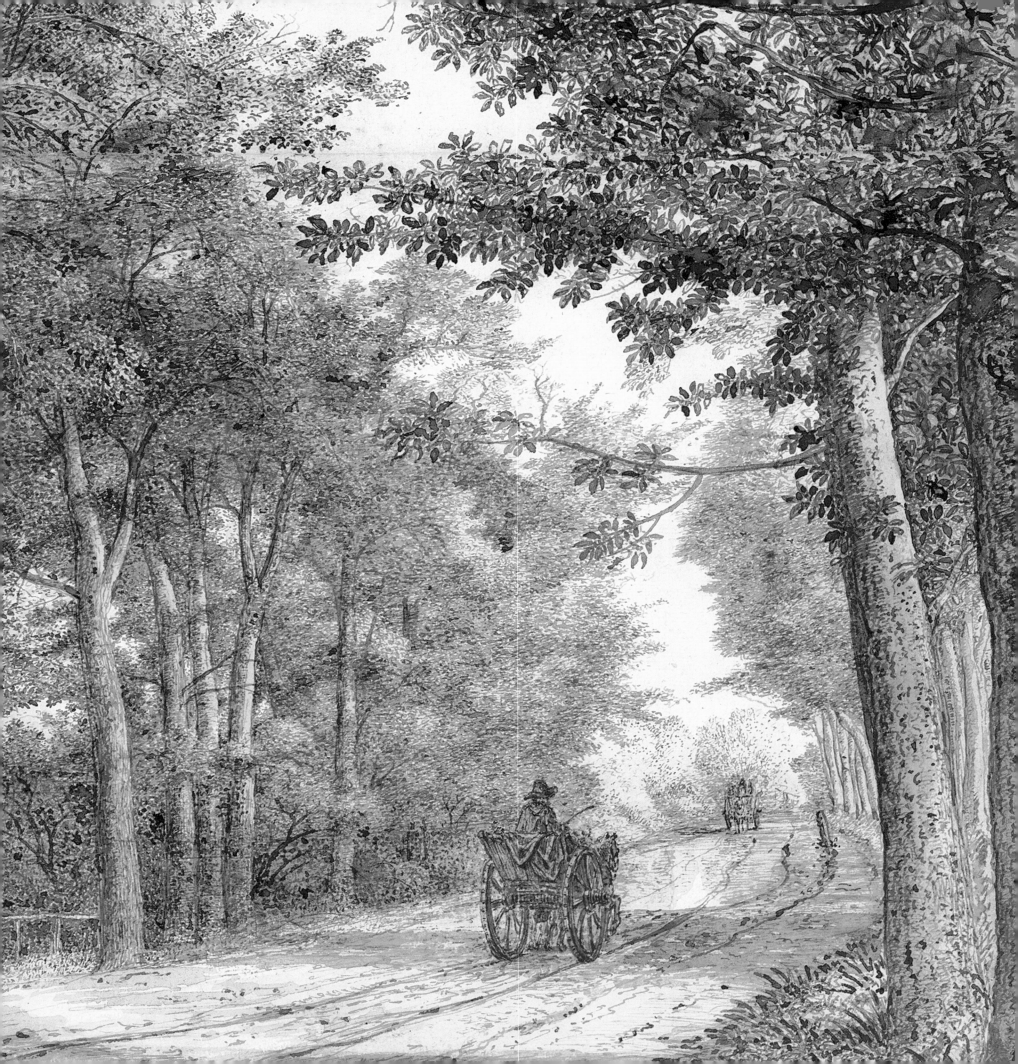

Vroom. His approximately twenty-five meticulously executed, finely detailed drawings display a highly individual character and occupy a prominent position in seventeenth-century landscape art. A renowned artist in his time, Vroom was commissioned by the stadtholder Frederick Hendrik and his court in The Hague and considerably influenced his younger contemporaries such as Jacob van Ruisdael. Nevertheless, after his death, he was forgotten for a long time.

Vroom's landscape drawings are highly finished, autonomous works that display no direct correlation to his paintings. The three Albertina sheets, which are among his most impressive examples, originated between 1638 and 1642 and correspond to a phase in his development that is characterized by a tendency toward full, monumental forms, despite their detailed rendering. *Trees behind a Wooden Fence* (cat. no. 70) evidences a certain originality in the artist's selection of the motif: a simple section of forest becomes the object of an intense examination of sunlight filtering through a delicate network of leaves. The close view of the emphatically rendered fence demonstrates the artist's sharp eye for unvarnished realism, which poses a unique contrast to the poetry of the subtly arranged weaving of leaves. The minute detail of the foliage applied with a pen and brush merges into increasingly pointillistic structures in the background, in no way contradicting the overall meditative, monumental effect.

The two other drawings (cat. nos. 71, 72), which were apparently conceived as pendants, are highly valued for the rarity of the subtle combination of watercolor and complex, finely detailed structures.[2] In both compositions, a road opens up to its full width and leads directly to a vanishing point that is set very low. Visible reality is exaggerated through abstraction: the towering trunks of the trees in *Wooded Road with Two Horse-Drawn Carts* (cat. no. 71) are smooth and straight and stand in columnar order. The foliage is made up of countless minute dots and dashes that vary in size depending on their distance from the viewer; only the leaves in the foreground are rendered as individual forms. The result is a shimmering, nearly impressionistic effect, in which the light filters through the thick foliage in *Wooded Road with Two Horse-Drawn Carts* and floods a large part

of the landscape in *Wooded Country Road with a Traveler* (cat. no. 72). Separate from the spectacular developments in Dutch landscape art, Vroom created a masterful oeuvre that is nevertheless equal in every way to the achievements of the famous pioneers.

1 For comprehensive information on Vroom's life and work, see Keyes 1975.

2 Another example that includes more watercolors is located in London, British Museum, Department of Prints and Drawings. See Keyes 1975, D 21. This loosely drawn, openly constructed landscape appears to have been created at a later date. See also the watercolor drawing *Farmstead at a Canal* (Berlin, Kupferstichkabinett), Berlin 2002, no. 53, illus., as an original work by Vroom, dated c. 1625–30.

Anthonie Waterloo

Lille 1609–1690 Utrecht

73 *The Hermannshof Inn near Danzig-Langfuhr,* c. 1660

74 *Heiligenbrunner Spring near Hermannshof near Danzig-Langfuhr,* c. 1660

CAT. NO. 73

Black chalk, brush and gray ink, gray wash, white bodycolor

44.3 x 57.3 cm

PROVENANCE: C. Ploos van Amstel (Auction Amsterdam, March 3, 1800, Kunstboek R no. 2); Ph. van der Schley; Duke Albert von Sachsen-Teschen

INV. NO. 15147

BIBLIOGRAPHY: Stubbe 1983, pp. 150ff., p. 183, pl. 53; Vienna 1993, no. 65, illus.; New York/Fort Worth 1995, no. 56, illus.

CAT. NO. 74

Black chalk, brush and gray ink, gray wash

44 x 57.3 cm

PROVENANCE: C. Ploos van Amstel (Auction Amsterdam, March 3, 1800, Kunstboek R no. 3); Ph. Van der Schley; Duke Albert von Sachsen-Teschen

INV. NO. 15148

BIBLIOGRAPHY: Stubbe 1983, pp. 148ff., p. 183, pl. 52

Anthonie Waterloo, whose training is not documented, excelled above all as a draftsman and etcher.[1] He was related on his mother's side to the Vaillant family, who were renowned for their engravings. Waterloo is primarily known for his carefully rendered drawings of topographical views, forest motifs, and panoramic landscapes. Extended trips through the lower Rhine region near Arnhem and Rhenen as well as through northern Germany to present-day Poland provided the impulse for these works. The significant holdings of drawings by this artist in several historic collections, including the Albertina, are a testament to how highly Waterloo's work was valued in the eighteenth and nineteenth centuries.

During his journey in northern Germany around 1660, the artist focused on two areas that are distant from one another. Most of the views from this trip were produced in Hamburg and its environs, in Holstein, and in the city of Lüneburg. A small group of eleven sheets depicts motifs from the area near Danzig and the neighboring Oliwa monastery.[2] The two present large sheets belong to this latter group.

The subject of the drawing *The Hermannshof Inn near Danzig-Langfuhr* (cat. no. 73) was identified only in recent times; in the old inventory, it was described as "hostelerie près de Danzig" ("inn near Danzig"). The other drawing (cat. no. 74) depicts the "Heiligenbrunn" ("Holy Spring") that lies near the Hermannshof estate. In both images, majestic trees fill the sheet, towering over the focal subject of the drawing. Waterloo's virtuoso handling of his preferred media—black chalk and brush and gray ink—is exemplary in these works. The artist worked in stages from the lighter, broadly painted areas to the fine nuances he added in brush and chalk; in cat. no. 74, the white surface of the paper is particularly integrated for its tonal value. Various materials and surface values are clearly differentiated from one another:

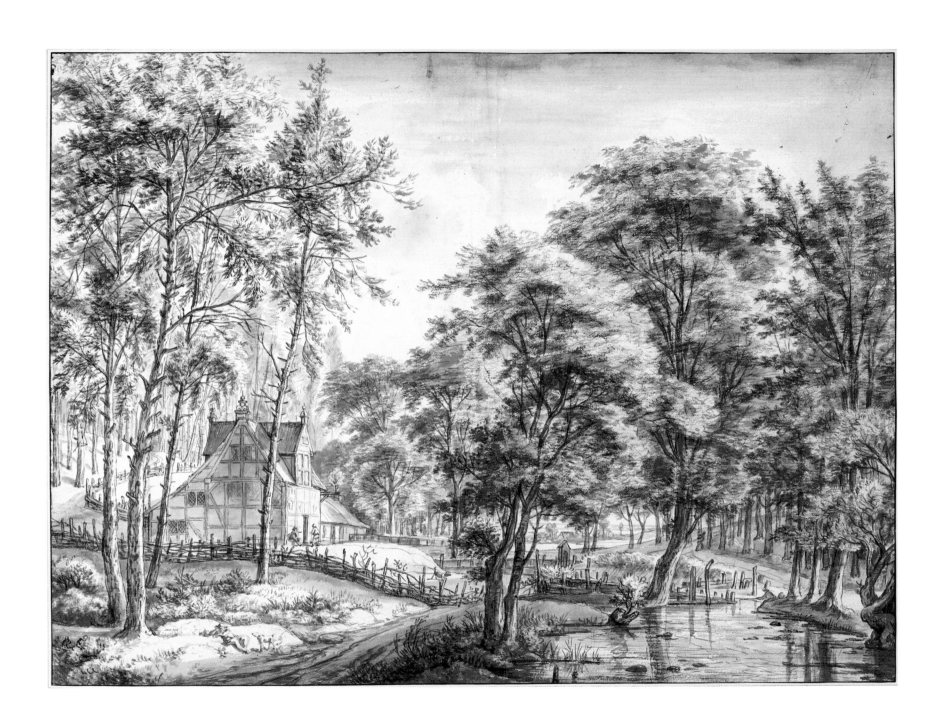

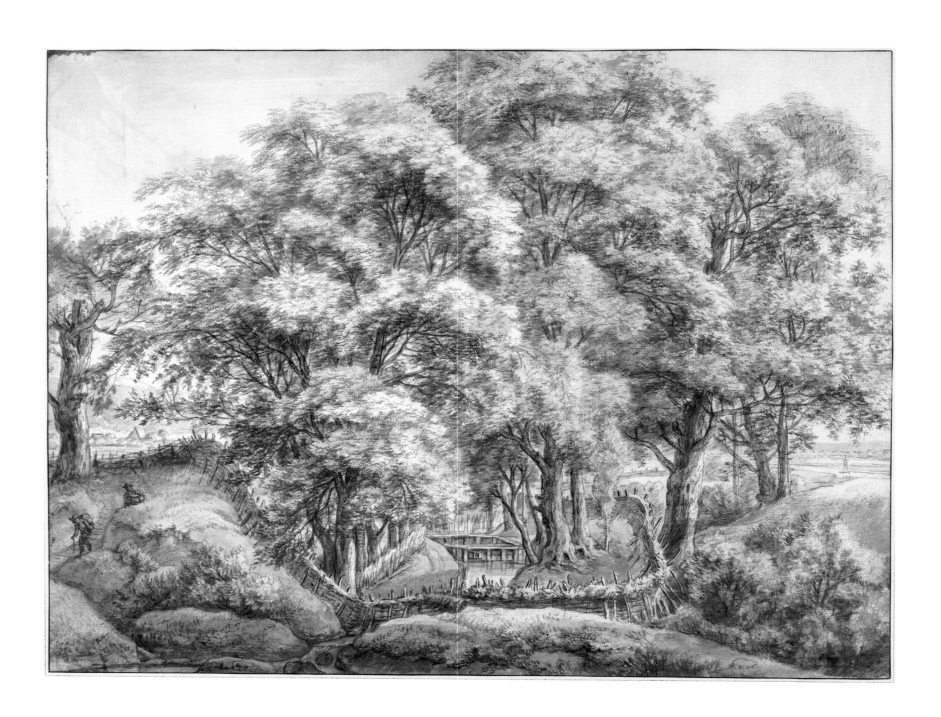

the artist convincingly represented the various textures of the surfaces of walls, water reflections, and the finely structured foliage. Added to this is the effect of the lively play of reflecting sunlight as it filters through the trees, lending a particular brilliance to the large-format views. Beyond the objectively defined, detail-oriented rendering, in both cases, the artist clearly worked to integrate his subjects into their natural environment in an atmospheric manner.

1 For biographical information on Anthonie Waterloo, see Peter Morse in Bartsch,
 The Illustrated, vol. 2, Commentary, 1992, pp. 1–5.

2 Stubbe 1983, p. 12.

Anthonie Waterloo

Lille 1609–1690 Utrecht

75 *Two Gnarled Trees,* after 1660

Charcoal, saturated with linseed oil, brush and gray ink, ocher and yellow watercolor, white, yellow, and brown chalk, on gray paper

35.2 x 28 cm

PROVENANCE: Duke Albert von Sachsen-Teschen

INV. NO. 9350

BIBLIOGRAPHY: Vienna 1993, no. 67, illus.; New York/Fort Worth 1995, no. 58, illus.

Representations derived from observation in nature or oriented on topographically identifiable motifs form the predominant share of Anthonie Waterloo's landscape drawings, in which light defines surface values with particular intensity. A small, distinct group of drawings in vertical format depicts close views of trees or groups of trees that display an imaginary character. An essential feature of these works, which are difficult to date, is the complex technique that sets them apart from the works by Waterloo in the drawing media he most commonly used: black chalk and brush and gray ink.[1]

The present drawing is an outstanding example of this special category. Most sheets in the group include a fence, a bridge, or other landscape elements. The present composition, however, focuses solely on the central motif of the vital, living tree and contrasts it strikingly with the dark, heavy stump with its obstructing branches in the foreground. The almost surreal light that penetrates the thickly interwoven branches and leaves is an effect that stems, above all, from the artist's unorthodox technique. Here and in this group as a whole, Waterloo used different colors of media and types of prepared paper. In the present drawing on gray paper, the artist worked layer by layer in a combined painting and drawing technique. Using a brush, he applied a mysteriously shimmering background in ocher and numerous tonal gradations of gray, supplemented with fine, short strokes in white and yellow chalk. In deep black charcoal saturated with linseed oil, Waterloo added the contours, interior drawing, and shaded areas of the trees; some of the leaves have been highlighted with accents applied by brush.

Thematically, the sheet appears to relate—if only loosely—to a type of image that derived from the work of Pieter Bruegel and was cultivated in the Netherlands in the early seventeenth century by Flemish artists such as Roelant Savery.[2] Typically, these were emphatic representations of individual, closely viewed arrangements of single trees or groups of trees with dramatically gnarled trunks and heavy roots. The symbolic "dialogue" between the living and the old or dead tree often plays an essential role in these images.

1 Examples of this group are mentioned in Vienna 1993, p. 122, n. 1, and New York/Forth Worth 1995, p. 124, n. 1.

2 Relevant examples by Roelant Savery are mentioned in Vienna 1993, p. 122, n. 3, and New York/Fort Worth 1995, p. 124, n. 3.

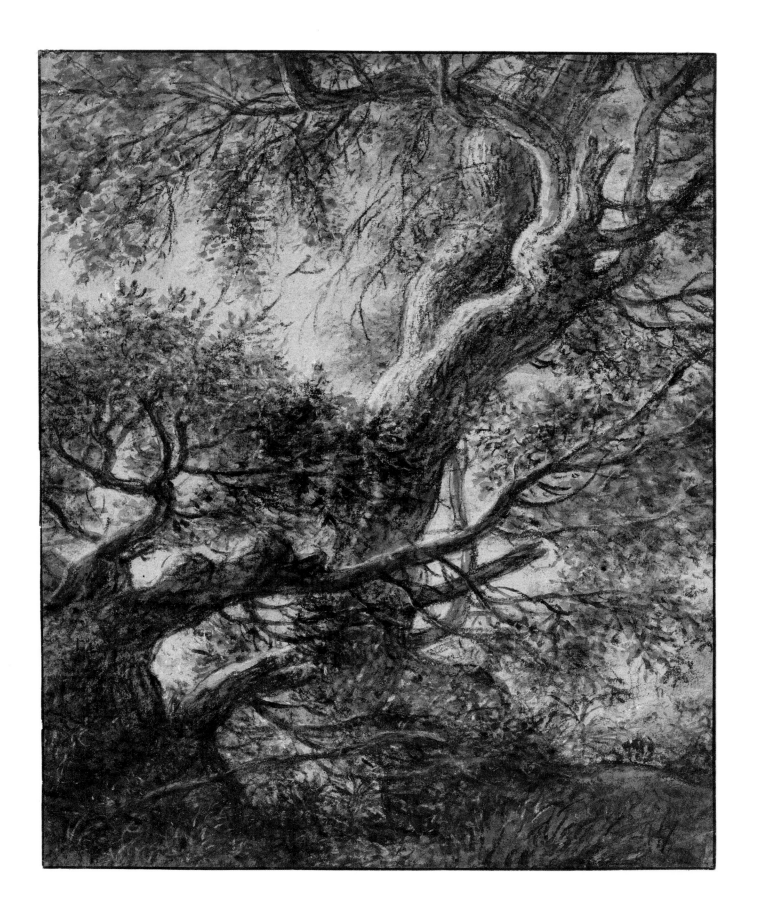

Joris van der Hagen

ARNHEM (?) 1613/15–1669 THE HAGUE

76 *In the "Haagsche Bos,"* 1658

Black chalk, black oil crayon, brush and brown ink, on gray-brown paper

41.1 x 53.9 cm

INSCRIBED AT CENTER LOWER EDGE: "Dit is int bo(sch) buyte Den Haegh Anno 1658 JH" ("JH" joined; the date traced over by a later hand); inscribed at lower right by a later hand: "Hagen"

PROVENANCE: Duke Albert von Sachsen-Teschen

INV. NO. 15132

BIBLIOGRAPHY: Vienna 1936, no. 70; Benesch 1964, no. 197, illus.; Vienna 1993, no. 69, illus.; New York/Fort Worth 1995, no. 60, illus.

Presumably Joris van der Hagen apprenticed in Arnhem with his father, Abraham van der Hagen. In 1639, he moved to The Hague, where he cofounded the confraternity "Pictura."[1] Van der Hagen is known as a painter and draftsman of landscapes that he studied locally and on trips through the lower Rhine region and in the environs of Kleve. The influences of Jacob van Ruisdael and the Italianizing artists are evident in van der Hagen's comprehensive oeuvre of paintings and drawings. It is notable that Arnold Houbraken valued the drawings of his contemporary van der Hagen more highly than his paintings.[2]

The "Haagsche Bos," a natural area near the city, was noted for its tall, old trees. In addition to van der Hagen, artists such as Roelant Roghman (cat. nos. 85, 86), Simon de Vlieger (cat. no. 69), and Anthonie Waterloo (cat. nos. 73–75) created many scenes of the region, often on large-format sheets.[3] The present characteristic, high-quality example of this type depicts a spacious forest scene, a subject popular around the mid-seventeenth century.

Van der Hagen captured the "Haagsche Bos" in some twenty drawings dated between 1653 and 1669. Most of these were drawn on blue paper; the gray-brown paper of the present drawing is less common.[4] The combination of a generous, overall approach and a careful, meticulous working procedure is characteristic for van der Hagen and links his work to that of Waterloo. In the present drawing, which is dated 1658, the fine details of the foliage are applied over larger, flat forms. Accents in black oil crayon add differentiation, increased by the coarse texture of the paper. The long diagonal shadows in the foreground combined with the distant backdrop of perspectively diminutive trees emphasize the broad spaciousness of the scene. This intimate fragment of landscape is animated by the lively play of subtle nuances of light and dark—from the muted daylight filtering through the foliage of the trees and the bright strips of sunlight in the shadows on the ground, to the diffuse transparency of the distant backdrop of trees. The horse and carriage in the middle ground of this intimately observed yet monumental forest scene further emphasize the expanse of space.

1 For the biography of Joris van der Hagen, see van der Haagen 1932, pp. 16–22.

2 Houbraken 1753, vol. 3, p. 203.

3 Regarding this technique, see Munich/Bonn 1993, p. 188, under no. 72 (with more extensive bibliography).

4 See Vienna 1993, p. 126, n. 4, and New York/Fort Worth 1995, p. 128, n. 4.

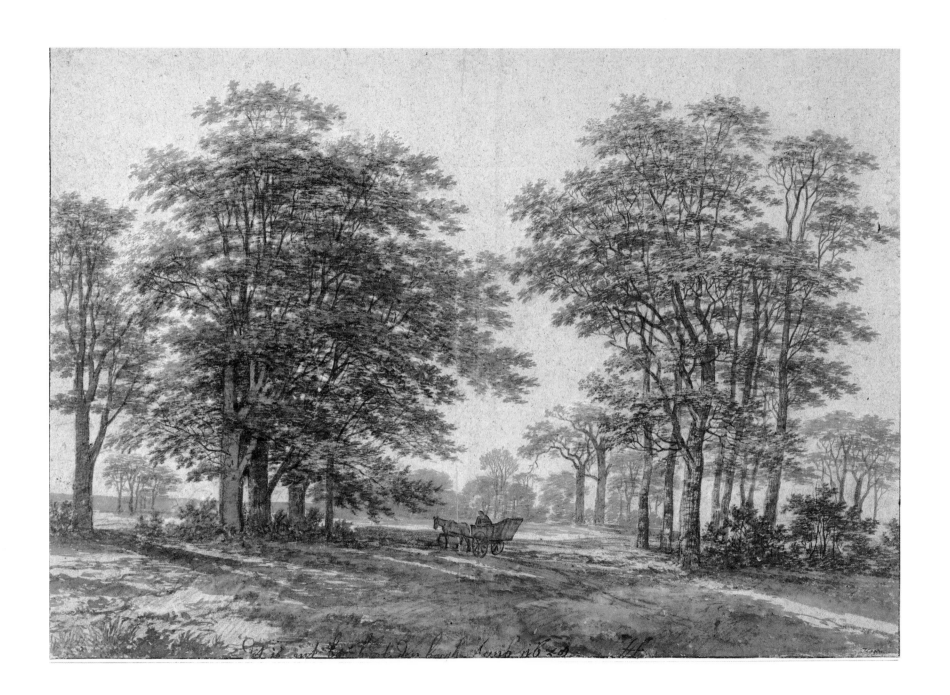

Allart van Everdingen

ALKMAAR 1621–1675 AMSTERDAM

77 *Log Cabins on a Stream in Scandinavia,* c. 1644 or later

78 *View of a Village with a Flogging Scene,* c. 1660

CAT. NO. 77

Brush and pen and brown ink, brown and gray washes, over black
chalk

19.4 x 17.1 cm

MONOGRAMMED AT LOWER RIGHT: "A.V.E."; inscribed at upper right: "373"
(by another hand)

PROVENANCE: (probably) A. Weigel; Rost sale in Leipzig on January 21,
1795, p. 485, no. 5650; Duke Albert von Sachsen-Teschen

INV. NO. 9581

BIBLIOGRAPHY: none known

CAT. NO. 78

Brush and brown and gray-brown ink, watercolors, over graphite

15 x 23.2 cm

MONOGRAMMED AT LOWER LEFT: "A V E"

PROVENANCE: Hendrik Busserus, Amsterdam; Sale Busserus 1782, pp.
133–34, no. 19.1240; Jan van Dijk, Amsterdam; Sale van Dijk 1791,
pp. 46–47, no. B.18; David Heemskerk; Duke Albert von Sachsen-
Teschen

INV. NO. 17541

BIBLIOGRAPHY: Davies 1978, p. 241, fig. 341; Davies 2001, p. 141, fig. 164

Allart van Everdingen was the son of a notary and the brother of the
history painter Cesar van Everdingen (1616/17–1678). According to
Houbraken, Allart apprenticed in Utrecht with Roelant Savery (cat.
nos. 3, 4) and in Haarlem with Pieter Molyn.[1] In 1639, he moved from
Haarlem to his birthplace, Alkmaar. His stay on the southeast coast
of Norway and Sweden in the Gothenburg area is documented in a
small group of watercolors, one of which is dated 1644.[2] He remained
in Scandinavia as late as the beginning of 1645; in February of that
year, he was married in Haarlem. In 1652, van Everdingen moved to
Amsterdam, where he lived with his wife and numerous children
until his death. Two of his sons became painters like their father. As a
painter, draftsman, and etcher, van Everdingen treated marine themes,
Netherlandish landscape motifs, and, above all, the Scandinavian land-
scape, making him in seventeenth-century Netherlandish art the single
northern counterpart to the numerous artists who traveled to Italy.
Like the Italianizing artists, he was inspired for decades by his travel
experiences and the drawings and watercolors he created on site.

Log Cabins on a Stream in Scandinavia (cat. no. 77) represents
van Everdingen's extensive group of Scandinavian landscapes that
range from his earliest on-site drawings to late compositions from
the imagination, which came to include more and more Netherlandish
motifs.[3] Many of his drawings relate directly to his etchings, but very
few can be linked to his paintings.[4] Most of these autonomous, highly
finished sheets are signed, though only two are dated.[5] According to
Alice Davies, the present work was produced in the 1640s, perhaps
even during van Everdingen's stay in Scandinavia in 1644.[6] In its objec-
tive execution—for example, in the crisp linear description of the
log buildings—the sheet compares well to the drawing *Waterfall and
Sawmill* at Mölndal, which was produced in Risör, Norway in 1644.[7]

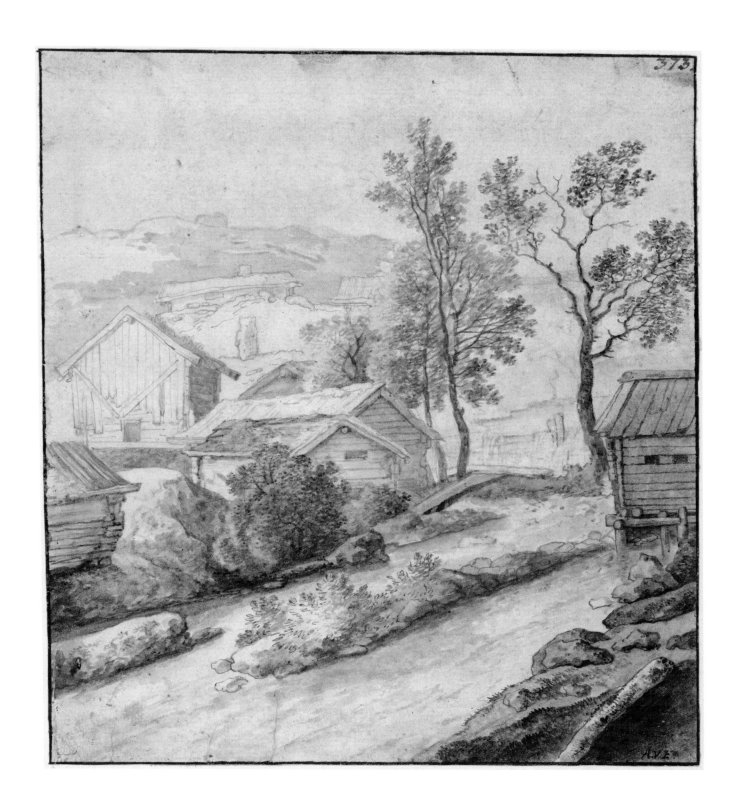

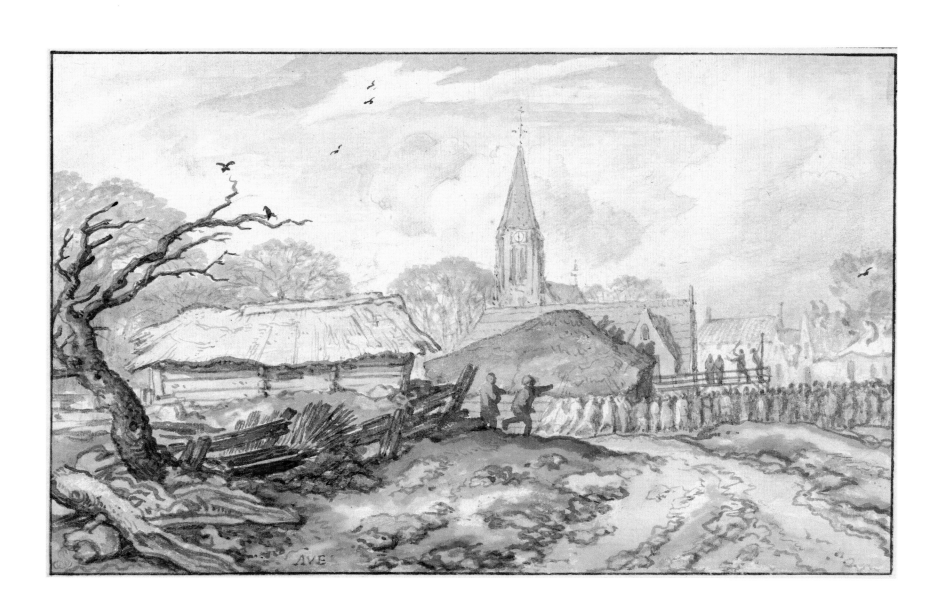

If the drawing dates to a time during or shortly after his Scandinavian trip, its vertical format notably anticipates the artist's vertical paintings, which originated, for the most part, beginning in 1650, though the earliest is dated 1648.[8] Two additional pendant watercolors in Hamburg and Paris relate to the Vienna drawing in theme, format, and subtle execution, though they were produced significantly later.[9]

Van Everdingen's preference for the non-Netherlandish, for landscapes distinguished by wild waters and rocky cliffs, can be traced back to the influence of Savery, who in the early seventeenth century had devoted himself to the Tyrolean mountain landscape in drawings that include watercolor.[10] Even van Everdingen's subtle style of recording in drawing and watercolor in the early Scandinavian drawings relates to the "from life" character of Savery's Tyrolean views.

The drawing *View of a Village with a Flogging Scene* (cat. no. 78), presumably from around 1660, belongs to the category of Netherlandish landscape motifs, mostly produced from the imagination, though they recall studies from life. What appears at first to be a harmless, even cheerful scene, actually depicts a public flogging. The artist schematically rendered the large crowd of eager on-lookers, brightly illuminating some of the figures and capturing the group's push toward the platform, where the main figures are clearly defined as dark silhouettes. As in early realistic landscape drawings by, for example, Esaias van de Velde (cat. nos. 13–16), a path opens in the foreground to lead the viewer's gaze gently upward to the middle ground; the green-brown-blue scheme of the layers of space recalls Flemish examples. The motif of the flogging scene as well as the related vanitas symbolism of the dark, bare tree and the silhouettes of the crows in the foreground are very rare in van Everdingen's work.[11] The harmonious integration into the village environment of a crowd of figures arranged parallel to the picture plane recalls the numerous scenes of kermiss and fairs that Jan van Goyen (cat. nos. 17–20) drew predominantly in the 1650s. The subject and its presentation bring to mind Jacques Callot's much more severe etchings of the horrors of war.[12]

1 Houbraken 1753, p. 94. Regarding the life of Allart van Everdingen, see Davies 2001, pp. 15–39. I would like to thank Alice Davies most heartily for her willingness to share unpublished information on the present drawings by van Everdingen, including the extensive provenance details.

2 *Risör*, watercolor, 19 x 29 cm, Arendal, Aust-Agdar-Museet. See Davies 2001, p. 45, fig. 13.

3 Regarding van Everdingen's drawings, see ibid., pp. 45–47.

4 Ibid., p. 46.

5 The two dated drawings with watercolor: *Risör* (note 2) and *Two Travelers in a Mountain Landscape* (1656; London, British Museum, Department of Prints and Drawings). See ibid., p. 45, fig. 32.

6 Alice Davies, written communication to the author, March 17, 2005.

7 Ibid.; see Davies 2001, p. 135, fig. 17 (*Watermill and Sawmill at Mölndal*, pen and brush and brown ink, white bodycolor, over black chalk, 19.7 x 19.4 cm, Mölndal, Mölndal Konsthall).

8 Alice Davies, written communication to the author, February 10, 2005. Davies 2001, pp. 95, 96, no. 34. For this painting dated 1648 in Hanover, Niedersächsisches Landesmuseum, van Everdingen used the drawing of a cabin that he produced in Scandinavia in 1644. See Davies 2001, p. 96, fig. 22.

9 Davies (note 6). *Nordic Landscape with Wooden House on a Weir*, Hamburg, Hamburger Kunsthalle (Davies 2001, fig. 149) and *Scandinavian Landscape with a Wooden House*, Paris, Institut Néerlandais, Fondation Custodia, Collection Frits Lugt. See Davies 2001, fig. 150.

10 Davies 2001, p. 25.

11 Davies 1978, p. 241, fig. 341; Davies 2001, p. 141, fig. 164.

12 The cycle of etchings *Les Grandes Misères de la guerre* (published 1633) and *Les Petites Misères de la guerre* (published 1636).

Herman Saftleven

ROTTERDAM 1609–1685 UTRECHT

79 *Dunes with a Village and a View of the Sea,* 1650

Black chalk, brush and brown ink, brown wash

22.1 x 28.1 cm

Monogrammed and inscribed at lower right (in ink): "HSL 1650" ("HSL" joined); inscribed at upper left: "35" (?)

PROVENANCE: G. Winckler; Duke Albert von Sachsen-Teschen

INV. NO. 9061

BIBLIOGRAPHY: Schulz 1982, no. 801; Vienna 1993, no. 86, illus.; New York/Fort Worth 1995, no. 76. illus.

Herman Saftleven apprenticed in Rotterdam and remained there during the early years of his artistic career. His father, Herman, and his brothers, Abraham and Cornelis, were also painters.[1] Cornelis, like his brother Herman, is noted, above all, for his impressive oeuvre of drawings. Few drawings exist by Herman Saftleven from before 1648. His earliest landscape etchings, which are dated 1627, clearly reveal the influence of Willem Buytewech, who died in 1624 but whose art continued to resonate strongly after his death. Around 1630, Saftleven investigated the tonal experiments of Jan van Goyen (cat. nos. 17–20) and Pieter Molyn in his paintings. His subsequent move from Rotterdam to Utrecht in 1632 signified a great change in Saftleven's life as well as in his artistic development. He achieved great stature in society and, under the influence of Roelant Savery (cat. nos. 3, 4), who also lived in Utrecht, shifted the main focus of his work to imaginary river and mountain landscapes.

The motif of the present dune landscape, which is dated 1650, is a rarity in Saftleven's drawings.[2] Most of his coastal and harbor scenes include steep cliffs and are imaginary in character. This type of realistic Dutch dune landscape with a view of the sea corresponds to the beach and dune landscapes by Salomon van Ruysdael and van Goyen. In the early 1630s in Rotterdam, Saftleven is known to have painted a coastal landscape with a similarly low horizon line, a pronounced contrast between near and far, and shifting light effects that call to mind early realistic examples by van Goyen and Molyn.[3]

The present dune landscape, created roughly twenty years later, is actually distinguished by a unique paradox: a relatively new, realistic way of representation combines with a retrospective approach in the artist's working methods. The elevated perspective and careful hatching lines in chalk and brush that describe the increasingly faint layers of the receding landscape recall the earlier tradition of Pieter Bruegel and his followers. The pervasive detail in the rendering of the houses, church, ships, and figures also recalls an earlier landscape tradition. On the other hand, the captivating description of the heavy masses of clouds and the light effects that create mood and bold highlighting would be unthinkable without the influence of van Goyen and other contemporaries.

1 For more recent literature on the life and work of Herman Saftleven, see Schulz 1982, pp. 1–48.

2 An additional drawing of a Dutch coastal landscape in the Albertina collection corresponds in format, date, and provenance to the present work (inv. no. 9072; Schulz 1982, no. 800).

3 Rotterdam, Museum Boijmans Van Beuningen; see Bol 1969, pp. 183–84, fig. 176; Schulz 1982, no. 258, fig. 3.

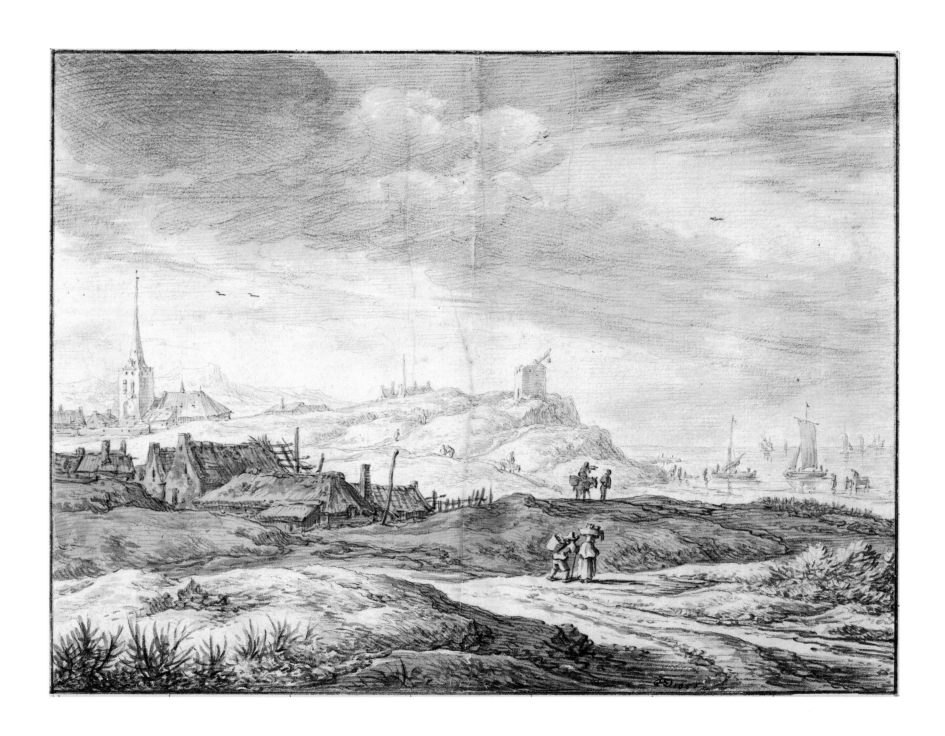

Herman Saftleven

ROTTERDAM 1609–1685 UTRECHT

80 *Mountainous Landscape on the Rhine,* c. 1677

Black chalk, gray-brown wash, brush and brown ink

49.6 x 60.8 cm

PROVENANCE: G. Winckler; Duke Albert von Sachsen-Teschen

INV. NO. 15140

BIBLIOGRAPHY: Schulz 1982, no. 1163

Presumably Herman Saftleven undertook a trip along the Rhine at the beginning of the 1650s. From the sketches he produced on this journey, he prepared thirty-seven drawings for the *Atlas Blaeu/ van der Hem* in the early 1660s.[1] The force behind this extensive project was the Amsterdam lawyer Laurens van der Hem (1621–1678), who commissioned a large number of Netherlandish artists to draw topographical views in various European countries. In addition to Saftleven, these artists included Lambert Doomer (cat. no. 81), Jacob Esselens, Frederick de Moucheron, Jan Hackaert, and many others. The works of these artists, who subsequently often prepared new versions from their travel sketches, were integrated, together with additional sheets from van der Hem's collection, into the eleven-volume *Atlas Blaeu* completed in 1662. This collection, which is unique in scope and quality, grew to forty-five volumes and was acquired in 1730 by Prince Eugene of Savoy (1663–1736). After his death, the collection went to the Hofbibliothek (today the Nationalbibliothek) in Vienna.

Inspired by his earlier views of the Rhine, Saftleven produced a number of "Rhine fantasies" in the 1670s. A few of these works, including the present drawing, are dated 1677.[2] This type of imaginary landscape can be traced back to the tradition of Pieter Bruegel (c. 1528–1569); characteristic elements are the bird's-eye perspective, the dramatic height differences, and the dense alternation of steep cliffs, trees, and fortresses. The formula of the silhouettelike rendering of the foreground, which is animated by a traveler and his dog, is also traditional. These conventional treatments are accompanied by the combination of the evenly articulated, careful hatching in chalk and brush and the large format. Here, the work of Saftleven's earlier master, Roelant Savery (cat. nos. 3, 4), was undoubtedly still influential.

These detailed, highly finished imaginary landscapes must have been very popular in the late seventeenth century; one may also refer in this context to the late drawing by Nicolaes Berchem, *Imaginary Rocky Landscape with a Castle and Hunters* (cat. no. 103).

1 Schulz 1982, pp. 75–79.

2 Ibid., p. 95.

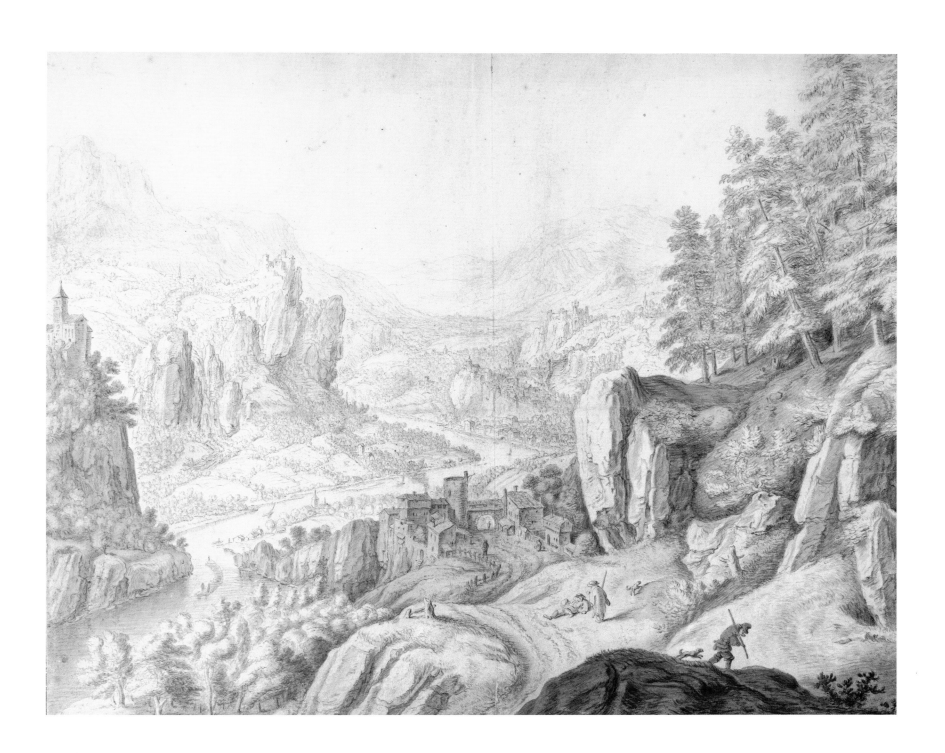

Lambert Doomer

AMSTERDAM 1624–1700 AMSTERDAM

81 *Village Street with a Barn,* early 1660s

Pen and brown ink, brown and brown-gray wash

13 x 25.9 cm

PROVENANCE: Duke Albert von Sachsen-Teschen

INV. NO. 9030

BIBLIOGRAPHY: Hofstede de Groot 1906, no. 1482; Schönbrunner and Meder 1896–1908, no. 496, illus.; Lugt 1920, p. 149, illus.; Leporini 1928, p. 246, fig. 121; Benesch 1964, no, 181, illus.; Schulz 1972, pp. 48, 226, no. 29; Schulz 1974, pp. 18, 20, 44, no. 27, fig. 16; Sumowski 1979–92, vol. 2, no. 482, illus.; Vienna 1993, no. 52, illus.; New York/ Fort Worth 1995, no. 44, illus.

Lambert Doomer worked in Amsterdam and Alkmaar as a painter and draftsman. He was the son of the framemaker Herman Doomer, whose portrait Rembrandt painted in 1640. He may have apprenticed with Rembrandt around 1644–45.[1] During a trip through France in 1645–46, Doomer drew numerous topographical views. He also produced historical and genre scenes, portraits, and figure and animal studies, in addition to a number of unidentifiable Netherlandish architectural motifs.

In this drawing, Doomer appears to refer to several of Rembrandt's different stylistic phases; he is known to have owned Rembrandt drawings, which he also copied.[2] The forceful lines and dramatic chiaroscuro effects recall Rembrandt's pen and wash style of the 1630s; at the same time, the parallel strokes of the foliage are reminiscent of Rembrandt's drawing style from the 1650s. Nevertheless, despite its affinities to Rembrandt, *Village Street with a Barn* presents an original and qualitatively outstanding solution, with a surprising "peep-hole" effect. Characteristic of Doomer are the schematic figures

drawn in the landscape, including the seated figure depicted at the right edge of the road.

At the time of its acquisition through Duke Albert, the founder of the Albertina, the drawing was considered to be a work by Lambert Doomer. In a roundabout way—for a time the sheet was assigned to Rembrandt's oeuvre—the drawing has now been returned to its initial attribution and is thought to have originated in the early 1660s.[3]

1 The supposition by Schulz and Sumowski that Doomer apprenticed with Rembrandt is disputed by Schatborn (1977), who believes that Doomer was not influenced by Rembrandt until after he acquired drawings by the artist in 1657–58. See Sumowski 1979–92, vol. 2, p. 788; Vienna 1993, p. 92, n. 1; and New York/Fort Worth 1995, p. 96, n. 1.

2 See note 1.

3 For a summary of the various attributions, see Vienna 1993, no. 52, illus., and New York/ Fort Worth 1995, no. 44, illus. Regarding the dating, see Sumowski 1979–92, vol. 2, no. 482, illus.

Johannes Leupenius

AMSTERDAM C. 1646/47–1693 AMSTERDAM

82 *Group of Trees on the Water,* 1665

Pen and brown ink, brown wash

19.3 x 31.4 cm

INSCRIBED AT LOWER RIGHT: "JLeupenius 1665/No 6"

PROVENANCE: Vienna, Hofbibliothek; Duke Albert von Sachsen-Teschen

INV. NO. 10105

BIBLIOGRAPHY: Schönbrunner and Meder 1896–1908, vol. 10, no. 1132, illus.; Bernt 1957–58, II, no. 59; Benesch 1964, no. 183, illus.; Chicago/Minneapolis/Detroit 1969–70, no. 190, illus.; Sumowski 1979–92, vol. 7, no. 1556, illus.; Vienna 1993, no. 53, illus.; New York/Fort Worth 1995, no. 45, illus.

It is presumed that Johannes Leupenius, a land surveyor and cartographer, apprenticed with Rembrandt around 1660. Approximately twenty-five drawings with landscape motifs are attributed to Leupenius. The present work, which is signed and dated 1665, is undoubtedly among the highlights of his small body of drawings. The contrast between the quiet motion of the water and the diagonal pull of the lines defining the foliage sets the tone of this light-flooded landscape. A building with a tower is visible through the trees at right. The pronounced horizontality, the short strokes that describe the foliage, and Leupenius's use of the untouched areas of the paper to impart light values recall Rembrandt's landscape drawings of the 1650s. A similarity to the drawing style of Jan Lievens is also evident, particularly in the short, diagonal strokes that capture the movement of the wind through the trees (cf. cat. no. 84).

This sheet was produced around the same time as the drawing *Nijenrode Castle on the Vecht* in the Rijksprentenkabinet, Amsterdam, which is signed in a very similar fashion and dated what appears to be 1665. The drawings strongly resemble each other in motif as well as execution.[1] The artist's command of the generous pen work and washes, combined with the lively effects of light and shadow, is impressive in both works. It is assumed that the Albertina drawing depicts an area on the picturesque and densely wooded banks of the Vecht River, where many castles and estates were located. Leupenius's interest in this region is also documented in a series of six etchings of castles and houses on the Vecht and Amstel rivers, which he made in 1668 and 1671.[2]

1 Schapelhouman and Schatborn 1987, no. 71, illus.; Sumowski 1979–92, vol. 7, no. 1555, illus.

2 Hollstein 1949– , vol. 10, pp. 54–55, nos. 1–6.

Philips Koninck

AMSTERDAM 1619–1688 AMSTERDAM

83 *Open Landscape with a Windmill and Houses,* early 1670s

Pen and brown ink, brown wash

9.8 x 18.3 cm

INSCRIBED IN GRAPHITE AT UPPER LEFT: "29"

PROVENANCE: S. Feitama (Auction Amsterdam, October 16, 1758, Portfol. I, no. 83); G. Winckler; Duke Albert von Sachsen-Teschen

INV. NO. 9358

BIBLIOGRAPHY: Wurzbach 1906–11, vol. 2, p. 325; Gerson 1936, pp. 36, 66, 147, no. Z. 82; Benesch 1964, no. 169; Sumowski 1979–92, vol. 6, no. 1511*, illus.; Vienna 1993, no. 55, illus.; New York/Fort Worth 1995, no. 47, illus.

Philips Koninck, who apprenticed with his older brother Jacob, lived in Amsterdam after around 1640. Although it is not certain whether he apprenticed with Rembrandt, the master's influence on Koninck's work became particularly evident beginning around 1645.[1] Koninck was a painter and draftsman of figural scenes and portraits, but his panoramic landscapes place him among the greatest talents of his time.[2] In their classical balance and tectonic severity, these works create an impression of total harmony of light, air, and space. The gentle curves of the landscape that compress as they recede into the distance ultimately merge with the horizon line, underscoring the sense of an endless expanse. This device in landscape composition is characteristic of his monumental paintings and his drawings, which often include watercolor.

In the present drawing, the broad curving path on the dike draws the eye into the scene and intensifies its spatial dynamic, with all lines of movement meeting at the windmill. Presumably the drawing was produced in the early 1670s, after the period when Koninck had created his greatest panoramic landscapes.[3] Nevertheless, the sheet is notable for its quality, and its commonalities with Rembrandt's landscape drawings cannot be overlooked. Koninck's lively, loose strokes and characteristic dashlike marks are reminiscent of Rembrandt's treatment of foliage in the early 1650s, when he was studying Titian's drawing techniques. The diagonal emphasis of the spatial dynamics brings to mind Rembrandt's landscape drawings of the 1640s. The lively division into areas of light and shadow and the summary notation of the windmill at the focal point of the image also recall the works of the older master. Typical of Koninck, however, is the punctuation of the horizon with briefly noted windmills and other unidentifiable structures that often appear simply as small rhythmically placed dots. Despite the diverse inspirations by Rembrandt, this drawing displays the unmistakable hand of Philips Koninck.

1 Gerson 1936, p. 10.

2 On the development of the panoramic landscape in seventeenth-century Netherlandish art, see Stechow 1966, pp. 33–49.

3 Regarding the dating, see Gerson 1936, pp. 36, 66, 147, no. Z 82, and Sumowski 1979–92, vol. 6, no. 1511*, illus. Regarding the similarity to the stylistically related drawing in the Museum der bildenden Künste in Leipzig, inv. no. MB 190, and the suggestion that the Albertina sheet may have been trimmed at the left edge, see Vienna 1993 and New York/Fort Worth 1995, no. 47.

Jan Lievens

Leiden 1607–1674 Amsterdam

84 *View of a Group of Houses Surrounded by Trees,* possibly c. 1670

Pen and brown ink on Japan paper

21.7 x 37 cm

INSCRIBED AT LOWER LEFT: "Jan Lievensze, de Jonge f. umtrent Ao. 1660."
(by an unknown hand)

PROVENANCE: Duke Albert von Sachsen-Teschen

INV. NO. 8907

BIBLIOGRAPHY: Wurzbach 1906–11, p. 62; Schneider 1932, pp. 241, 281, no. Z. 360; Ekkart in Braunschweig 1979, p. 31, no. 94, illus.; Sumowski 1979–91, vol. 7, no. 1737, illus.; Vienna 1993, no. 54, illus.; New York/Fort Worth 1995, no. 46, illus.

Like Rembrandt, Jan Lievens was trained in 1619–21 by the Amsterdam history painter Pieter Lastman (c. 1583–1633). Lievens shared a Leiden studio with Rembrandt and other artists for six years between 1625 and 1631. The two then went their separate ways: Rembrandt pursued his career in Amsterdam and Lievens, who was a year younger, went to London (1632–34) and to Antwerp (1634–44), where he came under the influence of the Flemish painters van Dyck and Rubens.

Within Lievens's diverse oeuvre, landscape holds a significant place.[1] The artist produced most of his landscape drawings in the last three decades of his life, which he spent in Holland. These included forest scenes and panoramic views in addition to topographical motifs. His close views of dense forests particularly exhibit the influence of the southern Netherlandish tradition.

In the present, finely detailed pen drawing, the middle ground of this seemingly randomly selected scene is densely worked. Lively, quick dashes and loops capture the fluid motion of the foliage and contrast eloquently with the static forms of the angular irrigation ditch, the edges of the paths, the tree trunks, and the rooftops. The effect of sunlight is revealed in lively nuances of light and dark, with the untouched paper support providing the brightest highlights.

Presumably the date noted by an unidentified hand is incorrect; the drawing may have been produced around 1670, though the dating of Jan Lievens's landscape drawings is problematic.[2] Stylistically, this drawing relates, among others, to *View of Haarlem* (Boston, Collection of Maida and George Abrams) and, in light of the dunes visible on the horizon, may also depict a scene from the Haarlem area.[3]

1 See S. Jacobs in Braunschweig 1979, pp. 21–26.

2 For Lievens's drawings, see R.E.O. Ekkart in Braunschweig 1979, pp. 27–32; Sumowski 1979–92, vol. 7, pp. 3710–11; and Amsterdam 1989, pp. 5–8, 16–20.

3 Sumowski 1979–92, vol. 7, no. 1732*.

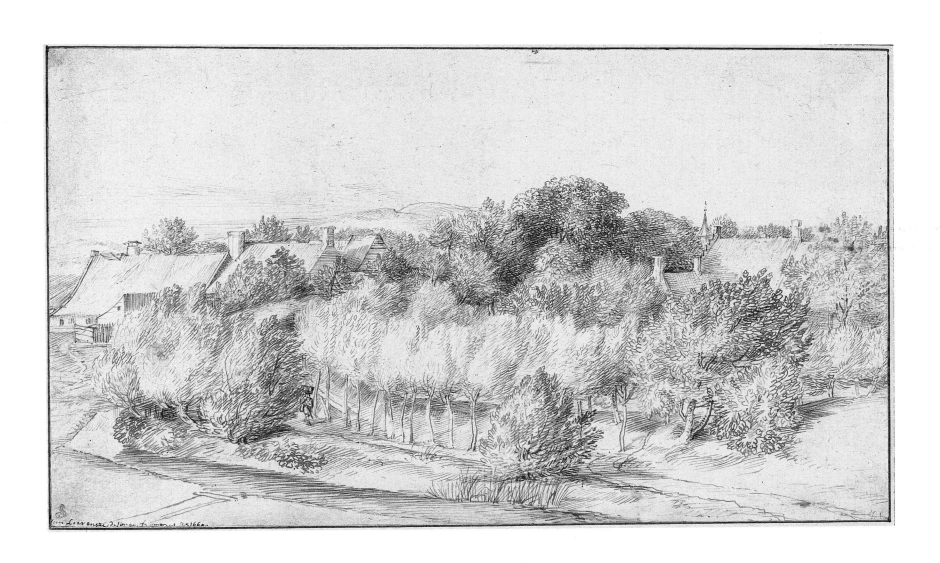

Roelant Roghman

AMSTERDAM 1627–1692 AMSTERDAM

85 *Swieten Castle,* 1646/47
86 *Duurstede Castle,* 1646/47

CAT. NO. 85

Pen and brown ink, brush and gray ink, gray wash, over graphite

38.8 x 52.9 cm

INSCRIBED AT LOWER LEFT: "R. Roghman"

PROVENANCE: Prince de Ligne; Duke Albert von Sachsen-Teschen

INV. NO. 15130

BIBLIOGRAPHY: Schönbrunner and Meder 1896–1908, vol. 8, no. 844, illus.; Wurzbach 1906–11, vol. 2, p. 464; Benesch 1964, no. 184, illus.; van der Wyck and Niemeijer 1990, vol. 1, p. vii, illus. (fragment), p. x, no. 187, illus.; Kloek and Niemeijer 1990, vol. 2, pp. 127–30, fig. 166

CAT. NO. 86

Black chalk, gray wash partially mixed with white bodycolor

35.8 x 50.8 cm

INSCRIBED AT LOWER RIGHT: "R. Roghman"

PROVENANCE: Albert or Hillebrand Bentes; Christiaan and Anthonie van Hoek; C. Ploos van Amstel (Auction Amsterdam, March 3, 1800); Duke Albert von Sachsen-Teschen

INV. NO. 15131

BIBLIOGRAPHY: van Gelder 1959, p. 48, no. 117, illus.; van der Wyck and Niemeijer 1990, vol. 1, p. 62, no. 42, illus.; Vienna 1993, no. 64, illus.; New York/Fort Worth 1995, no. 55, illus.

Roelant Roghman was the son of the engraver Hendrick Lambertsz. Roghman; his grandfather on his mother's side was Jacques Savery (d. 1602). The majority of his oeuvre comprises drawings of landscapes and topographical views.[1] In addition, fifty etchings and a relatively small body of paintings are known. The works of his grandfather, who died young, and of his great-uncle Roelant Savery (cat. nos. 3, 4), who outlived his brother by several decades, no doubt shaped Roghman's artistic activity. He was a friend of Gerbrand van den Eeckhout (cat. no. 50), a pupil of Rembrandt; it is possible that he also knew Rembrandt. In the 1650s, Roghman traveled to France, Germany, and perhaps Italy. Within his drawing oeuvre, which in general is difficult to date, an extensive group of large-format representations of castles stand out. The artist produced these drawings at various locations in Utrecht and Holland in 1646 and 1647, when he was about twenty years old.[2] Nothing is known of the impetus and function of these remarkable drawings; several scholars have suggested a connection to a possible commission by nobility.[3] The oldest extant inventory of the sheets is the so-called "Liste Bentes" (1708).[4] Of the original 250 drawings, 222 sheets remain, dispersed in several collections around the world, with the greatest concentration in the Rijksmuseum in Amsterdam, in a Netherlandish private collection, and in the Teylers Museum in Haarlem. The Albertina's two sheets from this series are both presented here.[5]

Roghman often portrayed his subject from several angles. For example, he drew three different views of Duurstede Castle (cat. no. 86).[6] The Albertina's sheet is representative of Roghman's process: he positioned himself at the edge of the castle moat at an oblique angle to the architectural complex in order to obtain the most varied overview possible. With a sharp eye for the essence of

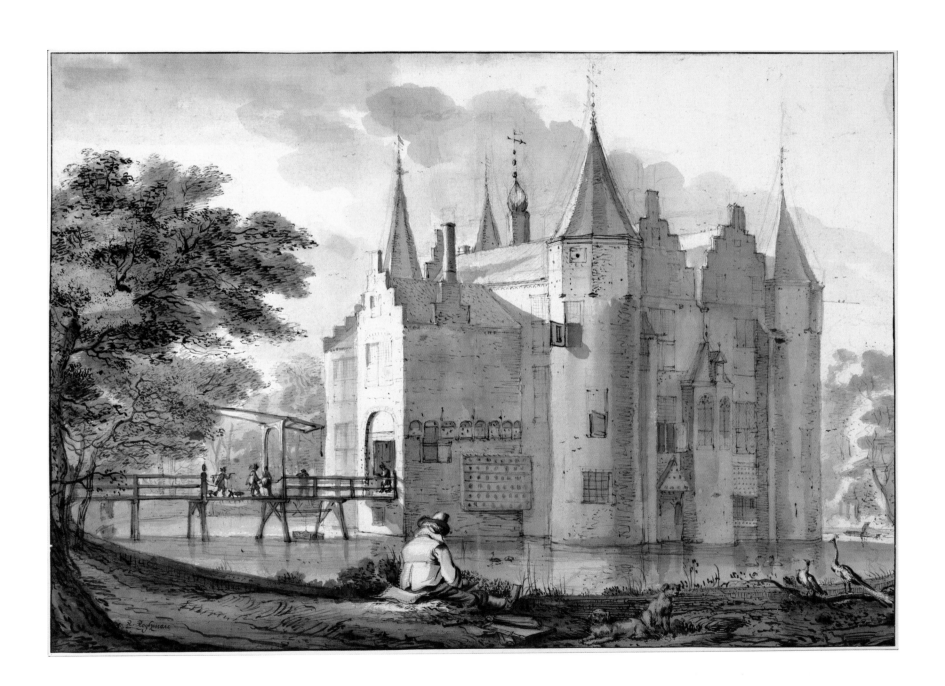

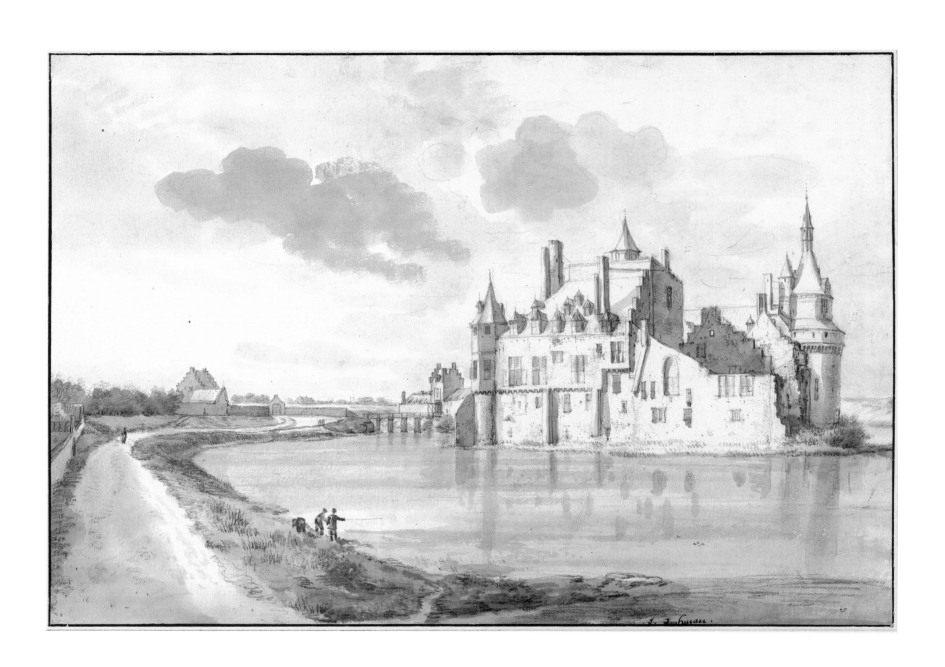

architectural volume, he concentrated on the simple, blocky forms. He applied washes in varying tones of gray to the preliminary black-chalk drawing and enhanced the image with additional refinements in black chalk and brush. Characteristic of Roghman's representations of castles is their objective content, which is far removed from a heroic metaphor of ruins.[7] At the same time, he achieved an optimum amount of atmosphere with minimal technical means, in which the complete scene—from the broad expanse of cloudy sky to the nuances of light on wall surfaces and subtle reflections in the water—is captured in a diffuse light.

Roghman executed four drawings of Swieten Castle, which was located near Leiden; two of these sheets (the Albertina's and one in the Rijksmuseum in Amsterdam) are largely identical in their rendering of the subject.[8] The artist's use of pen and the rendering of the draftsman and two dogs distinguish the Albertina's *Swieten Castle* (cat. no. 85) from the others in the series; this motif gives the image the character of a title sheet.[9] Based on the many pentimenti, it is presumed that the Vienna drawing was produced earlier than the Amsterdam sheet, in which the forms are summarized in a more monumental fashion. In addition, given the slight shift in the architectonic details in the Vienna drawing, Roghman positioned himself somewhat farther to the right; in this sheet, for example, the onion-shaped top of the central chimney can be clearly seen, whereas it is partially hidden in the Amsterdam sheet, which is also drawn from a lower viewpoint.[10]

The objective description and yet atmospheric quality of these drawings of castles are considered a unique achievement in seventeenth-century Netherlandish art. It is all the more impressive that the artist produced them when he was still a youth. Not until the eighteenth century did this specific type of landscape become more broadly prevalent. Nevertheless, the clear monumentality of the sheets by Roelant Roghman remains unsurpassed.[11]

1 On the life of Roelant Roghman, see Kloek and Niemeijer 1990, vol. 2, p. 1.

2 Van der Wyck and Niemeijer 1990, vol. 1; Kloek and Niemeijer 1990, vol. 2, passim.

3 The sheets in the Teylers Museum are discussed in Plomp 1997, pp. 322–44 (nos. 347– 94).

4 Van der Wyck and Niemeijer 1990, vol. 1, pp. 1–8.

5 Ibid., pp. 6–7; Plomp 1997, pp. 322–33.

6 Van der Wyck and Niemeijer 1990, vol. 1, nos. 42, 23, 44.

7 Ibid., pp. viii–x.

8 Ibid., nos. 187–90.

9 Kloek and Niemeijer 1990, vol. 2, p. 130.

10 Ibid., pp. 127–31.

11 Van der Wyck and Niemeijer 1990, vol. 1, p. x.

Jan de Bisschop

AMSTERDAM 1628–1671 THE HAGUE

87 *View of The Hague from the Northwest with Delft in the Distance,* after 1660

Pen and brush and brown ink, brown wash, brush and gray ink, blue and green watercolor, graphite (in contours of clouds), gouache (in figures)

24.5 x 40.2 cm

PROVENANCE: Simon Fokke (Auction Amsterdam, December 6, 1784 et seq., p. 59, no. 297); Duke Albert von Sachsen-Teschen

INV. NO. 10112

BIBLIOGRAPHY: Wurzbach 1906–11, vol. 2, p. 521; Benesch 1964, no. 202, illus.; van Gelder 1978, p. 118; Amsterdam/Ghent 1982–83, p. 55, under no. 4; Broos 1989, pp. 41–42, fig. 14; Vienna 1993, no. 73, illus.; New York/Fort Worth 1995, no. 64, illus.; Pittsburgh/Louisville/Fresno 2002, no. 75, illus.

This drawing offers a view of The Hague behind an expansive dune landscape; farther in the distance and to the right, the contours of the city of Delft are visible. Within the many landscapes and topographical views that Jan de Bisschop drew throughout his life, a central group emerges that depicts the environs of The Hague, where he lived.[1] Whereas the artist's earliest landscape drawings reveal the influence of Bartholomeus Breenbergh (cat. no. 100), the drawings de Bisschop produced after 1660—including the present view—display a far more individual pen and brush technique. Within generous, yet sharp, outlines, de Bisschop captured the modeling of form in cloudy washes. The bright edges of the forms and the gleaming tone of the paper that peeks out between the areas of wash are characteristic of the artist's work. In the present drawing, these qualities appear above all in the horizon area.

The powerful pen lines that describe the terrain and vegetation in the foreground are not considered authentic; the green and blue watercolors are also uncommon in de Bisschop's work. The figures may have been added later, and the mottled brushwork in the clouds also appears to be by a later hand.[2] All of these additions greatly dramatize the balance and the transparency of the work's original state.[3] The effect recalls the works of Jacob van Ruisdael, a painter who was very popular in the eighteenth century, and to whom the drawing was once attributed.[4] The landscape drawings of Jan de Bisschop are frequently mistaken for works by Constantijn Huijgens, to whom the present drawing has also occasionally been assigned.[5] This multitalented son of the court secretary Christian Huygens, of whom de Bisschop was a close friend and colleague in the 1660s, generally employed a more cursory pen and wash style.

1 Regarding the landscapes of Jan de Bisschop, see Amsterdam/Zwolle 1992, pp. 22–37.

2 Egbert Haverkamp-Begemann identified these additions on April 5, 1993. See Vienna 1993, p. 134, n. 3, and New York/Fort Worth 1995, p. 136, n. 3.

3 Frits Lugt, who attributed the sheet to Jan de Bisschop for the first time in a note on the mount, already established that the sheet had been "embellished." The auction catalogue for the Fokke Collection (see Provenance) mentions that this view of The Hague was drawn by Jan de Bisschop and was "lightly colored" by Isaac de Moucheron. See Broos 1989, pp. 41–42, fig. 14. Broos suggests that the two figures could also be the work of de Moucheron, who often reworked older drawings.

4 Wurzbach 1906–11, vol. 2, p. 521.

5 Van Gelder 1978, p. 118.

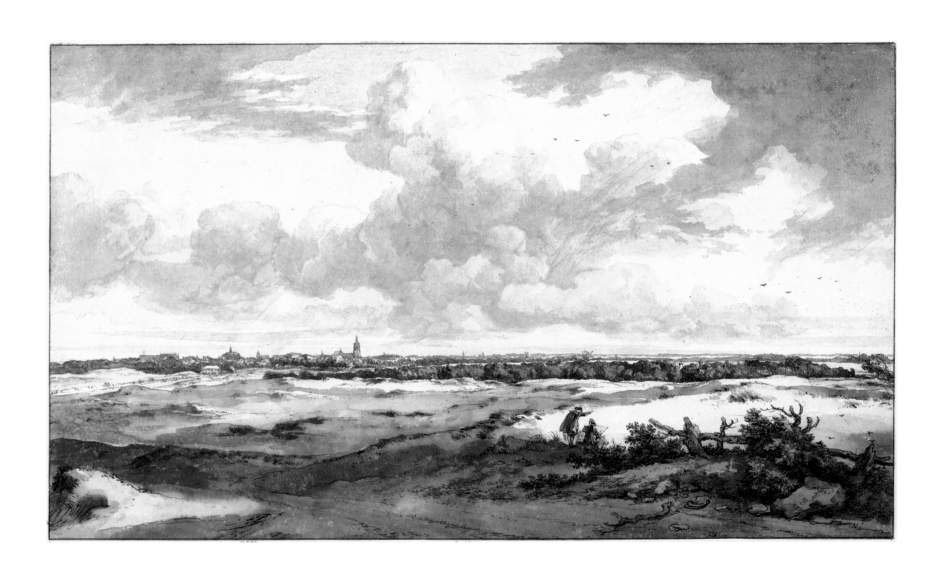

Gerrit Battem

ROTTERDAM 1636–1684 ROTTERDAM

88 *View of Rotterdam from the North,* c. 1665

Gouache

16.2 x 22 cm

PROVENANCE: C. Ploos van Amstel (Auction Amsterdam, March 3, 1800, no. K 33); Ph. van der Schley; Duke Albert von Sachsen-Teschen

INV. NO. 10789

BIBLIOGRAPHY: Vienna 1993, no. 72, illus.; New York/Fort Worth 1995, no. 63, illus.; Haarlem 2000, p. 128, n. 2

Little is known about Gerrit Battem's training; he was related to two artists in Rembrandt's circle[1] and may have apprenticed with his uncle Abraham Furnerius. The panoramic landscapes of Philips Koninck (cat. no. 83), who was married to his mother's sister, apparently influenced his work. Herman Saftleven (cat. nos. 79, 80), with whom Battem came in contact during a two-year stay in Utrecht from 1667 to 1669, was also an important figure for him. The majority of Battem's rather limited oeuvre consists of approximately sixty gouaches that depict imaginary mountain landscapes, Dutch winter scenes, and city views. Like Dirk Dalens II (1654–1688), Battem was among the few Netherlandish artists in the second half of the seventeenth century to devote himself to this type of detailed landscape in gouache.

The present work is rare in two respects. First, Battem's oeuvre contains few panoramic landscapes with topographical motifs.[2] Second, views of Rotterdam are uncommon, and this seventeenth-century rendering from the north side is an anomaly.[3] In this apparently realistic view of his hometown, the artist used a few tricks to dramatize the scene.[4] He reduced the distance between the Rotte River and the outer edge of the city, thereby accentuating the profile view of the city by moving it closer. Battem also altered the course of the river, making it broader than it was in reality. The buildings, though correctly placed, have been made taller. The wide building in the right half of the image, the "Schielandshuis," which was built in 1662–65, may serve to date the work to around 1665 as it appears to be in an unfinished state. This dating would support the assumption that Battem's landscapes were largely produced in the second half of the 1660s and in the 1670s.[5]

The artist's inventive modifications of topographical details reflect his eclectic working methods and the various stylistic components that shape his work. The composition of the present view recalls the landscapes of Koninck, whose watercolor technique may also have inspired him. The colorful, detailed style of painting may have been derived from the work of Flemish predecessors.[6]

1 Regarding the life and work of Gerrit Battem, see Hans Verbeek in Bolten 1985, pp. 36–38, and Hans Verbeek in Haarlem 2000, p. 128.

2 Hans Verbeek, verbal communication. See Vienna 1993, p. 132, n. 4; New York/Fort Worth 1995, p. 134, n. 4.

3 Pieter Ratsma, Gemeinde-Archiv Rotterdam, verbal communication. See Vienna 1993, p. 132, n. 5; New York/Fort Worth 1995, p. 134, n. 5.

4 For topographical details and identification of the buildings, see Vienna 1993, p. 132, n. 6; New York/Fort Worth 1995, p. 134, n. 6.

5 Hans Verbeek in Bolten 1985, p. 38.

6 According to Hans Verbeek, the gouache may have been trimmed slightly, as all of the sheets by Battem intended for sale were originally prepared with a border. See Vienna 1993, p. 132; New York/Fort Worth 1995, p. 134.

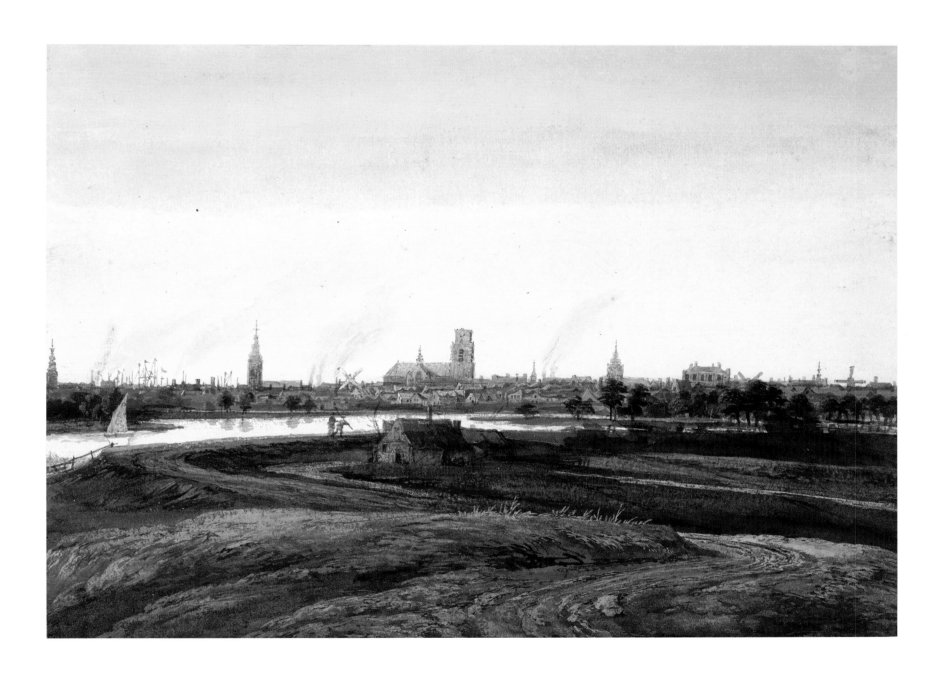

Allart van Everdingen

ALKMAAR 1621–1675 AMSTERDAM

89 *View of Alkmaar from the Southeast,* late 1660s

Brush and gray ink, watercolor, white bodycolor

11.2 x 17.8 cm

MONOGRAMMED AT LOWER RIGHT: "AVE"

PROVENANCE: Johan Aegidiusz. van der Marck, Leiden; Sale van der Marck 1773, p. 60, no. E. 360; Daniel de Jongh Az, Rotterdam; Sale de Jongh 1810, p. 163, no. V. 4, to Notstein; art dealer Louis B. Coclers (1819 or earlier), Amsterdam; Sale Coclers and van der Schaft 1819, p. 16, under no. D. 16), to Mensart; Duke Albert von Sachsen-Teschen

INV. NO. 9582

BIBLIOGRAPHY: Davies 1978, pp. 57–58, 262, fig. 384; Paris 1983, p. 50, under no. 29; Vienna 1993, no. 71, illus.; New York/Fort Worth 1995, no. 62, illus.; Davies 2001, p. 46, n. 14, pp. 69–70, n. 81, p. 90, fig. 59

The majority of Allart van Everdingen's oeuvre is comprised of Scandinavian landscapes (cat. no. 77) and marine views (cat. no. 93). Beginning in the 1650s, the artist also focused on Netherlandish motifs, which are more numerous in his drawings and watercolors than in his paintings.[1] In each of the six panoramic oil paintings by van Everdingen known today, a body of water opens before the viewer. *View of Alkmaar with Boats on the Zeglis* (Paris, Institut Néerlandais, Fondation Custodia, Collection Frits Lugt) is directly related to the present watercolor.[2] The distinct colors of the painting, which has been dated to the late 1660s, are characteristic of the artist's late period.[3] The dramatic treatment of space, the chiaroscuro effects, and the cloudy sky reflected in the water recall the work of Jacob van Ruisdael.

None of this drama is apparent in this intimate watercolor, in which the artist depicts the city in profile view from a closer viewpoint and includes the St. Lawrence Church and "De Waag" ("The City Scale") at the right. In this small composition, which may have served him as an aide mémoire in his execution of the painting, van Everdingen concentrated above all on the play of light and color. In fine, loose brushstrokes, he characterized the density and diversity of the architectural forms, enhancing them with the lively accents of the boats' masts and red sails. He rendered the colors of the clouds and the sails, which are reflected in the water, with great subtlety. The flat treatment of the foreground does not quite harmonize with the many layers of the image—a feature that is also notable in the painting.[4]

The autonomous character of the watercolor is underscored by the copy of the work by Abraham Rademaker (1675–1733) for use as a print.[5] At the time the watercolor and the painting of the view of Alkmaar were created, the city view had reached a pinnacle in Dutch seventeenth-century art.[6] In the late 1660s and 1670s, this type of landscape was represented by Jan van der Heyden, Gerrit Adriaensz. Berckheyde, Jacob van Ruisdael, Meindert Hobbema, and many others. In their works, these artists presented topographical features as part of a landscape shaped by light, air, and atmosphere.

1 Regarding Netherlandish landscapes in paintings by van Everdingen, see Davies 1978, pp. 237ff.; Davies 2001, pp. 139–56. Regarding my thanks to Alice Davies, see cat. nos. 77 and 78, note 1.

2 For the painted panoramic views of cities, see Davies 2001, nos. 14, 15, 18, 20, 21, 22.

3 The dating in Stechow 1966, p. 128; regarding the coloring, see Davies 2001, p. 69.

4 Davies 2001, p. 70.

5 Ibid.

6 See R. J. Wattenmaker in Amsterdam/Toronto 1977, pp. 14–41.

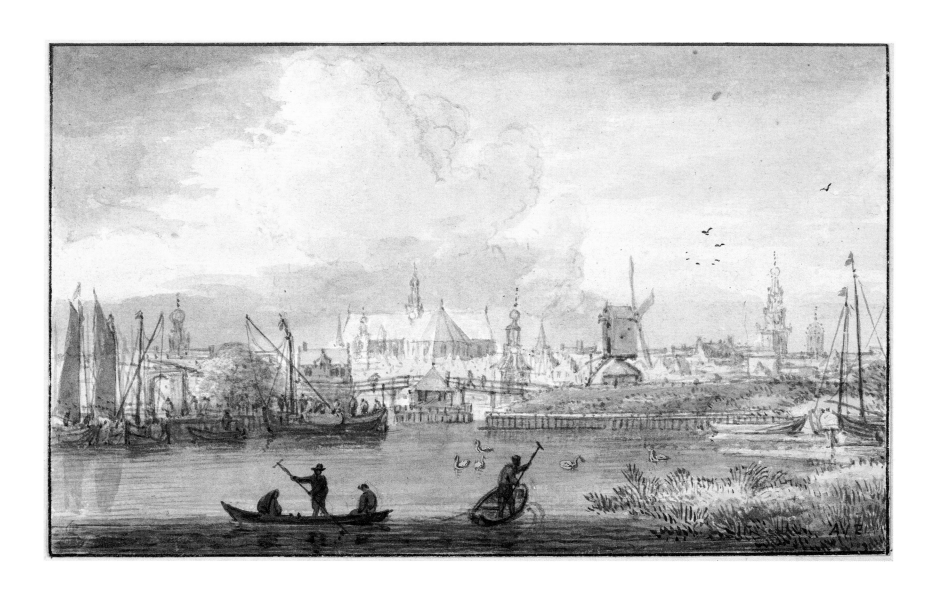

Pieter Jansz. Saenredam

ASSENDELFT 1597–1665 HAARLEM

90 *Interior of the Groote Kerk (Church of St. Lawrence) in Alkmaar,* 1661

Pen and brown ink, watercolor

45.3 x 60.5 cm

INSCRIBED ON BACK OF CHOIR STALL: "Anno 1661, in de Maent Maij, heb ick Pr Saenredam dese teeckening tot Alcmaer in de kerck gemaeckt."[1]

PROVENANCE: Duke Albert von Sachsen-Teschen

INV. NO. 15129

BIBLIOGRAPHY: Schönbrunner and Meder 1886–1908, vol. 9, no. 1009; Swillens 1935, no. 210, p. 61; Houtzager, Swillens, and van Regteren Altena 1961, no. 3; Benesch 1964, no. XVI; Washington/New York 1984–85, no. 33, illus.; Schwarz and Bock 1990, no. 3, pp. 232, 236, fig. 249

Pieter Jansz. Saenredam was the son of the engraver Jan Pietersz. Saenredam, who had been a pupil of Hendrick Goltzius. From 1613 to 1623, he apprenticed in Haarlem with Pieter de Grebber (c. 1600–1653). Saenredam began painting views of churches and other buildings in 1628, at which time he was acquainted with the architect Jacob van Campen (1595–1657) and with Salomon de Bray (cat. no. 52). In 1635, he was appointed secretary of the painters' guild in Haarlem. He became the most important architectural painter of the seventeenth century in the Netherlands, focusing especially on church interiors. Equally significant are the drawings that document his trips to Utrecht, 's Hertogenbosch, Rhenen, Assendelft, and Alkmaar. Many artists emulated Saenredam, but none ever attained the brilliant light qualities he captured in his work.

This strikingly large work belongs to a series of interior views of the Groote Kerk (Church of St. Lawrence), which Saenredam drew during his stay in Alkmaar in 1661, four years before his death.[2] An additional drawing from this series, also in the Albertina collection, is a detail study of the church's large organ with its shutters open.[3] In 1638–39, Saenredam had prepared a construction drawing of this wall area for van Campen, who had been commissioned to design a new architectural framework for the organ. The present drawing, which depicts the organ with its shutters closed, directly corresponds to a painting in the Stedelijk Museum in Alkmaar (although with the organ open).[4] The unusually large format for Saenredam and the use of canvas instead of his usual panel suggest that the painting may actually be by Izaak van Nikkelen, who painted a series of interior views of the Church of St. Bravo in Haarlem in the style of Saenredam; none of these, however, is dated earlier than 1693. On the other hand, the characteristic pink and yellow tints in combination with silver foil and gold powder speak for Saenredam's authorship.[5]

Saenredam made numerous studies in preparation for his paintings.[6] This sheet is a brilliant example of the natural character of his interior views. The low, somewhat off-center vanishing point corresponds to the position of the viewer and also produces a sense of immense height and depth—the latter accentuated considerably by the close view of the wall and the opening to the cloister. Saenredam is unsurpassed in the rendering of light reflected by the white walls and dispersed in the shadows: his carefully applied accents of color alternate effectively with the light ground tone, which is animated by delicate nuances of gray and brown.

1 "In the year 1661, in the month of May, I, Pieter Saenredam, made this drawing in the church at Alkmaar."

2 See Schwarz and Bock 1990, pp. 232–36.

3 Inv. no. 8566.

4 See Schwarz and Bock 1990, p. 251, fig. 251.

5 Ibid., p. 236.

6 See Liedtke 1971, pp. 116ff.

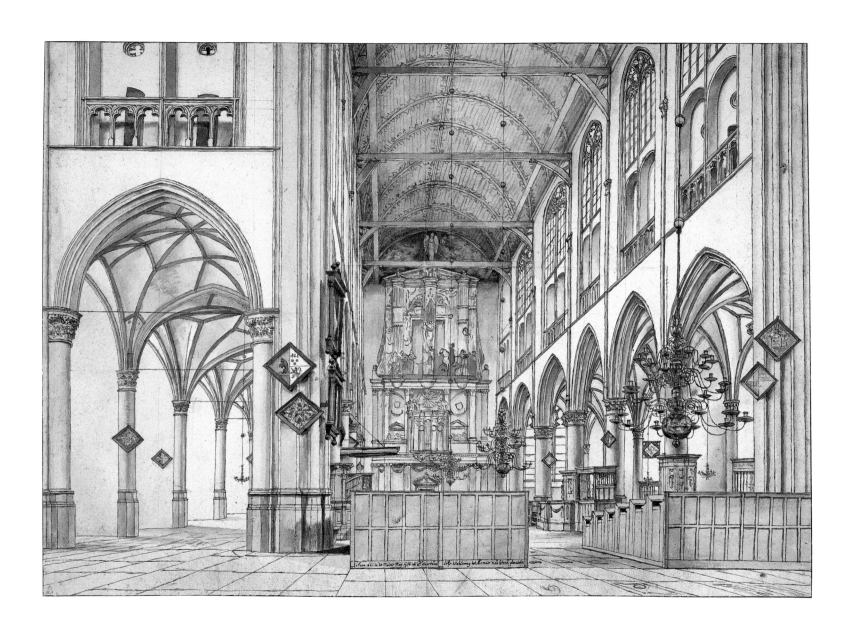

Abraham Rutgers and Ludolf Bakhuizen (Backhuysen)

AMSTERDAM 1632–1699 AMSTERDAM EMDEN 1630–1708 AMSTERDAM

91 *Two Ice Skaters on a Castle Moat with a View of the Vecht River,* late 1680s

Pen and brown ink, watercolor, gouache, over graphite

18.9 x 30.2 cm

INSCRIBED ON THE VERSO OF THE MOUNT: "Getekent door de oude Rutgers en de Beeltyes door L Bakhuysen" (presumably copied from the verso of the sheet during the mounting process)

PROVENANCE: Duke Albert von Sachsen-Teschen

INV. NO. 10015

BIBLIOGRAPHY: Wurzbach 1906–11, vol. 2, p. 524; Vienna 1993, no. 74, illus.; New York/Fort Worth 1995, no. 65, illus.; Pittsburgh/Louisville/ Fresno 2002, no. 78, illus.

The silk merchant Abraham Rutgers is among the most well-known self-taught artists in the Netherlands during the seventeenth century.[1] His friend Jacob Esselens (1626–1687) was an important model as an artist for Rutgers, who worked exclusively as a draftsman. Esselens, who was also a textile merchant, was connected to the circle of artists around Rembrandt and was a talented draftsman of topographical views. Esselens influenced Rutgers especially in his objective description and his style of drawing in often repetitive, parallel strokes.[2]

The naive freshness of Rutgers's drawings gives them a particular charm. The present drawing corresponds to the picturesque area near the wooded banks of the Vecht River that Rutgers frequently portrayed, where he and many seventeenth-century Dutch merchants built estates. The drawing demonstrates Rutgers's characteristic preference for diagonal elements, such as broad, tree-lined paths, canals, or rivers, where rows of trees segment the views and create a particular sense of depth. Instead of achieving depth through atmospheric effects, he employed the principle of reducing the size of figures, trees, and fences to indicate their recession into the background. The distinction between near and far is often intensified through an artistic device: in the present drawing, the trees in the foreground are cropped by the upper edge of the sheet. The weak rendering of the tree trunks and the even pen lines throughout reveal the hand of an amateur artist. The application of watercolor or gouache is rather rare for Rutgers, who customarily worked exclusively in pen. A significant clue in dating his works are eighty-eight sketches gathered in an album, which he noted were produced in 1686–87.[3] The present drawing may also date from this time.

The figures in the foreground are unusually large for Rutgers; the two ice skaters, equipped with sticks to play "kolf" ("golf"), are not by him. According to an old notation, these figures were rendered by Ludolf Bakhuizen. In the Rijksmuseum in Amsterdam, there is, indeed, a study sheet by Bakhuizen depicting two figures that are identical to the ice skaters in the Albertina drawing.[4]

1 For information on Rutgers, see Niemeijer 1964; Broos 1981, pp. 194–205.

2 Rutgers also copied compositional sketches by his friend; see Broos 1981, no. 56.

3 Dordrecht, Museum Simon van Gijn. In these sketches, Rutgers differentiated between "Principale, Inventive & Copijen." Intended are works based on sketches from nature, imaginary landscapes, and drawings after the works of other artists. The Albertina drawing undoubtedly belongs to the first category. See Niemeijer 1964 and Broos 1981, p. 194.

4 See Amsterdam 1985, p. 79, fig. 4; Russell 1993, p. 849.

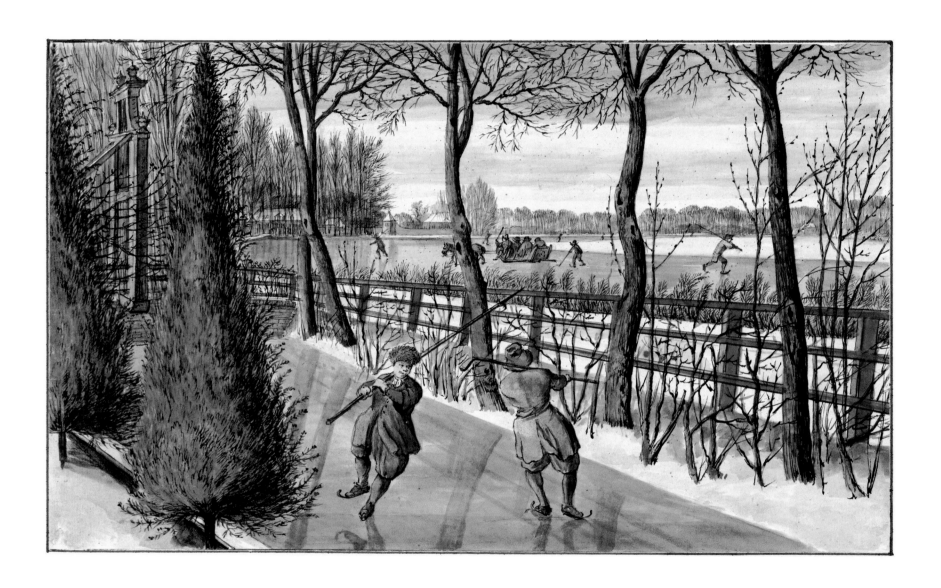

Marine and Italianate Landscape

Jan Porcellis

Ghent c. 1584–1632 Soeterwoude

92 *A Zeeland Cog (Een zeeusche Koch)*, c. 1626–27

Pen and brush and gray and brown ink, brown wash

16.5 x 26.9 cm

MONOGRAMMED AT LOWER LEFT: "I.P."; inscribed at upper left: "14"
(by a later hand)

PROVENANCE: G. Winckler; Duke Albert von Sachsen-Teschen

INV. NO. 8580

BIBLIOGRAPHY: Paris 1989, p. 48, under no. 41; Minneapolis/Toledo/
Los Angeles 1990–91, no. 73; Vienna 1993, no. 79, illus.; New York/
Fort Worth 1995, no. 69, illus.

The marine painter Jan Porcellis was born in the southern Netherlands
and may have been trained by the Haarlem marine painter Hendrick
Cornelisz. Vroom, the father of Cornelis Hendricksz. Vroom (cat. nos.
70–72). He is known to have lived in Rotterdam in 1605, in Antwerp
in 1617 (as the master of the guild), and in Haarlem in 1622–23.
He resided in Amsterdam in 1624–25, in Voorburg in 1626, and then in
Soeterwoude near Leiden.[1] Porcellis was a pioneer in marine painting
in the northern Netherlands. Rather than depicting historical events,
he concentrated on the interaction of the elements and their effect on
human activity. The artist often studied the different weather conditions
from his sailboat, which he took on extended tours of the western
provinces.

Porcellis is considered the founder of the tonal manner, which
he developed during the 1620s. He worked in a few reserved colors—
predominantly in tones of gray, brown, ocher, and green—to express
subtle effects of light and atmosphere. The "monochrome" period
of Dutch painting, represented by Jan van Goyen (cat. nos. 17–20),
Pieter Molyn, Salomon van Ruysdael, and others from around 1630 to
1645, largely had its origins in Porcellis's tonal works.[2]

The present work, one of the few drawings attributed to the
artist with certainty, served as a model for the engraving *Een zeeusche
Koch (A Zeeland Cog)*, number eight of the series *Icones Varium
Navium Hollandicarum*, published by Claes Jansz. Visscher in 1627
after Porcellis's designs. The engraver remains unknown. These twelve
engravings comprise the earliest known series to represent different
types of sailboats.[3] The cog, a small cargo ship known to exist since
the Middle Ages, was still common in Dutch and Zeeland waters until
the late seventeenth century.[4] In this drawing, Porcellis convincingly
integrated the modellike example into the natural environment.
The rhythmic movement of the waves rendered in fine brushstrokes
and washes diminishes with the recession into depth until the water
becomes absolutely still and bright near the far distant shoreline.
The fleeting play of the clouds completes the overall impression of
atmospheric unity. In its gray-brown tonalism, this significant work
is the equivalent in drawing of the artist's mature paintings of the
late 1620s.[5]

1 Regarding Porcellis's life and work, see Walsh 1974, parts 1 and 2.

2 See Stechow 1966, pp. 112–14; Bol 1973, pp. 91–102; Keyes in Minneapolis/Toledo/Los Angeles
 1990–91, pp. 14–17.

3 G. Keyes in Minneapolis/Toledo/Los Angeles 1990–91, p. 313.

4 Vienna 1993, p. 146, n. 4; New York/Fort Worth 1995, p. 146, n. 4.

5 Porcellis's drawing for the print *Damloopers* of the same series is of equal importance
 (Paris, Fondation Custodia, Institut Néerlandais, inv. no. 3441). See Paris 1989, no. 41, pl. 19.

Allart van Everdingen

ALKMAAR 1621–1675 AMSTERDAM

93 *Rocky Coast in Stormy Weather,* c. 1645

Brush and gray and brown ink, gray and brown wash, white bodycolor, over black chalk

22.5 x 41.6 cm

MONOGRAMMED AT LOWER RIGHT: "AVE"

PROVENANCE: Willem van Berckel, Delft; Gerard van Berckel (Sale van Berckel 1761); Sale Leipzig 1774, p. 488, no. 5724; G. Winckler; Duke Albert von Sachsen-Teschen

INV. NO. 9590

BIBLIOGRAPHY: Rosenberg 1928, p. 44, n. 1; Davies 1978, pp. 57–58, 74, fig. 25; Minneapolis/Toledo/Los Angeles 1990–91, no. 66, illus.; Vienna 1993, no. 81, illus.; New York/Fort Worth 1995, no. 71, illus.; Davies 2001, pp. 47, n. 13, p. 56, n. 36, 37, pp. 57, 90, 168, n. 68, fig. 24; Slive 2001, p. 458, fig. B, under no. 648

Marine themes hold a small but significant place in Allart van Everdingen's oeuvre, which is largely devoted to Scandinavian landscapes (cat. no. 77). His marine paintings and drawings most often depict ships on stormy or rough seas.[1] The present sheet is somewhat atypical for him with the tiny ships removed to the horizon line. Typically, van Everdingen's seascapes follow the examples of artists such as Adriaen Willaerts, Jan Porcellis (cat. no. 92), and Simon de Vlieger (cat. no. 69), where the stormy weather conditions and the action of the ships are fully and integrally connected and more prominently positioned in the foreground.[2]

In this drawing, van Everdingen concentrated on the drama of nature, emphasizing the lonely and majestic character of the mountain landscapes, waterfalls, and rocky seacoasts found in his paintings. The cliff formations recall landscapes by Roelant Savery (cat. nos. 3, 4); the choice of theme and monochromatic character of the drawing may owe something to the works of Porcellis and de Vlieger. In its restrained palette, the drawing also relates to the river views and seascapes by Jan van Goyen (cat. nos. 17–20).[3]

The overall brownish tone that has been applied to the paper and serves as a ground for the brown and gray inks heightened with white is unusual for van Everdingen. The colors are parceled out in large areas, small patches, and in short strokes that overlap in layers without blending. Brightly illuminated waves at the right and the nearby cliffs reflect the penetrating light from the left. Threadlike strokes describe the glittering, white crests of the waves, extending the effect into the surrounding environment.

The arrangement of the sea and the cliffs in this extraordinary work corresponds strongly to the painting in Frankfurt *Storm on a Rocky Coast*, which dates to around 1645.[4] In the painting, the ships in distress figure more prominently, and the dark, larger expanse of sky is heavy with clouds, creating stark contrasts in light and dark. The drawing is presumed to be a preparatory study for this painting,[5] however, its high degree of completion may indicate that it was created as an autonomous work around the same time.

1 Regarding the marine themes in van Everdingen's work, see Davies 1978, pp. 61–98; and Davies 2001, pp. 49–73. Additional van Everdingen drawings of ships on stormy seas are mentioned in Vienna 1993, p. 151, n. 2, and New York/Fort Worth 1995, p. 151, n. 2. The author wishes to thank Alice Davies for her helpful information on the provenance and bibliography of the drawing.

2 For comparison with the artists named, see Davies 1978, pp. 66–70, and G. Keyes in Minneapolis/Toledo/Los Angeles 1990–91, pp. 226–27.

3 There is also a belief that the landscape etchings of Hercules Seghers were a possible source of inspiration. See Vienna 1993, p. 150, and New York/Fort Worth 1995, p. 150.

4 Frankfurt, Städelsches Kunstinstitut, oil on canvas, 99 x 140.6 cm, inv. no. 777. See Davies 1978, p. 321, no. 8, fig. 22; and Davies 2001, no. 9, fig. 9.

5 Rosenberg 1928 and Davies 1978, pp. 57–58, 74, fig. 25. Alice Davies believes that the two are not mutually exclusive. See Davies 2001, pp. 56, 57.

Willem van de Velde the Elder

LEIDEN 1611–1693 LEIDEN

94 *Merchant Ships with Lighters on a Rough Sea,* 1641

Pen and brown ink, brown wash, graphite, on vellum; retouched in dark ink in the waves in the foreground and in the sky area at center left

27.5 x 37 cm

INSCRIBED AT LOWER LEFT: "W.V.VELDE 1641"

PROVENANCE: G. Winckler; Duke Albert von Sachsen-Teschen

INV. NO. 10037

BIBLIOGRAPHY: Hind 1923–31, vol. 4, p. 101; Munich/Bonn 1993, p. 18, n. 5, under no. 8; Vienna 1993, no. 80, illus.; New York/Fort Worth 1995, no. 70, illus.

Willem van de Velde the Elder, who for decades specialized in drawing ships, practiced a highly successful partnership with his son, the marine painter Willem van de Velde the Younger (cat. no. 95). Before they immigrated to England in the winter of 1672–73, both artists were focused largely on drawing scenes from Anglo-Dutch naval battles; they also received commissions from commercial shipping companies.[1] The elder van de Velde employed pen, brush, and chalk in different combinations to achieve very detailed representations of his complex naval scenes. The technique of his "penschilderijen" ("paintings in pen") recalls the earlier practice of Hendrick Goltzius and his contemporaries.

The present drawing, which is dated 1641, is among the artist's earliest works.[2] Three merchant ships are surrounded by a company of lighters.[3] These small, maneuverable boats navigated coastal or inland waters primarily to load goods onto large commercial ships or warships at anchor or at roadsteads just outside the shallow waters of the harbor. They also helped unload the larger ships returning from the Far East so that by riding lighter, the big vessels could navigate the shallower inland waters. The present scene depicts ships returning from

a voyage: the trading vessel visible in the background at center left is still in full sail, whereas the two three-masters nearer to the foreground have already partially furled their sails. Aided by a plentiful wind, the large and small ships set a common course for their mooring place.

The realistic rendering of the ships and their crews' activity points to the artist's great familiarity with the subject. The orientation of the ships' hulls and sails reveals careful consideration of the wind's direction. Despite the linear meticulousness of the drawing, the movement and lively action of the scene are convincingly conveyed, as seen, for example, in the flapping sails of the lighter at the lower left. The rhythmic movement of the waves, ships, and clouds blends into an organic unity. The use of vellum for this carefully detailed drawing indicates that it may have been for an important commission.

1 For comprehensive information on the life and work of Willem van de Velde the Elder, see Minneapolis/Toledo/Los Angeles 1990–91, pp. 419–20 (with extensive bibliography).

2 A drawing dated 1641 is located in The National Maritime Museum in Greenwich; van de Velde the Elder's earliest drawing is dated 1638. See Robinson 1990a, p. 4.

3 Vienna 1993, p. 148, n. 4; New York/Fort Worth 1995, p. 148, n. 4.

Willem van de Velde the Younger

LEIDEN 1633–1707 LONDON

95 *The Naval Battle at La Hogue*, c. 1701

Pen and brown ink, gray wash

29.6 x 46.4 cm

MONOGRAMMED AT LOWER LEFT: "W.V.V J"; inscribed at upper left: "no 2" (by a later hand); "La Hogue 1692 1. 2. 3. Juny" (by the artist)

PROVENANCE: M. Suppantschitsch, Krems; acquired by the Albertina in 1954

INV. NO. 31521

BIBLIOGRAPHY: Benesch 1964, no. 201, illus.; Vienna 1993, no. 84, illus.; New York/Fort Worth 1995, no. 74, illus.

The marine painter Willem van de Velde the Younger was the son of Willem van de Velde the Elder (cat. no. 94); the landscape painter Adriaen van de Velde (cat. nos. 54, 105) was his younger brother. Willem the Younger was trained by his father.[1] From 1650 to 1652, he apprenticed in Weesp with Simon de Vlieger (cat. no. 69), whose influence is notable in the atmospheric quality of his early seascapes and beach scenes. His rendering of light effects and reflections in the water was also significantly influenced by the works of the Amsterdam marine painter Jan van de Capelle.

Willem van de Velde the Younger worked closely with his father, an experienced draftsman who produced the studies of maritime events, naval battles, and ships from which the son created his paintings. Drawings by the younger artist from 1666 are known.[2] Due to the political and economic crisis in the Netherlands brought on by military conflicts with the French in 1672, father and son moved to England in the winter of 1672–73, where they were highly successful as marine painters for the royal court. In this capacity, their principal subjects shifted from war themes to royal maritime ceremonies; naval battles, however, continued to figure in their repertoire of images.

The present drawing depicts the battle at La Hogue in which twelve ships remaining from a recently defeated French flotilla were destroyed by English and Dutch forces (June 1–3, 1692, as inscribed on the sheet).[3] Further drawings by van de Velde on this same theme exist and one is dated 1701, suggesting a date for the entire group, including the present drawing.[4]

The apparent ease of execution evident in this sheet is in actuality the result of decades of the artist's intensive work grappling with problems of perspective, wind direction, and the effects of light.[5] The younger van de Velde is known to have studied different weather conditions from a boat.[6] The shorthand notation of the masts of the flotilla on the horizon contrasts effectively with the heavy forms of the burning ships in the foreground. Sunlit clouds of smoke obscure the more distant ships, intensifying the drama of the scene. The classical balance of the composition contrasts noticeably with the cursory, sometimes forceful strokes. Beyond the drawing's objective content, the subject suggests an idealized view of destruction—an impression possibly due in part to the lapse of time between the historical event and the later date of the drawing. This drawing is among the best and most characteristic of van de Velde's late works.

1 Biographical details are from Russell 1992, pp. 9–26.

2 Ibid., p. 15.

3 On May 19, 1692, Admiral Edward Russell and an Anglo-Dutch flotilla conquered the French under Comte de Tourville at Cap Barfleur. In a subsequent action, the remaining French ships were destroyed by fire in the bay of La Hogue by Sir George Rooke. Further details are given in Vienna 1993, p. 156, n. 3, and New York/Fort Worth 1995, p. 165, n. 3.

4 Three drawings in the British Museum and a drawing in The National Maritime Museum, Greenwich. See Vienna 1993, p. 156, n. 4, and New York/Fort Worth 1995, p. 156, n. 4.

5 Russell 1992, pp. 83–86.

6 Ibid., pp. 86–88.

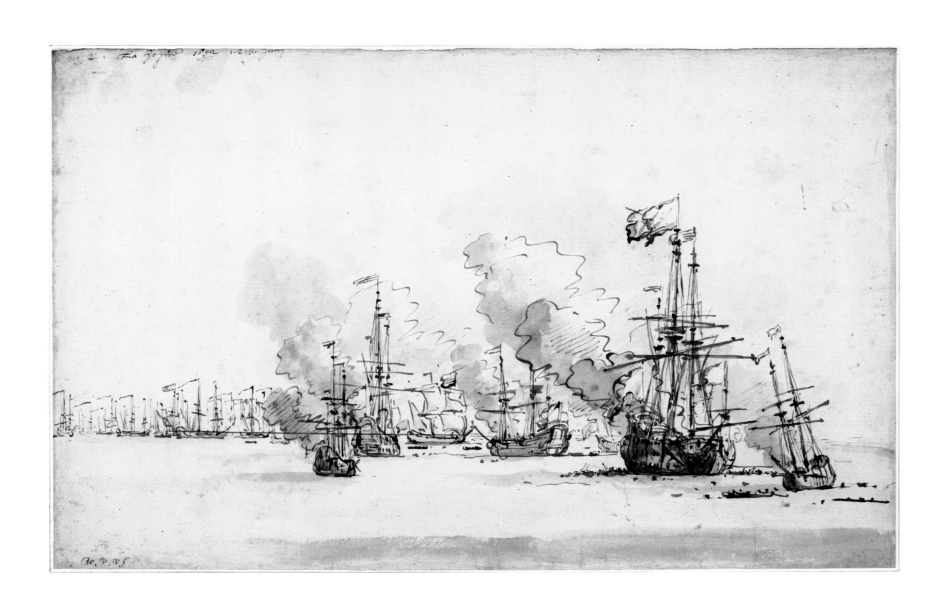

Ludolf Bakhuizen (Backhuysen)

EMDEN 1630–1708 AMSTERDAM

96 *Harbor View with an Approaching Storm,* 1688
97 *Stormy Sea with a Ship in Distress,* c. 1687
98 *Ships on a Stormy Sea,* c. 1697

CAT. NO. 96

Brush and gray ink, gray wash, white bodycolor, over graphite

24.3 x 33.3 cm

INSCRIBED AT LOWER LEFT (ON A BOARD): "L.B. 1688"

PROVENANCE: Sydervelt; Duke Albert von Sachsen-Teschen

INV. NO. 10005

BIBLIOGRAPHY: Trnek 1992, pp. 48, 50, fig. 16a

CAT. NO. 97

Brush and brown ink, brown wash, over graphite

16.9 x 27.6 cm

INSCRIBED AT LOWER RIGHT: "L B 1687" ("87" not clearly decipherable)

PROVENANCE: Duke Albert von Sachsen-Teschen

INV. NO. 10009

BIBLIOGRAPHY: Meder 1922, p. 11, pl. 44; Bernt 1957–58, vol. 1, no. 28, illus.

CAT. NO. 98

Brush and gray ink, gray wash

30.4 x 42.7 cm

INSCRIBED AT LOWER RIGHT CENTER: "L. Bak/hui(?)" (on floating barrel); "1698" (on driftwood)

PROVENANCE: G. Winckler; Duke Albert von Sachsen-Teschen

INV. NO. 17607

BIBLIOGRAPHY: Amsterdam 1985, pp. 75, 105, under no. T 21, illus.; Minneapolis/Toledo/Los Angeles 1990–91, p. 219, under no. 61; Vienna 1993, no. 83, illus.; New York/Fort Worth 1995, no. 73, illus.; Pittsburgh/Louisville/Fresno 2002, no. 77, illus.

Ludolf Bakhuizen, the son of the notary Gerard Bakhuizen, originally worked as a bookkeeper in his birthplace, Emden.[1] In 1650, he moved to Amsterdam, where he was employed as a bookkeeper and calligrapher for the merchant Guglielmo Bartolotti. At this time, he also devoted himself to drawing ships; his earliest works are "Penwerken" (carefully executed pen and ink drawings on panel or prepared canvas) in the manner of the marine painter Willem van de Velde the Elder (cat. no. 94). He was probably self-taught as an oil painter as well, though it is possible that Allart van Everdingen (cat. nos. 77, 78, 89, 93) and Hendrick Dubbels introduced him to painting in oils.[2] His fame grew in the 1660s, and beginning in 1665, he received large commissions from the mayors of Amsterdam. His artistic career was advanced when the two leading marine painters, the father and son Willem van de Velde the Elder and the Younger (cat. nos. 94, 95), moved to England in 1672. Carefully rendered weather conditions, presumably based on his own observations made at sea, are characteristic of Bakhuizen's marine paintings and drawings.[3] The pictorially finished brush drawings—his specialty—were highly valued as autonomous works of art.

Each of the present three drawings by Bakhuizen highlights, in its own manner, the artist's technical and artistic sophistication as a draftsman. *Harbor View with an Approaching Storm* (cat. no. 96) is directly related to the painting *Dutch Coastal Sailing Ships at a Mooring Place with a Light Breeze* (Vienna, Akademie der Künste), which, although unsigned, is attributed with certainty to Bakhuizen.[4] Aside from a slight difference in height of the horizon, the two works are identical in the rendering of the motifs. The frigate anchored in the distance at the right and the narrow strip of island visible on the

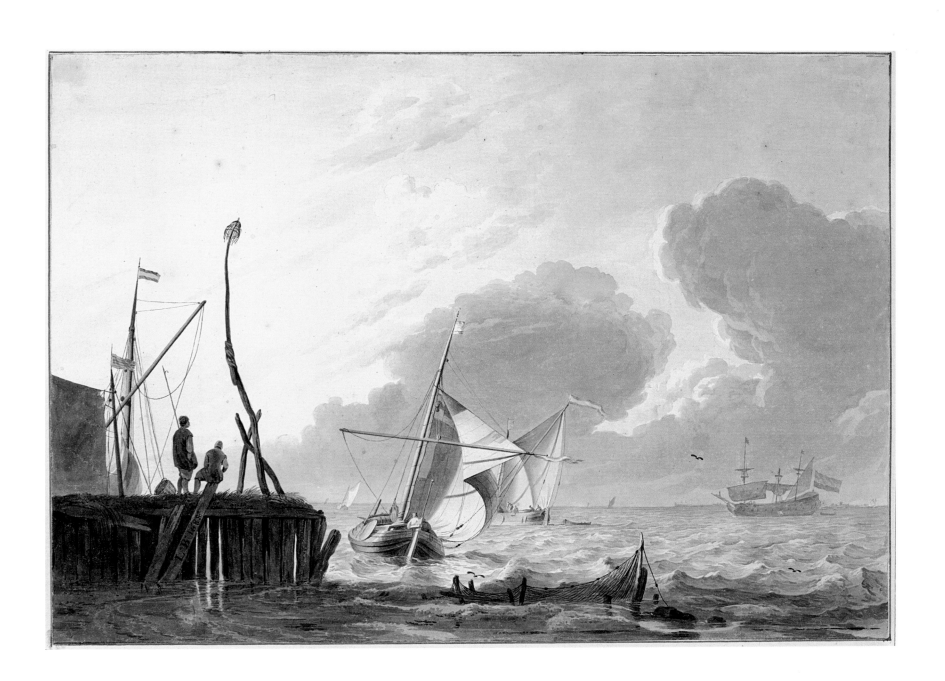

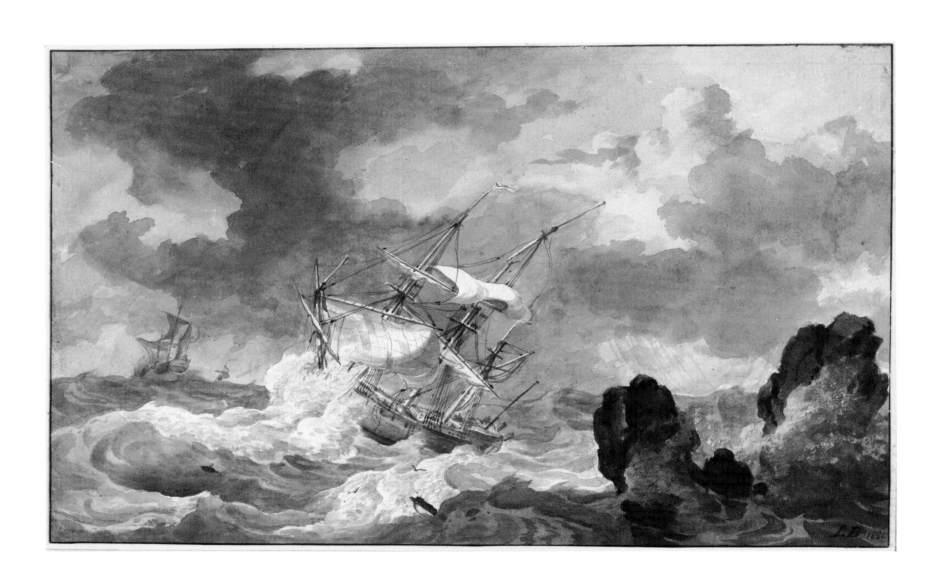

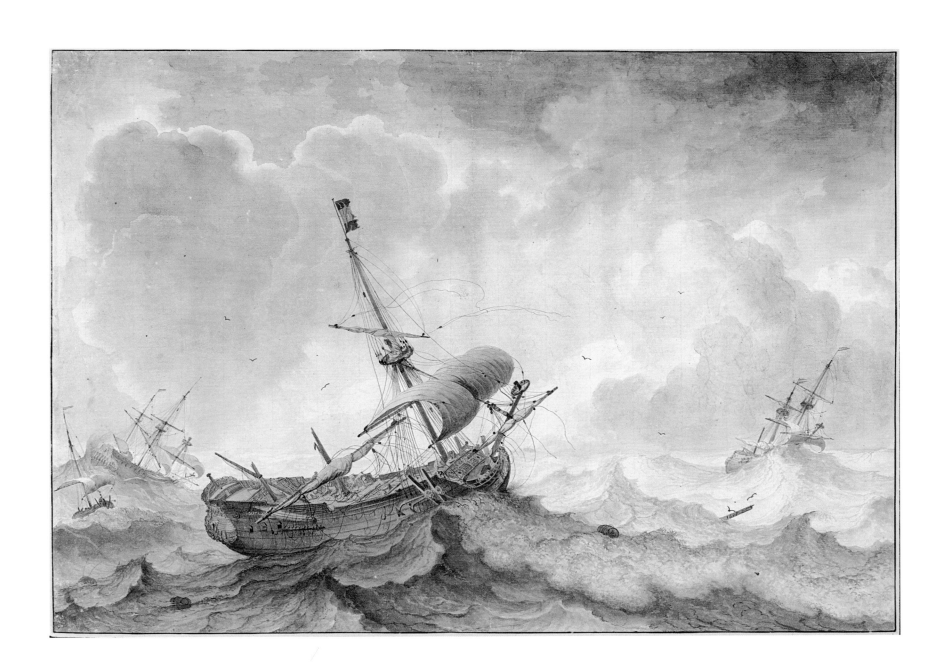

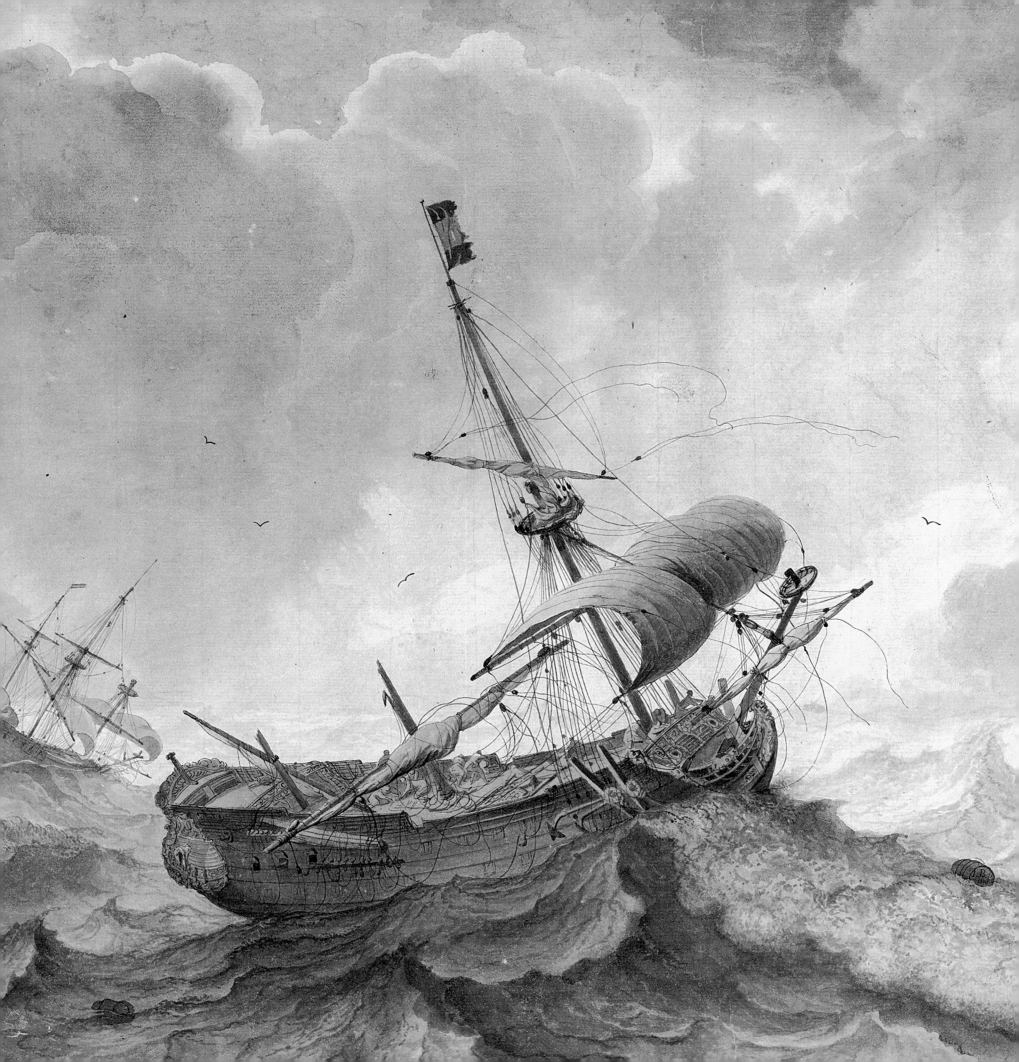

horizon have led to the supposition that Bakhuizen has depicted Den Helder roadstead (in northern Holland) that lies to the southeast of Texel Island—traditionally the most active junction for in- and outbound ships.[5] Its highly detailed execution establishes the drawing as an autonomous work produced concurrently with the painting rather than a preparatory study. Whereas the artist concentrated primarily on the coloristic effects in the painted version, in the grisaille drawing, he "hunted down the distinctive features of objective nature," to the ships' smallest details.[6] Despite the astounding precision of the fine brushstrokes—Bakhuizen did not use a pen—atmospheric values play a dominant role. In a spectrum of nuances of gray, the artist captured numerous differentiations, from the deepest darkness of the wooden pier to the sunlight that falls from the left, illuminating most of the expansive sky and diversely reflected in the sails and the lapping waves. The towering masses of clouds building on the horizon are presented far more dramatically in the painting, posing a threat within the otherwise peaceful weather conditions.

The other two drawings by Bakhuizen (cat. nos. 97, 98) represent ships in distress—a popular theme in Dutch marine painting in the sixteenth and seventeenth centuries. Metaphorically, these images suggested the fragility of all human endeavors and the impossibility of people being able to determine their own fate.[7] For many marine painters, the most vivid rendering of dramatic light conditions, high breaking waves, and severely affected ships presented a welcome challenge.

Ludolf Bakhuizen commanded this type of seascape in a virtuoso manner, as these two drawings impressively demonstrate. In the rendering in brush and brown ink (cat. no. 97), probably dated 1687, as well as in the grisaille executed at least ten years later (cat. no. 98), the impression of a highly dramatic moment is combined with the well-calculated placement of the ships and the countless refined gradations of the respective ground tones. Especially in the later drawing, this mixture of artificiality and spontaneous drama is carried to the extreme. In this hopeless battle with the elements, the calligraphy of the fine, hairlike lines of the ships' rigging joins the Manneristic elegance of the decoratively curling waves. This meticulously careful

rendering, executed solely with the brush, corresponded to the taste at the end of the seventeenth century. Although the latter drawing, like a related composition, presumably formed the foundation for a painting, the assumption can be made that this highly cultivated creation, like cat. no. 96, was produced as an autonomous work intended for sale.[8]

1 Houbraken 1753, vol. 2, p. 236. For biographical information on Ludolf Bakhuizen, see de Beer 2002, pp. 15–33.

2 Houbraken 1753, vol. 2, p. 237.

3 On Bakhuizen's study of weather conditions, see ibid., p. 238.

4 Trnek 1992, no. 16 (inv. no. 794).

5 Ibid., p. 48. Regarding the motif represented, see also Bakhuizen's painting *The Roadstead Southeast of Texel Island*, in Greenwich, National Maritime Museum. See Amsterdam 1985, no. S 6, illus.

6 Trnek 1992, p. 150.

7 Regarding the iconography of the storm at sea, see Goedde 1989.

8 Haarlem, Teylers Museum, inv. no. Q*79, pen and brush and gray ink, 30.6 x 42.6 cm (the dimensions are nearly identical to those of the Vienna drawing). See Ben Broos in Amsterdam 1985, pp. 104–105, nos. T 20, T 21, T21a, p. 75, fig. 2. See also G. Keyes in Minneapolis/Toledo/Los Angeles 1990–91, p. 219, under no. 61, and Amsterdam 2004, no. 37 (inv. no. Q*79) and no. 80 (inv. no. Q*80).

Cornelis van Poelenburch, attributed to

UTRECHT 1594/95–1667 UTRECHT

99 *The Aurelian Wall in Rome with a View of S. Stefano Rotondo,* 1620/23

Pen and brown ink, brown wash, over black chalk; blue watercolor
added by a later hand

27 x 39.1 cm

MONOGRAMMED AT LOWER RIGHT: "B.B." (by a later hand)

PROVENANCE: Duke Albert von Sachsen-Teschen

INV. NO. 9368

BIBLIOGRAPHY: Egger 1911, p. 41, pl. 80; Lugt 1929–33, vol. 2, p. 40,
under no. 782; Bernt 1957–58, vol. 1, no. 125, illus.; Vienna 1993, no. 87,
illus.; New York/Fort Worth 1995, no. 77, illus.; Schapelhouman 1998,
p. 121, under no. 264

Cornelis van Poelenburch apprenticed in Utrecht with the famous
Mannerist painter Abraham Bloemaert before moving in 1617 to Rome,
where he built a successful career. After 1625, he was presumably back
in Utrecht, where he remained, except for a period at the English court
of Charles I (1637–41). His earliest drawings and paintings suggest the
influence of Adam Elsheimer (d. 1610 in Rome) and especially the
influential Flemish Late Mannerist Paul Bril (d. 1626 in Rome).[1]
Poelenburch was a close friend of the artist Bartholomeus Breenbergh
(cat. no. 100), who came to Rome in 1619. Their early works are so
similar in style that they are sometimes difficult to tell apart.

Poelenburch was one of the earliest creators of the Netherlandish
Italianate landscape. His light-filled small paintings of ruins from the
1620s are still indebted to the Mannerist compositions of his mentor
Bril, but Poelenburch's more subtle, innovative treatment of sunlight,
atmosphere, the structure and surfaces of the architectural ruins and
settings, and aspects of local color would come to characterize his work
and that of successive Italianizing Netherlandish artists. His inventive-
ness is especially apparent in his drawings.[2] In Rome and its environs,

the artist devoted himself to the study of ruins, buildings, and landscape
motifs. The earliest known sheet from this period, dated 1619, shows
the influence of Bril, but Poelenburch quickly developed a freer pen and
wash style and a more sensitive treatment of light. In the present work,
the striking contrast between the dark areas of wash and the untouched
areas of paper creates brilliant light effects. Ink contours sharply define
the vegetation and crumbling walls.

The present drawing was considered a work by Breenbergh
until 1993, when it was attributed to Poelenburch.[3] Stylistically, it
relates to eight drawings by Poelenburch executed between 1620 and
1623 and inscribed "in roomen."[4] The angular view, dazzling illumi-
nation and heavy shadows of the masonry, and smooth transitions
between the architecture and the inclined terrain characterize this
impressive group of Italian landscapes. The massive structure in this
particular drawing is awash with intense southern light, as if embedded
in its environment.[5] Poelenburch, like Breenbergh, did not pursue an
object-oriented approach toward the Antique as many earlier artists
had done in Rome. Their interest was in the lyrical quality of decaying
buildings in a light-drenched landscape.[6]

1 Regarding the life and work of Poelenburch, see Utrecht 1965, pp. 60–61; Sluijter-Seijffert
1984; Chong 1987.

2 The drawings are catalogued in Chong 1987; see also Schatborn 2001, pp. 57–65.

3 The attribution to Poelenburch was suggested by Marijn Schapelhouman. See Vienna 1993,
p. 163, n. 4; New York/Fort Worth 1995, p. 163, n. 4.

4 Regarding the eight drawings that originated "in roomen," see Chong 1987, nos. 7–9, 13–16;
for no. 15, see Schapelhouman 1998, no. 264 (as in the Vienna sheet, blue watercolor has
been added to the sky by a later hand).

5 The identification of the edifice was first established in Egger 1911. For additional
representations of this motif, see Vienna 1993, p. 163, n. 7.

6 On the other hand, this drawing is clearly rooted in the tradition of Willem van Nieulandt
and Paul Bril. See New York/Fort Worth 1995, p. 163, n. 7.

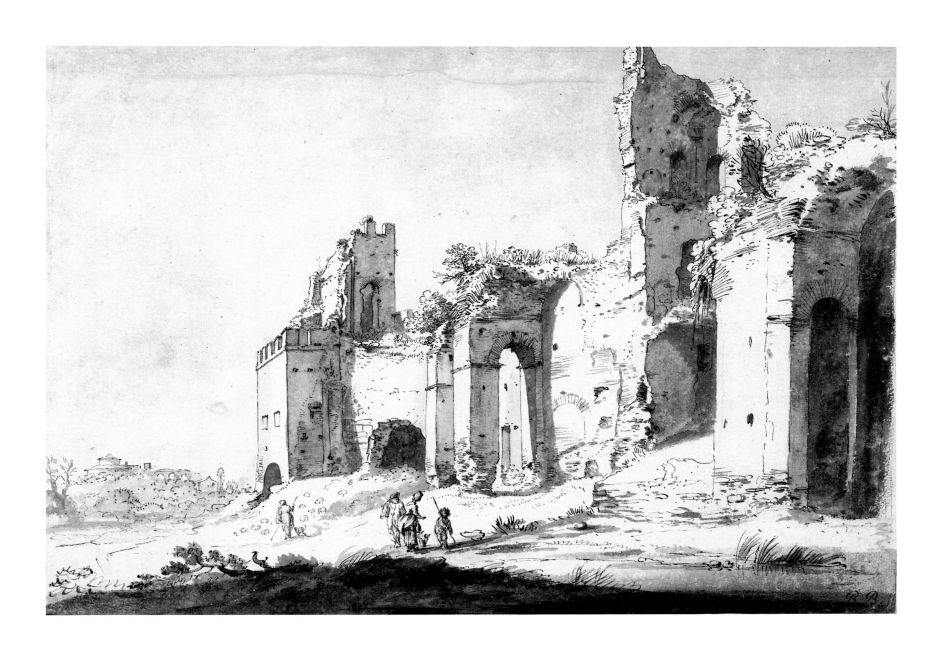

Bartholomeus Breenbergh

DEVENTER 1598–1657 AMSTERDAM

100 *View of Mugnano,* 1624/27

Pen and brush and brown ink, over black chalk

24.3 x 32.9 cm

INSCRIBED AT LOWER LEFT: "Bartholomeus Breenbergh / f Ao 1627"

PROVENANCE: Duke Albert von Sachsen-Teschen

INV. NO. 9366

BIBLIOGRAPHY: Vienna 1964–65, no. 56; Benesch 1964, no. 160, illus.; Roethlisberger 1969, pp. 8, 38, no. 99, illus.; Amsterdam 1989, p. 55, n. 2, under no. 10; Vienna 1993, no. 88, illus.; New York/Fort Worth 1995, no. 78, illus.

Little is known about the early life of Bartholomeus Breenbergh; perhaps he apprenticed with Jacob Pynas in Amsterdam, where documentation shows he was in October 1619.[1] Between 1619 and 1629, Breenbergh lived in Rome, where he worked with the considerably older Flemish master Paul Bril (1554–1626). Bril was one of the most influential representatives of Late Mannerism, and Breenbergh copied several of his works. The painter Cornelis van Poelenburch (cat. no. 99), who had arrived in Rome two years before Breenbergh in 1617, was also greatly inspired by Bril's work. Both Poelenburch and Breenbergh turned at the same time to the study of nature, developing an innovative approach: many drawings by the two young artists capture the painterly appeal of the Campagna, the rural environs of Rome. Their sketches in pen and wash display a great preference for dramatic chiaroscuro effects.[2] Their freely executed drawings of landscape and architectural motifs flooded with light rank them among the greatest of the first generation of Italianizing artists. The close stylistic relationship of the two artists is especially evident in the works they produced during the time they shared in Italy.

After Poelenburch's departure in 1625, Breenbergh remained in Rome for another four years, and a new stylistic phase began for the artist.[3] His landscapes show a distinct predilection for extreme angles and intensified contrasts, with an even freer handling of the drawing medium. The present sheet, which represents this phase, belongs to a group of twelve extraordinary drawings that Breenbergh produced during a three-year period (1624–27) in the Bracciano area, where the property of his patron, Duke Paolo Giordano Orsini, was situated.[4]

Striking in *View of Mugnano* are the exceptionally low viewpoint and the extreme diagonal effects. Brilliant sunlight bathes the sharply angled, overlapping forms of the houses, which appear to grow out of the steep cliffs. The originality of Breenbergh's drawing style is revealed in his choice of motif as well as in the tension between his generous, fluid brushwork—especially in the powerful areas of shadow—and his subtly differentiated handling of line. With delicate strokes in brush and pen, the artist emphasized the diverse surface values of the brilliantly lit planar areas of the walls and cliffs.

The greater and most significant part of Breenbergh's body of drawings originated in Italy. On the other hand, he produced the majority of his paintings, like his etchings, following his return to the Netherlands.[5]

1 Roethlisberger 1991, pp. 2–3. Regarding the life of Breenbergh, see Roethlisberger 1969, pp. 3–5; Schatborn 2001, p. 66.

2 For recent literature on Breenbergh's drawings, see Schatborn 2001, pp. 66–73.

3 Roethlisberger 1969, pp. 11–12.

4 Ibid., p. 8; Schatborn 2001, p. 67.

5 Roethlisberger 1991, p. x.

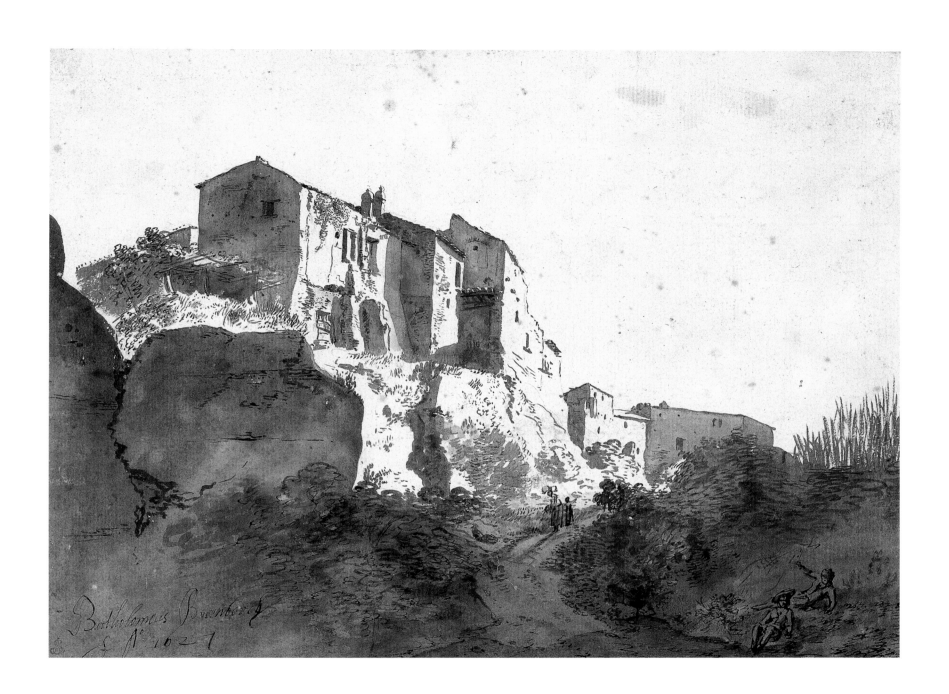

Bartholomeus Breenbergh
f. Nᵒ 1627

Jan Asselyn

DIEPPE C. 1610/14–1652 AMSTERDAM

101 *View of the Chancel of the Church of SS. Giovanni e Paolo in Rome,* c. 1638

Brush and gray-brown and brown ink, gray-brown and brown wash, over graphite

25.1 x 27.6 cm

INSCRIBED AT LOWER RIGHT IN INK: "asselyn" (original signature?)

PROVENANCE: G. Winckler; Duke Albert von Sachsen-Teschen

INV. NO. 9110

BIBLIOGRAPHY: Egger 1911, vol. 1, pl. 88; Egger 1931–32, pl. 99; Vienna 1964–65, no. 273; Utrecht 1965, p. 132, n. 1; Steland-Stief 1971, pp. 40–42, pl. XII; Steland 1989, pp. 24–25, 246, no. 154, fig. 40, pl. 20; Vienna 1993, no. 89, illus.; New York/Fort Worth 1995, no. 79, illus.

Jan Asselyn, who emigrated with his family from Dieppe, France, to Amsterdam, was trained by Jan Martsen de Jonge—a pupil and nephew of Esaias van de Velde (cat. nos. 13–16)—as an artist specializing in cavalry battles.[1] This theme dominated his earliest paintings and drawings in 1634–35. Presumably he departed for the south in 1636, remaining at least until 1644 in Rome, where he was influenced by Pieter van Laer and was in contact with the brothers Jan and Andries Both. After living for a time in Lyon in 1644, Asselyn spent 1644–45 in Paris, where he married the Frenchwoman Antoinette Huart. There he produced several paintings for the Hôtel Lambert and drew designs for three series of etchings executed by Gabriel Perelle that depict motifs from Rome and its environs. Documents show that in 1647 Asselyn was in Amsterdam, where he presumably lived until his early death.

In Rome, Asselyn turned to an intensive study of landscape and architecture. Expansive paintings flooded with sunlight and subtly recorded drawings make Asselyn, like Jan Both (cat. no. 104), one of the main representatives of the second generation of Italianizing Netherlandish artists.[2] The present work, which depicts the church, monastery, and campanile of SS. Giovanni e Paolo, belongs to a group of drawings from the artist's early years in Rome that present a number of architectural motifs rendered on site.[3] A moderately low viewpoint that allows the structures to fill the width of the sheet and the differentiated application of the media are characteristic of these works. The preliminary drawing was set down in graphite, followed by brushwork in several tonal gradations of gray and brown. A diverse range of shading was applied in broad brushstrokes, leaving untouched passages of the paper support in between to radiate as sunlit areas. Asselyn added the finishing touches with a fine brush. He was interested in the effects of broken sunlight in areas of shadow and the subtly changing light that emphasizes the surface features of the buildings. The combination of the characteristic architectural forms and the southern light conditions in this architectural study conveys an Italian mood that is very individual.

1 Regarding the life of Jan Asselyn, see Steland-Stief 1971, pp. 13–19; Steland 1989, pp. 11–14; Schatborn 2001, pp. 100–102.

2 Regarding the drawings of Asselyn, see Schatborn 2001, pp. 101–109.

3 The drawing *View of Porta del Popolo, Rome* (inv. no. 9109), also located in the Albertina's collection, is closely related in size and execution. Regarding the painted version of the left half of the image and the copy of the present drawing, see Vienna 1993, p. 166, n. 2; New York/Fort Worth 1995, p. 166, n. 2.

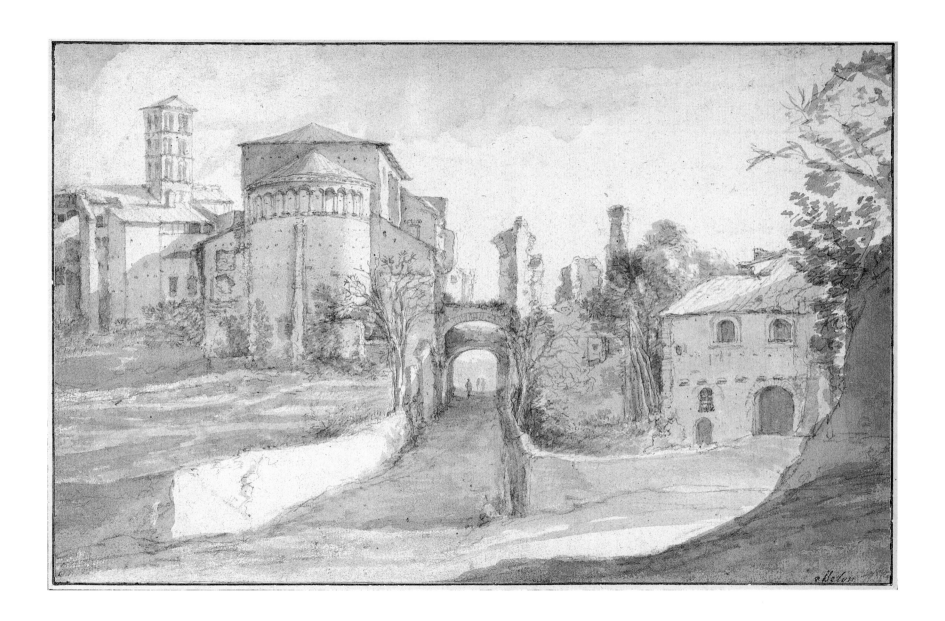

Nicolaes Berchem

HAARLEM 1620–1683 AMSTERDAM

102 *River Landscape near Montfoort*, c. 1655

Black chalk, brush and brown ink, pen and black-brown ink
(in the boats), gray and brown washes

28.1 x 44.2 cm

PROVENANCE: G. Winckler; Duke Albert von Sachsen-Teschen

INV. NO. 10107

BIBLIOGRAPHY: Michel 1910, p. 151, illus.; Benesch 1964, no. 192, illus.;
Knab 1969, p. 136, fig. 19; Roethlisberger-Bianco 1970, p. 101, under
no. 159; Broos and Schapelhouman 1993, p. 120, fig. a; Slive 2001,
no. DubD 50; Stefes 1997, no. II/57

Nicolaes Berchem, one of the most popular and versatile Italianizing
artists, was the son of the still-life painter Nicolaes Claesz. Arnold
Houbraken mentions a large number of possible masters for him—
Jan van Goyen, Nicolaes Moeyaert, Pieter de Grebber, Jan Wils, and
Jan Baptist Weenix—but this information cannot be confirmed.[1]
In 1642, Berchem joined the Guild of St. Luke in Haarlem. He is
documented in Haarlem in 1656, 1657, and 1670, and there is evidence
that he was in Amsterdam in 1660 and 1677. However, a trip to Italy
cannot be substantiated. His early works were inspired by depictions
of animals by Pieter van Laer (1592/95–1642). The works of Jan Asselyn
and Jan Both (cat. nos. 101, 104) were influential for their rendering
of the southern landscape and the Mediterranean light. Berchem was
also influenced by Jacob van Ruisdael (c. 1628–1682), with whom he
traveled to Bentheim around 1650.[2]

Berchem was very productive as a draftsman and a painter.
At the beginning of his career, he drew primarily historical and pastoral
scenes and figure and animal studies. Beginning in the 1650s, landscape
came increasingly to the fore, and his preference for expansive, hilly
scenery emerged. As *River Landscape near Montfoort* demonstrates, the
southern landscape was not his only area of interest.

Despite the historical attributions of this drawing to van Ruisdael
(Michel 1910, Knab 1969) and Asselyn (Benesch 1964), the attribution
to Berchem gained increasing support (Broos and Schapelhouman
1993). The question of authorship was finally resolved with the
discovery of Berchem's signed oil painting, for which the drawing had
apparently served as a preparatory model (Stefes 1997). Presumably
the artist drew on site the little town of Montfoort, which lies on
the Ijssel River in the southwestern part of the province of Utrecht.
Pieter Mulier, who moved to Italy in 1655, drew the same view from
a somewhat different angle.[3] Despite the Netherlandish motif, the
warm, penetrating light conveys a southern impression. With great
subtlety, Berchem differentiated between three parallel zones of
landscape: the dramatic chiaroscuro of the sky heavy with clouds, the
vegetation and walls along the banks distinctly modeled by sunlight,
and the reflections in the water broken by the gentle current. Berchem's
many-layered brush and chalk technique is optimally realized in this
impressive study of light. Characteristic of his working methods in this
period are lively brushstrokes over delicate, angular chalk lines.
The boats at the far left are a later addition, presumably by Isaac de
Moucheron (1667–1744).[4]

1 Houbraken 1753, vol. 2, p. 111.

2 On Berchem's life and work, see Utrecht 1965, pp. 147–49, nos. 73–94; and especially in
 regard to the drawings, see Schatborn 2001, pp. 187–95.

3 Broos and Schapelhouman 1993, no. 86, illus.

4 Stefes 1997, no. II/57. The drawing by Jan de Bisschop *View of The Hague from the Northwest,
 with Delft in the Distance* (cat. no. 87) also shows additions most likely by Isaac de Moucheron.
 See Broos 1989, pp. 34–35, 45 regarding this practice, which was popular in the eighteenth
 century. The author wishes to thank most heartily Annemarie Stefes, who generously provided
 information on Albertina drawings from her unpublished dissertation.

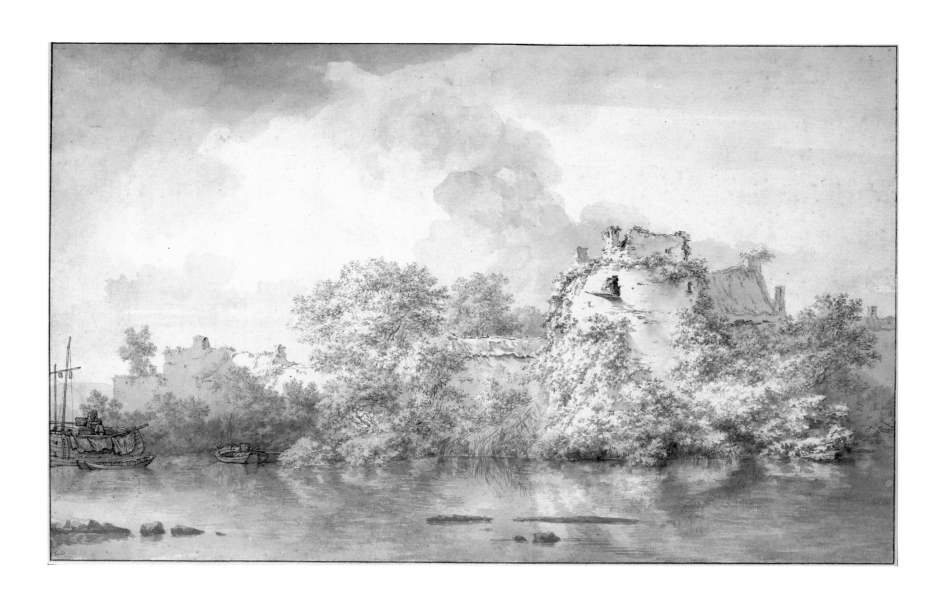

Nicolaes Berchem

HAARLEM 1620–1683 AMSTERDAM

103 *Imaginary Rocky Landscape with a Castle and Hunters,* late 1670s

Black chalk, pen and brush and gray ink, gray wash, white bodycolor
29.8 x 51 cm (section of a passe-partout)
INSCRIBED AT LOWER LEFT: "NBerchem f." ("NB" joined)
PROVENANCE: Possibly Auction Muilman, Amsterdam, March 29, 1773
et seq.; Auction Neyman, Paris, July 8, 1776; Auction Jan Gildemeester,
Amsterdam, November 24, 1800 et seq., sold to Yver; Duke Albert
von Sachsen-Teschen
INV. NO. 9808
BIBLIOGRAPHY: Von Sick 1930, no. 86; Benesch 1964, no. 198, illus.;
Vienna 1993, no. 93, illus.; New York/Fort Worth 1995, no. 82, illus.;
Stefes 1997, no. IV/13

Using subtle variations in his chalk and brush technique, Nicolaes
Berchem created this imaginary rocky landscape in the late 1670s.
The detailed execution of the work, which creates a striking contrast
to the monumentality of the composition, is unusual for the artist.
Deeply fissured masses of rock rise up behind the narrow shoreline
area in the foreground, which is animated with hunters and shepherds.
The forms of the craggy cliffs dissolve increasingly into the misty
atmosphere as they recede into depth. The castle seems to grow out
of the rock, the thin spire of its tower crowning the cliffs.

 In execution, size, and signature, this drawing corresponds to
six other landscape drawings by Berchem. The seven sheets appear
to comprise a series that may have been intended for a series of prints
based on the drawings.[1] Their suitability for reproduction is evident in
the etchings produced in the eighteenth century by the French engraver
Gabriel Huquier after four of the drawings.[2]

The theme of fantastic rock formations combined with the
artist's meticulously detailed technique points to a trend toward the
archaic in Berchem's work similar to Herman Saftleven's late *Rhine
Fantasies* of the 1670s (see cat no. 80).[3] Indeed, various stylistic
elements and traditions come together in Berchem's work. The many
layers of cliffs overgrown with conifers recall examples by Roelant
Savery (cat. nos. 3, 4) and his circle. The organic connection between
the architecture, which may have been viewed in reality, and the
powerful forms of the cliffs is reminiscent of fantastic Flemish
mountain landscapes from the sixteenth century. The motif of the
passageway through a rocky outcropping with figures illuminated from
behind is common in the works of many Italianizing Netherlandish
artists. Pastoral details are also part of Berchem's repertoire of motifs.
Here, the artist has successfully blended these diverse elements into
an atmospheric unity in which the diffuse light contributes considerably
to the distant, fairytalelike mood of this extremely delightful image.

1 Beyond the five sheets cited previously (Vienna 1993, p. 174, n. 1; New York/Fort Worth
 1995, p. 172, n. 1), an additional drawing is mentioned here: Nicolaes Berchem, *Mountain
 Landscape with Horseman, Beggars, and Reapers*, Groningen, Groninger Museum. Black
 chalk, brush in gray, white bodycolor, 30.3 x 48.7 cm. See Schatborn 2001, p. 192, fig. H.

2 Two of these etchings were produced after drawings now in the Albertina collection: H. I,
 no. 157 after the present sheet and H. I, no. 158 (*The Ferry*) after inv. no. 17669. See details
 in Vienna 1993 and New York/Fort Worth 1995, as cited in note 1.

3 Vienna 1993, p. 174; New York/Fort Worth 1995, p. 172.

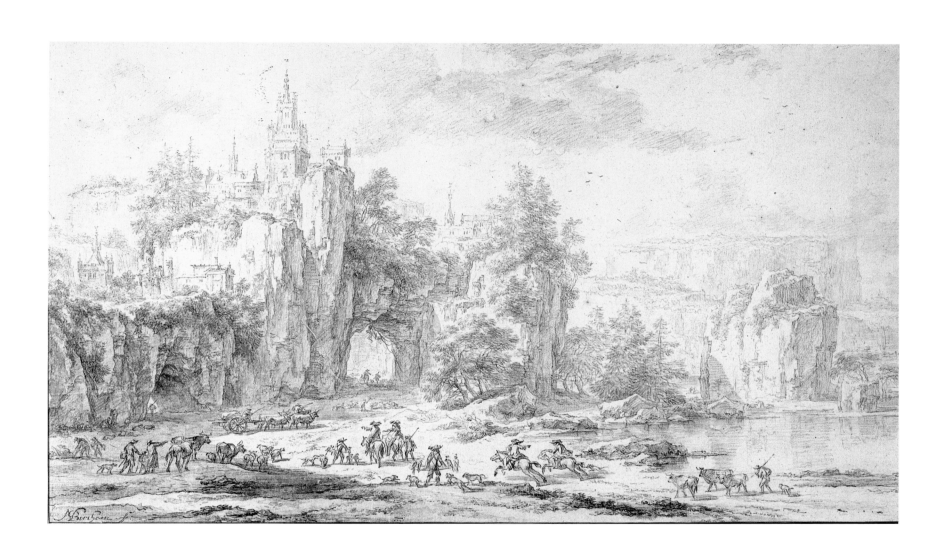

Jan Both

UTRECHT (?) C. 1618–1652 UTRECHT

104 *Wooded Mountain Landscape with Travelers,* late 1640s/1650

Brush and light and dark gray inks, gray wash, over black chalk and graphite

31.3 x 41 cm

INSCRIBED AT LOWER RIGHT IN GRAPHITE: "B..."; in ink: "Both"

PROVENANCE: G. Winckler; Duke Albert von Sachsen-Teschen

INV. NO. 9122

BIBLIOGRAPHY: Vienna 1964–65, no. 283; Burke 1976, p. 283, no. D 44; Vienna 1993, no. 91, illus.; New York/Fort Worth 1995, no. 80, illus.; Schatborn 2001, pp. 98–99, illus.

Jan and Andries Both (Utrecht 1612/13–1642 Venice) were sons of the glass-painter Dirck Both. It is unknown whether Jan Both apprenticed in Utrecht with Abraham Bloemaert, like his elder brother, or with Cornelis van Poelenburch (cat. no. 99); even less is known about Jan's life than Andries's.[1] The brothers lived for a time in Rome. Andries, a painter of genre scenes, was documented in Rome in 1635, while Jan, whose work focused on landscape, appeared in 1638 as a member of the Accademia di San Luca. Although only a few of his Roman works are known, Jan Both must have been successful: he was among a select group of artists—Claude Lorrain, Herman van Swanevelt, Nicolas Poussin, and Gaspard Dughet—who furnished landscape paintings for "Buen Retiro," the residence of the Spanish king Philip IV. On the brothers' journey home in 1642, Andries drowned in Venice.

Jan's presence in Utrecht was recorded beginning in 1644, and before his death there in 1652, he created an impressive oeuvre as a painter, draftsman, and etcher. His landscape art was influenced by the artists he had encountered in Rome, including Jan Asselyn (cat. no. 101). His stay in Rome largely coincided with Asselyn's, and the two are considered primary representatives of the second generation of Italianizing Netherlandish artists.

Despite the large number of drawings assigned to him, only a few sheets can be attributed to Jan Both with certainty.[2] Many copies and imitations point to the great influence he had on his contemporaries after his return to the Netherlands.[3] The present, pictorially composed landscape is one of the artist's finest drawings. It displays many of the traits of his idealized southern landscapes: tall groups of trees to one side near the paper's edge, a thickly vegetated foreground, and a distant view of gentle hills, with the scene animated by a few figures that are either traveling or resting. The density of the landscape features, the complex, interwoven layers of space, and the diverse nuances of light and shadow indicate a date in the late 1640s, though a date close to two paintings dated 1650 is also possible.[4] Unlike a few other similarly finished drawings, no corresponding painting is known in this instance.[5] In any case, Both achieved with the drawing media the monochrome equivalent of the glowing palette of his paintings, in which sunlight illuminates the edges of the landscape forms at an angle, intensifying the depth and weight of the shadows. The present drawing exhibits a similar intensity: backlighting dissolves contours in a painterly manner, while the mysterious shimmer of the vegetation is heightened effectively by sharp accents. Like his paintings, Both's drawings present a poetically transformed memory of the southern landscape he experienced.

1 Regarding the life of Jan Both, see Utrecht 1965, pp. 112–15; Schatborn 2001, pp. 88–99.

2 For Both's drawings and the problem of copies and imitations, see Schatborn 2001, p. 88–99.

3 Ibid., p. 98.

4 Regarding the dating, see Burke 1976, p. 283, no. D 44; the paintings dated 1650 are *Landscape with Robbers Leading Prisoners* (Boston, Museum of Fine Arts); *Landscape with a Draftsman* (Amsterdam, Rijksmuseum). See Vienna 1993, p. 170, n. 6; New York/Fort Worth 1995, p. 168, n. 6.

5 Burke 1976, p. 283, no. D 44.

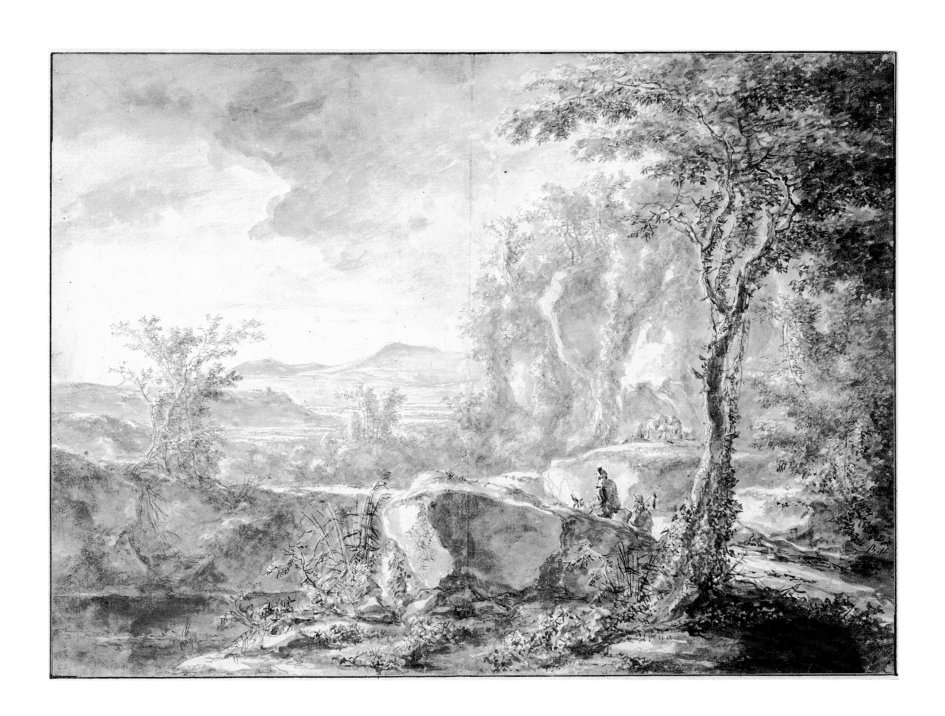

Adriaen van de Velde

AMSTERDAM 1636–1672 AMSTERDAM

105 *Shepherdess and Shepherd with Animals at a Stream,* c. 1667

Brush and gray and brown ink, over black chalk

26.1 x 24.9 cm

INSCRIBED AT LOWER LEFT: "A van de Velde"

PROVENANCE: C. Ploos van Amstel (Auction Amsterdam, March 3, 1800, no. F 11); Duke Albert von Sachsen-Teschen

INV. NO. 17605

BIBLIOGRAPHY: Vienna 1993, no. 96, illus.; New York/Fort Worth 1995, no. 85, illus.

Adriaen van de Velde was an extraordinarily diverse artist who worked with equal ease as a painter, draftsman, and etcher. This mastery of several techniques allowed him great flexibility in his work. His drawings encompass landscape studies "nae't leven" ("from life"), compositional sketches in which he noted his first ideas, chalk studies for figures and animals in his paintings (see cat. no. 54), and "modelli"—carefully executed drawings to which the artist directly referred in the preparation of his paintings.[1]

The present drawing, which belongs to the "modelli" category, relates to a painting (dated 1667) as well as to a compositional sketch and two figure studies from different phases.[2] Van de Velde combined studies from nature of figures and animals with landscape motifs, possibly borrowed from other artists, into a pastoral idyll. Beyond the intense sunlight, the southern character of the scene is articulated in the background hills and the arched structure at the right (both of which are even more pronounced in the painting). Using only a few colors and carefully nuanced brushwork, the artist evoked an infinite spectrum of dark and light values as well as surface textures.

A watering place for animals was a common motif for the Italianizing artists, and it occurs in van de Velde's Dutch landscapes as well as in his southern views. In the present instance, Arcadian timelessness and the realism of a momentary event merge in a characteristic combination for the artist. Antique and realistic elements unite in the figure of the shepherd washing his feet: his pose refers to the Roman statue *Lo Spinario* (a boy extracting a thorn from his foot), yet his appearance is very Dutch in character.[3]

1 See Robinson 1979.

2 The connection between the drawing and the painting was published for the first time in Vienna 1993, no. 96, illus.; New York/Fort Worth 1995, no. 85, illus. The painting appeared at auction on July 9, 1993 at Christie's, London, no. 161, illus., and is now located in a private collection. Regarding the other drawings, see Robinson 1979, p. 19, no. B 11, pl. 8; p. 21, no. D 6, pl. 7; p. 21, no. D 7, pl. 9. Cornelis Ploos van Amstel, who owned the sheet at one time, produced an aquatint after the Albertina drawing. See Robinson 1979, p. 20, no. C 4, p. 12, fig. 7.

3 Stechow 1966, p. 162, fig. 329. The author refers to the painting *The Shepherd*, formerly of the Cooke Collection, which is a variant of the painting discussed here, in which the figure of the shepherd appears without a female companion.

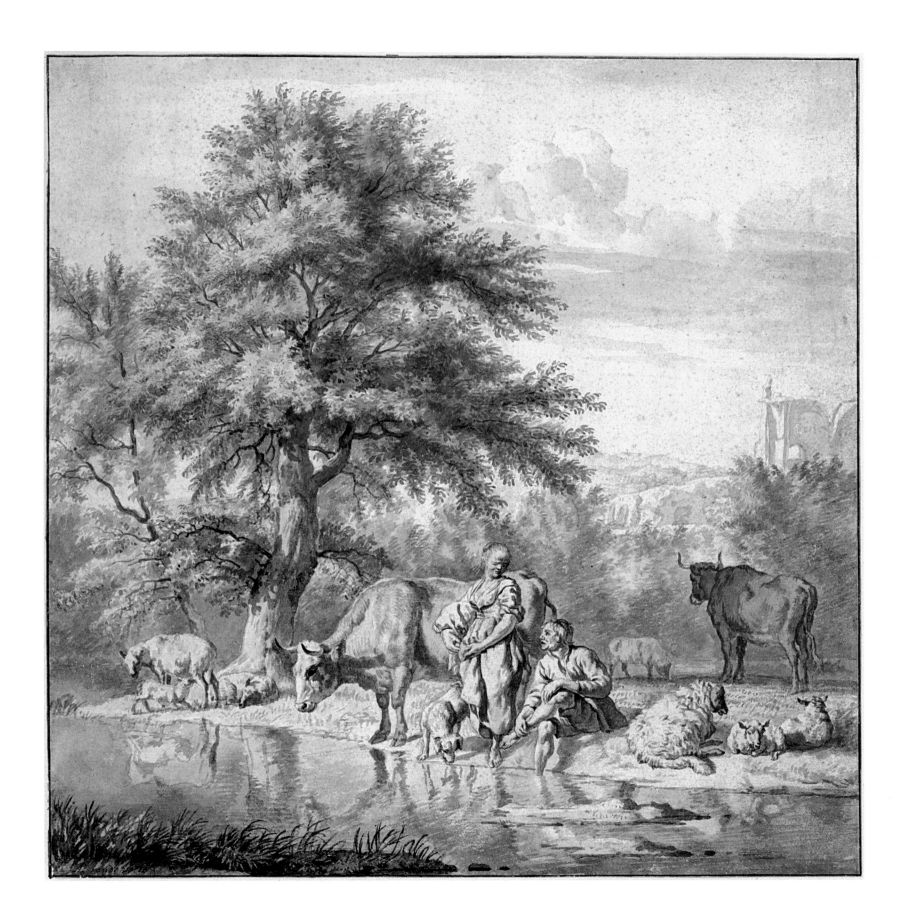

Jan de Bisschop

Amsterdam 1628–1671 The Hague

106 *Southern Landscape with Mountains and a River Plain,* c. 1650s

Brush and brown ink, brown wash, over graphite

12.2 x 16.8 cm

INSCRIBED AT UPPER RIGHT IN PEN AND BROWN INK: "Bisschop"

PROVENANCE: Duke Albert von Sachsen-Teschen

INV. NO. 10100

BIBLIOGRAPHY: Vienna 1964–65, no. 345, fig. 40; van Gelder 1971, p. 209, n. 36; Vienna 1993, no. 98, illus.; New York/Fort Worth 1995, no. 87, illus.

Jan de Bisschop was a lawyer by profession at the judicial court at The Hague after 1652 and a skilled amateur draftsman and an important connoisseur of the Antique.[1] His drawings and prints earned him great fame. De Bisschop was distinguished for his publications *Signorum veterum Icones* (1668–71), which includes one hundred etchings after Antique sculptures, as well as *Paradigmata Graphices* (1671), a collection of etchings after Italian drawings.[2] The details of his training are uncertain, but it is supposed that after completing his education at the Latin School in Amsterdam, he studied with Bartholomeus Breenbergh (cat. no. 100), who had been in Rome between 1619 and 1629. Through Breenbergh, de Bisschop may have seen and copied drawings produced in Rome by artists such as Herman van Swanevelt, Cornelis van Poelenburch (cat. no. 99), Claude Lorrain, and Nicolas Poussin.[3]

De Bisschop's some 500 drawings include copies after paintings, drawings, and prints by contemporaneous and earlier masters, drawings after Antique sculptures, a few portraits and genre scenes, and a large group of city views and landscapes. Of the approximately seventy-five drawings that are southern in character, some focus on Italian architectural motifs, although de Bisschop never visited Italy. This fact makes

even more astonishing his convincing rendering of southern light conditions, especially evident in the present drawing, in which raking sunlight illuminates a hilly landscape that recalls the Roman Campagna.[4] Backlighting brings the scene alive: bright areas of the paper, untouched by the brush, contrast effectively with the washes. Forms dissolve in light and shadow, and the diverse nuances of the ink flow gently into one another. The silhouettes of the donkey and his human companion provide a striking accent within the spatial dynamic of this small, densely arranged landscape. The slightly elevated vantage point allows a broad view over the plain.

The drawing is undoubtedly one of de Bisschop's finest efforts. Its chiaroscuro effects combined with broadly applied, subtle washes convey a very individual interpretation of the southern landscape. The broad ranges of brown ink flow easily to create seamless transitions from dark to light. The rust-brown medium that is a distinguishing feature of his works was a mixture of tusche and copper red, which was known as "Bisschops Inkt" in the eighteenth century.[5] This wash style was characteristic of de Bisschop's drawing style of the 1650s. In addition to the influence of Breenbergh, the work of Jan Asselyn (cat. no. 101) and the wash style of the French artist Nicolas Poussin may have played a role in shaping his Italianate drawings.[6]

1 Regarding Jan de Bisschop's life and work, see van Gelder 1971; Amsterdam/Zwolle 1992; Schatborn 2001, pp. 196–99.

2 Schatborn 2001, pp. 198–99.

3 Amsterdam/Zwolle 1992, p. 22.

4 A considerably larger drawing that relates in motif and execution is located in Paris, Fondation Custodia, Institut Néerlandais; see Vienna 1993, p. 184, n. 6, and New York/Fort Worth 1995, p. 182. See also Schatborn 2001, p. 196 (fig. A), p. 198.

5 Amsterdam/Zwolle 1992, p. 15, n. 24.

6 Regarding possible inspiration by Asselyn, see Vienna 1993, p. 184, n. 8, and New York/Fort Worth, p. 182, n. 8; and in general on artistic influences, see Schatborn 2001, p. 198.

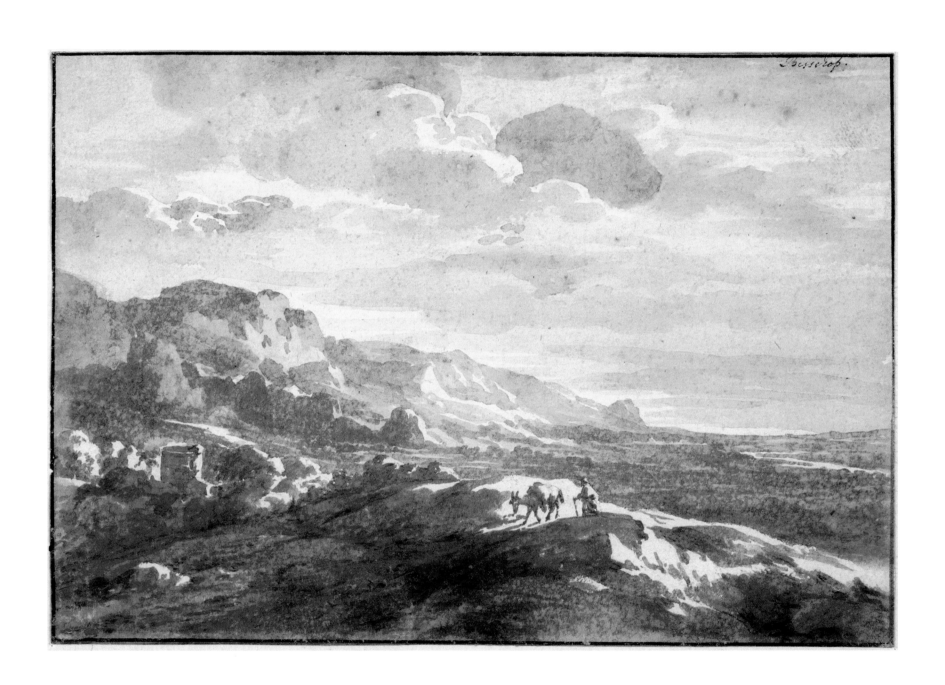

Willem Schellinks

AMSTERDAM 1626/27–1678 AMSTERDAM

107 *The Fontana Nuova near Valletta,* c. 1664

Pen and brown ink, brown and gray wash, over black chalk, on five adjoined sheets
31.6 x 66.9 cm
INSCRIBED AT LOWER CENTER: "W Schellinks ft 1664 op Malta na 't leven" (partially cut off at lower edge)
PROVENANCE: Duke Albert von Sachsen-Teschen
INV. NO. 15179
BIBLIOGRAPHY: Aikema 1983, p. 123, fig. i; Vienna 1993, no. 101, illus.; New York/Fort Worth 1995, no. 90, illus.; Schatborn 2001, pp. 176–77, fig. H

Though nothing is known about his training, Willem Schellinks was distinguished above all for drawings of topographical motifs that he produced during two long trips.[1] The first trip was along the Loire River during six months in 1646 with his contemporary Lambert Doomer (cat. no. 81). The views Schellinks drew at various locations, which he repeated in subsequent versions, reveal the influence of Doomer's characteristic pen and wash style. In drawings Schellinks produced after his return, the increasing influence of Jan Asselyn (cat. no. 101) is notable; it is possible that Schellinks worked with this important Italianizing artist in Amsterdam.[2]

The second, more lengthy trip (1661–65) took Schellinks to England, France, Switzerland, Italy, and Germany as a companion to the young son of a ship owner, Jacques Thierry, who, like many wealthy young people, completed a tour of Europe. Laurens van der Hem, who embellished his famous *Atlas Blaeu* with topographical drawings by numerous artists, additionally commissioned Schellinks to under-take the trip. In exchange, following his return, Schellinks prepared 120 new versions of views drawn in situ for the *Atlas Blaeu*. Sixty-one

of these, featuring motifs from southern Italy, Sicily, and Malta, were added to volumes 10, 11, and 12. The present drawing, which depicts the harbor near Valletta (the capital of Malta), originated as a study "na e't leven" ("from life") for one of these contributions.[3] It is one of four views of Malta by Schellinks in the Albertina's collection.[4]

Ships anchored during quarantine at the harbor near Valletta, where Schellinks landed on September 14, 1664. He drew scenes of this picturesque coastal region from various viewpoints. In his diary, he noted that fresh water was piped directly from the Neptune Fountain to the ships, without touching the ground.[5] The artist's viewpoint allowed the dark forms of the nearby boats, the fountain, and the projecting wall to come prominently forward. Sunlit clouds of smoke rising from the campfire in the left foreground dramatically emphasize the upward movement of the steps that lead toward the city. The artist described the shimmering, exotic diversity of forms and the mood evoked by the light conditions in a captivating manner. This on-site drawing is more lively than the final version for the *Atlas Blaeu*, which extends slightly farther to the left and right, suggesting that the Albertina drawing may have been trimmed at its edges.[6]

1 Regarding the life and work of Willem Schellinks, see Aikema 1983; Steland 1986; Schatborn 2001, pp. 174–78.

2 Steland 1986, pp. 89–104; Schatborn 2001, p. 174.

3 Vienna, Österreichische Nationalbibliothek, *Atlas Blaeu/van der Hem*, vol. 12, no. 37, illus., in Vienna 1993, p. 190; New York/Fort Worth 1995, p. 188. In this version, all of the buildings and points of interest are numbered and listed in van der Hem's own hand (Aikema 1983, no. 48).

4 See also Albertina inv. nos. 10017, 10018, 15180.

5 Aikema 1983, p. 122.

6 Vienna 1993, no. 101; New York/Fort Worth 1995, no. 90.

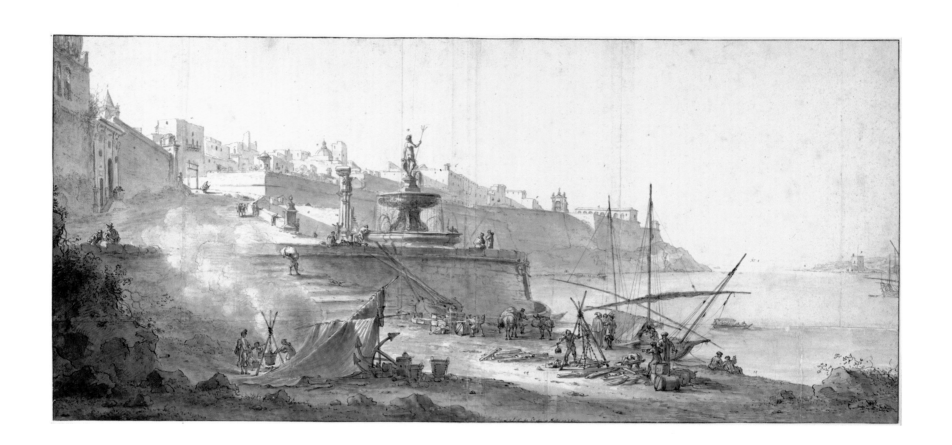

Still Life

Herman Henstenburgh

HOORN 1667–1726 HOORN

108 *Still Life of Fruit with Chestnuts and a Snail*, c. 1700

109 *Still Life of Fruit with a Finch and Sea Snail Shells,* c. 1700

CAT. NO. 108

Watercolor and bodycolor, on vellum

39.8 x 32 cm

INSCRIBED AT LOWER LEFT: "H. Henstenburgh fec."

PROVENANCE: Duke Albert von Sachsen-Teschen

INV. NO. 10886

BIBLIOGRAPHY: none known

CAT. NO. 109

Watercolor and bodycolor over lead stylus, on vellum

40.6 x 33 cm

INSCRIBED AT LOWER LEFT: "H. Henstenburg. fec:"

PROVENANCE: Duke Albert von Sachsen-Teschen

INV. NO. 10885

BIBLIOGRAPHY: none known

Herman Henstenburgh, a well-to-do citizen, practiced his occupation as a pie maker in his birthplace of Hoorn, which lies east of Alkmaar.[1] Because of the talent he exhibited in drawing, when he was sixteen, his parents sent him to Johannes Bronkhorst (1648–1727), a very gifted dilettante who was famous for his finely detailed watercolors of diverse, often exotic, birds. Bronkhorst also worked as a pie maker in Hoorn. Henstenburgh focused his own work on paintings of birds and especially flower, fruit, and vanitas still lifes; he was presumably influenced in this area by Hoorn still-life painters Jacob Rotius (1644–1681/82) and Pieter Gallis (1633–1697), who were followers of the influential still-life painter Jan Davidsz. de Heem (1606–1683/84). Early on, Henstenburgh's works found their way to a number of

domestic and foreign collectors, among them Cosimo III de' Medici, the Grand Duke of Tuscany. Herman's son and pupil, Anthony Henstenburgh (1695–1781), also practiced a dual career as a pie maker and watercolorist who concentrated on rendering butterflies and insects.

Recently, Herman Henstenburgh's still lifes have met with growing interest in exhibitions as well as in the art trade. His works housed in public collections are still largely unknown to the public—a situation true as well for the Albertina's three Henstenburgh still lifes, two of which are presented here for the first time. Duke Albert's interest in these works, which stand out in the perfection of their technique, corresponded to the taste of his time: in the eighteenth and early nineteenth centuries, Henstenburgh's still lifes were held in high regard.[2]

The brilliant surface effects of these finely detailed works, most of which are painted on vellum, are the result of the exacting technique and the artist's own experimentation. Using a very fine brush, the artist applied the colors in several layers within contours drawn with a lead stylus. He intensified his palette with a thin application of egg white and transparent oil colors.[3]

The largely symmetrically arranged *Still Life of Fruit with Chestnuts and a Snail* (cat. no. 108) is positioned on a slab of marble in front of a niche. Amidst the colorful splendor and shimmering glow of the meticulously described fruits, with the spiraling stems twining decoratively around them, is a snail. The observation that Henstenburgh's compositions, which are difficult to date, reveal greater variations around 1700—for example, still lifes that include different types of animals and natural specimens with a garden as a background—could also apply to the present *Still Life of Fruit with a Finch*

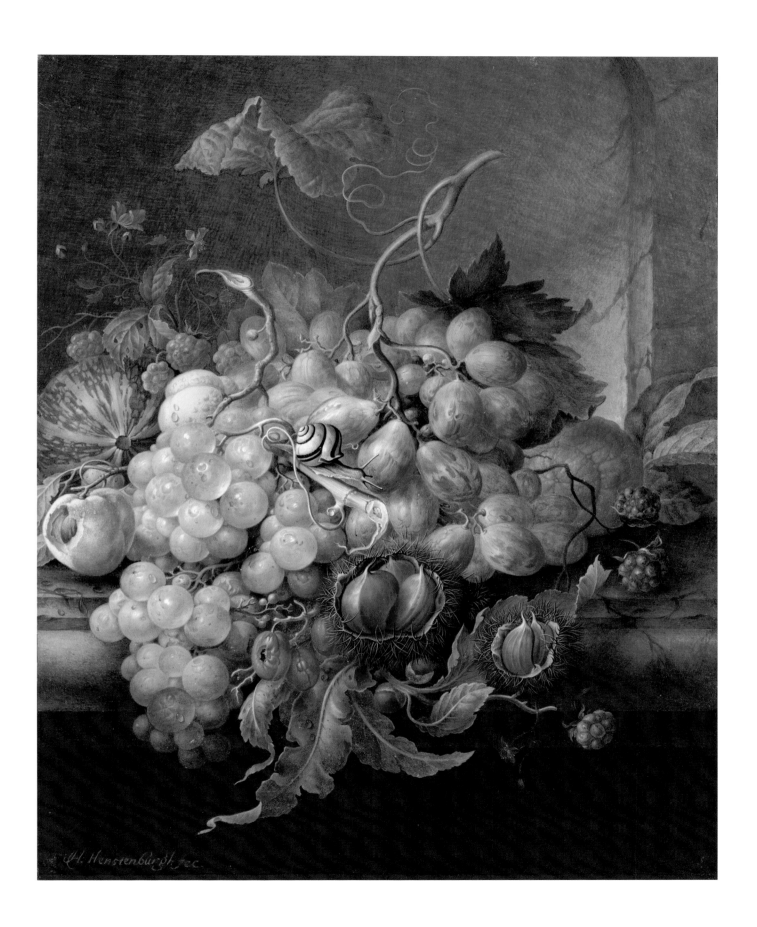

H. Henstenburgh fec.

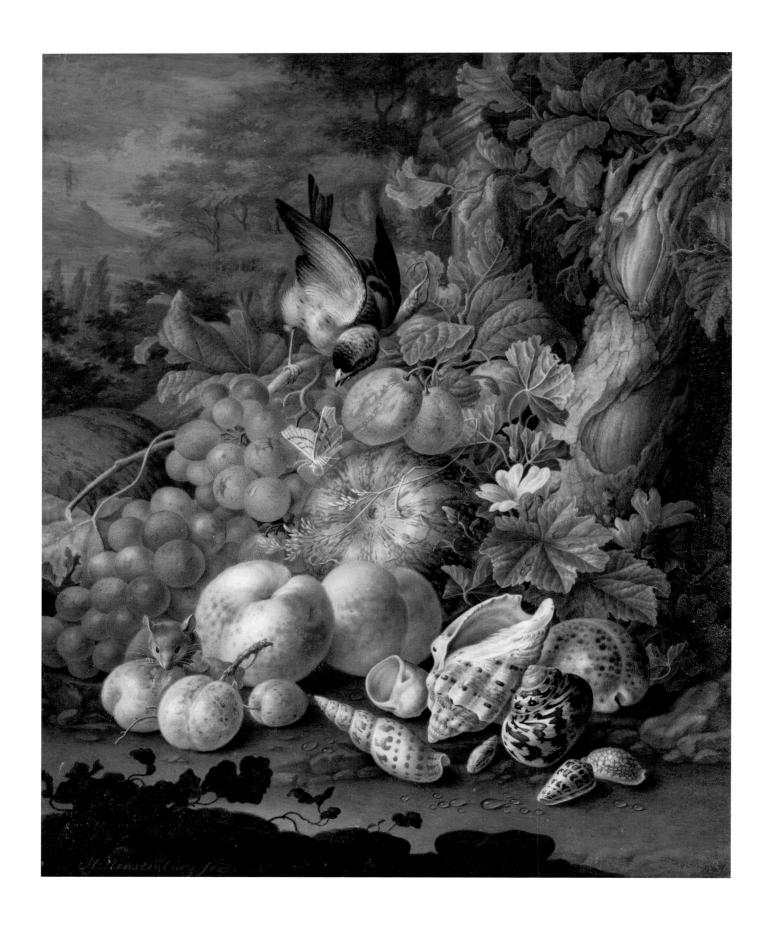

and Sea Snail Shells (cat. no. 109).[4] Here, the scattering in the fore-ground of various exotic snail and other shells—whose unusual forms, patterns, and light reflections commanded the artist's particular attention—was undoubtedly connected to the rising popular interest in collecting natural specimens at the end of the seventeenth and beginning of the eighteenth centuries.[5] Because of the small number of dated works by Henstenburgh and in view of the difficulty in placing the present works chronologically, one can start with the assumption that they may have originated beginning around 1700.

In a diagonal composition typical for Henstenburgh—in which de Heem's influence is notable—many types of flora and fauna are programmatically and simultaneously displayed.[6] With great care, Henstenburgh devoted himself to the rendering of the mouse, butterfly, bird, fruit, plants, and shells, the latter representing sea creatures. Nature and the human hand are symbolically implied in the close placement of the tree and the overgrown column. Such a reference perhaps reflects Henstenburgh's early commission of watercolors of plants, birds, and butterflies for the distinguished botanist and collector Agnes Block (1629–1704).[7] On her grand estate on the Vecht River, this notable woman cultivated rare, exotic plants. In addition to Henstenburgh and Bronkhorst, she commissioned a number of artists, including Herman Saftleven (cat. nos. 79, 80), Maria Sibylla Merian, and Willem de Heer. She also had an aviary with exotic birds and a collection of stuffed birds and butterflies.

1 For details on the life of Herman Henstenburgh, see Hoorn 1991, pp. 3–14.

2 Ibid., pp. 12–14.

3 Ibid., p. 1 (Oeuvre).

4 Ibid.

5 Ibid., pp. 7, 12.

6 On the influence of de Heem, see ibid., p. 3 (Oeuvre).

7 Ibid., p. 12.

Jan van Huysum

AMSTERDAM 1682–1749 AMSTERDAM

110 *Still Life of Flowers: Vase with a Relief of Putti, Standing on a Stone Plate,* c. 1720

111 *Still Life of Flowers: Vase in front of an Arched Niche,* c. 1734

112 *Still Life of Fruit in front of a Vase,* c. 1730/35

CAT. NO. 110

Black chalk, brush and gray ink, pen and brown ink, squared in red chalk

36.5 x 27.3 cm

INSCRIBED AT LOWER RIGHT: "J. v. Huysum fec."

PROVENANCE: Duke Albert von Sachsen-Teschen

INV. NO. 10551

BIBLIOGRAPHY: White 1964, no. 128, illus.

CAT. NO. 111

Black chalk, pen and brown ink, watercolors

40.1 x 31.6 cm

PROVENANCE: Duke Albert von Sachsen-Teschen

INV. NO. 10553

BIBLIOGRAPHY: White 1964, no. 134, illus.

CAT. NO. 112

Black chalk, brush and gray ink, watercolors

41 x 31.8 cm

PROVENANCE: G. Winkler; Duke Albert von Sachsen-Teschen

INV. NO. 10554

BIBLIOGRAPHY: White 1964, no. 131, illus.

Like his brothers, Justus II and Jacob, Jan van Huysum was trained in the workshop of his father, Justus van Huysum, who was a highly successful painter specializing in floral still lifes and interior decoration. Soon after the death of his father in 1716, Jan van Huysum became the most famous painter in the Netherlands of still lifes of flowers and fruit; his works were in great demand and commanded high prices. Despite the many patrons and buyers of his work among Amsterdam patrician families and European nobility, van Huysum is described in contemporaneous sources as being rather inaccessible; he lived reclusively and did not receive visitors in his studio for fear of plagiarism. For a short time, he taught Margaretha Haverman.[1]

Van Huysum brought the tradition of the flower and fruit still life, which originated during the early seventeenth century in paintings by Roelant Savery (cat. nos. 3, 4) and Jan Brueghel, to its undisputed high point.[2] His apparently arbitrarily arranged ensembles—which were actually very carefully composed—of diverse, often rare flowers and fruits combine astonishingly realistic detail with great painterly brilliance. The flowers were painted directly "from life," and often the completion of a painting depended on the duration of the bloom of the particular flowers. Though his early compositions featured a dark, Baroque backdrop, beginning in 1720, his works accommodated a background of architectural or parklike elements that favored bright illumination.[3]

It is worth noting that fewer drawings than paintings by van Huysum are known.[4] Executed in black chalk or in pen and often combined with gray washes or watercolors, his still-life drawings exhibit the same basic motifs as his paintings. Yet, in their liveliness and loose strokes, they differ greatly from the meticulous detail of the

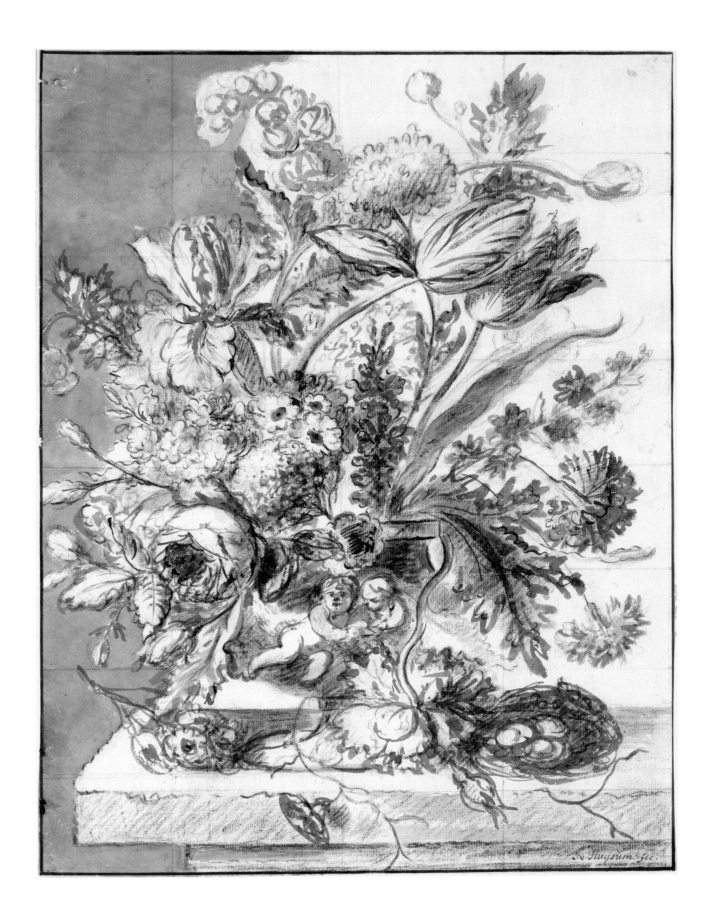

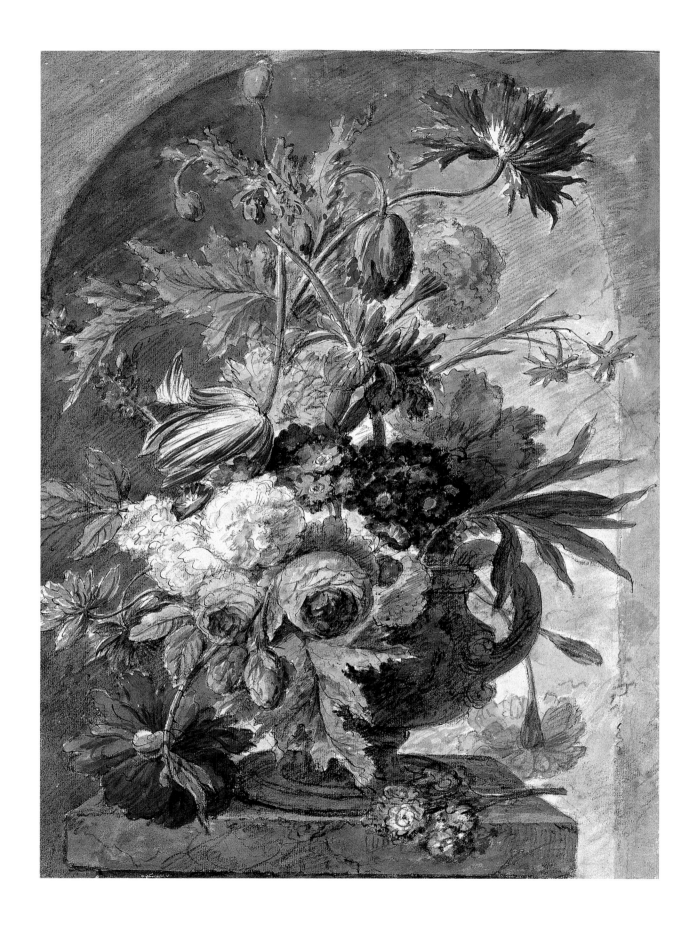

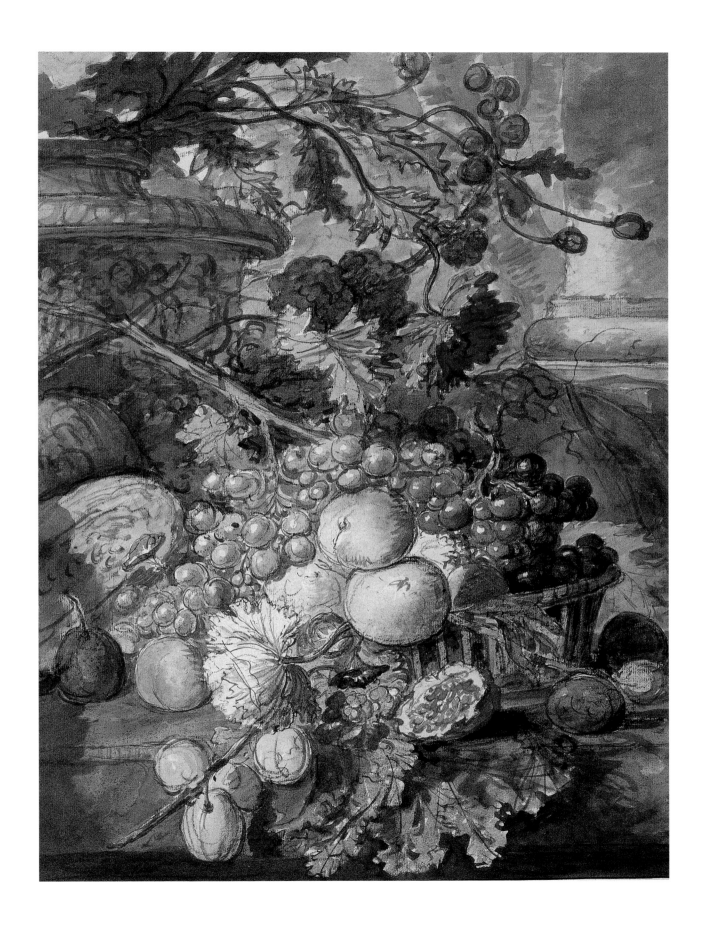

painted works. Although many of these sheets presumably originated as composition studies, only seldom do they reveal a direct connection to the paintings known today.

The present drawing (cat. no. 110), executed in black chalk and gray washes, stands out as one of the few exceptions in this respect. The red squaring reveals the drawing's function as a model for a painting. In fact, this work displays an unmistakable similarity to a painting that came up for auction in 1954 and again in 1978. Very similar are the arrangement of the flowers, the relief on the terra-cotta vase, the placement of the bird's nest, and the orientation of the background and the table.[5] The painting includes more details and slight differences in the condition of the blooms are apparent in the rendering of individual flowers. In the drawing, the combination of flowers of various blooming duration appears loose and natural. In the painting, the effort to achieve an extremely artful arrangement is clearly discernible in the refined interplay of forms and colors, the carefully balanced chiaroscuro effects, and even the twist of the stems. The undated painting includes a dark background, which, in regard as well to the drawing, may indicate a date of around or before 1720.

Less sketchlike is the still life of flowers in front of a recessed niche (cat. no. 111). Here, the architectonic framing conveys a sense of pictorial unity and watercolors add to its finished character. At the same time, the light conditions are varied: in the niche, a gradual transition from dark to light occurs from left to right. The brightly illuminated flowers, however, stand out against the dark half of the background, and darken to silhouettelike forms against the light area of the niche. A subtle play of light and shadow also activates the blooms and leaves. A direct relationship to a painting has not been established, although the motif of flowers in front of a niche resembles a painting dated 1734.[6]

In the still life of fruit arranged in front of a flower vase (cat. no. 112), virtuoso lines in black chalk combine with a lively application of watercolors. From the darkest shadows to the highlights on the grapes, the entire spectrum of van Huysum's brilliant watercolor technique is revealed. The light enters from the foreground—with an unknown object casting a shadow at the far left—as well as from the

background, which is dominated by the base of a partially illuminated column. Comparable painted compositions are found in a still life dated 1730 as well as in an undated still life of around 1735.[7] Thus, the present drawing presumably originated in the first half of the 1730s.

1 On the life of Jan van Huysum, see White 1964, pp. 7–9.

2 See Amsterdam/Cleveland 1999–2000, especially pp. 24–28 and no. 78.

3 Ibid., p. 283.

4 On Jan van Huysum's drawings, see White 1964.

5 *Roses, Tulips, Carnations and Other Flowers in a Sculptured Urn on a Stone Ledge with a Bird's Nest*, oil on panel, 78.9 x 69.3 cm, Auction R. M. C. Aked e.a., London, July 7, 1978, no. 199, illus.; Provenance: Viscountess Bertie of Thame, Shiburn Lodge, Waltington; Christie's, London, December 10, 1954, no. 162. The author would like to thank Robert-Jan te Rijdt for his helpful support in regard to the identification of the motifs of the present drawings.

6 *A Still Life of Flowers in a Terracotta Vase upon a Marble Ledge before a Niche*, Sotheby's London, *Old Master Paintings*, December 11, 2003, no. 74, illus. (from the Estate of Mary Fattorini).

7 *Fruits and Flowers*, dated 1730; Christie's, New York, January 12, 1994, no. 129, illus. See Amsterdam/Cleveland 1999–2000, p. 284, fig. A; *A Still Life of Fruit in a Basket with Flowers and Other Fruit*, c. 1735, Sotheby's London, *Old Master Paintings*, December 11, 2003, no. 75, illus. (from the Estate of Mary Fattorini).

BIBLIOGRAPHY

AUTHORS

Aikema 1983
Aikema, B. et al. *W. Schellinks, Viaggi al Sud, 1664–1665*. Rome, 1983.

Albach 1979
Albach, B. "Rembrandt en het toneel." *De Kroniek van het Rembrandthuis* 31, 2 (1979), pp. 2–32.

Auction Amsterdam, March 3, 1800
Catalogus der Teekeningen, Prenten, Schilderyen,. . . van wylen den Heer Cornelis Ploos van Amstel,…Al het welk, op Maandag den 3den Maart 1800 en volgende dagen, te Amsterdam, verkogt zal worden door Philippus van der Schley, Jan de Bosch Jeronz., Bernardus de Bosch Jeronz., Jan Yver en Cornelis Sebille Roos. Amsterdam, 1799.

Bartsch 1803–21
Bartsch, A. *Le Peintre-Graveur*. 21 vols. Vienna, 1803–21.

Bartsch, The Illustrated
Strauss, W., ed. *The Illustrated Bartsch*. New York, 1978–.

Beck 1972–91
Beck, H.-U. *Jan van Goyen, 1596–1656*. Vols. 1–3; *Jan van Goyen*. Vol. 4. *Künstler um Jan van Goyen*. Amsterdam and Doornspijk, 1972–91.

Becker 1923
Becker, F. *Handzeichnungen holländischer Meister aus der Sammlung Dr. C. Hofstede de Groot im Haag*. Leipzig, 1923.

de Beer 2002
Beer, G. de. *Sein Leben und Werk. Ludolf Backhuysen (1630–1708)*. Zwolle, 2002.

Benesch 1928
Benesch, O. *Beschreibender Katalog der Handzeichnungen der graphischen Sammlung Albertina*. Vol. 2, *Die Zeichnungen der niederländischen Schulen des XV. und XVI. Jahrhunderts*. Vienna, 1928.

Benesch 1932
Benesch, O. *Rembrandts spätestes gezeichnetes Selbstbildnis*, in: *Mitteilungen der Gesellschaft für vervielfältigende Kunst 55*, 1932, p. 30

Benesch 1949
Benesch, O. *A Catalogue of Rembrandt's Selected Drawings*. London, 1949.

Benesch 1954–57
Benesch, O. *The Drawings of Rembrandt: A Critical and Chronological Catalogue*. 6 vols. London, 1954–57.

Benesch 1960
Benesch, O. *Rembrandt as a Draughtsman*. London, 1960.

Benesch 1964
Benesch, O. *Meisterzeichnungen der Albertina: Europäische Schulen von der Gotik bis zum Klassizismus*. Salzburg, 1964. 2d ed., enl. and ed. Eva Benesch, 1980.

Benesch 1973
Benesch, O. *The Drawings of Rembrandt: A Critical and Chronological Catalogue*. 2d ed., enl. and ed. Eva Benesch. 6 vols. London, 1973.

Bernt 1957–58
Bernt, W. *Die niederländischen Zeichner des 17. Jahrhunderts*. 2 vols. Munich, 1957–58.

Bock and Rosenberg 1930
Bock, E. and J. Rosenberg. *Staatliche Museen zu Berlin. Die Zeichnungen alter Meister im Kupferstichkabinett: Die niederländischen Meister. Beschreibendes Verzeichnis sämtlicher Zeichnungen*. 2 vols. Berlin, 1930.

Bode and Valentiner 1907
Bode, W. von and W. R. Valentiner. *Handzeichnungen altholländischer Genremaler*. Berlin, 1907.

Bol 1969
Bol, L. J. *Holländische Maler des 17. Jahrhunderts nahe den großen Meistern: Landschaften und Stilleben*. Braunschweig, 1969.

Bol 1973
Bol, L. J. *Die holländische Marinemalerei des 17. Jahrhunderts*. Braunschweig, 1973.

Bolten 1985
Bolten, J., ed. *Oude tekeningen van het Prentenkabinet der Rijksuniversiteit te Leiden*. The Hague and Amsterdam, 1985.

Bredius and Gerson 1969
Bredius, H. Revised H. Gerson. *Rembrandt. The Complete Edition of Paintings*. London, 1969.

Briels 1987
Briels, J. *Vlaamse schilders in de Noordelijke Nederlanden in het begin van de Gouden Eeuw, 1585–1630*. Antwerp, 1987.

Broos 1981
Broos, B. P. J. *Rembrandt en tekenaars uit zijn omgeving: Oude tekeningen in het bezit van de Gemeentemusea van Amsterdam waaronder de collectie Fodor*. Vol. 3. Amsterdam, 1981.

Broos 1989
Broos, B. P. J. "Improving and Finishing Old Master Drawings: An Art in Itself." *Hoogsteder-Naumann Mercury* 8 (1989), pp. 34–55.

Broos and Schapelhouman 1993
Broos, B. and M. Schapelhouman. *Nederlandse Tekenaars geboren tussen 1600 en 1660*. Amsterdam and Zwolle, 1993.

Burke 1976
Burke, J. D. *Jan Both: Paintings, Drawings and Prints.*
New York and London, 1976.

Chong 1987
Chong, A. "The Drawings of Cornelis van Poelenburch."
Master Drawings 25, 1 (1987), pp. 3–62.

Coenen 2005
Coenen, B. J. L. "The Drawings of the Haarlem Amateur
Leendert van der Cooghen." *Master Drawings* 53, 1
(2005), pp. 6–90.

Corpus
Bruyn, J., B. Haak, S. H. Levie, P. J. J. van Thiel, and
E. van de Wetering, eds. *A Corpus of Rembrandt
Paintings.* 3 vols. The Hague, 1982–89.

Davies 1978
Davies, A. I. *Allart van Everdingen.* New York and
London, 1978.

Davies 2001
Davies, A. I. *Allart van Everdingen 1621–1675, First
Painter of Scandinavian Landscape. Catalogue Raisonné
of Paintings.* Doornspijk, 2001.

Egger 1911
Egger, H. *Römische Veduten: Handzeichnungen aus
dem XV.–XVIII. Jahrhundert.* 2 vols. Vienna and
Leipzig, 1911.

Egger 1931–32
Egger, H. *Römische Veduten: Handzeichnungen aus
dem XV. bis XVIII. Jahrhundert zur Topographie der
Stadt.* 2 vols. Vienna, 1931–32.

Elen 1989
Elen, A. J. *Missing Old Master Drawings from the
Franz Koenigs Collection Claimed by the State of the
Netherlands.* The Hague, 1989.

Emmens 1968
Emmens, J. A. *Rembrandt en de Regels van de Kunst.*
English ed. *Rembrandt and the Rules of Art.* The
Hague, 1968.

Erasmus 1908
Erasmus, K. *Roelandt Savery, Sein Leben und seine
Werke.* Halle, 1908.

Erasmus 1911
Erasmus, K. "De Teekeningen van Roelandt Savery."
Kunst en Kunstleven 1 (1911), pp. 5–8.

van Gelder 1933
Gelder, J. G. van. *Jan van de Velde, 1593–1641:
Teekenaar, Schilder.* 's-Gravenhage, 1933.

van Gelder 1971
Gelder, J. G. van. "Jan de Bisschop, 1628–1671."
Oud Holland 86 (1971), pp. 201–59.

van Gelder 1978
Gelder, J. G. van. "Constantijn Huygens als tekenaar."
In *Boymans bijdragen: Opstellen van medewerkers en
oud-medewerkers van het Museum Boymans-van
Beuningen voor J. C. Ebbinge Wubben*, pp. 111–28.
Rotterdam, 1978.

Gerson 1936
Gerson, H. *Philips Koninck.* Berlin, 1936.

Gerszi 1979
Gerszi, T. "L'Influence de Pieter Bruegel sur l'Art
du paysage de David Vinckboons et de Gillis
d'Hondecoeter." *Bulletin du Musée Hongrois des
Beaux-Arts* 53 (1979), pp. 125–36.

Giltaij and Lammertse 2001
Giltaij, J. and F. Lammertse. "Maintaining a Studio
Archive: Drawn Copies by the De Braij Family."
Master Drawings 39, 4 (2001), pp. 367–94.

Goedde 1989
Goedde, L. O. *Tempest and Shipwreck in Dutch and
Flemish Art.* University Park and London, 1989.

van Groningen 2003
van Groningen, C. L. "Van Proosdijhuis tot Kasteel."
*Bulletin van de Koninklijke Nederlandse
Oudheidkundige Bond* 102 (2003), pp. 81–114.

Gudlaugsson 1959
Gudlaugsson, S. J. "Einige Ausnahmefälle in der
Bildnisgestaltung Ter Borchs." In *Festschrift Friedrich
Winkler.* Berlin, 1959.

van der Haagen 1932
Haagen, J. K. van der. *De Schilders Van der Haagen en
hun werk, met catalogus van de schilderijen en
teekeningen van Joris van der Haagen.* Voorburg, 1932.

Haak 1969
Haak, B. *Rembrandt: His Life, His Work, His Time.*
New York, 1969.

Haverkamp-Begemann 1959
Haverkamp-Begemann, E. *Willem Buytewech.*
Amsterdam, 1959.

Haverkamp-Begemann 1961
Haverkamp-Begemann, E. "Rezension von Benesch
1954–57." *Kunstchronik* 14 (1961), pp. 10–14, 19–28.

Henkel 1943
Henkel, M. D. *Catalogus van de Nederlandsche
teekeningen in het Rijksmuseum te Amsterdam.* Vol. 1.
Teekeningen van Rembrandt en zijn school. 2nd ed.
The Hague, 1943.

Hind 1915–32
Hind, A. M. *Catalogue of Drawings by Dutch and
Flemish Artists Preserved in the Department of Prints
and Drawings in the British Museum.* 5 vols. London,
1915–32.

Hofstede de Groot 1906
Hofstede de Groot, C. *Die Handzeichnungen
Rembrandts: Versuch eines beschreibenden und kritischen
Katalogs.* Haarlem, 1906.

Hofstede de Groot 1907–28
Hofstede de Groot, C. *Beschreibendes und kritisches
Verzeichnis der Werke der hervorragendsten holländischen
Maler des XVII. Jahrhunderts.* 10 vols. Esslingen and
Paris, 1907–28.

Hofstede de Groot 1929
Hofstede de Groot, C. "Einige Betrachtungen über
die Ausstellung Holländischer Kunst in London."
Repertorium für Kunstwissenschaft 50, 3 (1929),
pp. 134–46.

Hollstein 1949–
Hollstein, F. W. H. *The New Hollstein Dutch and
Flemish Etchings, Engravings, and Woodcuts, c. 1450–
1700.* 62 vols. Amsterdam 1949–87, Roosendaal
1988–94, Rotterdam 1995–.

Houbraken 1753
Houbraken, A. *De Groote Schouburgh der
Nederlantsche Kunstschilders en Schilderessen.* 2d ed.
3 vols. The Hague, 1753. 1st ed. 1718–21.

Houtzager, Swillens, and van Regteren Altena 1961
Houtzager, M. E., P. T. A. Swillens, and J. Q. van Regteren Altena. *Pieter Janszoon Saenredam, Catalogue Raisonné*. Utrecht: Centraal Museum, 1961.

Judson 1973
Judson, J. R. *The Drawings of Jacob de Gheyn II*. New York, 1973.

Karau 2002
Karau, S. H. "Leben und Werk des Leidener Malers Jacob Toorenvliet (1640–1719)." Ph.D. diss., Freie Universität, Berlin, 2002.

Kettering 1988
Kettering, A. M. *Drawings from the Ter Borch Studio Estate*. 2 vols. Amsterdam and The Hague, 1988.

Keyes 1975
Keyes, G. S. *Cornelis Vroom: Marine and Landscape Artist*. 2 vols. Utrecht, 1975.

Keyes 1984
Keyes, G. S. *Esaias van de Velde, 1587–1630*. Doornspijk, 1984.

Keyes 1987
Keyes, G. S. "Esias van de Velde and the Chalk Sketch." In *WAS GETEEKEND…tekenkunst door de eeuwen heen. Liber amicorum Prof. Dr. E. K. J. Reznicek (Nederlands Kunsthistorisch Jaarboek 38)*, 1987, pp. 138–45.

Kloek and Niemeijer 1990
Kloek, W. T. and J. W. Niemeijer. *De kasteeltekeningen van Roelant Roghman*. 2 vols. Alphen aan den Rijn, 1990.

Knab 1969
Knab, E. "De genio loci." In *Miscellanea: I. Q. van Regteren Altena*. Amsterdam, 1969, pp. 133–37, illus. pp. 326–32.

Leporini 1925
Leporini, H. *Die Stilentwicklung der Handzeichnung, XIV bis XVIII Jahrhundert*. Vienna, 1925.

Leporini 1928
Leporini, H. *Die Künstler-Zeichnung*. Berlin, 1928.

Liedtke 1971
Liedtke, W. A. "Saenredam's Space." *Oud Holland* 86 (1971), pp. 116–41.

Lugt 1920
Lugt, F. *Mit Rembrandt in Amsterdam*. Berlin, 1920.

Lugt 1929–33
Lugt, F. *Musée du Louvre—Inventaire général des dessins des écoles du Nord: Ecole hollandaise*. 3 vols. Paris, 1929–33.

Lugt 1950
Lugt, F. *Ecole nationale supérieure des Beaux-Arts. Inventaire général des dessins des écoles du Nord. Ecole hollandaise*. Paris, 1950.

Lunsingh Scheurleer 1980
Lunsingh Scheurleer, P. "Mogolminiaturen door Rembrandt getekend." *De Kroniek van Het Rembrandthuis* 32 (1980), pp. 10–40.

van Mander 1604
Mander, K. van. "Den Grondt der Edel vrij Schilderconst." In *Het Schilderboek*. Haarlem, 1604.

Meder 1919
Meder, J. *Die Handzeichnung: Ihre Technik und Entwicklung*. Vienna, 1919. 2d ed. rev. 1923.

Meder 1922
Meder, J. *Handzeichnungen alter Meister aus der Albertina und aus Privatbesitz. Neue Folge*. Vienna, 1922.

Michel 1910
Michel, E. *Great Masters of Landscape Painting*. London, 1910.

von Moltke 1938
Moltke, J. W. von. "Salomon de Bray." *Marburger Jahrbuch für Kunstwissenschaft* 11–12 (1938–39), pp. 308–420.

von Moltke 1965
Moltke, J. W. von. *Govaert Flinck*. Amsterdam, 1965.

Naumann 1978
Naumann, O. "Frans van Mieris as a Draughtsman." *Master Drawings* 16, 1 (1978), pp. 3–34.

Niemeijer 1964
Niemeijer, W. "Varia Topographica IV. Een Album met Utrechtse Gezichten door Abraham Rutgers." *Oud Holland* 79 (1964) pp. 127–30, 134.

Orlers 1641
Orlers, J. J. *Beschrijringe der Stadt Leyden*. Leiden, 1641.

Plietzsch 1911
Plietzsch, E. *Vermeer van Delft*. Leipzig, 1911. Reprint, Munich, 1939.

Plomp 1997
Plomp, M. C. *The Dutch Drawings in the Teyler Museum. Artists Born between 1575 and 1630*. Haarlem, Ghent, and Doorspijk, 1997.

van Puyvelde 1944
Puyvelde, L. van. *The Dutch Drawings in the Collection of His Majesty the King at Windsor Castle*. London and New York, 1944.

van Regteren Altena 1936
Regteren Altena, I. Q. van. *Jacques de Gheyn: An Introduction to the Study of His Drawings*. Amsterdam, 1936.

van Regteren Altena 1983
Regteren Altena, I. Q. van. *Jacques de Gheyn: Three Generations*. 3 vols. The Hague, 1983.

Reiss 1975
Reiss, S. *Aelbert Cuyp*. London and Boston, 1975.

Rembrandt Documents
Strauss, W. L. and M. van der Meulen, eds. *The Rembrandt Documents*. New York, 1979.

Renger 1970
Renger, K. *Lockere Gesellschaft. Zur Ikonographie des Verlorenen Sohnes und von Wirtshausszenen in der Niederländischen Malerei*. Berlin, 1970.

Robinson 1979
Robinson, W. W. "Preparatory Drawings by Adriaen van de Velde." *Master Drawings* 17, 1 (1979), pp. 3–23.

Robinson 1979a
Robinson, M. S. *The Willem van de Velde Drawings in the Boymans-Van Beuningen Museum*. 3 vols. Rotterdam, 1979.

Robinson 1990
Robinson, W. W. "Early Drawings by Joris van der Haagen." *Master Drawings* 28, 3 (1990), pp. 303–309.

Robinson 1990a
Robinson, M. S. *The Paintings of Willem van de Velde.* London, 1990.

Robinson 1998
Robinson, E. W. "Five Black Chalk Figure Studies by Rembrandt." *Master Drawings* 36, 1 (1998), pp. 36–44.

Roethlisberger 1969
Roethlisberger, M. *Bartholomäus Breenbergh: Handzeichnungen.* Vol. 1. *Disegno: Studien zur Geschichte der europäischen Handzeichnung.* Berlin, 1969.

Roethlisberger 1991
Roethlisberger, M. *Bartholomeus Breenbergh.* New York, 1991.

Roethlisberger-Bianco 1970
Roethlisberger-Bianco, M. *Cavlier Pietro Tempesta and His Time.* Newark, 1970.

Rosenberg 1900
Rosenberg, A. *Adriaen und Isack van Ostade.* Bielefeld, 1900.

Rosenberg 1928
Rosenberg, J. "Cornelis Hendricksz Vroom." *Jahrbuch der Preussischen Kunstsammlungen* 49 (1928), pp. 102–10.

Rosenberg 1964
Rosenberg, J. *Rembrandt, Life and Work.* London, 1964.

Russell 1992
Russell, M. *Willem van de Velde de Jonge.* Bloemendaal, 1992.

Russell 1993
Russell, M. "Landscape in the Age of Rembrandt." *Burlington Magazine* 135 (1993), pp. 848–49.

Schapelhouman 1987
Schapelhouman, M. *Nederlandse tekeningen omstreeks 1600 in het Rijksmuseum Amsterdam.* Vol. 3. *Catalogus van de nederlandse tekeningen in het Rijksprentenkabinet, Rijksmuseum, Amsterdam.* The Hague, 1987.

Schapelhouman 1998
Schapelhouman, M. *Dutch Drawings of the Seventeenth Century in the Rijksmuseum, Amsterdam. Artists Born between 1580 and 1600.* 2 vols. Amsterdam and London, 1998.

Schapelhouman and Schatborn 1987
Schapelhouman, M. and P. Schatborn. *Land en Water: Hollandse Tekeningen uit de 17e eeuw in het Rijksprentenkabinet/Land and Water: Dutch Drawings from the 17th Century in the Rijksmuseum Print Room.* Amsterdam, 1987.

Schatborn 1976
Schatborn, P. "Schetsen van Rembrandt." *Kroniek van het Rembrandthuis* 28, 2 (1976), *passim.*

Schatborn 1977
Schatborn, P. "Review of *Lambert Doomer: Sämtliche Zeichnungen,* by W. Schulz." *Simiolus* 9 (1977), pp. 48–55.

Schatborn 1985
Schatborn, P. *Tekeningen van Rembrandt, zijn onbekende leerlingen en navolgers.* Vol. 4. *Catalogus van de nederlandse tekeningen in het Rijksprentenkabinet, Rijksmuseum, Amsterdam.* The Hague, 1985.

Schatborn 2001
Schatborn, P. *Drawn to Warmth. 17th-century Dutch Artists in Italy.* Amsterdam and Zwolle, 2001.

Schatborn and Bakker 1976
Schatborn, P. and B. Bakker. "Schetsen van Rembrandt." *Kroniek van het Rembrandthuis* 28, 2 (1976), pp. 1–9.

Schnackenburg 1981
Schnackenburg, B. *Adriaen van Ostade, Isack van Ostade. Zeichnungen und Aquarelle. Gesamtdarstellung mit Werkkatalogen.* 2 vols. Hamburg, 1981.

Schnackenburg 1984
Schnackenburg, B. "Das Bild des bäuerlichen Lebens bei Adriaen van Ostade." In Vekeman, H. and J. Müller Hofstede, eds., *Wort und Bild in der niederländischen Kunst und Literatur des 16. un 17. Jahrhunderts.* Erfstadt, 1984, pp. 31 ff.

Schneider 1932
Schneider, H. *Jan Lievens: Sein Leben und seine Werke.* Haarlem, 1932. Reprint, with supplement by R. E. O Ekkart, Amsterdam, 1973.

Schneider 1990
Schneider, C. P. *Rembrandt's Landscapes.* New Haven and London, 1990.

Schönbrunner and Meder 1896–1908
Schönbrunner, J. and J. Meder, eds. *Handzeichnungen alter Meister in der Albertina und anderen Sammlungen.* 12 vols. Vienna, 1896–1908.

Schulz 1972
Schulz, W. "Lambert Doomer, 1624–1700: Leben und Werke." 2 vols. Ph.D. diss., Berlin, 1972.

Schulz 1974
Schulz, W. *Lambert Doomer: Sämtliche Zeichnungen.* Berlin and New York, 1974.

Schulz 1982
Schulz, W. *Herman Saftleven, 1609–1685: Leben und Werke, Mit einem kritischen Katalog der Gemälde und Zeichnungen.* Berlin and New York, 1982.

Schwartz and Bock 1990
Schwartz, G. and M. J. Bock. *Pieter Saenredam, The Painter and His Time.* Maarssen and The Hague, 1990.

von Sick 1930
Sick, I. von. *Nicolaes Berchem: Ein Vorläufer des Rokoko.* Berlin, 1930.

Slatkes 1980
Slatkes, L. J. "Rembrandts Elephant." *Simiolus* 11 (1980), pp. 7–13.

Slive 2001
Slive, S. *Jacob van Ruisdael, a Complete Catalogue of His Paintings, Drawings and Etchings.* New Haven and London, 2001.

Sluijter-Seijffert 1984
Sluijter-Seijffert, N. C. *Cornelis van Poelenburch (ca. 1593–1667).* Leiden, 1984.

Spicer-Durham 1979
Spicer-Durham, J. A. "The Drawings of Roelandt Savery." Ph.D. diss., Yale University, New Haven, 1979.

Stechow 1966
Stechow, W. *Dutch Landscape Painting of the Seventeenth Century.* London, 1966.

Stefes 1997
Stefes, A. "Nicolaes Pietersz. Berchem (1620–1683). Die Zeichnungen." Ph.D. diss, Universität Bern, Bern, 1997.

Steland 1986
Steland, A. C. "Zu Willem Schellinks' Entwicklung als Zeichner." *Niederdeutsche Beiträge zur Kunstgeschichte* 25 (1986), pp. 79–108.

Steland 1989
Steland, A. C. *Die Zeichnungen des Jan Asselijn.* Fridingen, 1989.

Steland-Stief 1971
Steland-Stief, A. C. *Jan Asselijn, nach 1610 bis 1652.* Amsterdam, 1971.

Stubbe 1983
Stubbe, L. and W. Stubbe. *Um 1660 auf Reisen gezeichnet, Anthonie Waterloo, 1610–1690: Ansichten aus Hamburg, Altona, Blankenese, Holstein, Bergedorf, Lüneburg und Danzig-Oliva.* Hamburg, 1983.

Sumowski 1962
Sumowski, W. "Gerbrand van den Eeckhout als Zeichner." *Oud Holland* 77 (1962), pp. 11–39.

Sumowski 1979–92
Sumowski, W. *Drawings of the Rembrandt School.* 10 vols. New York, 1979–92.

Swillens 1935
Swillens, P. T. A. *Pieter Janszoon Saenredam.* Amsterdam, 1935.

Tietze-Conrat 1922
Tietze-Conrat, E. *Die Delfter Malerschule.* Leipzig, 1922.

Trnek 1982
Trnek, R. *Niederländer und Italien: Italianisante Landschafts- und Genremalerei in der Gemäldegalerie der Akademie der bildenden Künste in Wien.* Vienna, 1982.

Trnek 1992
Trnek R. *Die holländischen Gemälde des 17. Jahrhunderts.* Vol. 1. *Kataloge der Gemäldegalerie der Akademie der bildenden Künste.* Vienna, 1992.

Valentiner 1924
Valentiner, W. R. *Nicolaes Maes.* Berlin, 1924.

Walsh 1974
Walsh, J., Jr. "The Dutch Marine Painters Jan and Julius Porcellis." Part 1, "Jan's Early Career," and part 2, "Jan's Maturity and 'de jonge Porcellis.'" *Burlington Magazine* 116 (1974), pp. 653–62, 737–38.

Wegner 1973
Wegner, W. *Die Niederländischen Handzeichnungen des 15.–18. Jahrhunderts (Kataloge der Staatlichen Graphischen Sammlungen München,* vol. 1*).* 2 vols. Berlin, 1973.

Wegner and Pée 1980
Wegner, W. and H. Pée. "Die Zeichnungen des David Vinckboons." *Münchner Jahrbuch der bildenden Kunst,* 3d ser., no. 31 (1980), pp. 35–128.

Welcker 1933
Welcker, C. J. *Hendrick Avercamp, 1585–1634, bijgenaamd "de Stomme van Campen," en Barent Avercamp, 1612–1679, "schilders tot Campen."* Zwolle, 1933.

White 1964
White, C. *The Flower Drawings of Jan van Huysum.* Leigh-on-Sea, 1964.

White 1999
White, C. *Rembrandt as an Etcher. A Study of the Artist at Work.* New Haven/London, 1999 (2 edition).

White and Boon 1969
White, C. and K. G. Boon. *Rembrandt's Etchings, An Illustrated Critical Catalogue.* 2 vols. Amsterdam, London, and New York, 1969. The catalogue also appears as vols. 18, 19 in Hollstein's *Dutch and Flemish Etchings, Engravings and Woodcuts,* Amsterdam 1969.

Wurzbach 1906–11
Wurzbach, A. von. *Niederländisches Künstlerlexikon.* 3 vols. Vienna and Leipzig, 1906–11.

van der Wyck and Niemeijer 1990
Wyck, H. W. M. van der, and J. W. Niemeijer. *De kasteeltekeningen van Roelant Roghman.* Vol. 1. Alphen aan den Rijn, 1990.

Zwollo 1973
Zwollo, A. *Hollandse en Vlaamse veduteschilders te Rome, 1675–1725.* Assen, 1973.

EXHIBITION CATALOGUES

Adelaide/Sydney/Melbourne 1977
Master Drawings of the Albertina, Vienna.
Cat. by F. Koreny. Adelaide: Gallery of South Australia;
Sydney: Art Gallery of New South Wales; and
Melbourne: National Gallery of Victoria, 1977.

Amsterdam 1976
Tot Lering en Vermaak. Betekenissen van Hollandse genrevoorstellingen uit de zeventiende eeuw. Cat. by
E. de Jongh. Amsterdam: Rijksmuseum, 1976.

Amsterdam 1985
Ludolf Bakhuizen, 1631–1708: Schryfmeester, teyckenaer, schilder. Cat. by B. Broos, R. Vorstman, and
W. L. van de Watering. Amsterdam: Rijksmuseum
(Nederlands Scheepvaart Museum), 1985.

Amsterdam 1989
De Verzameling van mr. Carel Vosmaer (1826–1888).
Cat. by F. L. Bastet, J. F. Jeijbroek, H. Maes, J. W.
Niemeiger, M. Schapelhouman, and P. Schatborn.
Amsterdam: Rijksprentenkabinet, Rijksmuseum, 1989.

Amsterdam 1989–90
De Hollandse fijnschilders. Van Gerard Dou tot Adriaen van der Werff. Cat. by P. Hecht. Amsterdam:
Rijksmuseum, 1989.

Amsterdam 2004
Backhuysen aan het roer! Cat. by G. de Beer.
Amsterdam: Koninklijk Paleis op de Dam, 2004.

Amsterdam/Boston/Philadelphia 1987–88
Masters of 17th-Century Dutch Landscape Painting.
Cat. by P. C. Sutton and P. J. J. van Thiel, with
A. Blankert, J. Bruyn, C. J. de Bruyn Kops, A. Chong,
J. Giltay, S. Schama, M. E. Wiesman. Amsterdam:
Rijksmuseum; Boston: Museum of Fine Arts; and
Philadelphia Museum of Art, 1987–88.

Amsterdam/Cleveland 1999–2000
Het Nederlandse Stilleven 1550–1720 (Still Life Painting from the Netherlands 1550–1720). Cat. by A.
Chong, W. Kloek, C. Brusati, J. Berger Hochstrasser,
G. Jansen, J. Loughman, and B. Wieseman. Amsterdam:
Rijksmuseum; and Cleveland: The Cleveland Art
Museum, 1999–2000.

Amsterdam/Dordrecht 1994
Kleur en Raffinement, Tekeningen uit de Unicorno collectie. Cat. by C. Dumas and R.-J. te Rijdt.
Amsterdam: Museum Het Rembrandthuis; and
Dordrecht: Dordrechts Museum, 1994.

Amsterdam/Ghent 1982–83
Met Huygens op reis. Cat. by J. F. Heijbroek,
D. J. Roorda, M. Schapelhouman, and E. de Wilde.
Amsterdam: Rijksprentenkabinet, Rijksmuseum; and
Ghent: Museum voor Schone Kunsten, 1982–83.

Amsterdam/London 2000–2001
Rembrandt the Printmaker. Cat. by E. Hinterding,
G. Luijten, and M. Royalton-Kisch. Amsterdam:
Rijksmuseum; and London: British Museum,
2000–2001.

Amsterdam/Paris 1998–99
Landscapes of Rembrandt, His Favourite Walks.
Cat. by M. van Berghe-Gerbaud, E. Schmitz, and
J. Peeters. Amsterdam: Rijksmuseum; Amsterdam:
Gemeentearchief; and Paris: Institut Néerlandais,
1998–99.

Amsterdam/Toronto 1977
*Opkomst en bloei van het Nordnederlandse stadsgezicht in de 17de eeuw/ The Dutch Cityscape in the
17th Century and Its Sources.* Cat. by B. Haak, R. J.
Wattenmaker, and B. Bakker. Amsterdam: Historisch
Museum; and Toronto: Art Gallery of Ontario, 1977.

Amsterdam/Vienna/New York/Cambridge 1991–92
Seventeenth-Century Dutch Drawings: A Selection from the Maida and George Abrams Collection. Cat. by
W. W. Robinson, with introductions by G. Abrams and
P. Schatborn. Amsterdam: Rijksprentenkabinet,
Rijksmuseum; Vienna: Graphische Sammlung
Albertina; New York: The Pierpont Morgan Library;
and Cambridge: The Fogg Art Museum, Harvard
University Art Museums, 1991–92.

Amsterdam/Washington 1981–82
Dutch Figure Drawings from the Seventeenth Century.
Cat. by P. Schatborn. Amsterdam: Rijksprentenkabinet,
Rijksmuseum; and Washington, D. C.: National
Gallery of Art, 1981–82.

Amsterdam/Zwolle 1992
Episcopius: Jan de Bisschop (1628–1671): Advocaat en tekenaar. Cat. by R. E. Jellema and M. Plomp.
Amsterdam: Museum het Rembrandthuis; and
Zwolle, 1992.

Antwerp 1987
Chefs-d'Oeuvre de l'Albertina. Cat. by W. Koschatzky
and E. Mitsch. Antwerp: Koninklijk Museum voor
Schone Kunsten, 1987.

Berlin 1974
Die Holländische Landschaftszeichnung, 1600–1740: Hauptwerke aus dem Berliner Kupferstichkabinett.
Cat. by W. Schulz. Berlin: Staatliche Museen
Preussischer Kulturbesitz, 1974.

Berlin 1998
A Quintessence of Drawing. Masterworks from the Albertina. Berlin: Deutsche Guggenheim, 1998.

Berlin 2002–2003
Kunstsinn der Gründerzeit. Die Sammlung Adolf von Berckerath. Cat. by H. Bevers, H.-Th. Schulze
Altcappenberg, L. Eisenlöffel, and M. Roth. Berlin:
Staatliche Museen zu Berlin, Kupferstichkabinett,
2002–2003.

Berlin/Amsterdam/London 1991–92
Rembrandt: Der Meister und seine Werkstatt/De Meester en zijn Werkplaats/The Master and His Workshop.
Vol. 1. *Gemälde/Schilderijen/Paintings.* Cat. by C. Brown,
J. Kelch, V. Manuth, B. Schnackenburg, P. van Thiel,
et al. Vol. 2. *Zeichnungen und Radierungen/Tekeningen en Etsen/Drawings and Etchings.* Cat. by H. Bevers,
P. Schatborn, and B. Welzel. Berlin: Gemäldegalerie
and Kupferstichkabinett SMPK; Amsterdam:
Rijksmuseum; and London: The National Gallery,
1991–92.

Bilbao/Vienna 1999
La Quintaesencia del Dibujo. Obras maestras de las colecciones Albertina y Guggenheim. Cat. by T. Krens and
K. Oberhuber, eds. For authors, see New York 1997 and
Berlin 1998. Bilbao: Guggenheim Bilbao Museo; and
Vienna: Graphische Sammlung Albertina, 1999.

Boston/Chicago 2003–2004
Rembrandt's Journey. Painter, Draftsmen, Etcher.
Cat. by C. S. Ackley, R. Baer, T. E. Rassieur, and W. W.
Robinson. Boston: Museum of Fine Arts; and
Chicago: The Art Institute of Chicago, 2003–2004.

Braunschweig 1979
Jan Lievens: Ein Maler im Schatten Rembrandts.
Cat. by R. E. O. Ekkart, S. Jacob, and R. Klessmann,
with an introductory essay by J. Bialostocki.
Braunschweig: Herzog Anton Ulrich-Museum, 1979.

Chicago/Minneapolis/Detroit 1969–70
Rembrandt after Three Hundred Years. Cat. by C. C. Cunningham, J. R. Judson, E. Haverkamp-Begemann, and A.-M. Logan. Chicago: The Art Institute of Chicago; Minneapolis: The Minneapolis Institute of Arts; and Detroit: The Detroit Institute of Arts, 1969–70.

Cologne/Utrecht 1985–86
Roelant Savery in seiner Zeit (1576–1639). Cat. by E. Mai and K. J. Müllenmeister, with H. J. Raupp, A.-C. Buysschaert, and S. Segal. Cologne: Wallraf Richartz-Museum; and Utrecht: Centraal Museum, 1985–86.

Darmstadt 1992
Landschaftszeichnungen der Niederländer, 16. und 17. Jahrhundert: Aus der Graphischen Sammlung des Hessischen Landesmuseums Darmstadt. Cat. by J. Simane and P. Märker. Darmstadt: Hessisches Landesmuseum, 1992.

Dordrecht 1977–78
Aelbert Cuyp en zijn familie-schilders te Dordrecht: Gerrit Gerritsz. Cuyp, Jacob Gerritsz. Cuyp, Benjamin Gerritsz. Cuyp, Aelbert Cuyp. Cat. by W. Veerman, J. M. de Groot, and J. G. van Gelder. Dordrecht: Dordrechts Museum, 1977–78.

Dordrecht 1992–93
De Zichtbaere Werelt: Schilderkunst uit de Gouden Eeuw in Hollands oudste stad. Cat. by C. Brusati, A. Chong, J. M. de Groot, and M. E. Wieseman. Ed. P. Marinjissen, W. de Paus, P. Schoon, and G. Schweitzer. Dordrecht: Dordrechts Museum, 1993.

Frankfurt 1992
Städels Sammlung im Städel: Zeichnungen (Ausstellung anläßlich des 175. Todestages von Johann Friedrich Städel, dem Stifter des Städelschen Kunstinstituts Frankfurt am Main). Cat. by M. Stuffmann, H. Bauereisen, M. Sonnabend, and I. Federlin. Frankfurt am Main: Städelsches Kunstinstitut, 1992.

Ghent 1954
Roelandt Savery. Cat. by P. Eeckhout. Ghent: Museum voor Schone Kunsten, 1954.

Haarlem 2000
Travels through Town and Country. Dutch and Flemish Landscape Drawings 1550–1830. Cat. by H. Verbeek and R.-J. te Rijdt. Haarlem: Teylers Museum, 2000.

Hoorn 1991
Herman Henstenburgh, Hoorns schilder en pastijbakker. Cat. by A. M. Zaal. Hoorn: Westfries Museum, 1991.

Kassel/Amsterdam 2001–2002
Der junge Rembrant. Rätsel um seine Anfänge (The Mystery of the Young Rembrandt), Cat. by E. van de Wetering, and B. Schnackenburg, eds. and D. Hirschfelder, G. Korevaar, E. de Heer, B. van den Boogert, J. Lange, B. C. Mirsch, M. de Winkel, and C. Vogelaar. Kassel: Staatliche Museen Kassel, Gemäldegalerie Alte Meister; and Amsterdam: Museum Het Rembrandthuis, 2000–2001.

Leiden 1976–77
Geschildert tot Leyden Anno 1626. Cat. by M. L. Wurfbain. Leiden: Stedelijk Museum De Lakenhal, 1976–77.

Leiden 1988
Leidse Fijnschilders. Van Gerrit Dou tot Frans van Mieris de Jonge. Cat. by E. J. Sluijter, M. Enklaar, and P. Nieuwenhuizen. Leiden: Stedelijk Museum De Lakenhal, 1988.

London 1929
Dutch Art, 1450–1900. London: Academy of Art, 1929.

London 1986
Dutch Landscape. The Early Years, Haarlem and Amsterdam 1590–1650. Cat. by C. Brown. London: The National Gallery, 1986.

London 1992
Drawings by Rembrandt and His Circle in the British Museum. Cat. by M. Royalton-Kisch. London: British Museum, 1992.

Milan 1970
Rembrandt, Trentotto disegni. Cat. by K. G. Boon, P. Schatborn, and L. Vitali. Milan: Pinacoteca di Brera, 1970.

Minneapolis/Toledo/Los Angeles 1990–91
Mirror of Empire: Dutch Marine Art of the Seventeenth Century. Cat. by G. S. Keyes, D. de Vries, J. A. Weln, and C. K. Wilson. Minneapolis: The Minneapolis Institute of Arts; Toledo: The Toledo Museum of Art; Los Angeles: Los Angeles County Museum of Art, 1990–91.

Moscow/Leningrad 1973
Master Drawings from the Albertina. Cat. by F. Koreny and E. Knab. Moscow: Pushkin Museum; and Leningrad: The Hermitage, 1973.

Munich 1972–73
Das Aquarell 1400–1950. Cat. by W. Koschatzky and H. Pée. Munich: Haus der Kunst, 1972–73.

Munich 1986
Albertina Wien: Zeichnungen, 1450–1950. Cat. by R. Bösel, Ch. Ekelhart, and G. Klimesch. Munich: Kunsthalle der Hypo-Kulturstiftung, 1986.

Munich/Bonn 1993
Das Land am Meer: Holländische Landschaft im 17. Jahrhundert. Cat. by T. Vignau-Wilberg. Munich: Staatliche Graphische Sammlung; and Bonn: Rheinisches Landesmuseum, 1993.

New York 1997
A Quintessence of Drawing, Masterworks from the Albertina. Cat. by K. Oberhuber, ed., and M. Bisanz-Prakken, V. Birke, C. Ekelhart, A. Gnann, A. Hoerschelmann, F. Koreny, E. Pokorny, M.-L. Sternath, and A. Weidinger. New York: Solomon R. Guggenheim Museum, 1997.

New York/Fort Worth 1995
Drawings from the Albertina. Landscape in the Age of Rembrandt. Cat. by M. Bisanz-Prakken. New York: The Drawing Center; and Fort Worth: Kimbell Art Museum, 1995.

New York/Forth Worth/Cleveland 1990–91
Von Pisanello to Cézanne: Master Drawings from the Museum Boymans-van Beuningen, Rotterdam. Cat. by G. Luijten and A. W. F. M. Meij. New York: The Pierpont Morgan Library; Fort Worth: The Kimbell Art Museum; Cleveland: The Cleveland Art Museum, 1990–91.

Paris 1950
Le Paysage hollandais au XVIIe siècle. Paris: Orangerie des Tuileries, 1950.

Paris 1983
Reflets du Siècle d'Or. Cat. by S. Nihom-Nijstad. Paris: Collection Frits Lugt, Fondation Custodia, Institut Néerlandais, 1983.

Paris 1989
Eloge de la Navigation hollandaise au XVIIe siècle: Tableaux, dessins et gravures de la mer et de ses rivages dans la Collection Frits Lugt. Cat. by C. van Hasselt and M. van Berge-Gerbaud. Paris: Fondation Custodia, Institut Néerlandais, 1989.

Philadelphia/Berlin/London 1984
Masters of Seventeenth-Century Dutch Genre Painting. Cat. by P. Sutton, C. Brown, J. Kelch, O. Naumann, and W. W. Robinson. Philadelphia: The Philadelphia Museum of Art; West Berlin: Gemäldegalerie, Staatliche Museen Preussischer Kulturbesitz; and London: Royal Academy of Arts, 1984.

Pittsburgh/Louisville/Fresno 2002
Masterworks from the Albertina. Cat. by K. A. Schröder and M.-L. Sternath., eds., and M. Bisanz-Prakken, C. Ekelhart-Reinwetter, G. Gruber, and H. Widauer. Pittsburgh: The Frick Art and Historical Center; Louisville: The Speed Art Museum; Fresno: Metropolitan Museum of Art, 2002.

Rotterdam/Amsterdam 1956
Rembrandt: Tentoonstelling ter herdenking van de geboorte van Rembrandt op 15 juli 1606: Tekeningen. Cat. by E. Haverkamp-Begemann. Rotterdam: Museum Boymans van Beuningen; and Amsterdam: Rijksmuseum, 1956.

Rotterdam/Frankfurt 1999–2000
Hollandischer Klassizismus in der Malerei des 17. Jahrhunderts. Cat. by A. Blankert, J. Giltaij, F. Lammertse, K. Ottenheyn, and A. J. Gelderblom. Rotterdam: Museum Boymans van Beuningen; and Frankfurt am Main: Städelsches Kunstinstitut, 1999–2000.

Stockholm 1956
Rembrandt. Cat. by B. Dahlbäck and P. Bjurström, with an introductory essay by C. Nordenfalk. Stockholm: National Museum Stockholm, 1956.

Sydney 2002
Old Master Drawings from the Albertina. Cat. by M. Bisanz-Prakken and M. Dachs. Sydney: Art Gallery of New South Wales, 2002.

Utrecht 1965
Nederlandse 17e eeuwse Italianiserende Landschapschilders. Cat. by M. E. Houtzager, H. J. de Smedt, and A. Blankert. Utrecht: Centraal Museum, 1965. 2d rev. ed. A. Blankert. *Nederlandse 17e eeuwse Italianiserende Landschapschilders.* Soest, 1978.

Vienna 1936
Die holländische Landschaft im Zeitalter Rembrandts. Cat. by O. Benesch. Vienna: Graphische Sammlung Albertina, 1936.

Vienna 1956
Rembrandt: Ausstellung im 350. Geburtsjahr des Meisters. Cat. by O. Benesch and E. Knab. Vienna: Graphische Sammlung Albertina, 1956.

Vienna 1958
Neuerwerbungen alter Meister, 1950–1958. Cat. by O. Benesch. Vienna: Graphische Sammlung Albertina, 1958.

Vienna 1964–65
Claude Lorrain und die Meister der römischen Landschaft im XVII. Jahrhundert. Cat. by E. Knab. Vienna: Graphische Sammlung Albertina, 1964–65.

Vienna 1965
Hundert ausgewählte Zeichnungen von Pisanello bis Rembrandt aus eigenem Besitz. Cat. by W. Koschatzky and A. Strobl. Vienna: Graphische Sammlung Albertina, 1965.

Vienna 1969
200 Jahre Albertina: Herzog Albert von Sachsen-Teschen und seine Kunstsammlung. Cat. by W. Koschatzky. Vienna: Graphische Sammlung Albertina, 1969.

Vienna 1969–70
Die Rembrandt-Zeichnungen der Albertina. Cat. by E. Mitsch. Vienna: Graphische Sammlung Albertina, 1969–70.

Vienna 1970–71
Rembrandt. Radierungen aus dem Besitz der Albertina. Cat. by E. Mitsch. Vienna: Graphische Sammlung Albertina, 1970–71.

Vienna 1974–75
Otto Benesch Gedächtnisausstellung. Cat. by W. Koschatzky and A. Strobl. Vienna: Graphische Sammlung Albertina, 1974–75.

Vienna 1988
Prag um 1600: Kunst und Kultur am Hofe Kaiser Rudolfs II. Cat. by C. Beaufort et al. 2 vols. Vienna: Kunsthistorisches Museum, 1988.

Vienna 1993
Die Landschaft im Jahrhundert Rembrandts: Niederländische Zeichnungen des 17. Jahrhunderts aus der Graphischen Sammlung Albertina. Cat. by M. Bisanz-Prakken. Vienna: Graphische Sammlung Albertina, 1993.

Vienna 2004
Rembrandt. Cat. by K.A. Schröder and M. Bisanz-Prakken, eds., and S. A. C. Dudok van Heel, G. Luijten, P. Schatborn, M. Sitt, and E. van de Wetering. Vienna: Graphische Sammlung Albertina, 2004.

Vienna/Amsterdam 1989–90
Begegnungen/Ontmoetingen: Meisterwerke der Zeichnung und Druckgraphik aus dem Rijksprentenkabinet in Amsterdam und der Albertina in Wien/Meesterwerken van teken- en prentkunst uit de Albertina in Wenen en het Rijksprentenkabinet in Amsterdam. Cat. by M. Bisanz-Prakken, C. Ekelhart, J. P. Filedt Kok, I. de Groot, F. Heybroek, F. Koreny, E. Mitsch, J. W. Niemeijer, K. Oberhuber, M. Schapelhouman, P. Schatborn, and M.-L. Sternath. Vienna: Graphische Sammlung Albertina; and Amsterdam: Rijksprentenkabinet, Rijksmuseum, 1989–90.

Washington 1990
Rembrandt's Landscapes: Drawings and Prints. Cat. by C. P. Schneider; B. Bakker, N. Ash, and S. Fletcher. Washington, D.C.: National Gallery of Art, 1990.

Washington/London/Amsterdam 2001–2002
Aelbert Cuyp. Cat. by A. Wheelock, ed., and J.M. de Groot, A. Chong, E. E. S. Gordenker, M. Spring, E. Haverkamp-Begemann, and W. Kloek. Washington, D. C.: National Gallery of Art; London: The National Gallery; and Amsterdam: Rijksmuseum, 2001–2002.

Washington/New York 1986–87
The Age of Bruegel: Netherlandish Drawings in the Sixteenth Century. Cat. by J. O. Hand, J. R. Judson, W. W. Robinson, and M. Wolff. Washington, D. C.: National Gallery of Art; and New York: The Pierpont Morgan Library, 1986–87.

Washington/New York/Vienna 1984–86
Old Master Drawings from the Albertina. Cat. by V. Birke, M. Bisanz-Prakken, C. Ekelhart, E. Knab, F. Koreny, W. Koschatzky, E. Mitsch, and A. Strobl. Washington, D. C.: National Gallery of Art; New York: The Pierpont Morgan Library; and Vienna: Graphische Sammlung Albertina, 1984–86.

INDEX

Pages numbers in *italics* refer to illustrations.

A

Albertina Sketchbook, The, 48
Alkmaar, 166, 174, 190, 192
Amstel River, 36, 80, 82, 176
Amsterdam, 18, 22, 34, 36, 40, 54, 56, 72, 74, 76, 106,
 108, 114, 118, 120, 138, 150, 174, 178, 180, 182,
 185, 198, 204, 206, 214, 216, 218, 226, 228
Anglo-Dutch War, 120, 202, 204 and *n.* 3
animals, 12, 22, 30, 60, 148, 224, 235
Antwerp, 18, 26, 30, 32, 34, 40, 50, 180, 198
Arnhem, 50, 144, 158, 164
Asselyn, Jan, 15, 216–17, 218, 222, 226, 228
 View of Porta del Popolo, Rome, 216 and *n.* 3
 *View of the Chancel of the Church of SS. Giovanni e
 Paolo in Rome,* 216, *217*
Atlas Blaeu/van der Hem, 172, 228 and *n.* 3
Avercamp, Hendrick, 12, 36–37, 131
 Small Harbor with a Tavern on a River Estuary,
 36, *37*

B

Backer, Jacob, 106
Bakhuizen, Gerard, 206
Bakhuizen (Backhuysen), Ludolf, 14, 194–95, 206–11
 *Dutch Coastal Sailing Ships at a Mooring Place
 with a Light Breeze,* 206
 Harbor View with an Approaching Storm, 206,
 207, 211
 The Roadstead Southeast of Texel Island, 211 *n.* 5
 Ships on a Stormy Sea, 206, *209, 210,* 211
 Stormy Sea with a Ship in Distress, 206, *208,* 211
 *Two Ice Skaters on a Castle Moat with a View of
 the Vecht River,* 194, *195*
Baroque, 13, 70, 236
Battem, Gerrit, 14, 188–89
 View of Rotterdam from the North, 188, *189*
Bega, Cornelis, 13, 112–13, 116, 134
 Young Woman Sitting in the Midday Sun, 112, *113*
Bega, Pieter Jansz., 112
Benesch, Otto, 86, 102 and *n.* 4, 118

Berchem, Nicolaes, 12, 15, 118, 218–21
 The Ferry, 220 *n.* 2
 *Imaginary Rocky Landscape with a Castle and
 Hunters,* 172, 220, *221*
 *Mountain Landscape with Horseman, Beggars, and
 Reapers,* 220 *n.* 1
 River Landscape near Montfoort, 218, *219*
Berckheyde, Gerrit, 112, 116, 134, 190
Berlin, 62
Bible, 30, 54, 90, 92, 96, 98, 108
Bisanz-Prakken, Marian, 102 *n.* 3
Blaeu's World Map, 26
Block, Agnes, 235
Bloemaert, Abraham, 24, 148, 212, 222
Bol, Hans, 36
Bolswert, B. A., 30
Both, Andries, 216, 222
Both, Dirck, 222
Both, Jan, 15, 142, 216, 218, 222–23
 Landscape with a Draftsman, 222 *n.* 4
 Landscape with Robbers Leading Prisoners, 222 *n.* 4
 Wooded Mountain Landscape with Travelers,
 222, *223*
Breenbergh, Bartholomeus, 14–15, 186, 212,
 214–15, 226
 View of Mugnano, 214, *215*
Bril, Paul, 18, 34, 212 and *n.* 6, 214
British Museum, London, 69, 95 *n.* 5
Bronkhorst, Johannes, 232, 235
Brouwer, Adriaen, 24, 126, 131, 134
Bruegel, Pieter, 22, 24, 89, 131, 162, 170, 172
Brueghel, Jan the Elder, 14, 36, 131, 236
Brussels, 50
Buytewech, Willem, 38, 40, 131, 170

C

Calcar, 144
Callot, Jacques, 169 and *n.* 12
Charles I, King of England, 212
Claesz, Nicolaes, 218
Clock, Cornelis Cornlisz., 46
Commedia dell'Arte, 62
Coninxloo, Gillis van, 26, 32

Cuyp, Aelbert, 12, 14, 15, 38, 142–49
 Orpheus Making Music for the Animals, 148 *n.* 3
 *Panoramic Landscape with a View of the Dean's
 House in Maarsbergen,* 142, *143*
 Reclining Dog, 148, *149*
 Ruins of Ubbergen Castle, 146, *147*
 View of Arnhem from the Northwest, 144 *n.* 5
 View of Arnhem from the South, 144, *145*
Cuyp, Jacob Gerritsz., 142, 148

D

Dalens, Dirk II, 188
Danzig, 158
Davies, Alice, 166
de Bisschop, Jan, 14, 15, 186–87, 226–27
 Paradigmata Graphices, 226
 Signorum veterum Icones, 226
 *Southern Landscape with Mountains and a River
 Plain,* 226, *227*
 *View of The Hague from the Northwest with Delft
 in the Distance,* 186, *187,* 218 *n.* 4
de Bray, Dirck, 114
de Bray, Jan, 112, 114 and *n.*4, 116, 134
de Bray, Joseph, 114
de Bray, Salomon, 13, 114, 116, 192
 The Martyrdom of Saint Catherine of Alexandria, 114
 Triumphal Procession of Frederick Hendrik, 116
de Bray, Salomon, circle of, 114–15
 *Boy Climbing a Stair, Viewed from behind, with
 a Fragment of a Wheel,* 114, *115*
de Bray, Simon, 114
de Bruyn, Nicolaes, 28
de Cock, Maerten, 12, 34–35
 Herd of Cattle at the Edge of a Forest, 34, *35*
de Gheyn, Jacques I, 18
de Gheyn, Jacques II, 12, 15, 18–21, 24, 114, 152
 Seated Gypsy Woman and Child, 20, *21*
 *Wooded Landscape with a Lancer (?) and a Barking
 Dog,* 18, *19*
de Grebber, Pieter, 192, 218
de Heem, Jan Davidsz., 232
de Heer, Willem, 235
de Jonge, Jan Martsen, 216

Delft, 150, 186
de Man, Jan Arentsz., 46
de Moucheron, Frederick, 172
de Moucheron, Isaac, 186 *n.* 3
de Passe, Crispijn II, 22 and *n.* 7
de Vlieger, Simon, 14, 150–51, 164, 200, 204
 Beach near Egmond, 150 *n.* 4
 Beach near Scheveningen, 150
 Beach Scene, 150
 Fish Market on the Beach in Egmond, 150, *151*
d'Hondecoeter, Gijsbert, 32
d'Hondecoeter, Gillis Claesz., 12, 30, 32–33
 *Densely Wooded Landscape with a Water Mill and
 Houses,* 32, *33*
d'Hondecoeter, Hans, 32
d'Hondecoeter, Melchior, 32
d'Hondecoeter, Nicolaes Jansz., 32
Doomer, Herman, 174
Doomer, Lambert, 14, 172, 174–75, 228
 Village Street with a Barn, 174, *175*
Dordrecht, 108, 142
Dou, Gerrit, 124, 138
Dubbels, Hendrick, 206
Du Bois, Guillaume, 112
Dughet, Gaspard, 222
Dujardin, Karel, 118
Dürer, Albrecht, 20, 30
Dusart, Cornelis, 12, 13, 132, 134–37
 Lively Peasant Group in a Barn, 134, *135,* 137
 A Seated Smoker, His Eyes Closed, 137 *n.* 4
 *Seated Young Man with a Fur Hat and Vented
 Sleeves,* 134, *136*

E
early genre and landscape, 12, 18–51
Eindhoven, 126
Elsheimer, Adam, 212
Emden, 206
England, 123, 180, 204, 206, 212, 228
Esselens, Jacob, 172, 194
Eugene, Prince of Savoy, 172

F
Flinck, Govaert, 13, 106–107
 Seated Young Woman, 106, *107*
Fragonard, Jean-Honoré, 110
France, 169, 174, 182, 204 and *n.* 3, 216, 228
Furnerius, Abraham, 188

G
Gallis, Pieter, 232
genre, 12, 13
 early landscape and, 18–51
 mid-century portraiture and, 104–39
Germany, 112, 158, 182, 228
Gerritsz., Willem, 46
Gerszi, Teréz, 32
Glück, Heinrich, 100
Goltzius, Hendrick, 14, 18, 20, 38, 114, 124, 152,
 192, 202
Gooi region, 70
Guild of St. Luke, 38, 40, 112, 116, 132, 134, 138, 218

H
Haagsche Bos, 164
Haarlem, 12, 13, 18, 22, 38, 40, 44, 46, 112, 114, 116,
 126, 132, 134, 152, 166, 180, 192, 198, 218
Hackaert, Jan, 172
Hague, The, 18, 40, 44, 46, 144, 157, 164, 186, 226
 Huis ten Bosch, 114, 116
Hals, Frans, 12, 126, 131
Hamburg, 158, 169
Helmbreker, Dirck, 112, 116
Hendrik, Frederick, 116, 157
Henstenburgh, Anthony, 232
Henstenburgh, Herman, 12, 15, 232–35
 Still Life of Fruit with a Finch and Sea Snail Shells,
 frontispiece, 232, *234,* 235
 Still Life of Fruit with Chestnuts and a Snail, 232,
 233, 235
Hobbema, Meindert, 190
Hofbibliothek, Vienna, 172
Holstein, 158
Hoorn, 46, 232
Houbraken, Arnold, 116, 118, 124, 126, 132, 138, 164,
 166, 218
Huijgens, Constantijn, 116, 186
Huquier, Gabriel, 220
Huygens, Christian, 186

I
Icones Varium Navium Hollandicarum, 198
India, 100
Isacks, Pieter, 36
Italianate and marine landscape, 14, 198–229
Italy, 14–15, 18, 138, 166, 182, 212, 214, 216, 222,
 226, 228

J
Jacobsz., Lambert, 106
Jahan, Shah, 100
Jahangir, Great Mughal, 100
Jordaens, Jacob, 116

K
Kampen, 12, 36
Kleve, 50, 142, 164
Koninck, Jacob, 178
Koninck, Philips, 14, 178–79, 188
 Open Landscape with a Windmill and Houses, 178, *179*

L
landscape, 12, 13–14, 15
 early genre and, 18–51
 marine and Italianate, 14, 198–229
 mid-century, 142–95
Landscape in the Age of Rembrandt (exhibition), 12
Lastman, Pieter, 110, 180
Leeuwarden, 106
Leiden, 13, 46, 54, 120, 124, 138, 180, 185, 198
Leupenius, Johannes, 14, 176–77
 Group of Trees on the Water, 176, *177*
 Nijenrode Castle on the Vecht, 176
Lievens, Jan, 14, 54 *n.* 2, 176, 180–81
 View of a Group of Houses Surrounded by Trees,
 176, 180, *181*
 View of Haarlem, 180
Loire River, 228
Londerseel, Johannes, 28
London, 123, 180
Lorrain, Claude, 72, 222, 226
Lugt, Fritz, 186 *n.* 3
Lüneburg, 158
Lyon, 216

M
Maarsbergen, 142
Maes, Nicolaes, 13, 108–109, 110
 Old Woman Contemplating the Bible, 108, *109*
 *Old Woman with her Hands Folded Reading the
 Bible,* 108
Mannerism, 12, 14, 20, 22, 28, 32, 34, 38, 144, 211,
 212, 214
marine and Italianate landscape, 14, 198–229
Matham, Jacob, 38
Medici, Cosimo III de', 232
Merian, Maria Sibylla, 235
mid-century genre and portraiture, 13, 106–39

mid-century landscape, 13–14, 142–95
Moeyaert, Nicolaes, 218
Molyn, Pieter, 32, 44, 46, 152, 166, 170, 198
Montfoort, 218
Mughal miniatures, 100
Mulier, Pieter, 218
Musée du Louvre, Paris, 102
Muziano, Girolamo, 18

N

National Gallery of Canada, Ottawa, 64
Nijmegen, 146
Norway, 166
nudes, 66–69

O

Orlers, Jan J., 46
Orsini, Duke Paolo Giordano, 214

P

Paris, 169, 226 n. 4
peasant genre, 13, 112, 131, 132, 134, 137
Perelle, Gabriel, 216
Philip IV, King of Spain, 222
Pisanello, 95
Poland, 158
Porcellis, Jan, 14, 150, 198–99, 200
 Damloopers, 198 n. 5
 Een zeeusche Koch (A Zeeland Cog), 198
 A Zeeland Cog (Een zeeusche Koch), 198, *199*
portraiture, 13
 mid-century genre and, 104–39
Potter, Pieter, 118
Poussin, Nicolas, 222, 226
Prague, 22, 30
Pynas, Jacob, 214

R

Rademaker, Abraham, 190
Rembrandt, Pupil of, *Standing Male Nude,* 69 n. 2
Rembrandt, School of, 66–69
 Standing Male Nude, 66, *67,* 69
Rembrandt Harmensz. van Rijn, 12, 13, 14, 15, 38,
 54–103, 106, 108, 110, 120, 124, 131, 174 and n. 1,
 176, 180, 182, 188, 194
 Adam and Eve, 60
 Annunciation to the Shepherds, 70
 Bust of a Sleeping Child, 86, *88,* 89
 Child in a Small Chair with Nanny, 56, *58,* 59

Christ Disputing with the Doctors, 89 n. 1
*Christ Healing the Sick ("The Hundred Guilder
 Print"),* 90, *91,* 92
Christ with His Disciples and the Bleeding Woman,
 98, *99*
A Coach, 74
Cottages under a Stormy Sky, 70, *71*
Ecce Homo, 92, 95n.4, 96, *97*
An Elephant, 60
"Het Molentje," 82 and n. 3
Indian Prince, Presumably Emperor Jahangir, 100, *101*
Landscape with Stone Bridge, 70
The Life of Women with Children, 20, 56
*Male Nude, Standing and Sitting (The Child's
 Walker),* 66, *68,* 69
*Man with a Wooden Leg, a Crutch, and a Cane,
 Seen from Behind,* 86, 89, *89*
The Night Watch, 90
Old Man with a Wide-Brimmed Hat, Seated, 86, *87*
*Open Landscape with Houses and a Windmill
 (The Former Copper Mill on the Weesperzijde),*
 80, *81*
The Quack, 62, *63*
The Raising of Lazarus, 54, *55*
*Self-Portrait, The Artist Drawing on an Etching
 Plate,* 102 n. 2
Self-Portrait at the Easel, 102
Self-Portrait in Beret, 102, *103*
Self-Portrait with Two Circles, 102 n. 2
The Snail, 74
The Three Crosses (c. 1653), 13, 92, *93, 94,* 95, 96
Three Gabled Cottages, 84, *85*
*Three Studies of an Elephant, an Attendant
 Alongside,* 60, *61*
The Three Trees, 72, *73,* 174
Two Boyers at Anchor, with a Man Taking in Sail,
 74, *75*
View of "Het Molentje" ("The Little Windmill"),
 82, *83*
View of the Pesthuis from the Ramparts, 76, *78,* 79
View over the Ramparts near the "De Tor" Mill,
 76, *77,* 79
View over the Ramparts near the Heiligewegspoort,
 76, *77,* 79
A Young Woman at Her Toilet, 64, *65*
*Young Woman with a Child in a Harness;
 Half-Length Figure of a Man,* 56, *57,* 59
Renaissance, 95, 138
Rhenen, 144, 158, 192
Rhine River, 172
Rijksmuseum, Amsterdam, 26, 90, 120, 182, 185, 194
Robinson, William, 86
Roghman, Hendrick Lambertsz., 182

Roghman, Roelant, 14, 164, 182–85
 Duurstede Castle, 182, *184,* 185
 Swieten Castle, 182, *183,* 185
Rome, 14–15, 138, 212, 214, 216, 222, 226
Rosendael, Nikolaes, 138
Rotius, Jacob, 232
Rotterdam, 38, 150, 170, 188, 198
Rotte River, 188
Rubens, Peter Paul, 112, 180
Rudolf II, Emperor, 22
Rutgers, Abraham, 14, 194–95
 *Two Ice Skaters on a Castle Moat with a View of
 the Vecht River,* 194, *195*

S

Saenredam, Jan, 24, 192
Saenredam, Pieter Jansz., 14, 192–93
 *Interior of the Groote Kerk (Church of St. Lawrence)
 in Alkmaar,* 192, *193*
Saftleven, Abraham, 170
Saftleven, Cornelis, 148, 170
Saftleven, Herman, 14, 24, 170–73, 188, 235
 Dunes with a Village and a View of the Sea, 170, *171*
 Mountainous Landscape on the Rhine, 172, *173*
 Rhine Fantasies, 220
Savery, Jacques, 22, 30, 36, 131
 Earthly Paradise, 30
 Orpheus and the Animals, 30
Savery, Roelant, 12, 14, 15, 22–25, 30, 32, 131, 142,
 162, 166, 169, 170, 172, 182, 200, 220, 236
 Elephant Rubbing against a Tree, 22, *23*
 Elephant with a Monkey on Its Back, 22
 Farmyard with a Beggar Woman, 24, *25*
Schatborn, Peter, 118
Schellinks, Willem, 15, 228–29
 The Fontana Nuova near Valletta, 228, *229*
Schnackenburg, B., 132
Schönbrunn Castle, Vienna, 100
Seghers, Hercules, 38, 40, 72, 200 n. 3
Soeterwoude, 198
Spain, 146, 222
Steen, Jan, 12, 131, 134
still life, 15, 232–40
Sumowski, Werner, 106
Sweden, 166
Switzerland, 112, 228

T

ter Borch, Gerard the Elder, 120
ter Borch, Gerard the Younger, 13, 110, 120
ter Borch, Moses, 13, 120–23
 Head of a Young Woman, 120, *122*, 123
 Self-Portrait, 120, *121*, 123
Teylers Museum, Haarlem, 114 and *n.* 4, 182
Thobois, Elisabeth, 102 *n.* 3
Titian, 178
Toorenvliet, Abraham, 124, 138
Toorenvliet, Jacob, 13, 138–39
 Kitchen Maid Cleaning a Kettle with Two Joking Men, 138, *139*
 Market Scene, 138 *n.* 5

U

Utrecht, 22, 24, 142, 148, 166, 170, 182, 188, 192, 212, 218, 222
Uylenburgh, Hendrick, 56

V

Vaillant family, 158
van Amstel, Cornelis Ploos, 34
van Campen, Jacob, 116, 192
van Coninxloo, Gillis, 40
van de Capelle, Jan, 56, 64 *n.* 2, 204
van den Eeckhout, Gerbrand, 13, 110–11, 182
 Boy Leaning on a Chair, 110, *111*
van den Eeckhout, Jan Pietersz., 110
van den Tempel, Abraham, 124
van der Cooghen, Leendert, 13, 112, 116–17
 Head of a Soldier in a Plumed Beret, 116
 Standing Halberdier Holding a Lance; Study of a Halberd, 116, *117*
van der Hagen, Abraham, 164
van der Hagen, Joris, 14, 164–65
 In the "Haagsche Bos," 164, *165*
van der Hem, Laurens, 172, 228
 Atlas Blaeu, 172, 228 and *n.* 3
van der Heyden, Jan, 190
van der Vinne, Vincent, 112
van de Velde, Adriaen, 13, 15, 118–19, 134, 204, 224–25
 The Shepherd, 224 *n.* 3
 Shepherdess and Shepherd with Animals at a Stream, 224, *225*
 Standing Shepherd Boy, 118, *119*, 224
van de Velde, Esaias, 12, 32, 34, 36, 38, 40–45, 46, 76, 131, 152, 169, 216
 Fortified City on a River, 40, *42*, 43
 Ruins of a Tower and Houses on a Country Road, 44, *45*

Village Street with a Dilapidated Mill, 40, *42*, 43
Winter Landscape with Ice Skaters, 40, *41*, 43
van de Velde, Hans, 40
van de Velde, Jan II, 12, 38–39, 40, 43, 131, 144
 Dune Landscape with Two Resting Figures, 38, *39*
 Pastoral Landscape with a Farm and Ruins, 38, *39*
 Some Pleasing Landscapes, 38
van de Velde the Elder, Willem, 12, 14, 118, 202–203, 204, 206
 Merchant Ships with Lighters on a Rough Sea, 202, *203*
van de Velde the Younger, Willem, 12, 14, 118, 202, 204–205, 206
 The Naval Battle at La Hogue, 204, *205*
van Dyck, Anthony, 180
van Eindhoven, Jan Hendricx., 126
van Everdingen, Allart, 12, 14, 166–69, 190–91, 200–201, 206
 Log Cabins on a Stream in Scandinavia, 166, *167*, 169
 Nordic Landscape with Wooden House on a Weir, 169 *n.* 9
 Risor, 169 *n.* 5
 Rocky Coast in Stormy Weather, 200, *201*
 Scandinavian Landscape with a Wooden House, 169 *n.* 9
 Storm on a Rocky Coast, 200
 Two Travelers in a Mountain Landscape, 169 *n.* 5
 View of Alkmaar from the Southeast, 190, *191*
 View of Alkmaar with Boats on the Zeglis, 190
 View of a Village with a Flogging Scene, 166, *168*, 169
 Waterfall and Sawmill, 166
van Everdingen, Cesar, 166
van Goyen, Jan, 12, 14, 32, 40, 44, 46–51, 76, 142, 152, 169, 170, 198, 200, 218
 Bridge with a Horseman and Two Figures outside a Village, 48, *49*
 Country Road with a Farm and a One-Horse Cart, 46, *47*
 Country Road with Groups of Figures in Front of a Village with a Church, 50, *51*
 Dune Landscape with Houses and Two Figures, 48, *49*
van Haarlem, Cornelis, 20, 114
van Hoogstraten, Samuel, 69, 110
 Introduction to the High School of Painting, 110
 Standing Male Nude, 69 *n.* 2
van Huysum, Jacob, 236
van Huysum, Jan, 12, 15, 236–40
 Fruits and Flowers, 240 *n.* 7
 Roses, Tulips, Carnations and Other Flowers in a Sculptured Urn on a Stone Ledge with a Bird's Nest, 240 *n.* 5
 A Still Life of Flowers in a Terracotta Vase upon

a Marble Ledge before a Niche, 240 *n.* 6
A Still Life of Fruit in a Basket with Flowers and Other Fruit, 240 *n.* 7
Still Life of Flowers: Vase in front of an Arched Niche, 236, *238*, 240
Still Life of Flowers: Vase with a Relief of Putti, Standing on a Stone Plate, 236, *237*, 240
Still Life of Fruit in front of a Vase, 236, *239*, 240
van Huysum, Justus, 236
van Huysum, Justus II, 236
van Laer, Pieter, 118, 216, 218
van Leyden, Lucas, 20
 Ecce Homo, 96
van Mander, Karel, 20, 24
van Mieris, Jan, 124
van Mieris, Jan Bastiaensz., 124
van Mieris, Willem, 124
van Mieris the Elder, Frans, 13, 124–25, 138
 Sick Woman in Bed, 124, *125*
van Mieris the Younger, Frans, 124
van Nieulandt, Willem, 212 *n.* 6
van Nikkelen, Izaak, 192
van Ostade, Adriaen, 12, 13, 24, 112, 126–31 and *n.* 1, 132, 134, 137
 Group of Peasants in a Tavern, 126, *127*, 131
 Peasants Smoking and Drinking outside an Inn, 126, *128*, 131
 Room at an Inn with Peasants Drinking, Smoking, and Playing Tric-Trac, 126, *129*, *130*, 131
van Ostade, Isack, 12, 13, 24, 126, 131 and *n.* 1, 132–33, 134
 Peasant Inn with a Fiddler and a Dancer in the Middle of the Room, 132
 Peasants at an Inn with a Fiddler and Dancers, 132, *133*
van Poelenburch, Cornelis, 14–15, 212–13, 214, 222, 226
 The Aurelian Wall in Rome with a View of S. Stefano Rotondo (attributed to Cornelis van Poelenburch), 212, *213*
van Rijn, Saskia, 56, 64
van Rijn, Titus, 56
van Ruisdael, Jacob, 157, 164, 186, 190, 218
van Ruysdael, Salomon, 12, 46, 170, 198
van Santvoort, Pieter, 46
van Schilperoort, Conraet, 46
van Swanenburgh, Isaack Claesz., 46
van Swanevelt, Herman, 222, 226
van Wieringen, Cornelis Claesz., 38
Vecht River, 176, 194, 235
Venice, 18, 138, 222
Vermeer, Jan, 12, 110, 131
Vienna, 62, 100, 138, 169, 172, 185
Vinckboons, David, 12, 26–31, 32, 36, 40, 131

Adam and Eve in Paradise with Animals, 30, *31*
Landscape with a Hare Hunt, 28, *29*
Nautical Company, 26, *27*
Religious Gathering, 26
Vinckboons, Philip, 26
Visscher, Claes Jansz., 36, 38, 198
Visscher the Younger, Cornelis, 116
von Sachsen-Teschen, Duke Albert, 12, 48, 110, 144,
 174, 232
Voorburg, 198
Vroom, Cornelis Hendricksz., 14, 152–57, 198
 Trees behind a Wooden Fence, 152, *153,* 157
 Wooded Country Road with a Traveler, 152, *155,* 157
 Wooded Road with Two Horse-Drawn Carts, 152,
 154, 156, 157
Vroom, Hendrick Cornelisz., 152, 198

W

Waterloo, Anthonie, 14, 158–63, 164
 Heiligenbrunner Spring near Hermannshof near
 Danzig-Langfuhr, 158, *160,* 161
 The Hermannshof Inn near Danzig-Langfuhr, 158,
 159, 161
 Two Gnarled Trees, 162, *163*
Weenix, Jan Baptist, 218
Weesp, 150, 204
Willaerts, Adriaen, 200
Wils, Jan, 218
Wynants, Jan, 118